1499

MW00668560

**Linking Shipping
with
Public Benefit and Culture**

GREEK ART

GREEK ART

ANCIENT GOLD JEWELLERY

AIKATERINI DESPINI

Former Ephor of Antiquities

EKDOTIKE ATHENON

Publisher: George A. Christopoulos

Managing editors: Aristeides G. Christopoulos, John C. Bastias

Series editor: Efi Allamanis
Art director: Angela Simou
Editor: Thetis Xanthakis
Assistant editor: Eleni Xypolitou
Translation: Alexandra Doumas
Photo research: Lina Andrianakis, Evi Atzemis,
 Aikaterini Dracopoulou-Pesmazoglou
Proof reading: Rania Oikonomou
Secretariat: Regina Geroulanou
Phototypesetting: S. Panagopoulos & Co.
Colour separations: Ekdotike Hellados S.A.

Production director: Emil C. Bastias
Printed and bound by Ekdotike Hellados S.A.

ISBN 960-213-311-2

Copyright © 1996 by Ekdotike Athenon S.A.
11 Omirou St., Athens 106 72
Printed and bound in Greece

CONTENTS

PROLOGUE

In the modern age, deeply scarred as it is by painful disputes and realignments, we have a duty and a moral obligation to promote those values and ideals that have remained constant and unsullied throughout the ages, so that contemporary man, in his spiritual and intellectual anxiety, may be guided effectively on his course to his imaginary Ithake.

Greek art is a fertile concurrence of myth and reason, a perfect matching of idea and deed, a celebration of and a hymn to mankind and his works. Through its continuity, its cohesion, its ability to assimilate, and its robust vigour over the long course of its evolution, Greek art has become a life-giving spring, the fount of spiritual and intellectual endeavour, and a decisive parameter of our moral destiny.

Ekdotike Athenon long ago noted the lack of a comprehensive work through which the reader could become acquainted with, or consolidate his knowledge of the multi-faceted and diverse representational arts of Hellenism, from the Neolithic period to the present day. We felt that there is a pressing need today for the publication of a series of visually rich, scholarly volumes devoted to the complete spectrum of Greek art; a need for Greeks not only to become acquainted with their own roots and to forge their cultural identity, but also to proclaim the achievements to the Greek nation and ensure a proper awareness of Greece's historical role, both within the European Union and internationally. Three eminent Greek scholars, the late Manolis Andronikos, and Manolis Chatzidakis and Chrysanthos Christou, both members of the Athens Academy, shared our concerns and have made invaluable contributions towards the planning of this arduous, time-consuming and costly enterprise. They have not only selected the forms of Greek art to be presented in each volume, and determined its structure, but have also assigned the composition of the relevant texts to experts and scholars of repute.

In accordance with the overall plan for the series, which will initially comprise fifteen volumes, the art of the prehistoric period is presented in a single, comprehensive volume, the Dawn of Greek Art - Early Art, Cycladic, Minoan and Mycenaean Art; the art of Antiquity appears in five volumes (Ancient Vases, Ancient Sculpture, Ancient Gold Jewellery, Ancient Silver and Bronze Works of Art, Ancient Coins); the art of Byzantium in four volumes (Byzantine Mosaics, Byzantine Wall-paintings, Byzantine Icons, Byzantine Illuminated Manuscripts); and five volumes are devoted to the art of Modern Hellenism (Folk Art, Modern Greek Engraving, Modern Greek Sculpture, Nineteenth Century Painting, and Twentieth Century Painting).

Each volume is divided into three sections. The first contains a general introduction that records the evolution of the art form dealt with by the volume, with reference mainly to matters of style. This

is followed, in the second section, by a superb illustration of the most brilliant and representative works of the art form in question, which have been specially photographed in situ on monuments, and in museums, art galleries, and public and private collections, in Greece and abroad. This is an uninterrupted, self-contained unit that enables the reader to approach the works depicted directly, both as individual items and as an ensemble, without any visual or intellectual distraction. For, over and above their obvious dependence on the socio-historical context of their period and the personality of their creator, works of art also function as entities in their own right, with an innate, autonomous value. The third section of each volume consists of full, concise entries dealing with the works, which offer an aesthetic analysis and evaluation, relevant historical information, biographical data relating to their creators or brief discussions of the monuments that they adorn, and bibliographical notes. Finally, each volume is enriched by a general bibliography, an index and, when necessary, diagrams.

The challenge, and consequently the responsibility, involved in carrying out this noble and ambitious enterprise, is unquestionably great. In the past, however, Ekdotike Athenon has readily accepted similar challenges, and is widely respected for the high quality of the resulting publications – a quality that has been recognised and has received accolades both in Greece and at international level. On this occasion, too, we have made every attempt to respond to the challenge with the reliability and sense of responsibility for which we are known, and which now set their seal on our presentation and promotion of the Greek cultural heritage not only to its natural heirs and guardians, but also, through the foreign language editions of this monumental work, to the entire world; for it is our belief that:

> And from hope's struggle a new earth is made ready
> So that on a morning full of iridescence
> The race that vivifies dreams
> The race that signs in the sun's embrace
> May stride forth with eagles and banners

(Odysseus Elytis, Selected Poems, ed. E. Keeley - P. Sherrard)

The Publisher
GEORGE A. CHRISTOPOULOS

FOREWORD

This book endeavours to present a concise picture of the art of goldsmithing in Greece from the Geometric to the Hellenistic period. To ensure that this picture is as comprehensive as possible some general information is provided on the beginnings and meaning of jewellery (Introduction), on the ancient Greek myths associated with gold (Gold in Myth), as well as on the most important sources of the raw material and the methods of extracting it in antiquity (The Material and the Working of It). Considerable attention has been focused on technical issues (Techniques of Working and Decoration), since technique is an inextricable part of the art and an understanding of the effort demanded of the craftsman in giving the material form enhances our appreciation of his work. The jewellery is discussed according to kind in sub-chapters (Wreaths, Diadems etc.), in which the pieces are examined by type so that the reader can easily follow the chronological development of each. The texts in the sub-chapters relate directly to the jewellery illustrated in the book and in no case exhaust the subject. The scientific documentation of the views expressed is given in the special bibliography in the same sequence as in the text.

It is a well-known fact that dating jewellery is fraught with difficulties, not least because the form of many items remained unchanged over long periods. Moreover, most of the jewellery in foreign museums and in private collections in Greece and abroad was discovered in illicit excavations, so catastrophic for research since the context is unknown. To some extent light is shed on this problem by jewellery recovered from systematic excavations. These are essentially finds from sanctuaries, although in many cases from levels that cannot be precisely dated, but above all from graves, where the dating of the jewellery is based on the evidence provided by the accompanying finds. These data have been taken into account in dating the examples presented here. The view that a piece of jewellery might be much earlier than the time of its placement in a grave is in many cases correct, but opinions on how much earlier are to a considerable degree subjective and even arbitrary unless secure criteria exist. One such exception are finger rings, for which long series of systematic typological classifications are available.

The pieces illustrated in the book were chosen mainly from jewellery recovered from excavations in Greece and from the areas of the ancient Greek colonies of the Euxine Pontus (Black Sea). The latter, particularly from the fourth century BC onwards – and independent of a tendency for conspicuous display –, express a common artistic language with the jewellery of mainland Greece, especially of its northern regions, as well as with the more refined pieces from the Aegean islands and Ionia. Fewer examples have been chosen from the cities of Southern Italy (Magna Graecia), where the art of goldsmithing is characterized by distinctive peculiarities, as is the Greek art of the western

colonies as a whole. The remaining items of jewellery, now in foreign museums, were selected specifically to fill the lacunae in the typological development of certain forms or in order to include certain important types not represented in Greek museums. Special emphasis has been placed on jewellery of Northern Greek provenance because the abundance of recent finds has not only changed the existing picture of this region's output to a significant degree, but has also helped to resolve problems plaguing research for years.

Thanks are due to the directorates of all the museums in which pieces of jewellery illustrated here are housed, as well as to the collector N. Metaxas, for either providing photographs or granting permission to photograph. For permission to publish material or for all manner of assistance, I wish to thank Professor A. Delivorrias, the archaeologists I. Vokotopoulou († 1995), I. Zervoudaki, A. Ziva, D. Ignatiadou, H. Koukouli-Chrysanthaki, A. Lebessi, P. Muhly, F. Pachiyanni, N. Prokopiou, E. Sapouna-Sakellarakis, B. Stasinopoulou, K. Tsakalou-Tzanavari, M. Tsibidou-Avloniti, Ch. Kritzas, M. Besios and D. Triantaphyllos; the conservators G. Damigos, St. Delilambos, T. Magnisalis, D. Mathios and T. Moditsis; and last but not least, the personnel of Ekdotike Athenon, the archaeologists E. Allamani and Th. Xanthaki, the graphic artists A. Simou and T. Kotsoni, as well as E. Atzemi, R. Geroulanou, D. Drakopoulou and E. Xypolitou. I am especially grateful to my colleague E. Kakavoyannis and the chemist G. Varoufakis for information on mining and metallurgical matters, to the jeweller Gr. Marinakis for technical expertise and to the unforgettable conservator at the National Archaeological Museum Ch. Chatziliou for information concerning the manufacture of ancient chains. I also wish to thank A. Doumas for her translation and willing collaboration and R. Oikonomou for her meticulous proof reading.

AIKATERINI DESPINI

ANCIENT GREEK JEWELLERY

INTRODUCTION

The first pieces of jewellery worn by man are lost in the mists of time and remain unknown to us. Thus we do not know whether jewellery came before clothes or vice versa. Opinions are divided as to which psychological factors contributed to the conception of jewellery: the innate desire for adornment to allure the opposite sex, or the innate sense of self-preservation that gave birth to superstitions and amulets. Whatever the case, jewellery in its distant past functioned as a magical medium, either to attract benign forces or to ward off evil ones, with fluid boundaries between the two.

The earliest items of jewellery were unworked objects, such as animal teeth, sea shells, nuts, unusual stones etc. It could be assumed that gold jewellery first appeared in lands where gold is abundant. The dominant and continuous role of Asia and Egypt in the art of goldsmithing is indeed due in large part to this factor. However, it is acknowledged that the earliest gold jewellery known to date is that found in the Balkans. The advent of metal jewellery did not mean that jewellery lost its magical power. The opposite is far more likely, because in early periods metals were themselves regarded as a kind of magical substance. This was surely true for gold jewellery, since gold, with its imperishability and eternal brilliance – properties that seemingly defied the laws of nature –, stood closer than anything else to the concept of the supernatural. As the centuries passed and religion

emerged distinct from magic, the magical character of jewellery diminished, though to what extent is unknown. In Greece for example, certain iron finger rings found in Mycenaean tombs – from the period before iron entered man's daily life – as well as a specific class of seals worn as amulets, have been attributed with magical potency.

The destruction of the splendid Mycenaean centres was followed by two centuries of poverty, the eleventh and the tenth BC. There is a dearth of jewellery from these times: some pieces in bronze, occasionally of iron and hardly any of gold. In the general clime of decline and isolation the goldsmith's art was abandoned, for Greece had but minimal gold resources. However, during the ninth century BC, with the Euboeans as trailblazers, overtures were made again to the East and the Greeks renewed contact with the traditional centres of goldsmithing and the gold markets. Cyprus, with which communication seems to have been restored already in the tenth century BC, must have been instrumental in these first tentative moves, as well as in the dissemination of certain jewellery forms. So in the ninth century BC the history of Hellenic gold jewellery recommenced. The eighth century BC can be described as its heyday, at least in Attica (see figs 9-10, 45, 58, 75, 106, 108, 110, 130, 180-181), and it is from this period that the first literary testimonies date.

The jewellery mentioned in the Homeric epics is either exquisitely wrought functional objects, such as fibulae and pins, or adornments intended

to enhance beauty. Most of the jewellery of the Geometric period that has been brought to light in excavations corresponds to the picture presented in these texts: they are mere adornments, since their form belies no special content. An exception are those pieces featuring representations associated with worship, such as pomegranates or snakes (figs 59, 75, 107-108, 130), elements usually qualified as fertility or chthonic symbols. By the seventh century BC, however, the Mistress of Animals (Potnia Theron), griffins, sirens, sphinxes and other daemonic figures, borrowed again by Greek art from the mystical world of the East and Egypt, embellished many articles of jewellery, mainly in the island centres (figs 19-20, 52, 69, 109, 131-134), and resuscitated that most ancient apotropaic and protective property of jewellery for the wearer and for the dead in the Afterlife, in the existence of which ordinary folk had evidently never ceased to believe. Some pieces of jewellery were to retain this quality, with intermittent upsurges, until the end of antiquity, and it was to be transmitted after the end of the pagan era in crosses and other ornaments with Christian symbols.

In this jewellery of the seventh century BC and after the apotropaic or protective power functioned in tandem with its role as adornments to emphasize beauty, an intrinsic property of every piece. The protective power emanated from the deities or daemonic creatures represented on it. However, ornaments existed whose form does not bespeak a direct link with religion. Included among these are pieces featuring the so-called *Herakleion amma*, the Herakles knot or *Herakleios desmos*, according to Athenaeus (XI 500 A), that dominated jewellery from the second half of the fourth century BC, mainly as a centrepiece on diadems and necklaces (figs 25-37, 40, 157-160, 162-164, 217). An early motif, known from the second millennium BC in Egypt, where it lived on until the period of the Ptolemaic kingdom, it consists of two antithetically intertwined loops forming the well-known reef-knot of nautical terminology. It is not known why or when this knot was named after Herakles. It has been suggested that the pretext for the name was the frequent representation of Herakles – from as early as Archaic times – on whose chest the two forelegs of the lionskin are tied with such a knot. The extant literary testimonies are from Roman times, though it is possible that the name existed before. As has been pointed out, this was perhaps the reason why the Herakles knot was introduced into the thematic repertoire of goldsmithing in Macedonia, where ornaments pertaining to the hero – as for example on some fibulae (p. 42f., figs 183-187) – were very popular, presumably because they alluded to the descent of the Macedonian dynasty from the Herakleids. Aside from this, however, Herakles was the Hellenic hero *par excellence* in the fourth century BC and from this time onwards references to him served, to a considerable degree, eschatological beliefs in the heroization of the dead. Moreover, the knot in general, as a 'bond' with protective and even curative properties, was one of the oldest elements of folk belief and the rapid and far-reaching spread of the Herakles knot as a decorative device is probably due to these associations.

The jewellery from graves falls into two major categories, real, that is jewellery worn in life, and substitute, that is jewellery made exclusively for funerary use. The latter, usually of gold foil, as a rule imitates real pieces which it replaced in the tomb when the preparation of the dead with real jewellery was not possible for economic or other reasons. The substitutes, which are found quite frequently in graves, bear witness to the strength of the burial custom of furnishing the dead with jewellery as grave goods (*kterismata*). It is certain that the majority of pieces of real gold jewellery did not

constitute part of the everyday attire, but were only worn on special occasions, in particular on the wedding day. The dead – especially the dead woman – was also accorded a formal preparation of this kind, to induct him/her into the Netherworld. As the excavation data confirm, if the real jewellery was not dedicated in some sanctuary, it ended up sooner or later in the tomb. This final prospect justifies the choice of subjects encountered on some pieces of jewellery, particularly from the second half of the fourth century BC. These are themes relating to contemporary ideologies on man's life after death (figs 71, 73-74) and immortality (figs 82, 85, 98), as is also the case for many pieces of substitute jewellery.

As in other artistic genres, so in jewellery the beliefs in life after death are projected through a mythological context. The imagery is symbolic. For instance, it was most probably not the Rape of Ganymede (fig. 97) or the Transportation of Aphrodite (fig. 215) that the craftsman wanted to show in these mythological representations, but the idea of the Ascent to Olympos, which was expressed with a representation. In the context of funerary beliefs the Ascent to Olympos signified transcendance to the realm of the immortals. The chariot bearing a human figure and driven by a divine figure (fig. 85) is the old iconographic schema of the heroic apotheosis, known mainly from vase-painting, as in the case of Herakles being led to Olympos by Athena or a Nike. An analogous interpretation that leads us to another plane has been proposed for an earring, now in Boston, in which a Nike is represented alone on a chariot (cf. fig. 98). The idea that the soul was the immortal component of man which, liberated after death from the perishable body, ascended to heaven whence it had come, belongs to the cycle of old eschatological myths and was combined with the various teachings on transmigration of the soul (*metempsychosis*) that are

attributed chiefly to the Orphics and the Pythagoreans. Plato (*Phaedrus* 246A ff.) likens the soul in its upward course 'to the composite nature of a pair of winged horses and a charioteer'. It has been argued that the image of the Platonic myth was inspired by a crystallized iconographic model reflected in the Boston earring with a Nike on a chariot. Analogous are other contemporary examples (fig. 82), as well as two later ones (fig. 98). In the last is reflected a not unusual amalgamation of beliefs on the journey of the soul and the passage of the dead to the Isles of the Blessed, for the representation perhaps insinuates that the chariot not only crossed the heavens but also lands and seas.

The transmission of ideas on the heroization of the dead or the immortality of the soul to real (or substitute) jewellery forms, from the second half of the fourth century BC, is a phenomenon coinciding with the more general tendencies of sepulchral art in this period, which are mainly manifested in funerary reliefs and epigrams. The host of winged figures encountered in the jewellery from this era (figs 82, 84-85, 88, 99-101) is the result of the influence of this ideology on the goldsmith's art, the echo of which continued to exist throughout the Hellenistic period. The meaning of these pieces of jewellery is not the apotropaic-protective one, that continued to obtain for some others; in this case the destination of jewellery with eschatological content is basically no different from that of the funerary wreaths, which are grave goods expressing a secret wish of the living for the fortunes of the dead (see p. 27ff.).

GOLD IN MYTH

Charged with supernatural properties, gold, imperishable and immortal in its brilliance, was to enchant man in the early stages of civilization, when

belief in the existence of supernatural, magical forces and recourse to sorcery for protection and averting evil, formed the substrate of religion. Later, myth was to give this radiant metal another dimension, associating it with deities and daemonic monsters.

The gold of myth lay in the distant North, the hibernal abode of the god of light, Hyperborean Apollo. There it was said to be guarded by griffins – an allusion to beliefs about the metal's divine nature. This myth is rendered on an Attic squat lekythos with a representation of a pile of gold flanked by two griffins. Aeschylus' (*Prometheus Bound* 803) characterization of griffins as the 'beaked watchdogs of Zeus' succinctly expresses, as has been remarked, the widely held view that these creatures were custodians of a divine force. Sappho (fragm. 141-142 Berg), more explicitly attributed its indestructibility to its divine origin: '... gold is the child of Zeus'. According to another curious tale – bequeathed to us in the name of Aristotle (fragm. 191 Rose) –, the philosopher Pythagoras, who had been virtually deified by his followers and in the opinion of some was the incarnation of Apollo himself, in order to prove his divine descent, one day exposed his thigh, which was golden. The middle, the only undying head of the Lernaian Hydra was also said to be of gold. Last, the men of Hesiod's renowned golden race (*Works and Days* 121ff.) were honoured with godly powers and became good daemons, benign guardians of mortals and givers of wealth.

The properties of gold and the myths and legends associated with it, support the view that this metal had been elevated to a symbol of immortality. In folk beliefs, however, its magical aspect, which was combined with the magical power of jewellery, apparently prevailed for a long time. Gold pendants, for example, were worn even in Neolithic times, probably as amulets, the magical character of which – overt or not – was never completely cast off.

THE MATERIAL AND THE WORKING OF IT

Sources of gold

Gold is a rare metal. In only a few places in the world is it found in appreciable quantities. Its rarity is attributed to its specific gravity. According to theories on metallogenesis it remained in the deep strata of the earth because the lack of volatile compounds prevented it rising to the part of the mantle accessible to man, whereas quite the opposite is the case with other ores. Greece, with virtually no sources of gold – barring a few exceptions of limited duration –, is believed to have obtained this precious commodity from other lands.

From early times the main gold-extracting regions were located in Africa and Asia. In the area between the Nile and the Red Sea, where the 'all-gold' Berenice of the Ptolemies was later founded, and above all in Nubia (Northern Sudan), which belonged to Egypt for long intervals, the metal was so abundant that, according to Herodotus (III 23), the prisoners' chains were of gold because copper was rare and precious. Many believe that the gold of the treasures from 'gold-rich' Mycenae came from Egypt. On the other hand, the myths of the expedition of the Argonauts and the golden fleece, of King Midas and the gold-bearing sand of the river Pactolos, prime source, later, of Croesus' legendary wealth, bear witness to the existence and early exploitation of the metal in those parts of Asia known to the Greeks from ancient times.

After two centuries of turmoil which followed the collapse of the Mycenaean cities, contacts with the East began to be re-established. With the early settling of Euboeans at Al Mina in Northern

Syria, in the ninth century BC, and the founding of the chain of Greek cities in the Asia Minor littoral, the Greeks once again came close not only to the traditional centres of the jeweller's art but also to the sources of its raw material, gold. Lydia not only supplied quantities of the metal in Geometric times but also transmitted to the Greeks of Ionia the idea of using it for commercial transactions. This was the stimulus for the momentous invention of coinage, probably in the first half of the seventh century BC. The colonization of Geometric times was followed by the founding of colonies, by Miletos and other cities, in the Euxine Pontus, giving access to other gold-bearing regions, such as the Caucasus.

Sporadic gold finds, from Sesklo and Rizomylos in Thessaly, from Sitagroi, Drama and Dimitra, Serres, and, primarily, the jewellery hoard from Aravissos, Yannitsa, attest that in these places at least, gold was known even in Neolithic times. However, appropriate technology has not yet been developed for locating the provenance of the gold from which the various ancient objects are made. It is known from literary tradition that gold was also obtained from several sites in Greece, particularly in the North, many of which can be confirmed today. The myths mentioning the Theban king Kadmos as the first to discover the gold mines of Pangaion, or the rich monarch of the region, Rhesos, who departed for Troy fully equipped with 'enormous golden' weapons, including his armature – shield and cuirass –, befitting an immortal, a god, support the view that gold was extracted from these areas as early as Mycenaean times. The wealth of the Athenian tyrant Peisistratos mainly derived from the gold and silver mines he owned in Pangaion in the third quarter of the sixth century BC, while about 510 BC the tyrant of Miletos, Istiaios, came to Myrkinos in the lower Strymon to acquire riches. There were gold mines in the Peraia of Thasos as well. The information preserved

in the name of Aristotle (*On Marvellous Things Heard* 833b; cf. Strabo VII, fragm. 34), that after continuous rainfall the Paiones were able to collect 'unfired gold' (that is the natural metal and not the product of smelting) from their fields also alludes to Macedonia.

In recent years studies have been made of the antiquity and duration of the exploitation of the gold deposits on Thasos, one of whose ancient names was *Chryse* (= Golden). There are indications of mining activity on other Aegean islands too, such as Siphnos which prospered in the sixth century BC after the discovery of gold-bearing lodes (Herod. III 57. Paus. X 11 2). Gold was also collected from the rivers, such as the Echedoros (present Gallikos near Thessaloniki), famed since antiquity as auriferous. The gold of the Archaic jewellery found at Sindos probably came from this river; analysis of four samples taken from gold sheets from Sindos, conducted by the chemist of the Thessaloniki Archaeological Museum, E. Mirtsou, showed similarities in composition with alluvial gold collected today from the region of this river.

It seems, however, that the Greek sources yielded gold for only limited periods, either because the deposits exploited were soon exhausted or because the waters which created the sediments along the river margins did not have a constant gold content. Tradition has it that the gold mines of Siphnos were submerged. Important information on the Pangaion region re-appears in the fourth century BC. In 357/356 BC Philip II captured the Pangaion and then the city of Krenides (which he renamed Philippi), together with the gold mines in the vicinity. According to Diodorus Siculus (XVI 8, 6) 'turning to the gold mines in its territory, which were very scanty and insignificant, he [Philip] increased their output so much by his improvements that they could bring him a revenue of more than a thousand

talants' a year. A large part of the raw material for the abundance of jewellery produced in Macedonian workshops in the second half of the fourth century BC most probably came from the mines of this region, which, as the sources record, were reactivated by Philip V.

Mining and metallurgy

Gold, though relatively rare, was most probably the first metal 'seen' and used by man, perhaps even before the sixth millennium BC. Because it occurs native it did not demand those 'magical' – in those remote times – metallurgical activities, particularly smelting, necessary in other cases for transforming the ore into metal. Gold is usually found in veins of quartz (reef-gold), or in erosion products of such rocks in the alluvial deposits of rivers (placer-gold). In the first instance the extracted rock was hammered into tiny pieces, which were then pounded into smaller fragments on stone mortars and ground in hand-driven millstones. The resultant powder was then washed to carry off the lighter quartz particles. This last process, the so-called enrichment, took place in 'washeries' which, in organized workshops at least, were some kind of installation with a cistern and artificially generated currents of water, similar to those in the silver mines of the Lavreotiki, which have been brought to light in excavation. This is a most plausible hypothesis because it seems that the Athenians learnt a great deal about the technique of extracting metal in the mines of Pangaion, from where a large part of their specialized labour force was recruited.

In the second instance, of alluvial gold, Strabo's testimony (XI 2, 19) that in Colchis in Pontos the river-borne particles of gold were trapped in fleeces has been proven correct, for this same method was used in this area until modern times. The process is echoed in the myth of the golden fleece, as, in addition to Strabo, Appian (XII 103) also observed. Analogous information in the *Etymologicum Magnum* (404, 9) is that the inhabitants of the area around the river Echedoros used sheared goatskins to collect particles of gold borne by the water. However, the gold from riverine sediments was usually obtained by panning or by washing away the lighter, sandy materials, probably in clay basins, which task usually took place in nearby workplaces known as *chrysoplysia* (gold washeries).

The gold collected after washing was seldom pure, but usually alloyed with silver, sometimes with traces of copper and, more rarely, iron. If the silver content was significant, in a ratio of one to five according to Pliny (*NH* XXXIII 80), then the metal was called electrum or, according to Herodotus (I 50, 2-3), white gold, which was naturally paler in colour. Because impurities endowed jewellery or other objects with a desired degree of hardness and resistance, it was not necessary to remove them. On the contrary, their removal was imperative in order to assay the exact value of gold when this was to be used in transactions. Gold was refined as early as the third millennium BC by the Sumerians as it is also mentioned in the text on one of the fourteenth-century BC clay tablets found at Tel el Amarna in Egypt. In Lydia gold-refining is believed to have been practised since the late seventh century BC. The relevant methods were learnt in Greece later, possibly via the Ionian Greeks.

The so-called method of cupellation was applied for producing silver from argentiferous lead ores. In the case of alloys of gold or argentiferous gold this method entailed the addition of lead in order to cleanse them of other metal impurities, such as copper for example. In contrast to gold and silver, copper, when heated with lead in an ample supply of air, oxidizes and can then be

removed. There is, however, no evidence for the present that cupellation was applied in Greece for refining gold, perhaps because the Greeks mainly used alluvial gold which is relatively pure, and because the traces of copper or other metals in the natural alloys were so minimal their removal was not essential. As has been said, the metal most frequently found in relatively large proportion in natural alloys of gold is silver. Though the ancient sources are somewhat vague on the methods used for removing it, two pyrochemical metallurgical processes are generally believed to have been implemented: the gold alloy was placed in a porous clay crucible or cupel and melted in a furnace together with either sodium chloride (common salt) or a sulphur compound, (styptic earth – 'στυπτηριώδης γῆ' – is mentioned in the texts) and some organic substance. At the right temperature the silver reacts with the salt to form silver chloride, which being volatile is absorbed by the walls of the crucible, or, in the second case, is converted to silver sulphide which floats on the surface as a scum and is easily removed. The pure gold which remains was poured into stone or clay moulds to form block- or tablet-shaped ingots. In this form it was traded and brought to the mints or the goldsmith's workshops. Small pieces of cast gold in different shapes were found together with fragments of wire and other remains from goldworking, hidden in a small vase at Eretria.

TECHNIQUES OF WORKING AND DECORATION

Production and decoration of sheet gold

Gold objects, like those of silver and of copper, are classed in two large categories from the point of view of metalworking technique: sheet-metal and cast. Sheet metal is formed by beating, the age-old art of Hephaistos which began with the cold hammering of native metals. All gold sheet was beaten and its method of production remained unchanged throughout antiquity, requiring two basic tools, the hammer and the anvil, likewise most ancient and sanctified by long centuries of metalsmiths' toil. The smith placed a piece of metal on his anvil and hammered it till it spread and flattened. Whenever the metal became hard and brittle it was annealed repeatedly by heating in an open fire and then beaten out to the desired thinness. Gold is the most malleable of all the metals and an experienced craftsman could produce gold leaf just a tenth of a millimetre thick when this was needed for gilding.

In the next phases luxury objects were wrought from sheet gold and decorated. Fine sheet gold was mainly used for jewellery or goods intended exclusively for funerary use, as well as for the investment of other, relatively small objects, such as wooden caskets. Thicker sheet was required for various gold vessels, applied ornaments on furniture, chryselephantine statues and other artifacts. The decorative motifs on the gold sheets were either engraved or in relief. Geometric designs and linear patterns were mainly engraved or incised. Relief decoration demanded a more complex process and over time several methods were developed, depending on the nature of the object and the thinness of the gold sheet.

Low-relief representations or individual motifs on fine, flat sheets (figs 9-11 et al.) were produced in hollow moulds or dies of stone or wood, and from the seventh century BC on copper plaques bearing the decorative theme in intaglio (negative). On these the sheets were beaten or pressed lightly from the back with appropriate tools. In order to protect the mould from the blows and to inflate the volumes of the embossed representations, a

strip of lead may well have been placed on top of the sheet gold, as is done today, so that this was not struck directly by the hammer. This task was relatively easy. More difficult was the chiselling of the decorative theme in the mould or die, which may sometimes have been done by the goldsmith himself or most probably by a specialist engraver. More than one gold sheet could be hammered on the same mould and the whole motif or part of it could be reproduced or repeated exactly.

Smaller, individual motifs, such as rosettes, were usually stamped. The gold sheet was usually laid on a bed of some yielding substance, normally pitch, and struck from the back with punches bearing the motif in relief at the bottom end. Similar punches, with the design in exergue relief were also used for making ornaments in the round from two sections of sheet gold, such as the vase-shaped pendants of necklaces or earrings. These and other little ornaments, such as the tiny animal heads on the finials of necklaces or earrings, as well as larger objects, could also be formed over a wooden or bronze core, in which case the sheet was worked from the front.

The fine gold sheets decorated by the aforementioned processes belong in general to the category of repoussé ornaments. They were the work of the goldsmith and involved the application of methods devised for relatively fast production. However, in this particular case the original craftsmanship did not lie in the hammering of the design but in the creation of the mould or die. Authentic repoussé decoration demanded another process and was the work of the toreutic artist. The various opinions expressed on this process are mainly based on research on bronze works which have survived. The toreutic artist first roughed out the representations or the decorative motifs on the front of the relatively thick sheets of metal with a tracer, in very fine outline so that they could be

corrected without leaving blemishes. Next he pressed or beat the final outlines which were thus transferred to the back in slight relief. Within these limits he then hammered the back of the sheet with a special round-faced punch so that the volumes of the figures were brought to the fore. Lastly, the decoration was completed on the front with engraved details. Some simple cases of repoussé decoration could be executed by the goldsmith. In general, however, this was a highly specialized technique demanding skills and experience beyond the bounds of the jeweller's art. It belonged to another major sphere of ancient metalworking defined as toreutics, which was clearly distinguished from goldsmithing from Classical times onwards.

Cast objects

Man surely realized the possibility of forming solid shapes from molten metal the moment he made the ground-breaking discovery of smelting ores. However, the casting of metal objects in a mould is a later technique than hammering, yet was known in the Aegean region from at least the third millennium BC. In addition to metal, wax and clay were the basic materials used from the outset in the 'lost-wax' (à cire perdue) process. The first phase of the evolution of this technique, the so-called direct method, which was actually retained for small objects until the close of antiquity, can be easily understood today: the object to be cast was modelled in wax, in perfect detail, then smeared with a coat of fine clay, perhaps using a brush, and covered with a layer of thick clay. When the clay investment had dried the whole was fired and the wax, which melted, ran out through the hole specially left for this purpose. The hollow created within the clay casing was then filled with molten metal. When this had cooled and set the clay mantle

was shattered. Within it the metal had assumed, unseen, the form of the vanished wax. Nowadays this, almost mystical, mysterious act of filching elicits no awe or astonishment, but the people of early antiquity regarded bronzecasters and toreutic artists as sorcerers and daemonic creatures.

Though the *cire-perdue* technique was used for all metals, it is self-evident that the majority of cast works were of bronze, for which reason they are the most numerous to have survived. A significant number of silver pieces, mainly jewellery and vases, have also survived. Gold cast objects were far rarer than hammered ones because this technique required more metal. It is almost certain that the gold statues mentioned from antiquity were hammered, that is made of sheet gold, or were gilded. Most oī the gold vases were also toreutic works. Cast gold items of jewellery known are mainly finger rings and some categories of earrings, bracelets, fibulae and pins.

Stone moulds – or even clay ones in Hellenistic times – with the intaglio (negative) of the ornament were used for casting jewellery. Each piece of jewellery usually required two moulds (three for finger rings with bezel), in each one of which exactly half the ornament to be cast was carved. By placing one mould on top of the other, so that the outlines of the sections matched, a closed cavity was created, into which some scholars believed the molten metal was channelled directly. However, it has been observed that as gold cools it contracts slightly and ornaments cast in this way do not display great precision in the details. Moreover, the surviving moulds shown no signs of damage from the high temperatures the pouring of the metal demanded. So it is likely that more often than not melted wax was poured into the double moulds to form a wax model of the ornaments, which were then cast by the *cire-perdue* method. Thus meticulously made jewellery could be reproduced, since the wax model could be corrected and refined before being covered with clay for the casting process. It is also possible that the same process as used for larger bronze objects, perhaps as early as the seventh century BC, was used for jewellery: that is each of the moulds was filled separately with wax and then the two wax models were joined together (one of the factors in the development of the technique of casting hollow statuettes in the sixth century BC). This might explain why of the two sections of a jewellery mould only one plaque usually survives: it was presumably used successively for the two halves of the wax models. Ornaments with one face and a flat back were cast in open moulds, sometimes with such accomplished technique that details as delicate as wire were rendered, as on an ornament found at Stavroupolis, Thessaloniki.

The mould had the advantage of speed of production, but the self-same ornament was reproduced each time. Original creations were modelled in wax by hand, thus adding the element of uniqueness to the ornament's artistic value, as with the Solokha comb (figs 41-43). It seems, however, that a compromise solution had been found. The bronze statuettes of the Hellenistic period, found at Galjub near Cairo, are believed to be casts from roughly modelled maquettes, probably of clay, which were transferred to bronze since clay is easily damaged. The intention was that the goldsmith would have a stock of subjects on hand in his workshop, which he perhaps showed to the customer. By using new wax models each time, freely modelled on these bronze samples, and applying the *cire-perdue* method, the craftsman could reproduce, in silver or gold, similar but not identical miniature statuettes, which were intended for the finials of pins of the type in figures 176, 178-179. However, whether the metal was cast directly or with the wax model, these processes pro-

duced solid ornaments, of inordinate cost if made of precious metal. For this reason the history of gold jewellery is basically the history of sheet gold, filigree and granulation.

Wires, filigree technique, chains

Gold wire was used in the art of jewellery and along with sheet metal was one of its principal elements in ancient times. Filigree is the technique which uses wires for decorating a surface of sheet metal or, more rarely, for creating openwork patterns in which the wires are soldered to each other and not to a solid background as in the previous case. From the fourth century BC onwards free palmettes, rinceaux and flowers on flexible stems could be rendered almost exclusively with wires. In antiquity filigree technique was only occasionally used for silver objects. Historically it is considered only slightly earlier than the technique of granulation. Known in Mesopotamia, Syria and Asia Minor from the third millennium BC, it first appeared in Crete about 2000 BC, but its use was limited until Late Mycenaean times. Its re-appearance in the ninth century BC in the art of Hellenic jewellery (figs 59, 67) is due to renewed contacts with the Syro-Palestinian lands where Greeks from the Mainland arrived, probably via Cyprus.

As has been said, the openwork variation of filigree technique is rarer. Perhaps the earliest example in Greece, a grave good of the eighth century BC from Athens, is a finger ring with wire guilloche, in which there is no background to the guilloche, as is the case on similar rings. In the seventh century BC this technique is encountered on a particular kind of bracelet which was especially popular in Etruria, and from about the second quarter of the sixth century BC it appeared in Macedonia, here too associated with a particular kind of earrings

(figs 60-64). Some pieces in exceptional quality openwork filigree are unrivalled creations of the fourth century BC (figs 28-29). On the contrary, the application of filigree on a background, that is the gold sheet, enjoyed very wide diffusion and longevity, persisting into recent times.

In essence the history of filigree technique is the history of gold wire. The Egyptians already knew how to make wire by the late fourth or the early third millennium BC, but the technical details of its manufacture are not all clear. In general it is believed that for relatively thick and smooth wires a narrow strip was cut from a thickish piece of gold leaf, then twisted or hammered until it was of circular section and finally rolled between two stone or bronze plates to even the surface. Such wires, which were used for the hoops of finger rings or earrings, for hair rings, for pin shafts and fibula bows, could also be cast in moulds together with the decorative annulets of the ornament. Fine wires, however, the main material craftsmen used for decorating surfaces with filigree technique, were made as a rule by tightly twisting a thin strip of sheet until it acquired wire form. In certain instances a very thin strip of sheet gold, the flat wire, could be substituted for wire of circular section (figs 59, 75, 107, 110).

According to an old and still controversial viewpoint, which has quite recently been claimed, on the basis of experimental research, perhaps from Hellenistic times another mechanical method for making wire was used, known much earlier in Egypt. This is the drawplate, used today for the manufacture of wires. It consists of a rather thick bronze or iron plate perforated with different-sized holes of gradually decreasing diameter. The strip of sheet metal was first drawn through the larger holes in the plaque, immediately acquiring the form of a tube, and subsequently through the smaller holes until it ended up as a solid, tightly

wound roll, a smooth wire. One view is that Greek goldsmiths combined the two methods, drawing the already twisted strip of sheet metal through the holes of the plate. Gold is extremely ductile and a wire can be drawn to the fineness of hair.

With the making of wire the process of filigree ornamentation began. The first step was the invention of different forms of twisted wires. Two strands twisted together formed the 'rope', the oldest, traditional decorative type. By juxtaposing two ropes twisted in opposite directions a kind of 'braid' was created (figs 59, 131, 133 et al.). This result could also be achieved using single twisted wires. Initially the decorative motifs of filigree work were simple or the wire, twisted or flat, was used as a surround for precious stones or amber (figs 75, 107, 110).

From the mid-seventh century BC beaded wire appeared on the island of Rhodes, in Ephesos and the Peloponnese. This gives the impression of a row of granules (figs 51, 69, 174) and was probably invented as a more easily applicable substitute. In Early Archaic times filigree did indeed begin to supplant granulation. Beaded wire is essentially a plain strand of wire worked with appropriate swages to create curved incisions, the overall effect of which was that of a series of globules. Beaded wires were almost as popular as twisted ones. It was probably from these former that bead-and-reel wire (figs 36-37, 197), like the astragal ornament more familiar from architecture, and spool wire, which gives the impression of a series of tiny spools (fig. 134), developed. Another variant, resembling a screw-thread, was the spiral-beaded wire, with horizontal or oblique spiralling grooves (figs 35, 142-143, 167, 197). By combining different types of wires and decorative motifs a gifted craftsman in filigree could achieve remarkably impressive results (figs 32-33).

In addition to their decorative use, wires played an essential role in the manufacture of a very an-cient component of jewellery, chains. Although the simple chain composed of circular wire links is the earliest type, only limited examples occur. On the contrary, the type of chain with wire loops, that is elliptical links (see p. 24, drawing a), is that which dominated throughout antiquity. The single loop-in-loop chain was created by inserting one loop inside the other (drawing b), while the double loop-in-loop chain (drawing c) resulted in a more compact form. A more composite concatenation of two, three or more cross-linked double loop-in-loop chains (drawing d) rendered cord-chains of quadrilateral, hexagonal or polygonal section (figs 107, 161-162 et al.). Single or double loop-in-loop chains were already known in the third millennium BC, as attested by finds from the Sumerian city of Ur, from Egypt and from Minoan Crete. From the sixteenth century BC their technique was imported to the Mycenaean cities. After the collapse of the Mycenaean world the earliest examples of cord-chains in Greece are from Crete (fig. 107) and Anavyssos, Attica.

Another related kind of jewellery are straps (figs 33, 36, 146-160 et al.). They consist of several separate loop-in-loop chains (drawing e) placed alongside each other and interlinked by passing another loop of the same wire through each row of loops, like a weft. By interlinking transverse loops in this way the lengthwise edges of the strap were formed. According to one viewpoint, based on the early dating of finds from Nimrud, chain straps were known in Assyrian art perhaps from the eighth century BC. However, the first Greek examples come from Rhodian workshops of the seventh century BC (fig. 146). The method of constructing straps was also known at this time in Etruria, Italy, from where some examples have been preserved. Whereas straps were absent from Greece during the immediately succeeding centuries (see p. 38ff.), from the second half of the fourth century

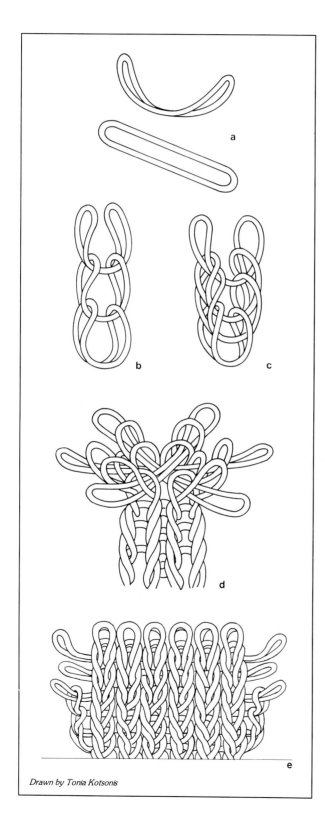

Drawn by Tonia Kotsonis

BC there was a veritable boom in their popularity (figs 147-160) throughout the Hellenic world.

The technique of granulation

Granulation is a technical process in which grains of gold, usually in rows, are used either to surround or outline a figure, or to form geometric designs, such as triangles and other motifs, to decorate the surface of sheet gold. In other words, granulation was used for the same purpose as filigree but had greater decorative potential (for example, granules could be used to fill the triangles, lozenges and other designs on the sheet gold, or to form pyramidal arrangements etc.), being more striking, skilful and refined. It enjoyed a long tradition, from the third millennium BC in Mesopotamia, Syria and Asia Minor. In the early second millennium BC it was introduced in Crete, but remained extremely rare in the Aegean region until the fifteenth century BC and disappeared after the collapse of the Mycenaean world. Its re-appearance at Lefkandi in Euboea and in Athens in the ninth century BC (figs 68 and 59 respectively) is most probably due to the influences of Syro-Palestinian workshops, which reached Greece directly or via Cyprus. It attained a remarkably high standard in the seventh century BC with perfectly aligned granules and impeccably regular patterns, primarily in the ateliers of Rhodes (figs 131, 133-134). Examples of technical excellence are also encountered in Macedonia in the sixth century BC (fig. 114), though from this time granulation gradually began losing ground to filigree. It was finally abandoned in the tenth century AD.

It is not known how the grains of gold were made in antiquity. Gifted Italian artists of the sixteenth century AD, who tried to emulate this decorative technique, left instructions on the manufac-

ture of grains. From these, and modern applications and experiments, it is presumed that several methods were probably used in antiquity too. According to one method, equal-sized minute fragments of gold wire were dispersed in successive layers of ash or powdered charcoal in a clay crucible. Gold melts at 1063°C and at a slightly higher temperature, around 1093°C, the bits of melted wire become microscopic globules. Though this method is the most time and fuel consuming, it is the only one which produces grains of uniform size and so obviates the additional task of sifting them to grade them.

Producing the granules was a relatively easy task compared with what was to follow, namely the soldering of the granules, one by one, to the motifs sketched on the sheet-gold ground (in some instances thousands on a single object), since these were difficult to control, to see and to handle.

How the granules were soldered to the decorative surface was an enigma too until 1933 when H.A.P. Littledale patented his method, which is based on a natural phenomenon: when gold is heated in contact with copper the melting point of the two is lower than that of either metal separately. This method (colloid hard-soldering) involves preparing a mixture of equal quantities of pulverized copper salts and vegetable gum or animal glue (resin or fish glue), with the help of which the grains stick firmly to the surface of the sheet. When the mixture sets there is no danger of the granules moving and the whole piece is then exposed to heat. In a succession of chemical reactions which take place as the temperature progressively rises, the copper salts are reduced to pure copper. At 890°C gold and copper melt together at the point of contact and so the soldering is achieved. Theoretical documentations as well as recent chemical analyses of Etruscan jewellery have shown that this method was known at least from the seventh cen-

tury BC. The copper salts were probably obtained from malachite – hydrous copper carbonate –, which is believed to be what the ancient Greeks called *chrysokolla* (gold-glue). The processes involved in granulated decoration are among the many at which we marvel today. The whole of technology in those distant days was summed up in the ancient goldsmith's observation, his naked eye – for the lense did not exist – and his experienced and accomplished hand.

GOLD JEWELLERY

Wreaths

The earliest gold wreaths mentioned in epigraphic and literary *testimonia* date from the second half of the fifth century BC and mainly concern awards to honour eminent personages, votive offerings on the Acropolis and prizes for the victors in the music contests at the Panathenaea. However, fragments of votive wreaths with gold or gilded silver leaves, of the seventh or the first decades of the sixth century BC, from the sanctuary of Artemis Orthia in Sparta, attest that metal wreaths existed long before. Gilded silver wreaths were found in graves dated to the late sixth and the fifth century BC, at Taranto and in the region of ancient Barke in Cyrenaica. Some fragments of gold and gilded bronze wreaths from Athenian and Macedonian tombs are likewise assigned to the fifth century BC, but their dating is dubious and should be re-examined. In general our knowledge of gold wreaths is based almost exclusively on finds from funerary contexts. The majority of them date from the second half of the fourth century BC and to certain phases of the Hellenistic era, periods in which gold jewellery was also abundant.

Gold wreaths imitate natural ones, that is chap-

lets made from branches, fruits and flowers. On account of their more composite and detailed form, flowers are usually rendered in a somewhat conventional manner in metal, but leaves and fruits are, as a rule, verisimilar versions of the particular species the goldsmith or customer had in mind. Indeed the reproduction is sometimes so good that the use of real leaves as models for their shape is assumed (fig. 1) – at least the intention is obvious. Acorns, for example, are never rendered on a wreath without pinnately cleft leaves (figs 3-4). When the broadest part of the metal sheet is towards the petiole and the free end is acute, a myrtle leaf is shown (figs 2, 5-7). When a protuberance incised with a cross is added to the end of a fruit (fig. 7), this denotes a myrtle berry. It is difficult to distinguish between laurel and olive leaves since, in nature too, in both instances, these narrow towards the petiole, while the widest part is towards the middle or the free end, that is the opposite of the myrtle leaf. However, wreaths with narrow leaves of this shape are more likely to imitate those of olive (fig. 8), since in real life laurel leaves tend to be broader. In general, the artist usually rendered one species of plant on a wreath. The mixing of plants is extremely rare.

The preference for a particular floral species in metal wreaths is perhaps related to the deity worshipped by the family or the wider political or religious community of which the deceased was a member, as was also the case at *symposia* (drinking parties) where, according to Athenaeus (V 192 B), symposiasts '... made use of chaplets appropriate to the gods ...'. Thus, in Macedonia, for example, wreaths of oak (figs 3-4), the sacred tree of Zeus, with whose cult the Argead dynasty of the Macedonian kings was especially associated, were frequent. At Amphipolis (and probably also Potidaia), which was an Athenian colony, wreaths of olive (fig. 8), the sacred tree of Athena, predominated. Nevertheless, the commonest wreaths in all regions were those of myrtle (figs 2, 5-7), a plant linked with Demeter, Kore (Persephone) and Aphrodite, all goddesses of fertility and vegetation and consequently of chthonic character, as indeed were all the symbols of fertility (dove, cockerel, pomegranate et al.). Laurel wreaths cannot be identified with certainty among grave goods except in very few cases. The laurel was the sacred tree of Apollo, god of light, who had very tenuous connections with the dead, which explains the absence of such wreaths from tombs, remarked on too in the literary sources. Strangely enough, gold ivy wreaths (fig. 1) are rare, although this is the sacred plant of Dionysos, who of all the occult deities of vegetation is the one most overtly linked with death and resurrection. Perhaps the popular masses who were the most fervent devotees of Dionysiac cult could not afford to substitute wreaths of gold for those of the actual plant, but there will have been other reasons too, possibly more serious.

Victors' wreaths, as a rule of natural plants – with the exception of the gold ones for music contests –, were usually dedicated by the recipient to the deity in whose honour the games were held or to some god of his homeland. Some scholars believe that this custom extended to gold wreaths as well. The texts as a whole are notably reticent on what happened to these wreaths after they were awarded. The same uncertainty prevails for wreaths of honour. That some wreaths of these two categories ended up in the owner's grave cannot be ruled out, yet it has been observed that although there was a greater number of honorary wreaths in the city of Athens gold wreaths are lacking from Athenian graves. The phenomenon is ascertained by examining the issue from another angle. Certain individuals enjoyed the privilege of wearing a gold wreath at specific events, such as *choregoi* (sponsors of theatrical performances),

choreuts in drama competitions, *rhapsodoi* (singers who accompanied themselves on the lyre) and flautists, and possibly all other artists serving Dionysos in a later period. Some of these wreaths perhaps accompanied some deceased persons in the grave. However, in this case we would expect most of the gold wreaths to have been found in the cemeteries of Athens and only a few in Northern Greece, for example, whereas exactly the opposite is the case. During Late Hellenistic and Roman times, in special cases gold wreaths were awarded to the dead. However, the plethora of gold or gilded funerary wreaths from the fourth century BC onwards – sometimes more than one in the same tomb – cannot be characterized as special cases. Most of these pieces were probably made exclusively for funerary use being theoretically a privilege of all the dead, though in practice gold objects were the privilege only of the wealthy.

In ancient Greek consciousness, the wreaths of natural branches and leaves, were interwoven with festivals and triumph. They were the prize for the victors in the games, an essential item of adornment at cult rituals and official ceremonies, and a precondition for participation in the competitive revels (*komoi*) at the Anthesteria for Dionysos, from where they probably passed to the secular *symposia* at which men, reclining on couches and wearing a wreath, discoursed while drinking. From this viewpoint there is something odd about the essential role of the wreath in the formal preparation of the dead for burial, the last stage of which was the dressing of the hair and its binding with a band diadem or a wreath, after which the corpse lay in state (*prothesis*) in the house for the mourners' lament. The wreath, ostensibly identical in meaning with the band diadem in funerary use, is unknown in Homer. It appears in representations of the *prothesis* of the dead in Late Geometric vase-painting, though indications that it was worn by the dead do

not occur until the seventh century BC. The earliest clear archaeological evidence for such a use dates from the sixth century BC. But which victory, in which contest and which festive associations gave rise to this custom of crowning the dead with a wreath?

According to the Eudaemonic teachings, which are ridiculed or criticized by Aristophanes and Plato, and which the latter (*Republic* II 363c) attributed to Mousaios (a pupil of Orpheus) and his son (Eumolpos), after death the gods lead the just to Hades, where they provide them with a 'symposium of the saints' and 'crowned with wreaths, they entertain the time henceforth with wine' which they consider 'the fairest meed of virtue'. These paradisial descriptions, clearly popular in character and unconnected with official religion, bring to mind analogous contemporary eastern religions and echo a deep folk conviction in vindication, nurtured by many years of experience of social injustice. The concept of the dead wreathed like a symposiast occurs long before the idealistic Plato and the irreverent Aristophanes, in an excerpt from *Alkmaionis,* perhaps the earliest testimony, about 600 BC, preserved for us by Athenaeus (XI 460 B: 'and placed crowns on their heads'), that is from about the same time as the first archaeological indications of this practice. Just how deep-rooted these beliefs were is often expressed by a part of the tomb's contents as well, particularly objects used at *symposia* (usually vessels, but also furniture, spits etc. in Macedonia).

Nevertheless, in later times a few, yet significant, ancient references add another dimension to the interpretation of the funerary wreath. According to the Scholiast of Aristophanes (*Lys.* 601) the relatives of the dead gave them a *melittouta* (a honeyed cake) for the guardian of the gateway to Hades, Cerberus, an obol to pay the Ferryman (who rowed the dead from one bank of life – to

the other of the Underworld) and a wreath 'ὡς τὸν βίον διηγωνισμένοις' (as to those who had contested in life). This statement derives from the concept that assimilated the dead to an athlete; 'like an athlete' is an expression known from the fifth century BC and encountered time and again for personalities honoured in life for their virtuous deeds. Brasidas, for example, whom the Scionaeans 'publicly crowned ... with a golden crown ... and privately bedecked ... with bands and made offerings as for a victor in the games' (Thucyd. IV 121). Bearing in mind that in antiquity athletics were closely bound up with the concept of 'virtue', 'like an athlete' is an expression with moral content. Thus the third provision, the wreath, in some way certified that the dead was worthy of being rewarded with 'what was befitting', according to a corresponding excerpt from Plutarch (*Moral.* 561 A): 'ἀγωνίζεται γὰρ ὥσπερ ἀθλητὴς τὸν βίον, ὅταν δὲ διαγωνίσωνται, τότε τυγχάνει τῶν προσηκόντων' (for it is like an athlete's contest, and only when it has fought that contest to the end does it receive its befitting deserts). Of course underlying this excerpt of Plutarch is Greek thinking on the various phases of testing through which the soul had to pass and emerge victorious in order to attain the 'befitting' reward, namely immortality, however, the phrasing is so closely affined to that of the Scholiast of Aristophanes concerning the folk custom, that, regardless of qualitative nuances, we may suggest the implicit reason why the dead was provided with a wreath: in order to lay claim among the virtuous to eternal life after death.

Diadems

In earlier literary tradition (Xenoph. *Cyropaed.* VIII 3, 13) the word diadem is used principally to characterize the crown of the royal family of Persia, which was basically a specially woven headband or fillet. It was received by Alexander the Great when he defeated Darius III and thus passed from the Persian to the Macedonian kings. The diadem is first mentioned in the sense of the gold female head ornament (the ancient *stephane*) in a text by Callixeinus Rhodius (3rd/2nd century BC), preserved by Athenaeus (V 201 D). Nowadays the word diadem is used for a headband or head ornament in general. The diadem bands known from antiquity are mainly of sheet gold and were found in tombs. In funerary use the headbands, like the wreath, had a special significance, being linked from early times with the preparation of the dead for burial and associated with religious concepts and beliefs about the Netherworld (see p. 27ff.).

Band-shaped or elongated elliptical diadems of sheet gold are known from Mochlos in Crete, about 2200 BC, and later mainly from Mycenae. After the destruction of the Mycenaean centres the use of gold funerary diadems returned to mainland Greece in the ninth century BC, probably via Cyprus and the emporia in Syria, where there was a long tradition of grave goods of this kind. The earliest known examples, from Attica and from Lefkandi on Euboea, are usually parallelogram bands – rarely pedimented –, normally incised with geometric motifs. On two ninth-century BC diadem fragments from Lefkandi, embossed animal figures also appear, while animals and humans are represented on a fillet from Tekes near Knossos, dated about 800 BC.

Although diadems with engraved geometric designs continued in use during the eighth century BC, the overwhelming majority of diadem bands bear embossed figured decoration executed in a hollow mould. The principal centre of production was Attica. At first they featured friezes of wild animals (figs 9-10), but a little later humans, horses and other subjects drawn from the repertoire of

contemporary vase-painting were added and diffused to other regions. One such representation with women 'dancing' is preserved on a gold band from Corinth (fig. 11). These diadems, of parallelogram shape, persisted into Late Hellenistic times. The Geometric fillets from Eretria and Skyros, on which there is a tongue-shaped protrusion centre top, constitute an exception. Pedimental diadems re-appeared in the fourth century BC (figs 23-24). Representations with animals or other figures occur on sporadic finds of the seventh and sixth centuries BC, as well as on a limited number of examples from Hellenistic times too, such as a diadem in the Metaxas Collection in Herakleion, Crete.

In the seventh century BC, however, when the strong current of Oriental influences flooded all forms of art in Greece, the decoration of diadems changed and floral elements came to predominate. The ornamental motif *par excellence* was the rosette, believed to derive from Assyrian prototypes. Rhodes emerged as the main workshop centre, though the contribution of other Aegean islands was by no means insignificant. Bands with stippled or embossed or applied rosettes (fig. 12), even single rosettes, such as the elaborately embellished ones found on Melos (figs 13-18) and on Rhodes, in all probability affixed to fillets of perishable material, constitute the main types of diadem in the seventh century BC. An outstanding example from Kos, unfortunately in fragmentary condition, bears applied embossed sphinxes in addition to the rosettes (figs 19-20).

Diadems with rosettes continued in use in the sixth century BC, though on a limited scale, in Rhodes and elsewhere. In the course of this century the floral repertoire was enriched with lotus blossoms and palmettes, as evident from painted and engraved traces on diadems of female statues; actual examples have yet to be found, with the exception of some from Amathous in Cyprus. The

Archaic period is in any case generally poorer in jewellery, apart from South Italy, the cities of the northern shore of the Euxine Pontus, and Cyprus, though there too the number of diadems is small. Macedonia is a striking exception, where the gold finds of recent years, dependent on southern Greek workshops, indicate that the sixth century BC was its first 'golden age'. The standard ornament of Macedonian gold bands is, with few exceptions, the embossed guilloche.

From the fifth century BC vegetal scrolls in lyre- and heart-shaped arrangements made their appearance on diadem bands, such as that in the Benaki Museum (fig. 22). Later the centre was emphasized and flanked by symetrically arranged rinceaux with undulating tendrils, developing outwards towards the ends. From the second half of the fourth century BC these became the dominant theme on diadems of sheet gold, embellished with palmettes and other flowers as filling motifs, as on the Derveni diadem (fig. 21), or continuously springing from unfurled acanthus leaves, as on a pedimental diadem, most probably from Madytos (figs 23-24). One of the very few sheet-metal bands decorated in a different manner is the diadem from Amphipolis (fig. 25), at the centre of which is an applied Herakles knot, the much loved ornament of the day.

From the time of their re-appearance in the ninth century BC, diadems of sheet gold were probably intended exclusively for funerary use. The view has been expressed that some of the bands, for example the rosette bands of the seventh century BC, were also worn in life. It is known that diadems of this type were worn by deified kings in the East. Nevertheless, relevant testimonies are lacking for the Greeks at this time. There are some indications that the Derveni diadem (fig. 21) was worn in life as well: not only the relatively stiff and durable gold sheet of which it is made, but also the

carefully finished edges, inturned to hold a lining of perishable material, secured in place with silver rivets. It dates from a period when real head ornaments also appeared in tombs (figs 26-31).

The fourth century BC, and in particular the second half, was an era of renaissance for Greek jewellery. Recently excavated finds reveal the important role of the Macedonian workshops in this period, hardly surprising considering the fact that most of the preconditions essential to a renaissance were concentrated in Macedonia at that time: political power, conquests and wealth. New forms appeared and old ones were remodelled. As far as diadems are concerned, actual pieces of jewellery replaced the customary funerary bands in many tombs. The themes from the embossed or engraved ornaments on the latter were transferred to intricate filigree openwork. Lyre-shaped motifs, as on the band in the Benaki Museum (fig. 22), also feature on the diadem from Sedes, Thessaloniki (figs 26-27), and form the base of the composite monumental diadem from Vergina (figs 30-31). Vegetal scrolls sprouting from acanthus leaves, very similar to those on the Madytos diadem (figs 23-24), can be seen on another diadem, in the Helen Stathatos Collection, with wire combinations (figs 28-29). The endeavour to create on diadems of this type a central ornament that fits in with the other elements and justifies its role as a starting point for them, as in the case of the Vergina example (figs 30-31), or a terminus, as it clearly is on the Sedes diadem (figs 26-27), was perhaps the reason for the successful choice of the Herakles knot – a device known from earlier periods. Charged with symbolic meaning and protective properties, this motif described a glorious orbit, adorning necklaces, diadems and other pieces of jewellery. Since its burgeoning coincides with the heyday of the Macedonian state, in the second half of the fourth century BC and its typological development ceased in

the second century BC, when Macedonia collapsed, it is rightly regarded as a typical Macedonian ornament alluding to the Macedonian dynasty's descent from the Herakleids.

Another type of diadem embodies a completely new concept of form and decoration (figs 32-37). The largest assemblage of this type appeared, together with other ornaments (and coins), on the Athens market in 1929, and the diadems were purchased by the Helen Stathatos Collection and the Benaki Museum. The conflicting claims of some dealers that the jewellery was from Almyros, Thessaly or Lamia-Lianokladi, and of others that it came from Domokos in Phthiotis or Karpenisi in Evrytania, contain a large dose of misinformation. Quite apart from the problem of where they were found, there is the question of their workshop provenance. The French archaeologist Pierre Amandry, who studied the jewellery in this hoard as a whole and assessed its quality – and indeed without recourse to the host of comparanda available today – considered them to be of Macedonian workmanship. The common feature of all these diadems is an impressive, almost emblematic Herakles knot, articulated from trapezoid plaques in the form of a specific type of anta capital (sofa) with tiny volutes at the upper corners, encountered in architecture, including that of northern Greece, and particularly Macedonia, from the fourth century BC (Vergina, Pella, Propylon of Ptolemy II on Samothrace, Veroia, and earlier in Olynthos), as well as in earlier jewellery from the same region (fig. 147). The overall effect is monumental and seems to have been designed to propagandige a symbolic message. The examples of this type illustrated here (figs 32-37) probably date from the troubled reign of Philip V. That this type enjoyed a wide diffusion is attested by examples from Ithaca (fig. 35), Ptolemaic Egypt and Pantikapaion in the Crimea.

On the northern shore of the Euxine Pontus the

impressive Herakles knot, with similar gold bindings, was subsequently incorporated in another type of diadem of the second century BC (fig. 40), consisting of two parts of semicircular section, curved in order to fit on the head. The prehistory of this type probably goes back to the second half of the fourth century BC, to metal diadems with a stem of circular or almost circular section, like those from graves in the vicinity of Taranto, as well as the much-discussed diadem in tomb II (of Philip) at Vergina, the tubular stem of which forms a full circle. The diadem from Crispiano in the region of Taranto (fig. 39) was probably affixed to a stem of this kind, maybe of wood. The diadem with stem of semicircular section is encountered later at Canosa in the same area (fig. 38). The end of their development is marked by the diadems of the Artjukhov type (fig. 40), which combine the stem of semicircular section with the Herakles knot and are the last representatives of this genre.

Earrings

Earrings, like necklaces, display a remarkable variety of shapes and forms. Many of them seem very strange today and indeed we are puzzled as to how they were worn. We are now able to say that most ancient earrings, possibly including those with an open suspension hook, that is however splayed at the end to form a kind of schematic snake's head, were worn hanging from a link of fine wire which passed through the earlobe. These links, invariably of silver or bronze, regardless of the quality of the earrings, have been lost due to oxidation and have only survived in a very few cases, such as the recent examples from Aghia Paraskevi (earrings of Omega type, as in fig. 57) and Epanomi, Thessaloniki (earrings with double wire, as in fig. 66). The example from Epanomi indicates that the Mace-

donian band earrings (figs 60-65) were probably worn in the same manner, suspended from a link.

The earliest earrings known from the period under consideration are plain gold hoops, recovered from an eleventh-century BC grave at Lefkandi on Euboea. In the tenth century BC so-called spiral earrings appeared. Known in the Sumerian city of Ur (Southern Iraq) from the third millennium BC, and indeed together with the link that passed through the earlobe, these are the first earrings of decorative shape in Greece, in historical times. One category comprises those with multiple spirals or a single curve, usually of relatively fine wire, and with disc terminals in diverse variations. On the earliest tenth-century BC example, from Palaiomanina, southwest of Agrinion, these terminals are embellished with impressed dots, whereas in Corinth, in the eighth century BC, flat discs incised with a simple cruciform motif were preferred (fig. 46). On other examples from Lefkandi, of ninth century BC date, the terminals are slightly conical, solid or hollow (fig. 44), as are those on bronze and gold examples of the eighth century BC, from Corinth, Tegea, Thebes and Amphikleia, Locris. From Attica there are monumental earrings of this type, decorated with luxurious granulation, unusual for the period (fig. 45). Another class of very early spiral earrings with a stem of thicker metal forming a single spiral with plain terminals, as a rule, or multiple spirals engraved with herring-bone motif at the ends, is mainly known from the Peloponnese (figs 47-48), but has also been found in other regions. On some examples, formed from one (fig. 49) or more spirals, there was an elongation of the spiral already in the eighth century BC, which persisted into the fourth century BC, decorated consonant with the spirit of the age (fig. 50).

In Late Geometric times a type of earring with elongated, loop-like spiral and upturned ends with disc terminals in symmetrical arrangement, came

to the fore. In the seventh century BC this type was very popular on Rhodes – as well as other Aegean islands – with both relatively simple (fig. 51) and exceptionally impressive examples (fig. 52). The bent ends of the stem were no longer crossed but turned up in opposite direction on either side of the central loop. In Rhodes, the eastern Aegean islands and the Asia Minor littoral, earrings with one low spiral, as on the example from Myndos (fig. 49), were also formed with twisted ends (fig. 53) from the seventh century BC. With this form of stem, but with variously embellished terminals (figs 54-56), they survived also elsewhere until the fourth century BC.

A peculiar version of the type are those earrings in which the ends are bent upwards and sideways, assuming the shape of the letter Omega. The earliest example, in the Helen Stathatos Collection (fig. 58), is dated to the eighth century BC, mainly on account of the form of the conical terminals which also occur on another type of early earrings. So far the Stathatos earring remains the only one known until the sixth century BC, when the type, with certain differentiations of the ends, became widespread, mainly in Macedonia – as is deduced from the large number of finds – and later in Thrace. The Macedonian earrings are usually of silver with terminals in the form of snake heads, excepting a few in the form of a flower bud, whereas in Thrace there was a preference for pyramidal terminals (fig. 57).

A strange pair of earrings found in Athens and dated to the ninth century BC (fig. 59) appears to be an unicum. Its distinctive feature is the emphasis on one end, which is unprecedented – and would so remain – in Southern Greece, where the two ends of an earring were always equivalent. At present there is no visible link between the Athenian find and the Archaic band earrings of Macedonia, some of which also display a band of par-allel wires (fig. 65) and all, without exception, have one end stressed (figs 60-65). It is certain, however, that the Athenian earrings formed a hoop, even if there is no hook behind for the loop of the band, as is the case for the majority of Macedonian ones too.

The largest number of Macedonian band earrings are included in two groups; that in the Helen Stathatos Collection, which comes from Chalkidiki (figs 60, 64), and the securely dated finds from Sindos (figs 61-63). The earliest pair from Sindos, from grave 28 of about 560 BC, is a fully elaborated type. The other examples from the same cemetery date from the second half of the sixth century BC and just after, and the best quality pieces from the final quarter of the century. Two earrings from grave 20 at Sindos are identical to, and probably by the same goldsmith as, two from Vergina, one in the Stathatos Collection from the vicinity of Thessaloniki, and two in the Herskovits Collection in New York. Another pair found recently at Aiani, Kozani, is verisimilar to two pairs from graves 56 and 101 at Sindos. Thus the workshops producing jewellery for the funerary needs of the Sindos cemetery enjoyed a dominant position.

The earrings with tongued terminal in the Stathatos Collection (fig. 60) give the impression that they are earlier than, or at least contemporary with, the earliest ones from Sindos. P. Amandry remarked on the technical and stylistic affinities which relate them to some pieces of jewellery from Etruria, of the seventh century BC. Even earlier, from the eighth century BC, is a ring from Athens comprising a single guilloche framed by wires, just like the bands of the Sindos earrings (figs 61-63). This form of earrings persisted until the end of the Archaic period, even when the decoration of the 'head' was simplified, being limited to a circular terminal, as on a recent silver find from Nea Michaniona, Thessaloniki. The earrings in the

Helen Stathatos Collection with a similar circular terminal (fig. 64) will not be earlier than the final quarter of the sixth century BC. In Late Archaic times, however, there was a gradual abandonment of the guilloche decoration of the band, which was constructed solely of parallel wires (fig. 65). The shape of all these ornaments, a band with one end developed and the other tapered, is apparently of Northern provenance, mainly known from the Balkans. Another type of Macedonian earrings belongs to this wider category (fig. 66). Fashioned from folded wire, usually silver, and dated to the Late Archaic period, they continue a tradition of jewellery of double twisted wire whose origin scholars trace to Central Europe. Earrings of this type were perhaps also worn for a time in the fifth century BC.

For a type of earrings with hoop and elongated conical pendant formed from globules or granules and closely resembling a mulberry, a parallel development is observed from the sixteenth century BC in Syria and Cyprus, as well as in Crete, where it quickly evolved into a stylized bucranium. In the Benaki Museum there is another variation of Late Mycenaean times, with four mulberries (inv. no. 2089). Probably dependent on this tradition is a pair of earrings with three such pendants, of the ninth century BC, found at Lefkandi in Euboea (fig. 68). Research has been concerned with relating these earrings to those mentioned twice in the Homeric epics as 'τρίγληνα μορόεντα', usually interpreted as with three pendants or mulberries etc., with insistence on the number three. However, the word 'τρίγληνα', essentially untranslatable, should perhaps not be associated with indicating the number of pendants but with the interpretation of the Scholiast of Homer (Iliad XIV 183) as 'πολλῆς θέας ἄξια' or Hesychius 'πολυθέατα' ('spectacular'). The number of pendants was perhaps a local variation, since a second pair of earrings

with three conical pendants, though not mulberry-like ('μορόεντα'), is known from Lefkandi (fig. 67).

Later, and for many centuries, earrings with one conical pendant were produced. On a seventh-century BC pair from Argos (fig. 69) the pendant is of the old conical shape with added globules, as on an earring from Poros, near Herakleion, Crete. For the first time, however, a typological change is observed, which proved decisive for the years to come: the cone is used as a kind of base for a figure modelled in the round. From earrings in silver and bronze it is evident that the mixing of typological elements in rendering the form of the cone began in the sixth century BC. In the years of the Severe Style this form crystallized into a peculiar, fantastical hotch-potch of traits with earlier roots. At this time the pendant (figs 70-74) has the architectural form of an inverted pyramid above, of a cone coiled with wire below – just like the cones on the earlier earrings from Lefkandi (fig. 67) – and as a transitional element between the two, a zone of coarse globules, possibly a vestige of earrings of the Argos type (fig. 69).

Perhaps the earliest example of this type in gold is an earring in the Benaki Museum (fig. 70). Its form is severe and the individual decorative elements are embodied in a compact whole with almost straight triangular outline on each side. In all likelihood the addition of multifarious, mainly filigree ornaments (volutes, palmettes et al.), which resulted in the abandonment of clear forms, commenced in the second quarter of the fourth century BC. Around the middle of the century an architectural conception is apparent in the crowning of the pyramidal body with an anthemion or a pediment (as on two earrings from grave 70 at Amphipolis), which lived on in certain workshops (such as in one example in the British Museum and another in Basle, Switzerland). From the third quarter of the century at the latest significant changes were effect-

ed (fig. 71): the proportions of the ornament became more elongated, its upper part was occupied by modelled figures like a kind of akroteria and chains were added with other pendants. These were all suspended from a decorative disc. By the last quarter, and particularly towards the end of the fourth century BC, all hint of architectural form had regressed and a palmette at the apex of the pyramid (fig. 72) is a floral element just like the rest, creating an efflorescent setting, in which may be seated a female figure with a lyre, and therefore characterized as a Muse (figs 73-74). The representation of the Muse is interpreted as an allusion to the Elysian Fields (see pp. 213-214, nos 23-24, pp. 225-226, no. 71). In keeping with the ideology of the age, it recurs on many pieces of jewellery. After this phase, the fall in demand for this type of earrings was rapid.

A type of crescent or semilunate earrings is known from the eighth century BC, but in a limited number of examples (fig. 75). The *pelta*-shaped pendant on a pair of Eretrian earrings of the fifth century BC (fig. 76) perhaps recalls this shape. In contrast, a type which remained in vogue for centuries is the so-called boat-shape (figs 77-88). Earrings of this type were already worn in the third millennium BC, in the Sumerian city of Ur, and evidently enjoyed uninterrupted use in these regions. A simple pair from a pithos burial in Lefkada (Leucas) is the unique find in Greece of comparable antiquity, dated to the third quarter of the third millennium BC.

In historical times this type appeared in the seventh century BC, at Ephesos, while its wider diffusion in Greece mainly began in the sixth century BC, with plain decoration at first (figs 77-78). However, already from this century certain special decorative canons were formulated (fig. 78), which were to be basic in the years to come: division of the surface into two lengthwise zones of decoration

and filling of the hollow of the boat with figures in the round. From the fifth century BC onwards these standard traits were to pass to a separate branch of boat-shaped earrings in which the boat now is suspended from a rosette and bears at the bottom additional pendants, as on the example from Eretria (fig. 79). The upper zone of decoration was developed in depth but continued to be fully visible and equal to the lower. The next immediate example, from Vratsa in Bulgaria (fig. 80), of the second quarter of the fourth century BC, features the same decoration as the Eretria earrings (siren in the round, wire scrolls, rosettes on the horn-shaped ends of the boat) along with innovative elements typical of the second half of the century: the rosette device of the Eretrian earrings has been incorporated in a round disc, the pendants are vase-shaped and a garland of rosettes masks the curved end of the boat.

From the third quarter of the fourth century BC and culminating in the fourth quarter, goldsmiths in different workshop centres vied with one another in quality of craftsmanship, imaginative inspiration and wealth of details. On a boat-shaped earring dated to the third quarter of the century, from Kul Oba in the Crimea (fig. 83), a palmette has been substituted for the figure of a siren. Henceforth these daemonic figures are ousted. The very next phase seems to be represented by a pair of earrings from Derveni, Thessaloniki (fig. 81) and one again from Kul Oba (fig. 84). From this time onwards the body of the boat is covered with the typical decoration of rows of tiny granulated lozenges. The palmette in the hollow is elevated on a lyre-shaped pedestal. Both rosettes at the horn-shaped ends have been replaced by palmettes, framed by interlaced tendrils on the Derveni earrings and by two Nikai on those from Kul Oba. From now onwards winged Erotes and Nikai become the favourite subjects on boat-shaped earrings. The suspension

disc on the Derveni earrings is filled with free flowers which presage the next phase, while the upper zone of granulation on the Kul Oba 'boat' has already lost its decorative substance. During the last quarter of the century, in the earring from Madytos on the Hellespont and that from Trapezous (Trebizond), the upper zone has been eliminated completely from the field of vision. Close to the latter example is a pair of earrings from Western Asia Minor (fig. 82), which represents the ultimate refinement of this phase and sets its seal on the final stage in the evolution of this type: a pedestal with a two-horse chariot (biga) is interposed, still visually hovering, between the hollow of the boat and the suspension disc. The earrings with four-horse chariots (quadriga) driven by Nikai, from Theodosia in the Crimea (fig. 85), and their counterparts – a pair from Crete, now in the British Museum, and another from Chersonesos in the Crimea, now in the Hermitage State Museum –, are the last in this line of development. A pair in the Louvre, with quadriga driven by Helios, constitutes the final echo of the type. It goes without saying that there were no fixed bounds between local workshops, hence the chronological sequence outlined above represents the general course of the evolutionary tendencies and conservative elements may well have survived into later phases (fig. 86). The production of plainer pieces, belonging in the general category of boat-shaped earrings (figs 87-88), also depended on earlier tradition.

From the reign of Alexander the Great, alongside the opulent jewellery other, simpler, types of earrings appeared, variations of which persisted throughout the Hellenistic period. One large category, with countless examples and very wide geographical distribution, are the hoops of one or more wires wound around a core (fig. 89), or of several wires twisted together (fig. 90), terminating at one end in a zoomorphic or anthropomorphic head.

Some Etruscan examples may have been precursory forms, but the Hellenistic type that spread throughout the Hellenic world was probably fashioned in the third quarter of the fourth century BC, in Macedonia, where there was moreover a long tradition of earrings with one decorated terminal (see p. 32ff.). In any case the earliest known examples of the crystallized type are of Macedonian provenance: an earring from Derveni (fig. 89) and a pair of earrings from ancient Mieza. Earrings of this type appear in many variations, depending on the technique of fashioning the hoop and, primarily, on the kind of zoomorphic or anthropomorphic finial. The wire of the hoop was usually coiled around a wooden core (fig. 89), that perished as time passed, for which reason many hoops of this kind are now hollow. In some examples the core is of gold, around which one or several wires were wound. The lion head is the earliest form of finial and the most popular (figs 89-90). The repertoire was later augmented with heads of the lion-griffin and the antelope, which enjoyed wide diffusion, the goat, more rarely (fig. 91), as well as a negro head of semiprecious stone (figs 92-93), and from the second century BC the lynx (fig. 94), the dolphin and so on.

Another large category of earrings are those with all manner of pendants in the round. Heads (figs 95-96) and complete tiny sculpted groups, such as that of Ganymede with the eagle (fig. 97) or a fully equipped chariot with horses and charioteer (fig. 98), are among the most impressive and elaborate, while winged figures (figs 99-100) – primarily Erotes (fig. 101) – some of them rendered with exceptional artistry and skill, are among the favourite subjects. Little amphoras (fig. 102) as well as joyful figures of tiny birds, picked out in coloured stones or enamel, such as ducks, geese (fig. 103) and, above all, doves (figs 104-105) prevailed in the second century BC.

Necklaces and pendants

The necklace is essentially a concatenation of tiny similar or dissimilar objects, strung on a thread and worn around the neck, initially, or affixed to the garment with fibulae or pins – as a pectoral ornament – later. One of the component objects could be worn individually as a pendant or medallion. Pendants and necklaces may well be the first items of jewellery to have been wrought in gold and were for a long time probably the most widely distributed gold artifacts. Indeed, in Egyptian hieroglyphic script gold is denoted by the ideogram of a necklace.

In the jeweller's art the components of a necklace, regardless of their shape or form – product of the artist's imagination or the fashion of the age – are covered by the blanket-term beads. However, the word automatically brings to mind certain basic shapes, such as spherical, biconical, ellipsoidal or cylindrical beads, which are encountered in all eras, sometimes decorated and sometimes plain. In the early centuries of the period we are considering, gold beads were rare and confined to a small number of isolated examples. An exception is the necklace of eighty solid spherical beads found in a grave dated 1100-1050 BC, near Knossos, on the site now occupied by the Medical School of the University of Crete.

The first gold necklace of artistic merit was found at Lefkandi, Euboea. Dated to the ninth century BC, it consists of cylindrical beads of sheet gold decorated with two pairs of wire spirals. Of similar form is a later piece (fig. 106), found in a grave at Anavyssos, Attica, which had probably been used as a pendant. Morphologically these pieces are variations of somewhat earlier necklaces known from Mycenaean times. In technique, the working of sheet metal and wires was known in Greece from the fashioning of jewellery in a much

more difficult metal, bronze. Even so, the sheet-gold disc-shaped pendant hanging from the middle of the Lefkandi necklace mentioned above bespeaks both a knowledge and the influence of analogous jewellery from Eastern lands. It is from there, particularly the Syro-Palestinian region with its long and unbroken tradition in the goldsmith's art, that the mainland Greeks learnt the more intricate techniques of jewellery-making, either directly or via Cyprus. Pairs of earrings found at Athens and Lefkandi (figs 59, 68) confirm that already in the ninth century BC Greek craftsmen began to become familiar with both filigree and granulation. A necklace (fig. 107) from a parure found at Tekes, Knossos, about 800 BC, presents three technical innovations: inlaid stones, cord-chains (cross-linked double loop-in-loop chains) and tiny pendants hanging from simpler chains. By the dawn of the eighth century BC all the techniques of gold jewellery had become known – by one way or another – in Attica, where goldsmithing workshops certainly existed (see figs 9-10, 45, 58, 75, 106, 108, 110, 130, 180-181). A necklace of beads and pendants (fig. 108), another of plaques forming a kind of band, probably with similar pendent ornaments (fig. 110), and lastly a cord-chain like the Tekes ones, found in a grave at Anavyssos, Attica, 775-750 BC, represent three general categories of necklaces that continued to evolve in the centuries to come.

The first and largest of the three categories includes necklaces of beads and pendants. The beads, of basic shapes requiring no comment, made of sheet gold, series of granules or wires, are sometimes a major element in the composition (figs 121, 125) and sometimes a minor, when the pendants, whose forms essentially determine the special form of the necklace, predominate. In the eighth century BC pomegranate pendants, known also from elsewhere in bronze, were particularly

popular in Attica (figs 108, 130); they appear on later necklaces too (fig. 118), hung in a new manner. Particularly striking are certain Rhodian necklace elements of the seventh century BC, in the form of a siren and a daemonic bee (fig. 109), perhaps separated by ribbed spherical spacer beads, common in Rhodes in that period. These elements constitute the transfer to cut-out ornaments of analogous embossed figures on plaques of sheet gold (fig. 132). Despite their impressive appearance, their use remained limited at that time. A distant echo of the daemonic bee can be seen in the tiny wingless figures that hang from some earrings and necklaces of the fourth century BC (figs 82, 153). Dated to the last quarter of the seventh century BC is a pendant from Argos (fig. 111), of a form known from elsewhere in the Peloponnese. The rosette at the top and the grooves are so arranged as to resemble a poppy capsule. However, through the appropriate modelling of the lower part of a ribbed bead and the addition of a cylinder to the upper it acquired the form of a vase. Such ornaments were worn as single pendants or incorporated as pendent elements in a necklace. In the form of a pointed-bottom or globular vase, with plain or decorated surface, they were great favourites in Macedonia, and elsewhere, in the sixth century BC (figs 113-114, 116). Vase pendants were enormously popular in another category of necklace (figs 138-141, 144-145, 150, 153-156) and on earrings (figs 80-86), in the fourth century BC, when they essentially ceased to evolve.

Two pendants from Thera (fig. 112), probably of the late seventh century BC, attest another method of suspension. Tubular beads, like those bearing spiral decoration during the ninth and eighth centuries BC (fig. 106), are now used as T-shaped arrangements for pendants – spherical in Thera, vase-shaped in the Peloponnese –, while in the sixth century BC they were combined with

pyramidal (fig. 114) and pomegranate pendants (figs 115, 117). In the early examples, like those of Thera, this system of suspension is somewhat clumsy – it survives later in Eretria (fig. 118) –, while in the Macedonian ateliers of the second half of the sixth century BC it has a more concise and symmetrical scheme (figs 114-115, 117). However, from the early fifth century BC at least, in some workshops – Eretrian or Cypriot for example –, it evolved into a transitional shape (figs 119-120) with a vertical narrower cylinder, the upper part of which is modelled as a pierced bead through which the necklace string passed. After the fifth century BC these systems of suspension were finally replaced by links of a chain, except in very few cases.

In the last example from Eretria (figs 119-120) the midpoint of the necklace is emphasized by the head of a powerful animal, an element introduced into the necklace repertoire in the sixth century BC, as were acorn pendants. On another piece, perhaps slightly later (fig. 121), with just one, ram-head pendant, the necklace is of elegant form and the beads no longer play the graceless role of secondary spacers but a substantial one in their own right. The necklace with only a biconical bead as the central pendant, from the area of Amphipolis (fig. 122), was similarly modest. From the second half of the fourth century BC there was a proliferation of simple bead necklaces, of which a Herakles knot, some special terminals, a central pendant are frequently the only additional embellishment (figs 123-126). In the third century BC new types of beads appeared, such as cylindrical ones of reticulated wire (fig. 127) and even more frequently spool-shaped (fig. 128).

A second general category of necklaces that appeared in the eighth century BC, are those with a kind of band consisting of decorative elements from which hang diverse pendants, depending on

the period. These were mainly worn as pectoral ornaments. The band was initially formed from sheet-gold plaques with geometric decoration (figs 110, 130). In the seventh century BC, however, there were pronounced Oriental traits, as indeed in all works of art. Many examples come from the islands, especially Rhodes, which was an extremely important centre of production. For Rhodes the seventh century BC was its 'golden age', the memory of which lived on in the ensuing centuries and is echoed in the poetry of Pindar (*Olymp.* VII 62ff., see also Strabo XIV 2, 10). The gold necklace plaques, mainly recovered from Rhodian cemeteries, were decorated with embossed daemonic figures (figs 131-134) and the overall effect was monumental in comparison with the previous examples. Evidently the mode for these necklaces did not last beyond the seventh century BC. Just one plain example with plaques, about 510 BC, was found in the Sindos excavation (fig. 135). The decorative conception is entirely different and in no way monumental, in which respect it is more like the necklace from Spata, Attica (fig. 130), dating from the eighth century BC. On some necklaces of the second half of the fifth century BC, from Cyprus and from Nymphaion in the Crimea (fig. 136), ribbed cylinders function as a kind of 'plaque' embellished with applied rosettes. Ribbed cylinders of this kind were later placed on the back of the elements forming the band of certain necklaces (figs 138-140, 142-145).

Another type of necklace, in which other elements have been substituted for the plaques (figs 137-140), perhaps appeared as early as the fifth century BC. Here parenthetic curves of pairs of antithetic lotus blossoms frame a rosette in such a way that they create the aesthetic impression of a continuous band without gaps. Variations of the motif already existed in Assyrian art, on representations of diadems of the seventh century BC, while during the fifth century BC it is executed in relief on the cut-out sheets of necklaces from Cyprus. The last, however, ostensibly continue an earlier tradition, since a similar sheet-gold ornament was found at Ephesos. The motif was most probably crystallized in the form of antithetic lotus blossoms framing rosettes and transferred to necklace 'beads' in the Greek goldsmithing workshops active on the northern shore of the Euxine Pontus, which is also the provenance of the earliest example (fig. 137) and the largest assemblage of these pieces.

This type enjoyed a wide distribution, as indicated by the impressive necklace from Taranto (figs 138-139), and another from Omolion in Thessaly (fig. 140), and considerable longevity, since it continued to be produced throughout the fourth century BC, as other examples attest. Nevertheless, towards the end of the century, in the necklace from Karagodeuashkh (fig. 141) the floral freshness has given way to a stylized vegetal motif which is combined now with beads instead of rosettes. In another necklace of unknown provenance, now in London, of the third century BC, the rosettes still exist but the antithetic lotus blossoms have been reduced to capsae with green enamel, resembling double-axes in shape. Lotus blossoms survived in a more succulent and natural form, combined with local motifs, in the very late Hellenistic necklaces from far-off Taxila, capital of Gandara (in present-day Pakistan), where the Hellenistic influence from the time of Alexander the Great's conquest of India was intense and enduring in all spheres of art, as excavations there have revealed.

A necklace from Derveni, Thessaloniki (figs 144-145), in which the band is formed by just one row of rosettes, is a variation of the preceding type. This garland is encountered on a host of other necklaces (as well as contemporary earrings, see figs 80-86), though relegated to the bottom of the

band which is henceforth formed from interlinked rows of loop-in-loop chains (on the method of manufacture see p. 23f., drawing e). The earliest examples of such a chain strap appeared with a type of Rhodian necklace of the second half of the seventh century BC (fig. 146). No other examples are known until the fourth century BC, with the exception of certain Etruscan gold necklaces which researchers date to the late sixth century BC or to the years of the Severe Style. After the middle of the fourth century BC straps of this kind featured on necklaces all over the Hellenic world, from Magna Graecia to Asia Minor, from South Russia to Egypt, as well as on a particularly impressive type of diadem (figs 33, 36-37), of later date.

Two kinds of necklaces can be distinguished on the basis of the form of the pendants: necklaces with spear-head pendants (figs 147-149, 151-152) and necklaces with vase-shaped pendants (figs 150, 153-156). Necklaces of the first category have been identified with the so-called 'lance-headed chains' in the lists of *hieropoioi* of Delos from the year 279 BC onwards, and those of the second with the 'chains of amphorae' mentioned there. Although in reality the lanceolate pendants are not spear-heads but arrow-heads, with three flanges, the identification seems secure. Necklaces of spear-head pendants may not have persisted beyond the turn of the fourth to the third century BC and examples cited from the third century BC, as for example in the Delos lists, are perhaps of the fourth century BC. On the contrary, the necklaces with vase-shaped pendants hanging from a mesh of chains and embellished with relief floral, granular and filigree decoration, were much beloved throughout the third and into the second century BC (fig. 155). From the late fourth or the early third century BC chain straps were used in a limited number for another type of necklace, sometimes combined with a Herakles knot (figs 157-160).

A third general category of necklaces are those in the form of cord-chains (on their history and manufacture see p. 23f., drawing d). The earliest example, the necklace from Tekes, Knossos (fig. 107), comprises two such chains holding a pendant in place. Not long afterwards, this type appeared in Attica, as is deduced from a gold cord-chain without pendant, from a tomb at Anavyssos, of the second quarter of the eighth century BC. Its two ends are likewise modelled as snake's heads, but are more schematic than on the Tekes necklace. So far no other examples are known from Greece until the last quarter of the sixth century BC, excepting fragments of a simple gold chain of the seventh century BC, from the sanctuary of Artemis Orthia at Sparta, and of course the short chains for jewellery pendants, indeed with bifurcate terminals on Rhodian jewellery of the seventh century BC.

A considerable number of cord-chains in silver, in fragmentary condition, is known from Late Archaic times, from Sindos, Vergina and Trebenischte in Yugoslavia. According to the evidence from the excavations at Sindos and Vergina, these necklaces were worn fastened to the chest with fibulae. On an intact gold necklace recovered from Sindos (fig. 161) the chain ends bifurcate and are fashioned as snake-head terminals, as on all the silver parallels. This site is also the provenance of the latest example with forked ends, for the present, a silver necklace of the mid-fifth century BC. Each end terminates in a cylindrical device, with which the member bearing the snake's head connects. A gold chain from Eleftheres, Kavala ends in two such cylindrical terminals, as does a silver chain passed through arched fibulae, said to come from Elis and of late fifth or early fourth century BC date. From the fourth century BC onwards, following the fashion of the age, the ends of cord-chains and of simple chains assumed the form of zoomorphic or anthropomorphic terminals (figs 162-166), and

were frequently combined with a Herakles knot. From the third century BC necklaces were embellished with precious stones and later decorated with central sections (fig. 167) which, mainly from the second half of the second century BC onwards, were to develop into elaborate composite ornaments once again held in place by two chains (fig. 168), as in the Geometric necklace, of about 800 BC, from Tekes (fig. 107).

Pins

Pins are already known from the Early Bronze Age. In prehistoric times they often occur individually, vary considerably in size and their exact purpose is obscure. Those found in pairs have been associated with fastening garments, while the single ones were probably ornaments, some of them perhaps for the adornment of the head, in combination with diadems or headdresses. The use of pins became more widespread from Late Mycenaean times onwards, when they are found in pairs, in variations of a new type. Their appearance has been linked with the prevailing of a particular female garment, the peplos, which was not sewn and had to be fastened on the shoulders. It is in this position that pins are found on female burials of the period in question, and it is presumably because of this function that they are far more ubiquitous than other items of jewellery in Early Geometric times. Countless bronze and iron pins from this period have survived, many of them half a metre in length.

The earliest pins are simple with a flattened disc-shaped head, just below which, integral with the shaft, there is a spherical bead or an ellipsoidal bulge, framed by slightly raised rings on specimens from the Peloponnese and Crete. Indeed this is the form of the two earliest known pairs of gold pins, of the tenth century BC, discovered at Fortetsa and Tekes near Knossos. On these the bulge is already biconical. This type of embellishment of the pin, with biconical protuberance flanked by rings, features on another pair of elaborate pins from Tekes (fig. 169). In the eighth century BC it was crystallized into a form typical of Crete until the early seventh century BC (fig. 170). In the Peloponnese, and in Attica a little later, the basic pin type, which persisted for a long time, has a disc-shaped finial and spherical bead. Ninth- and eighth-century BC pins of this kind, found in Athens, of iron invested in gold foil, bearing engraved or granulated decoration on some, could be described as monumental. The type began to evolve from the eighth century BC, primarily in the Peloponnese. Through the addition of other decorative elements and minor alterations to the spherical bead, pins with a composite, ornate head appeared in the seventh century BC and, mainly wrought from bronze or silver, these remained in use until the final years of antiquity.

From the seventh century BC vertical incisions or grooves, separating ribbed fields, appeared on the spherical beads or on beads formed as pendants of other items of jewellery (see figs 111 and 134). In the sixth century BC the ribs between the grooves were modelled as bulges, and in this form the beads, either as annulets on pin heads (fig. 171) or fibula bows, or as components of necklaces (fig. 118), enjoyed wide distribution and great longevity. Gold pins with disc-shaped terminal and spherical beads have only been recovered from the Archaic tombs of Macedonia. On the examples from Sindos (figs 172-173) the decoration is developed on the surface of the spheres in filigree technique, while on a pair of pins from Vergina and on another pin from Aiani, Kozani, this with conical terminal, the beads are of typical shape with modelled bulges.

A significant number of gold pins, of smaller dimensions and found singly, have been recovered from the eastern Ionian regions, especially Ephesos. Dating from the seventh century BC, these are plainer with just one apex as the head, though in a variety of forms, such as a flower, fruit (fig. 174), drum et al. A pin from Delos (fig. 175) probably owes its form to influences from workshops in these regions.

The peplos, which, according to Herodotus (I 88), was originally the garb of all Greek women, lost ground after the fifth century BC, being supplanted by the Ionic chiton, which was a sewn garment. Pins likewise gradually disappeared. They are still shown in vase-paintings of the fourth century BC. The sporadic examples from the third and second centuries BC are found singly (figs 176-179) and not in pairs, which fact probably attests a different function. Maybe they were worn as jewellery or, in the opinion of some scholars, hair ornaments, or perhaps they held in place the ends of a diadem or headdress, for which purpose fibulae were sometimes used.

Fibulae

Of all pieces of ancient jewellery fibulae were the last to appear. They first occurred in Late Mycenaean times, virtually concurrent with those pins used for fastening the female garment on the shoulders, and were probably for the same purpose, though they may have been used also for closing the side opening of the peplos, thus complementing the pins. Certainly from Archaic times onwards, as the host of recently excavated tombs in Macedonia indicate, fibulae were mainly associated with holding pectoral ornaments in place. Their initial use for fastening the peplos on the shoulders was also retained later, occasionally and mainly for the clothing of young girls. Isolated fibulae found close to the skull in tombs were most probably used for uniting the ends of band diadems or headdresses. The jewellery a woman took with her to the Underworld often included more than one pair of fibulae, just as there was often more than one necklace or finger ring. In the area of Thessaloniki in the second half of the fourth century BC, it seems that five or six gold fibulae was a normal number for a wealthy woman (figs 183-187). Five, six or even ten fibulae were not uncommon even in Geometric times.

The early form of fibula was simple, of thick wire fashioned in the shape of a violin bow. The form of the bow, slightly thicker in the middle, flattened or leaf-shaped (fig. 80), also determined the variations of the fiddlebow fibula. In the immediately succeeding years another type appeared alongside it, the so-called arched fibula, which was to endure for several centuries, subject to diverse developments and local variations. Up until the seventh century BC fibulae were mainly bronze. Very few gold ones are known, either early or later, except in the second half of the fourth century BC. A pair of gold fibulae with leaf-shaped bow is known from Attica in the ninth century BC (fig. 180), but already in this century the type was on the wane. It gave way to another one, which developed in Attica (fig. 181) and spread rapidly elsewhere, in particular to Boeotia, in the eighth century BC. Although Blinkenberg has characterized this type as Attico-Boeotian, the output of other local workshops, not least those of Thessaly, was by no means insignificant. The leaf-shaped bow of these fibulae is markedly curved, the thicker end of the pin shaft springs erect, the catch-plate is enlarged and its free edge displays an upward sweep, endowing the overall shape with remarkable dynamism.

The evolution of the arched fibula was ana-

logous. Generally, shapes and forms of all the types of fibulae vied with one another in quality and distribution, so that the eighth century BC may well be characterized as the splendid age of the fibula. In some regions these tendencies continued during the seventh century BC, but this century is mainly characterized by the countless variety of arched fibulae fashioned in local workshops. In the sixth century BC fibulae production evidently plummeted, though the ornament continued to be used in provincial centres. Apart from isolated gold examples, such as a pair from Sindos (fig. 182) and one of another type from Vergina, most of the fibulae of this period are of silver or bronze, and a smaller proportion of iron.

A distinctive type of arched fibula which mainly developed in the wider area of Macedonia during the sixth century BC will be discussed here, even though no gold examples have come to light as yet, because many gold fibulae of the second half of the fourth century BC evidently derive from it (figs 183, 186). The type appears fully elaborated in three pairs of silver fibulae recovered from grave 119 at Sindos, about 560-550 BC. Their bow is decorated with five annulets or beads, each with six modelled bulges, corresponding to those beads decorating the heads of contemporary pins (fig. 171) or composing necklaces (fig. 118). All the fibulae of this type are articulated (like the fibulae of another type in fig. 182), with an additional pin attached by a rivet to one end of the bow. This is a new technique which can be traced back to some perhaps seventh-century BC fibulae found at Olympia. For the present, the covering of the attached end of the pin between two palmette-shaped plates appears to be a local Macedonian peculiarity.

The palmette-embellished end of the silver and bronze examples, which is thick and cast in one piece with the bow, has been cut with a suitable saw to create a socket in which the end of the pin, splayed by hammering, is inserted. On the gold examples (cf. fig. 182) the palmette end is composed of two overlying sheet-gold plates. The catch-plate at the other end of the bow of these fibulae retains the general T-shaped form known from eighth-century BC examples of Phrygian type from Gordion, and in the seventh century BC from the insular regions of Ionia and the Peloponnese. On the Macedonian fibulae the ends of the crossbar of the T are rounded, forming two semicircular projections bearing two globules, probably decorative imitations of two rivets which will have occupied this position in earlier examples. Intruded between the two globules is a snake head, a motif well known from other items of Archaic Macedonian jewellery, such as Omega-shaped earrings or chains (fig. 161).

This type of fibula remained virtually unchanged until the fifth century BC, spreading to other regions, particularly the Balkans. In the first half of the fourth century BC the volume of the six modelled bulges around the perimeter of the beads on the bow was already significantly compressed, so that by the second half of this century the beads had finally evolved into six-lobe annulets (figs 183, 186). Moreover, through radical changes to the decoration at the ends of the bow, from the third quarter of the fourth century BC the fibulae acquired a new form, equal in splendour to the Archaic and Classical. Gold specimens were now numerous, both of this type and of related ones (figs 184-185, 187). Mythical creatures (griffins, sphinxes, Pegasos) replaced the snake's head between globules on the catch-plate and the double plate at the other end of the bow is embellished with the representation of the head of a lionskin or a human head with lionskin. This is not the head of the Queen of the Amazons, Omphale, as formerly interpreted, but of the young Herakles, who in

these times was elevated to a 'symbol'. He is depicted on coins of the Macedonian state or embellishes luxurious metal vases and other decorative objects, such as the gilded plaques with the head of a lionskin and unbearded Herakles, from a tomb at Katerini, Pieria. Sporadic examples of articulated fibulae with six-lobe rings persisted in remote regions until the second century BC.

From as early as Geometric times, alongside the other types of fibulae, brooches also appeared in the form of spectacle spiral ornaments or four spirals, disc-shaped, shield-shaped and others. An outstanding example of the seventh century BC is the brooch in the shape of a hawk, from Ephesos (fig. 188).

Bracelets

In Antiquity bracelets were normally worn on both arms, either as armlets above the elbow or round the wrist, as today. Only relatively few bracelets, even of bronze, are known from early times. At first they were simple in form, of wire, sheet metal or solid stem, wound into a single or multiple spiral, or penannular, with plain or discreetly decorated ends. Only after relations had been established with Eastern lands, where these pieces of jewellery had a long tradition, did their popularity increase among the Greeks, steadily rising from the seventh century BC onwards.

The most common and enduring form is that with snake-head terminal at either end. The earliest examples of this type are in bronze, date from the eighth century BC and were found in a grave at Spata in Attica. However, this type developed mainly during the Archaic period, reaching its zenith in the sixth and fifth centuries BC. Wrought in silver or bronze, they were widely diffused throughout northern Greece, mainly in Macedonia, as well

as being strongly represented at Olympia. Up until the fourth century BC gold examples were few and far between (fig. 189). This situation changed only in Hellenistic times when bracelets with snake terminals assumed a new form – perhaps influenced by serpentine symbols linked with Egyptian cults –, and maybe acquired a new meaning. This new type, of which earlier examples can also be detected, was more widely disseminated than any other and remained in vogue throughout the Hellenistic period. The bracelets were now rendered as full-bodied snakes, with the head at one end and the tail at the other, coiled into one or more spirals (fig. 190) or formed from two intertwined snakes (fig. 191). The most remarkable example of this category, in terms of conception and execution, are the two very famous bracelets with a Triton and a Tritoness (figs 192-193). Here the wonderfully gifted craftsman, quite possibly inspired by the repertoire of contemporary monumental art, surpassed the established bounds of goldsmithing and entered the sphere of miniature sculpting with his unprecedented creation.

The earlier type, with two snake-head terminals, belongs essentially to a more general category of bracelets, of Eastern provenance, with symmetrically arranged animal-head terminals. Isolated examples of these, with clumsily modelled lion-head terminals, made a cautious appearance on Rhodes at the end of the seventh century BC, becoming firmly established there in the sixth century BC, yet their Oriental dependence was still obvious (fig. 194). The Classical form of the type is represented by an outstanding pair of bracelets with terminals in the form of ram heads, from Kourion on Cyprus (figs 195-196). However, there are relatively few examples of this category until the fourth century BC. The quantitative imbalance in relation to snake bracelets was redressed to a degree after the dynamic renewal of contacts with

Eastern cultures consequent upon Macedonian expansionism. Gold bracelets became more numerous and their thematic repertoire was enriched with traditionally oriental figures, such as the head of an antelope, a lion-griffin, etc. (fig. 201), subjects with which Greek jewellers had become partially familiar through executing orders for a foreign clientele. The famous bracelets from the Scythian barrow at Kul Oba in the Crimea, with terminals formed as half-bodied sphinxes (fig. 197), most probably correspond typologically to the customer's wishes, since terminals in the form of full-bodied animals, as well as human figures – on bracelets and other items of jewellery –, were much loved by the local Scythian population. By this time the hoop was usually twisted or, more commonly, comprises two or more spiralling wires, a form known from earlier periods, particularly from certain types of Classical finger rings as well as from Hellenistic earrings also with zoomorphic or anthropomorphic terminal (figs 89-94). This twisting is imitated on the rock crystal hoops of a magnificent pair of bracelets from the environs of Thessaloniki (fig. 198). A different kind of hoop, fashioned from a twisted ribbed tube of sheet gold, is encountered on another bracelet with exquisite caprine heads (figs 199-200). Other Hellenistic bracelets, such as the bands with Herakles knot and filigree decoration or set with stones are rarer.

Finger rings

Finger rings are among the earliest items of gold jewellery worn by man; plain bands of sheet gold are known from Neolithic times. In the period under discussion here, such finger rings occurred occasionally in the tenth century BC, but were more numerous in the ninth, some of them lavishly engraved (fig. 202). Most of them were probably used only as grave goods (*kterismata*) or, more rarely, as votive offerings in sanctuaries. An impressive find from Athens, of the eighth century BC, constitutes the earliest example of openwork filigree technique in Greece, its hoop consisting of a band with guilloche of the type that appears on certain Macedonian earrings (figs 61-62). Solid finger rings of simple form, like today's wedding bands, continued to be made after the Sub-Mycenaean period, but the early ones are of bronze. Gold rings of circular, crescentic or other section appeared slightly later and persisted for centuries.

The well-known finger rings of the Mycenaean Age, with the integral elliptical bezel transverse to the hoop, continued in vogue in the Geometric period, though no longer of gold (except one from the islands, about 700 BC) and with only rudimentary engraved or relief decoration, no match for the intaglio representations of the Mycenaeans. The intaglio emblem reappeared in Early Archaic times on one type of finger ring, primarily of bronze and of silver, with raised, oblong bezel parallel to the hoop. Of Egyptian provenance, these cartouche rings were adopted in Phoenicia and Cyprus, whence they perhaps came to east Greek lands. Before the mid-sixth century BC craftsmen from these regions probably imported this form of ring to Etruria, where it enjoyed a remarkable development. From the rings of this type starts the series of Archaic types with elliptical bezel and intaglio device, from which the corresponding Classical ones derived. Rings of this type, principally of bronze, were also used as seal rings, like their gold Mycenaean counterparts. But whereas the latter were usually worn around the neck or the wrist, Archaic seal rings were actually worn on the fingers, as indeed were Greek scarabs or scaraboid sealstones. At first the iconography is characterized by a preponderance of mythical or natural animals, which remained popular in subsequent centuries

(fig. 203). Concurrent with the gradual evolution of the bezel, which became leaf-shaped, lozenge-shaped, elliptical, broader and finally circular in the fourth century BC (figs 203-208), the thematic cycle of the intaglio representations was enriched, as was the corresponding repertoire of contemporary sealstones. Other figures were added, symbolic (fig. 204), mythological, but above all divine (figs 205-208). Much loved in the Classical and Hellenistic periods were representations of Aphrodite (figs 206, 208, 215-216).

A small group of finger rings and seal rings of Classical times is particularly important for their contribution to the development of the early Greek portrait, since male heads with facial features that can be characterized as personal or of a human type are depicted. The series begins with a sealstone from Athens, engraved with the head of a man of noble countenance and bearing the signature of Dexamenos from Chios, to whom other gems with analogous theme are attributed. The artist of the gold ring now in Berlin (fig. 209) is also believed to have been dependent on him.

Intaglio designs on metal ring bezels, like the devices on coin-dies, were executed by engravers, whose chief work, however, was the carving of seals from precious and semiprecious stones. An outstanding exponent of the glyptic art was the aforementioned Dexamenos from Chios. Of the four extant seals signed with his name, one (fig. 210) bears the superb representation of a heron and swivels about an axis affixed to the two open ends of a hoop. Swivel rings of this form were used in Egypt and Phoenicia for the suspension of scarabs worn as pendants. In Greece such rings,

with scarabs or scaraboid seals, are known from Archaic times and were worn as finger rings. This manner of wearing them also influenced the form of some rings of purely decorative character, thus rings were made with a penannular hoop but fixed bezel, or with a swivel bezel which was not a signet (figs 211-213), or even with the unseen reverse of a fixed bezel embellished as if it were a swivel one (fig. 214). In addition, it must have also played its part in enhancing the decorative character of finger rings with sealstone, especially manifest in those rings found with female burials and thus probably worn by women. From the late fifth and particularly the second half of the fourth century BC onwards engraved stones were set in hollow ring bezels (figs 215-216), which became more popular than rings with a solid gold bezel.

The form of finger rings was also influenced by other pieces of jewellery, not least some types of bracelets, with which many rings will have formed a set. Such examples are the finger rings with the very popular Herakles knot (fig. 217) and those in the form of a full-bodied snake (fig. 218).

In the second century BC new decorative themes appeared. Artificial ring-stones of enamel were introduced, at once increasing the range of the jeweller's palette and satisfying the penchant for polychromy so typical of the age (fig. 219).

Very often more than one ring – indeed sometimes as many as twenty – is found in a grave. Some of these, like many of the pieces of jewellery to have survived, were quite probably presents to persons held dear. On the finger rings with flat bezel this could be expressed explicitly by engraving upon it the word gift: ΔΩPON (figs 220-221).

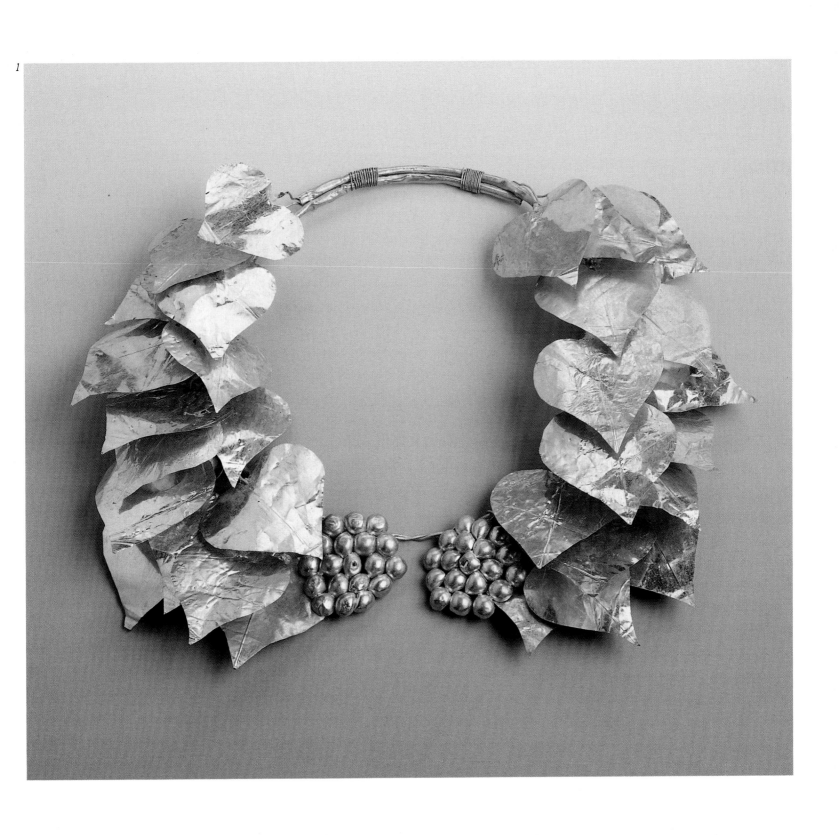

1. Ivy wreath, mid-4th century BC. Dion, Archaeological Museum.

2. Flowering myrtle wreath, third quarter of 4th century BC.
Thessaloniki, Archaeological Museum.

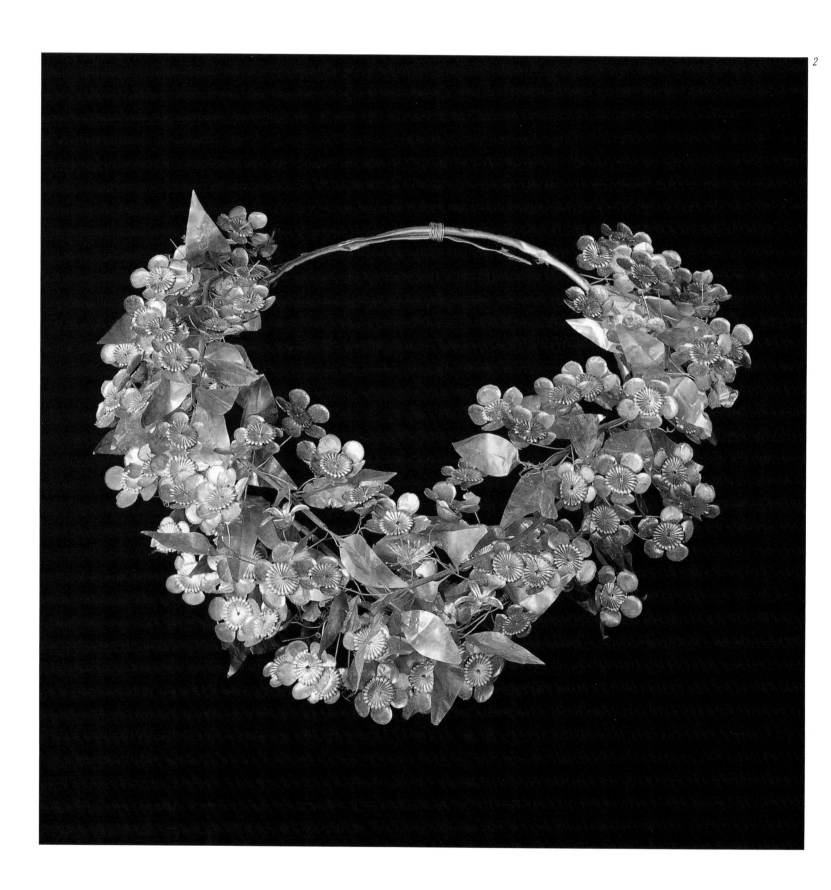

3. Oak wreath, last quarter of 4th century BC. Thessaloniki, Archaeological Museum.

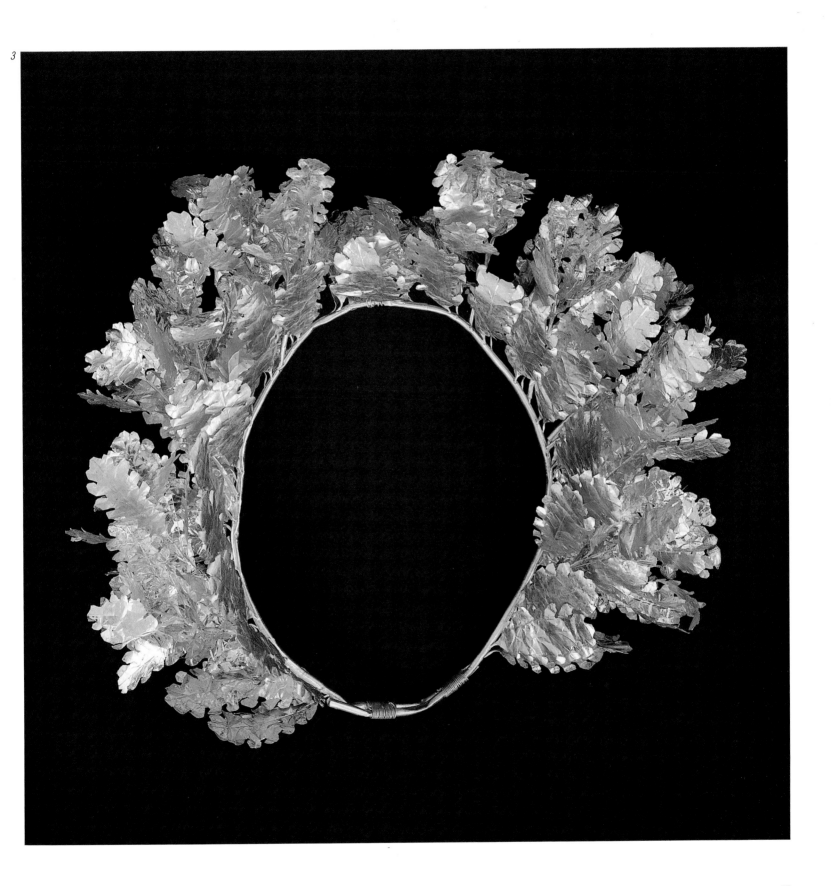

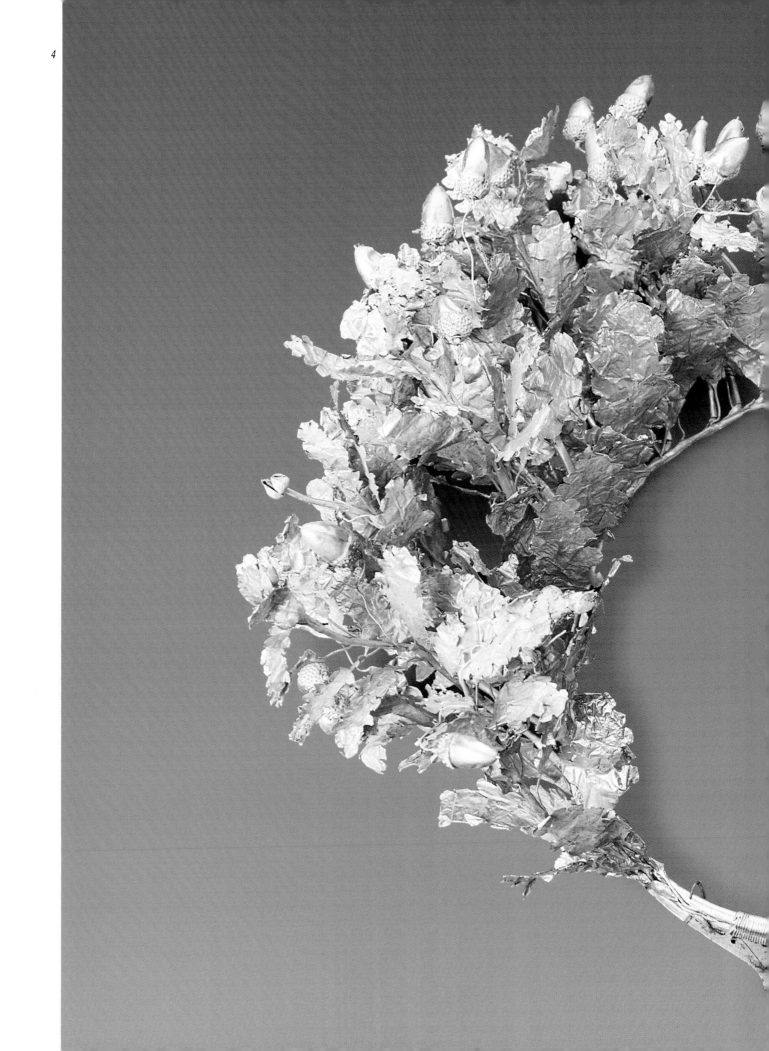

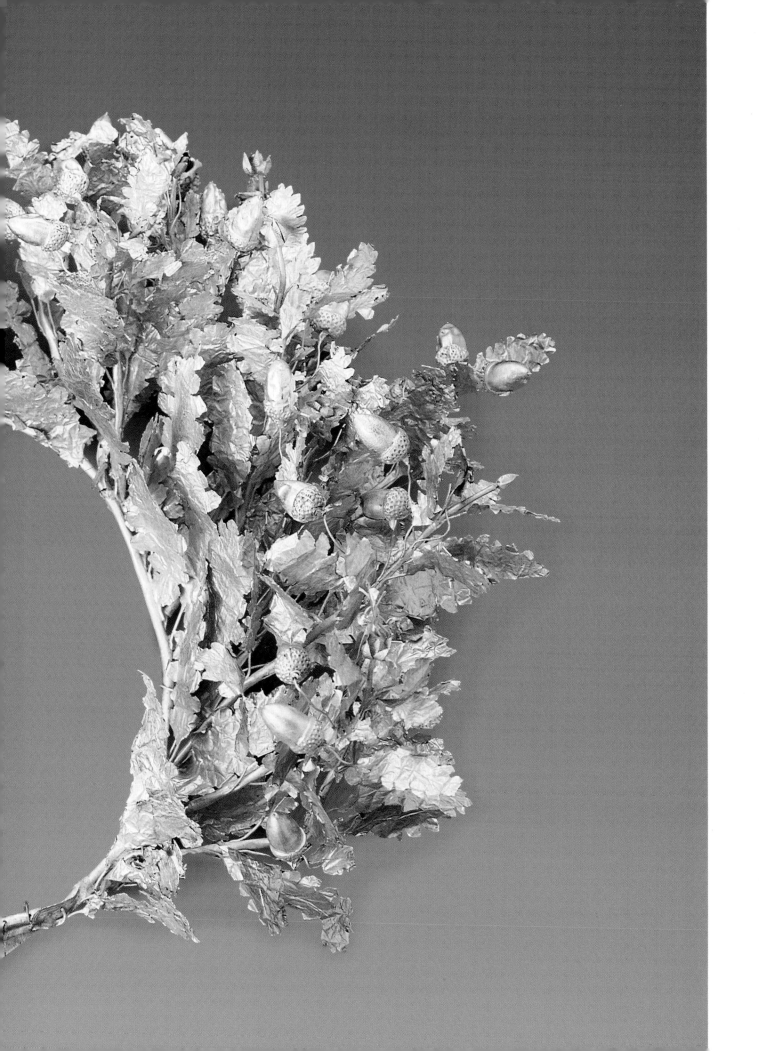

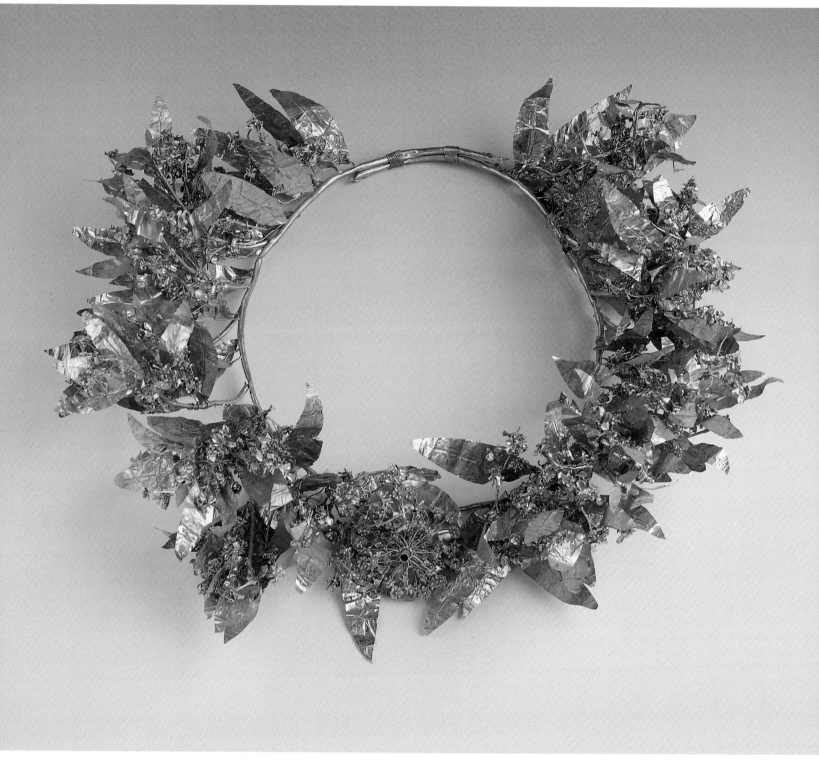

4. *Oak wreath, third quarter of 4th century BC. Thessaloniki,*
Archaeological Museum.

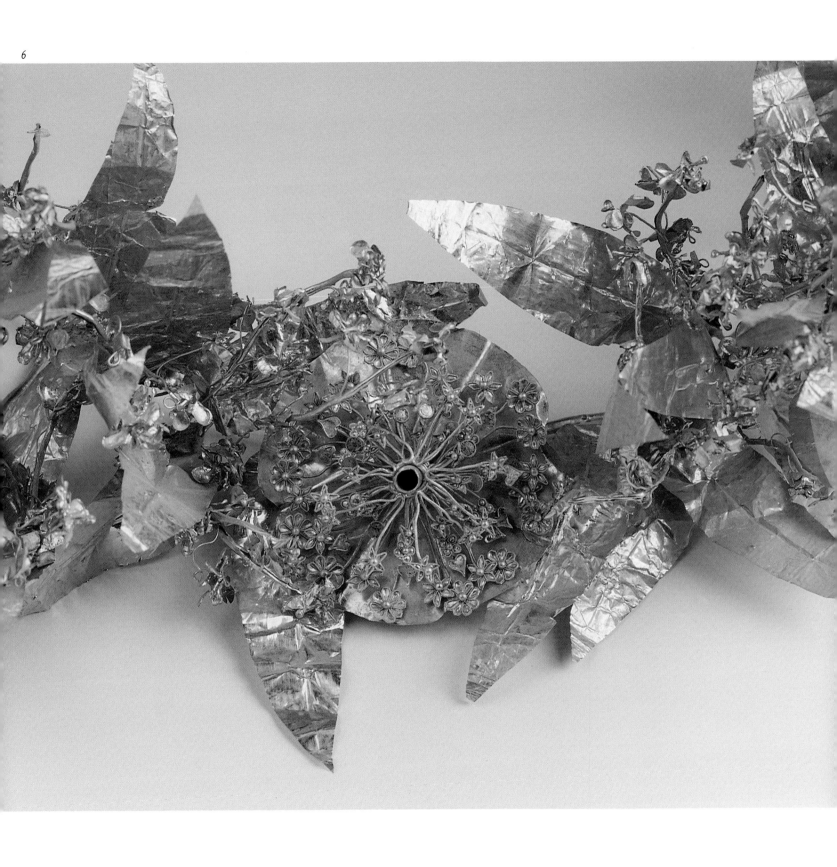

5-6. *Flowering myrtle wreath, c. 330 BC. Thessaloniki,*
Archaeological Museum.

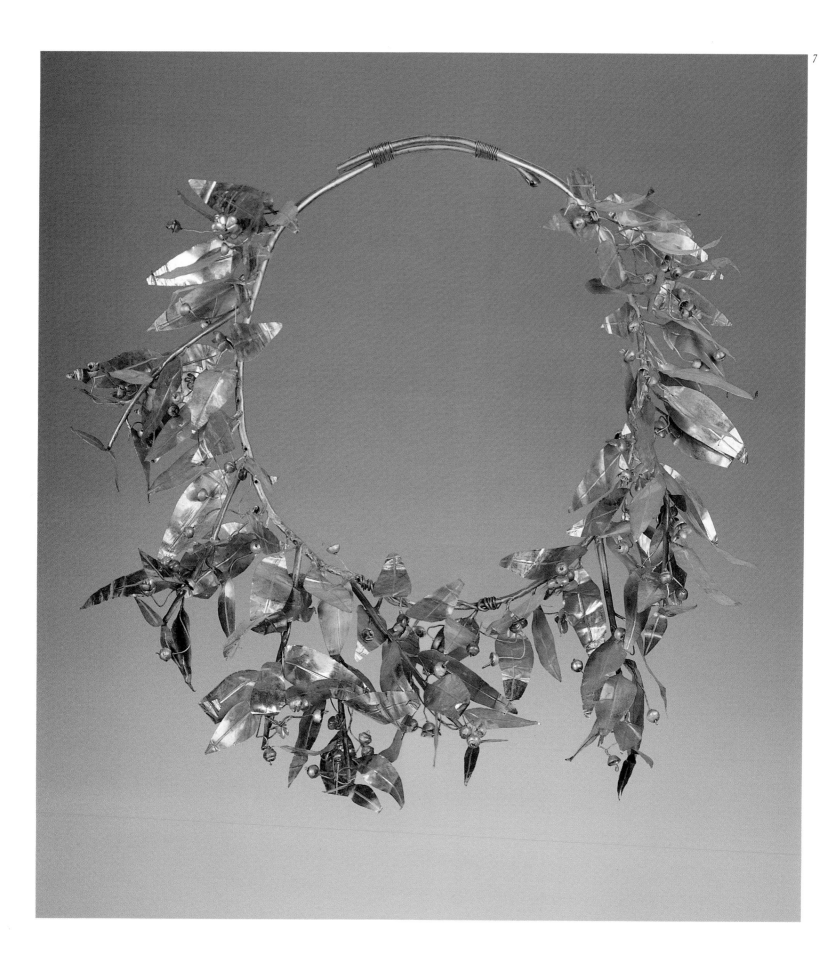

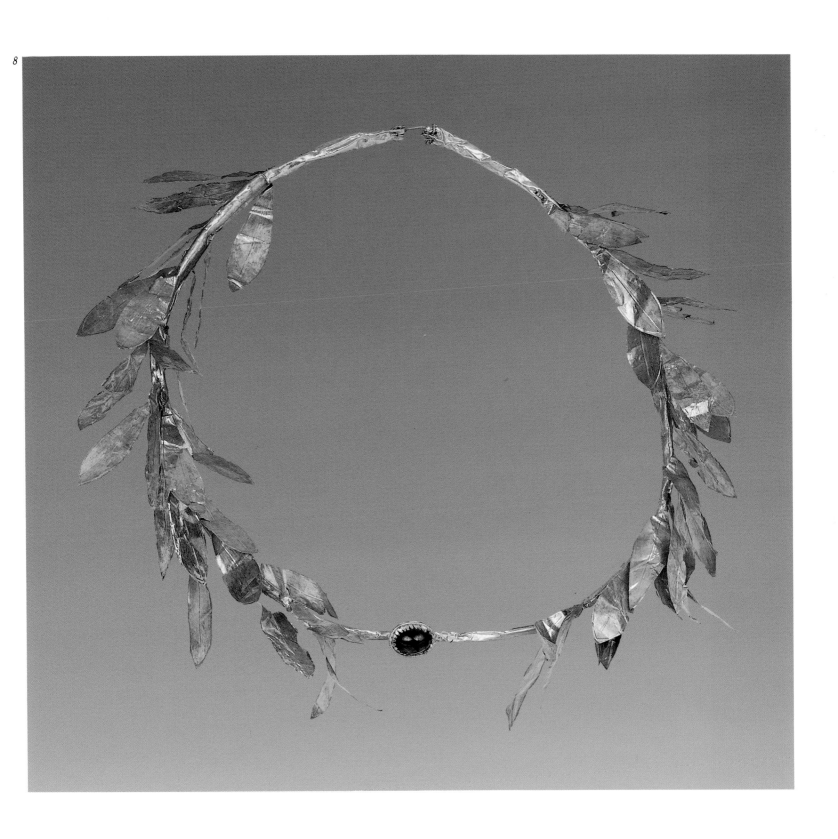

7. *Berry-bearing myrtle wreath, c. 320 BC. Thessaloniki, Archaeological Museum.*

8. *Olive wreath, second half of 3rd century BC. Kavala, Archaeological Museum.*

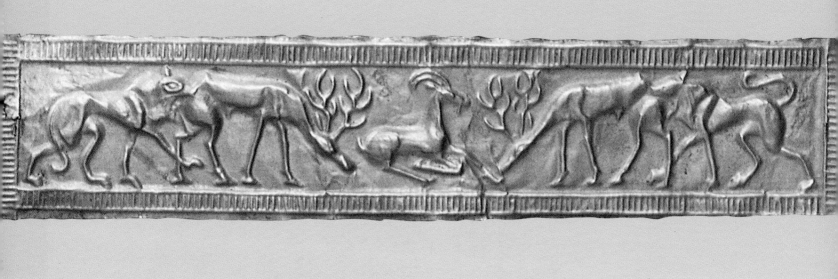

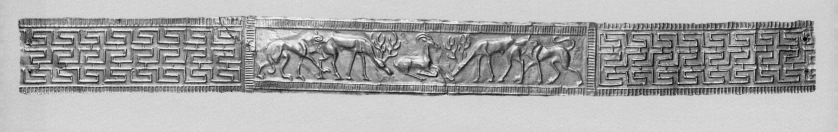

9-10. Band diadem with animal frieze, c. mid-8th century BC. Paris,
Musée du Louvre.

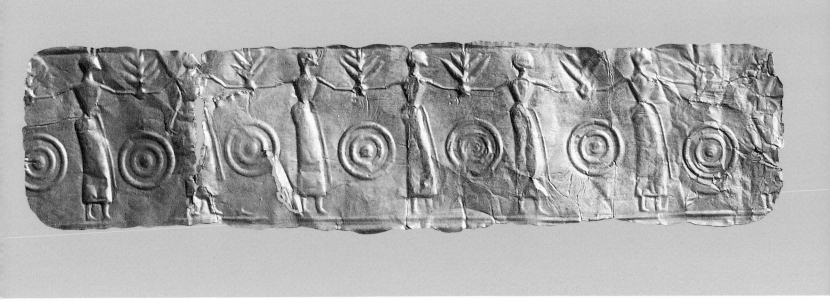

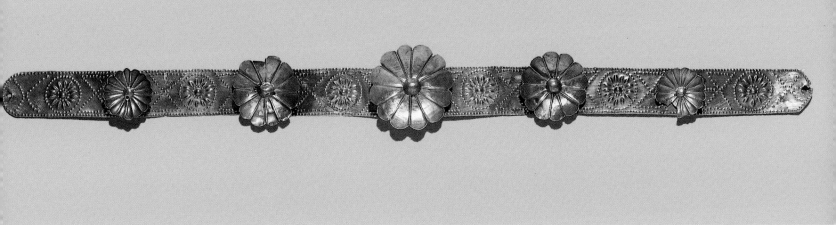

11. Band diadem with dancing women, c. 700 BC. Berlin, Antikenmuseum.

12. Band diadem with applied rosettes, second half of 7th century BC.
London, British Museum.

13-15. Three rosettes from a diadem with bull or lion head at the centre, second half of 7th century BC. Athens, National Archaeological Museum.

16. Rosette from a diadem with eagle at the centre, second half of 7th century BC. Athens, National Archaeological Museum.

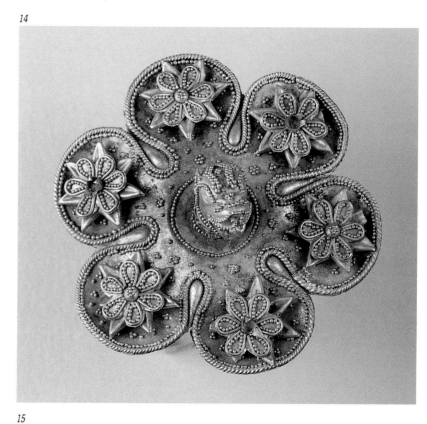

14

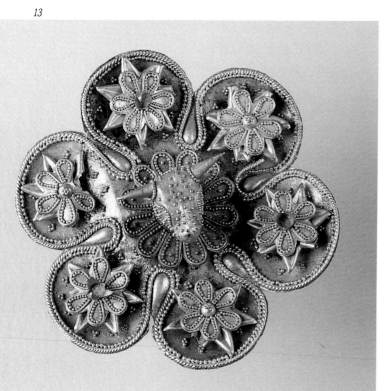

13

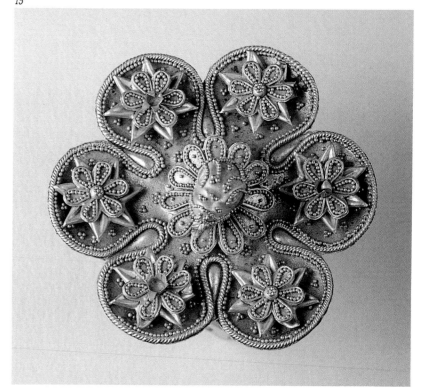

15

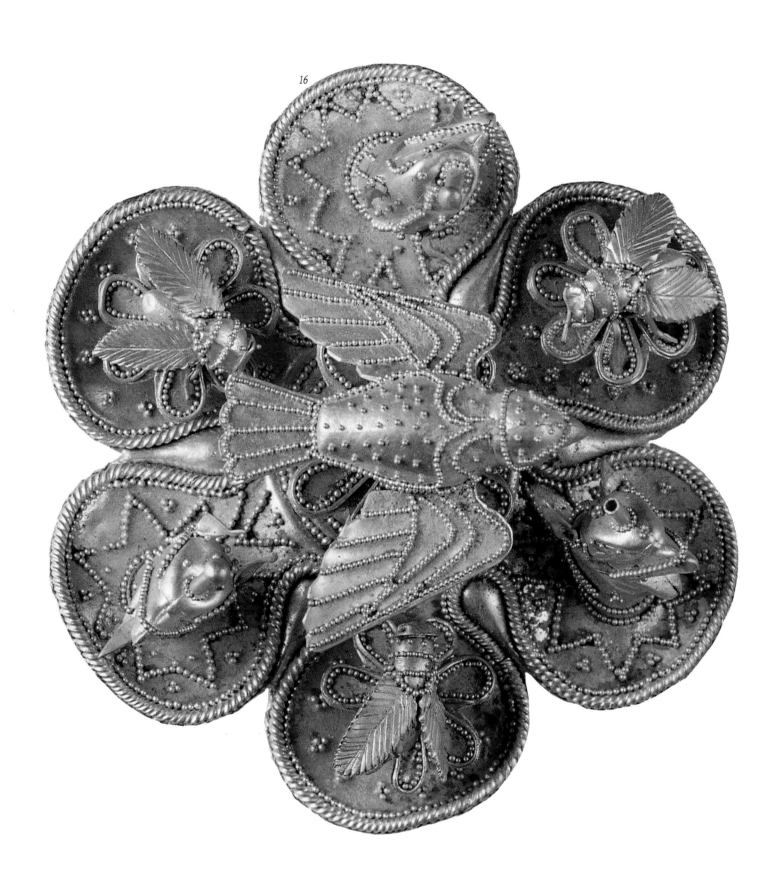

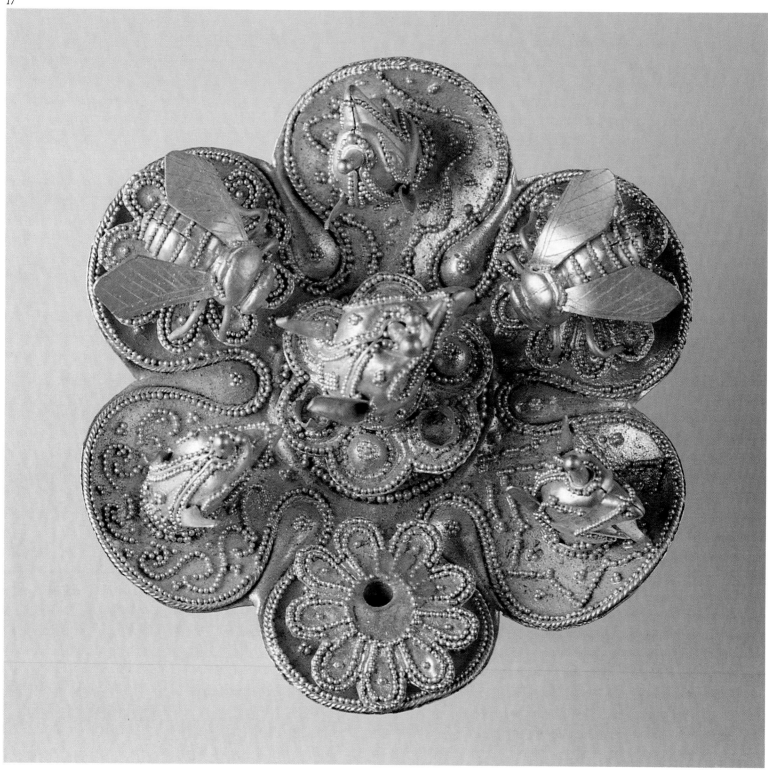

18

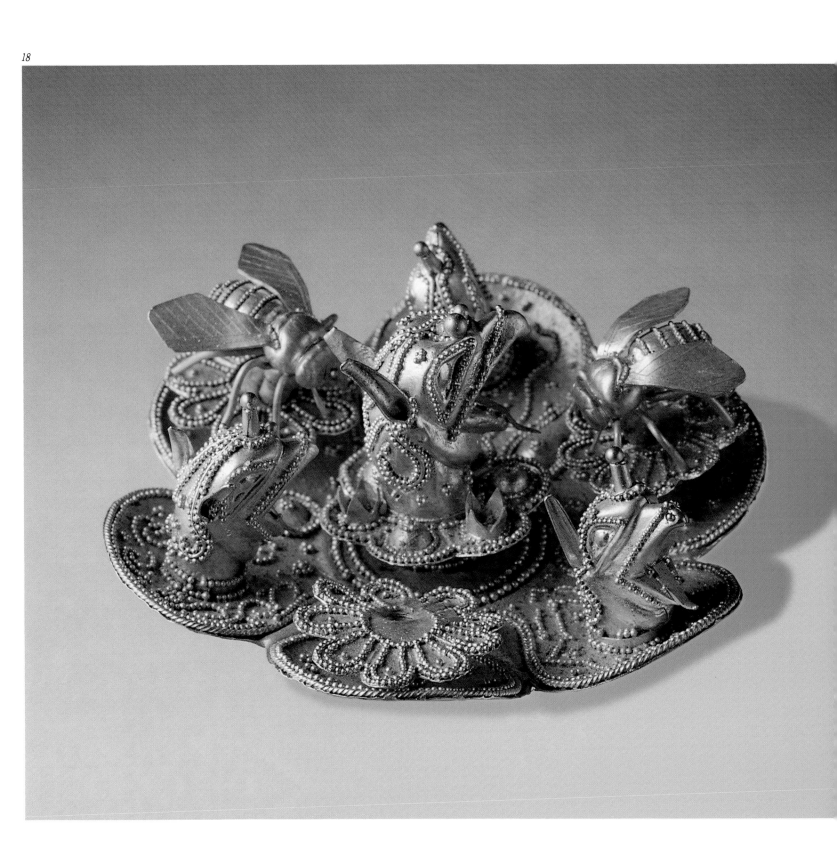

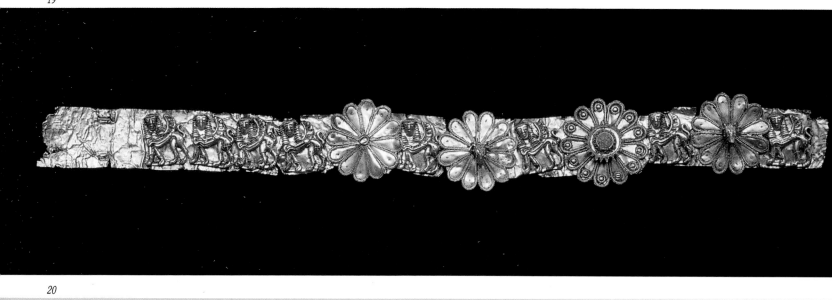

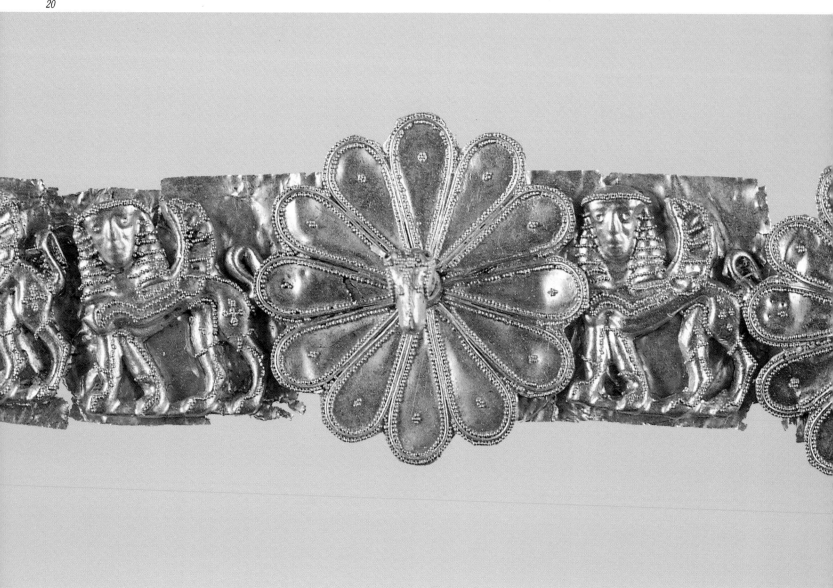

*19-20. Band diadem with sphinxes and rosettes, second half of 7th century BC.
Athens, Benaki Museum.*

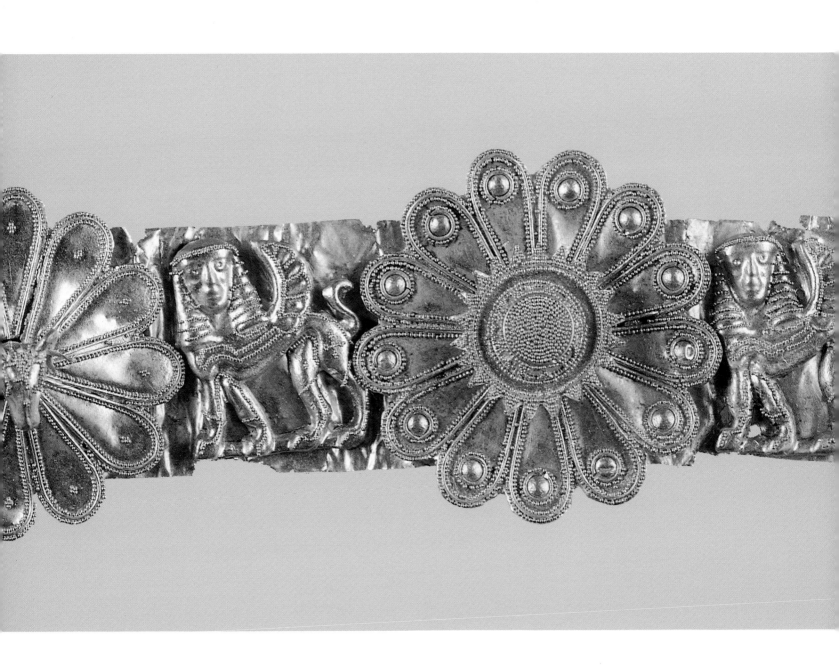

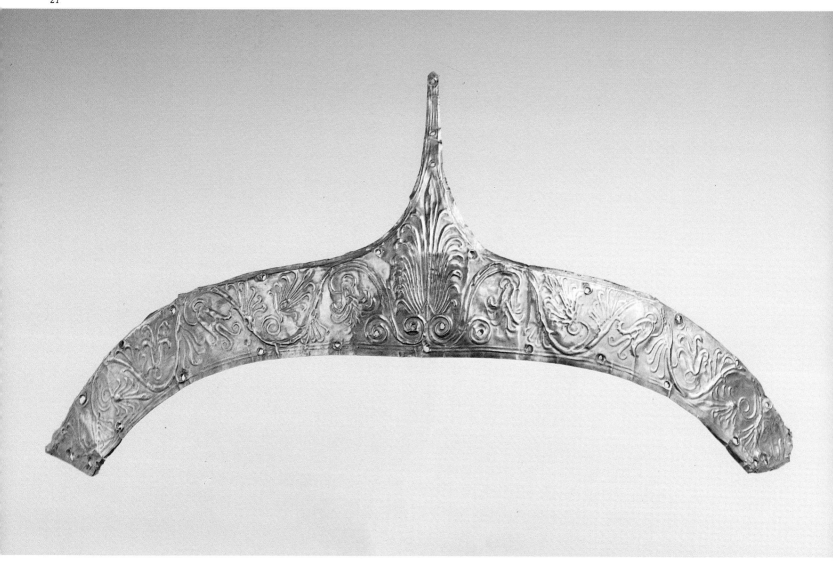

21. Diadem with embossed floral decoration, c. 320 BC. Thessaloniki,
Archaeological Museum.

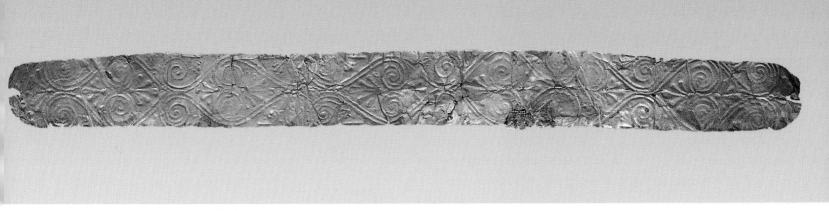

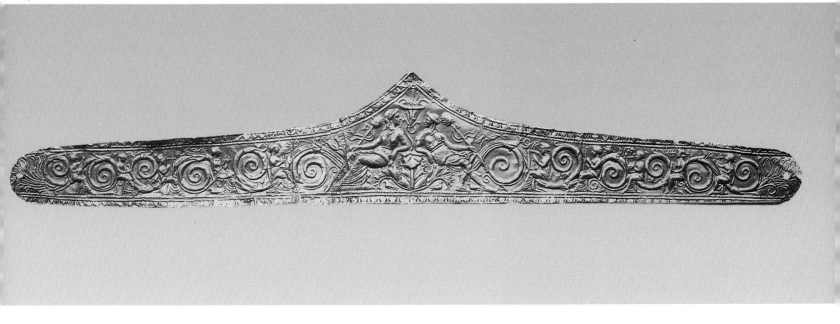

*22. Band diadem with embossed lyre-shaped motifs, 5th century BC.
Athens, Benaki Museum.*

*23. Diadem with embossed representations of Dionysos, Ariadne and Muses,
last quarter of 4th century BC. New York, Metropolitan Museum of Art.*

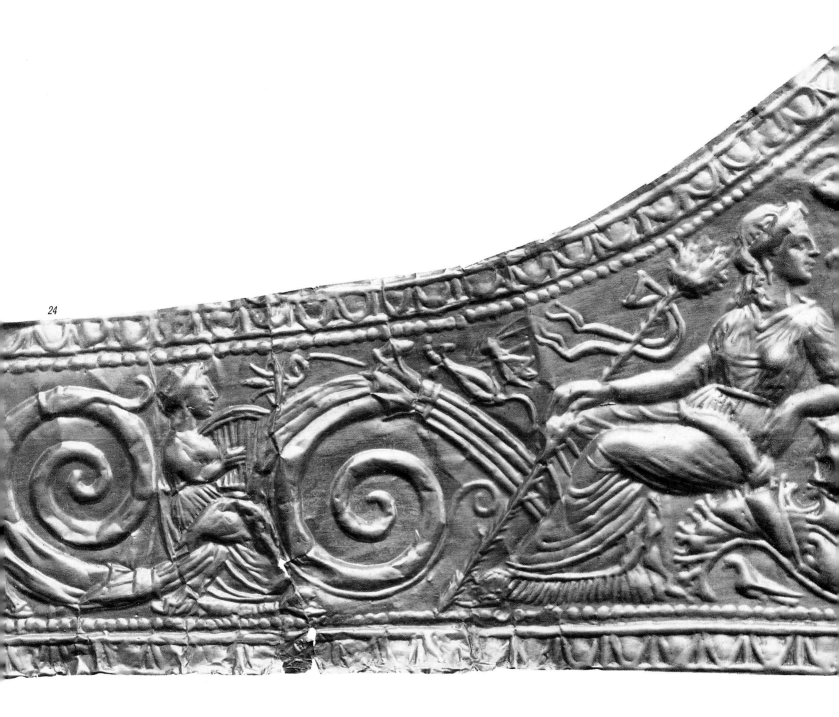

24. *The central section of the diadem in fig. 23.*

24

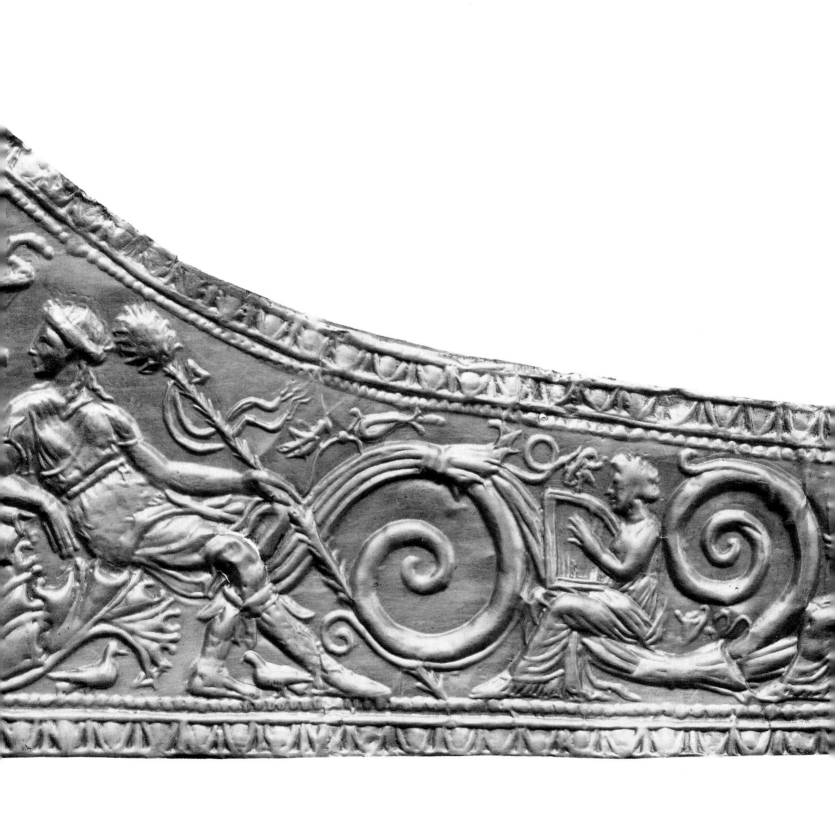

25. Band diadem with Herakles knot, late 4th - early 3rd century BC.
Kavala, Archaeological Museum.

26-27. Diadem with lyre-shaped elements and Herakles knot with Eros,
c. 320 BC. Thessaloniki, Archaeological Museum.

25

26

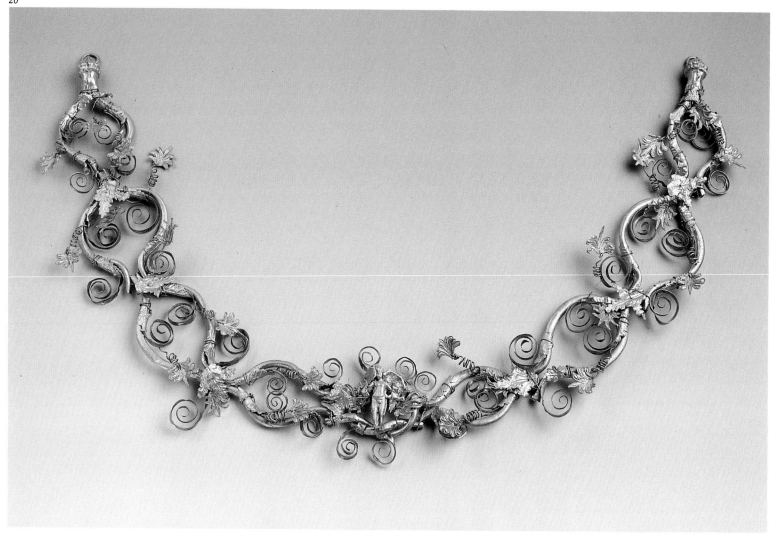

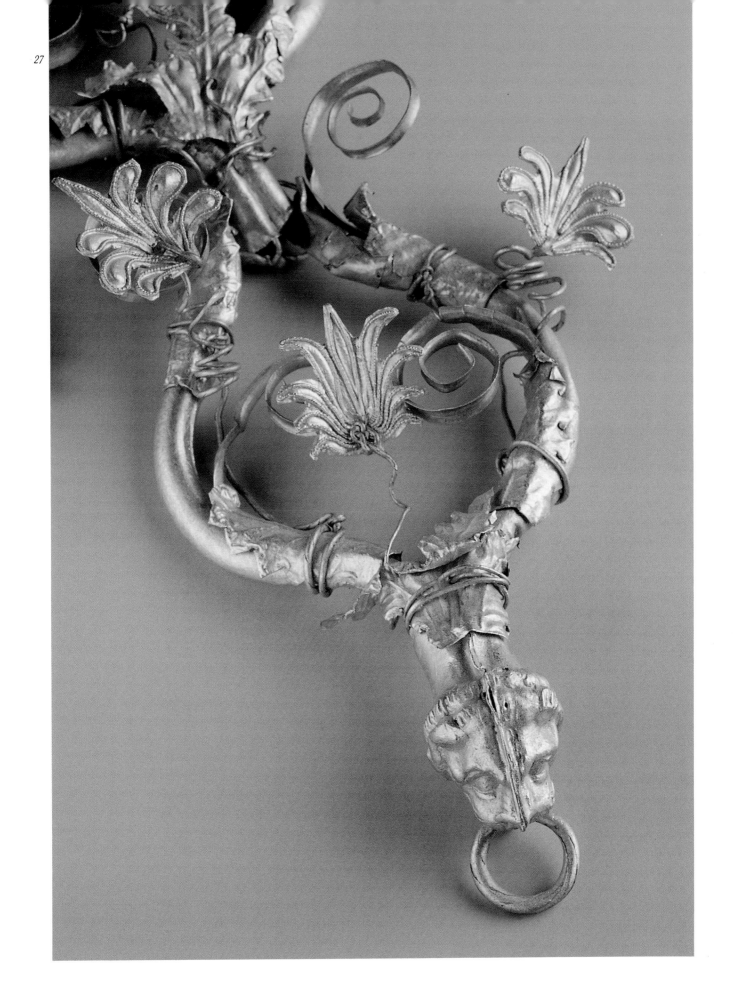

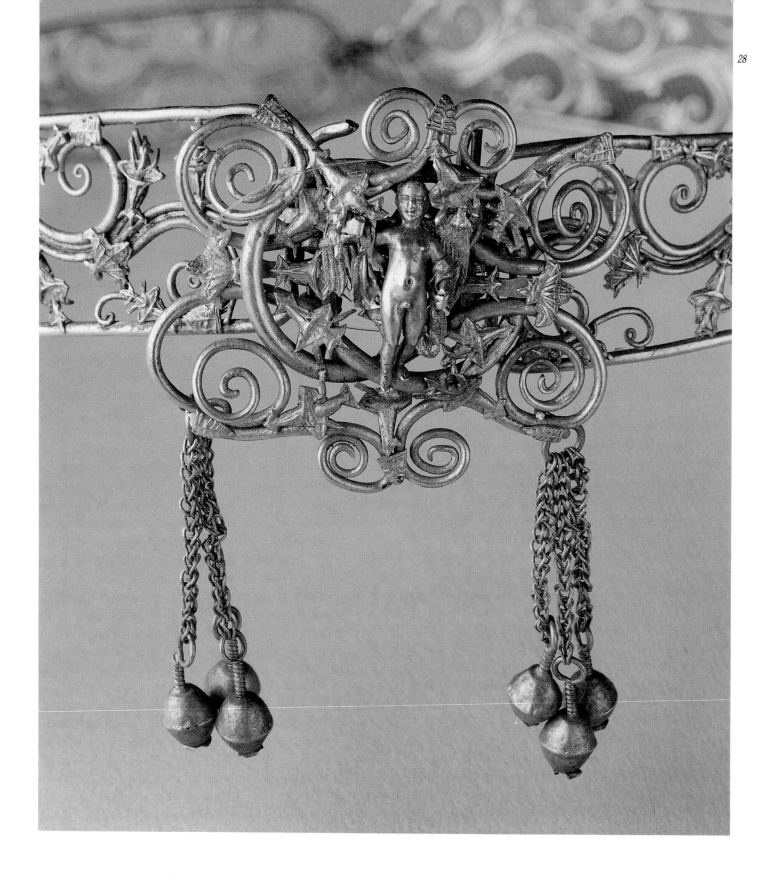

28-29. *Diadem with tendril scrolls and Herakles knot with Eros, last quarter of 4th century BC. Athens, National Archaeological Museum.*

30. *The Vergina diadem, third quarter of 4th century BC. Thessaloniki, Archaeological Museum.*

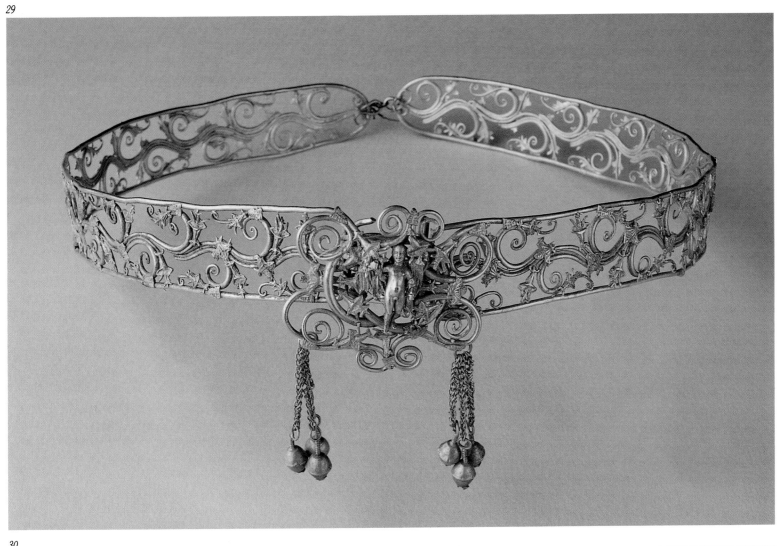

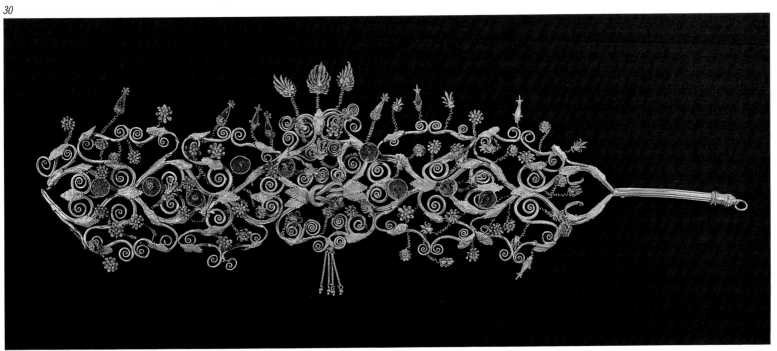

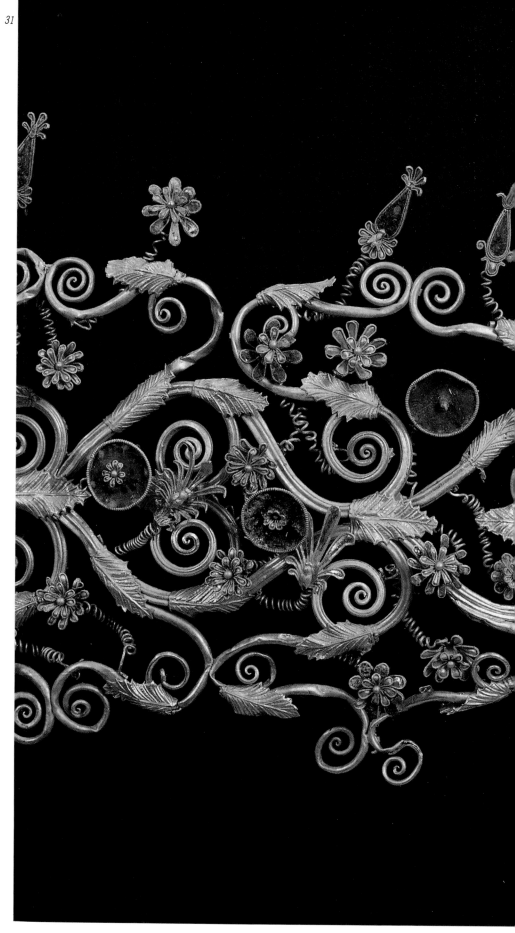

31. The central section of the diadem in fig. 30.

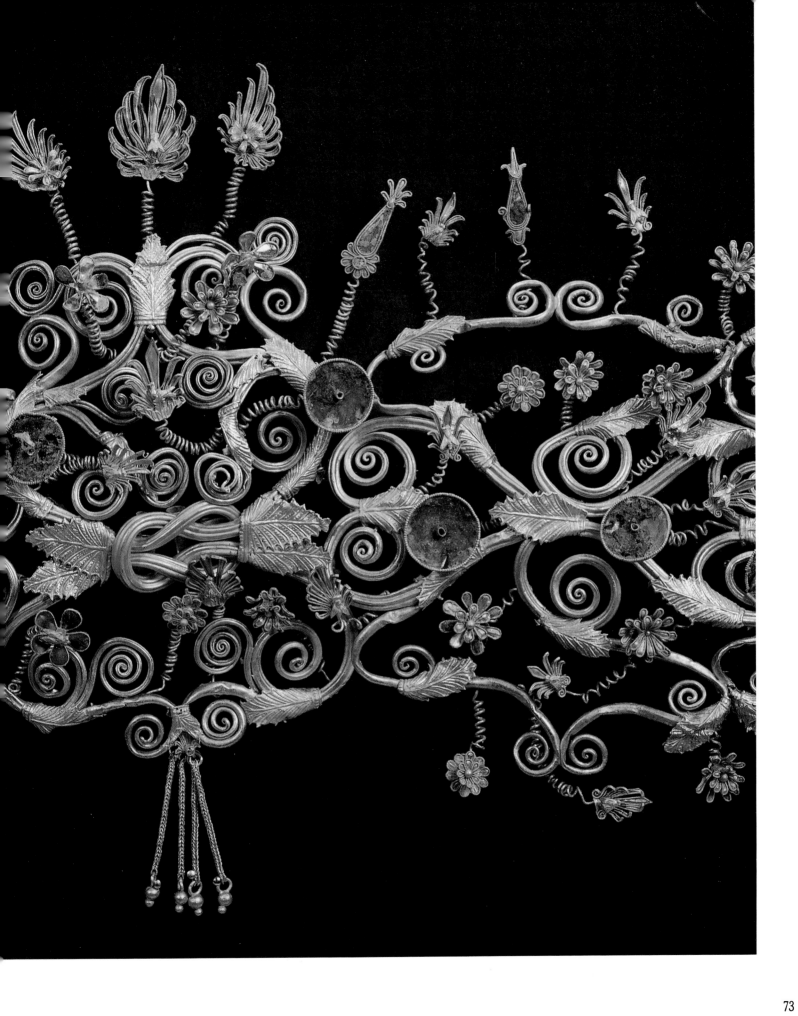

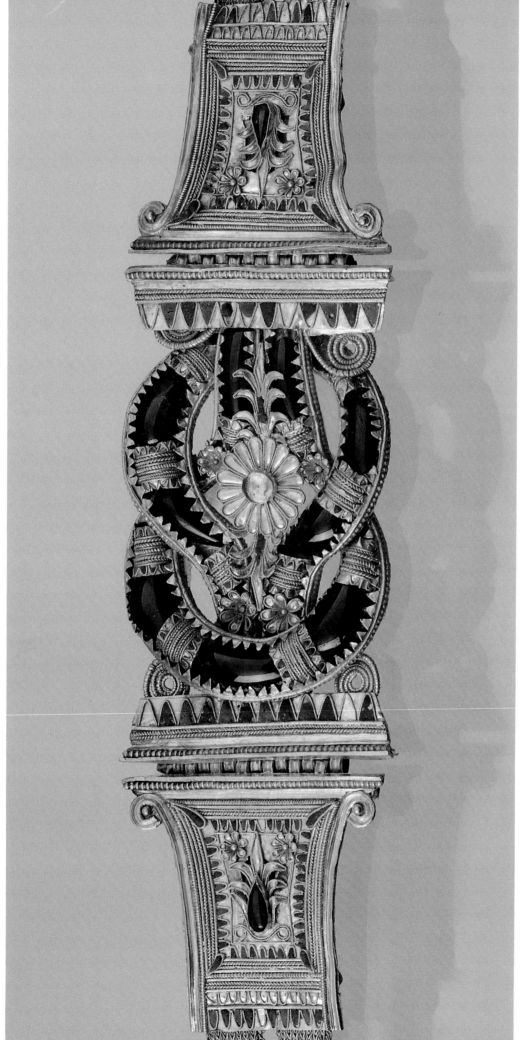

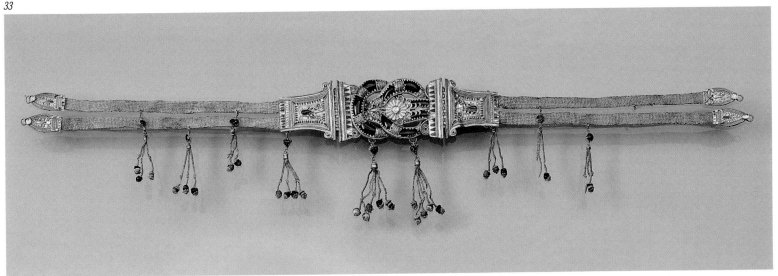

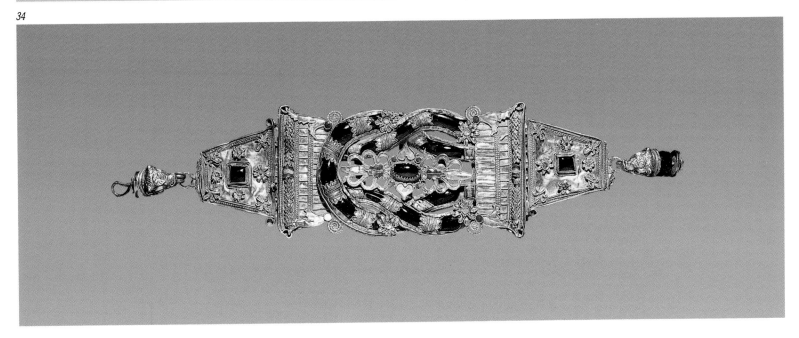

32-33. Diadem with Herakles knot and chain straps, last quarter of 3rd century BC. Athens, Benaki Museum.

34. Central section of a diadem with Herakles knot, first quarter of 2nd century BC. Athens, Benaki Museum.

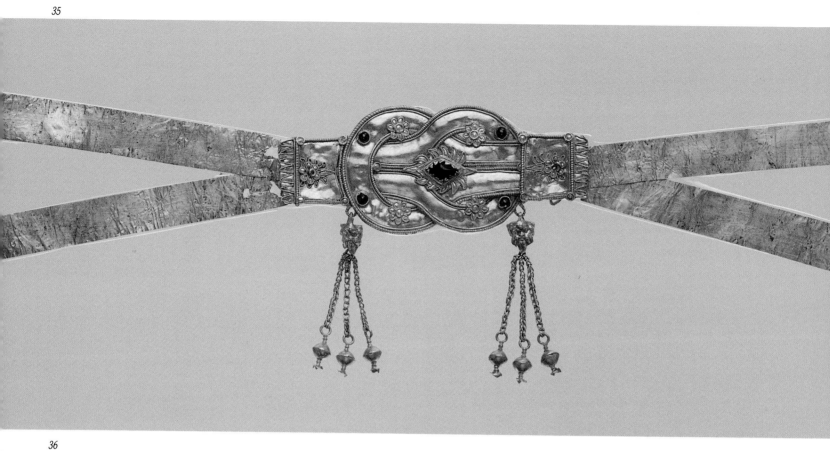

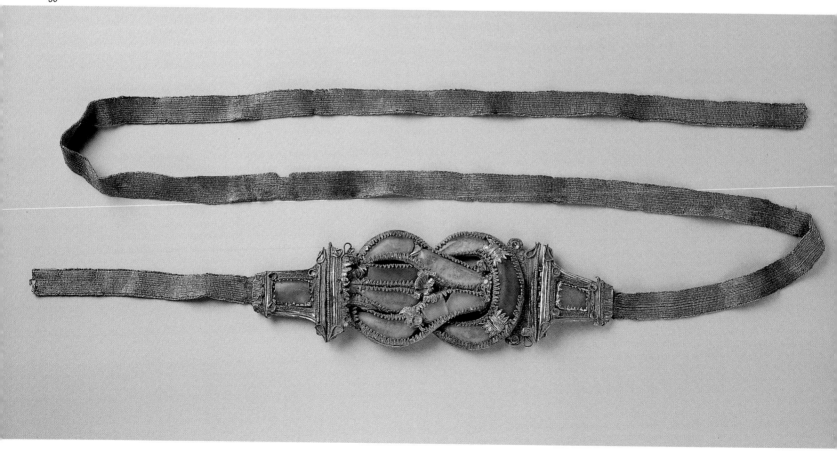

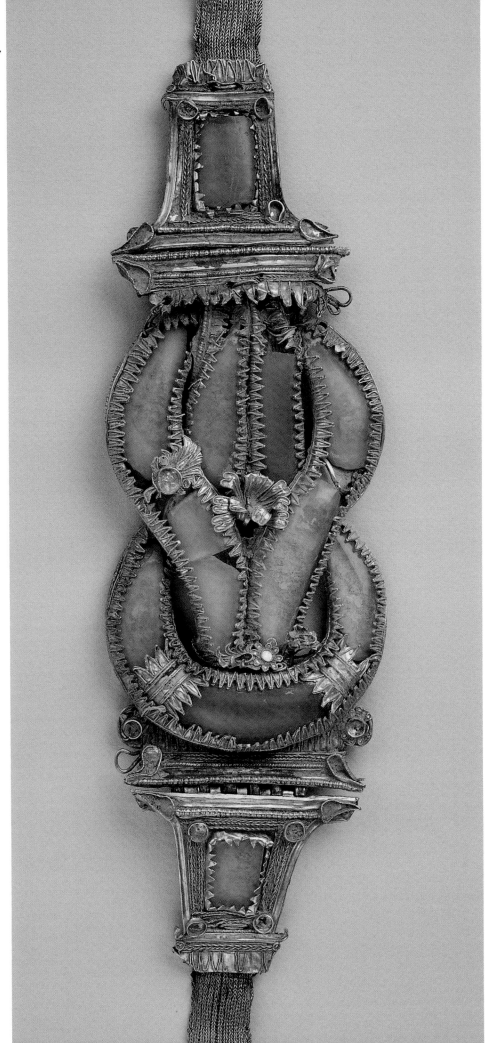

35. Diadem with Herakles knot and sheet-gold bands, late 3rd - early 2nd century BC. New York, Metropolitan Museum of Art.

36-37. Diadem with Herakles knot and chain straps, late 3rd or early 2nd century BC. Athens, National Archaeological Museum.

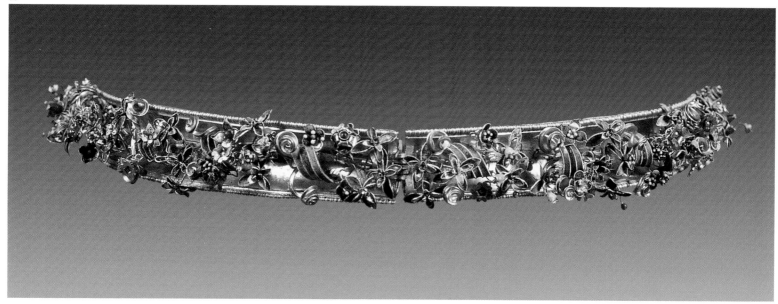

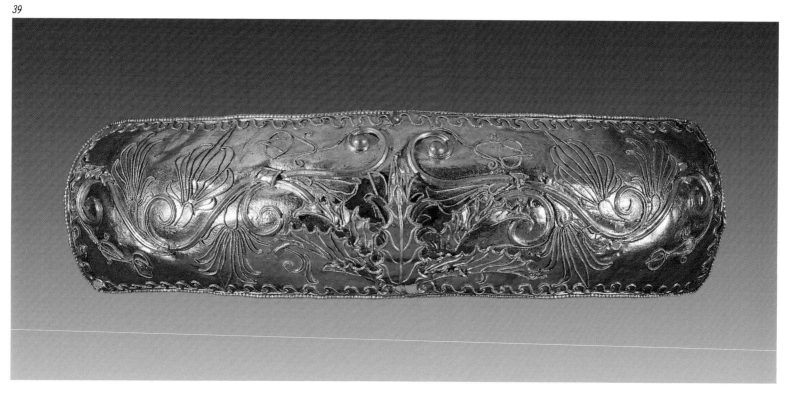

38. Diadem in the form of a floral wreath, c. 200 BC.
Taranto, Museo Archeologico Nazionale.

39. Diadem of curved metal sheet with tendril scrolls, c. 350 BC.
Taranto, Museo Archeologico Nazionale.

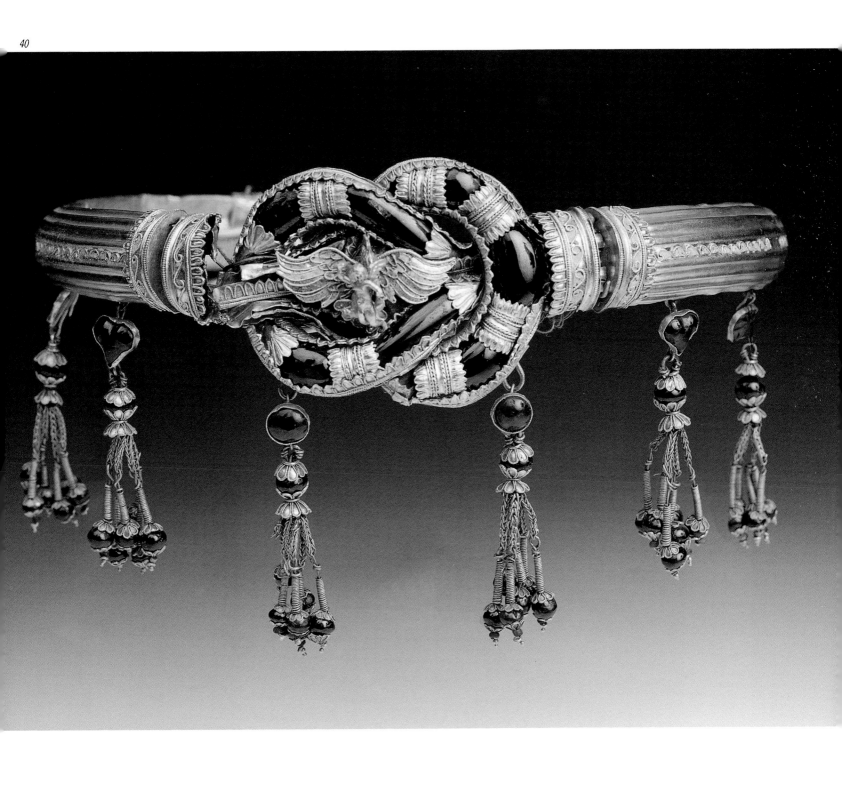

40. Diadem with Herakles knot, second half of 2nd century BC.
Saint Petersburg, Hermitage State Museum.

41-42. *Comb decorated with a scene of Scyths in battle, first half of 4th century BC. Saint Petersburg, Hermitage State Museum.*

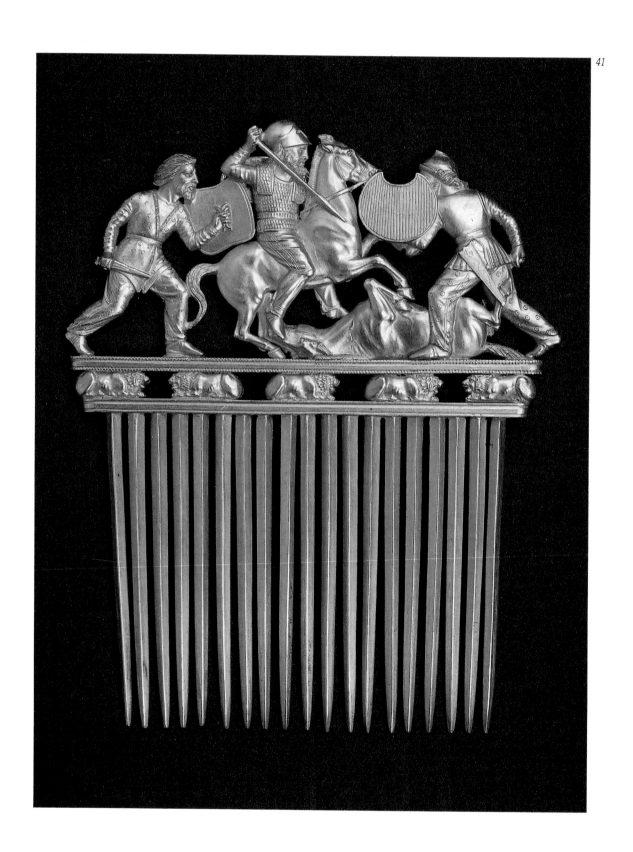

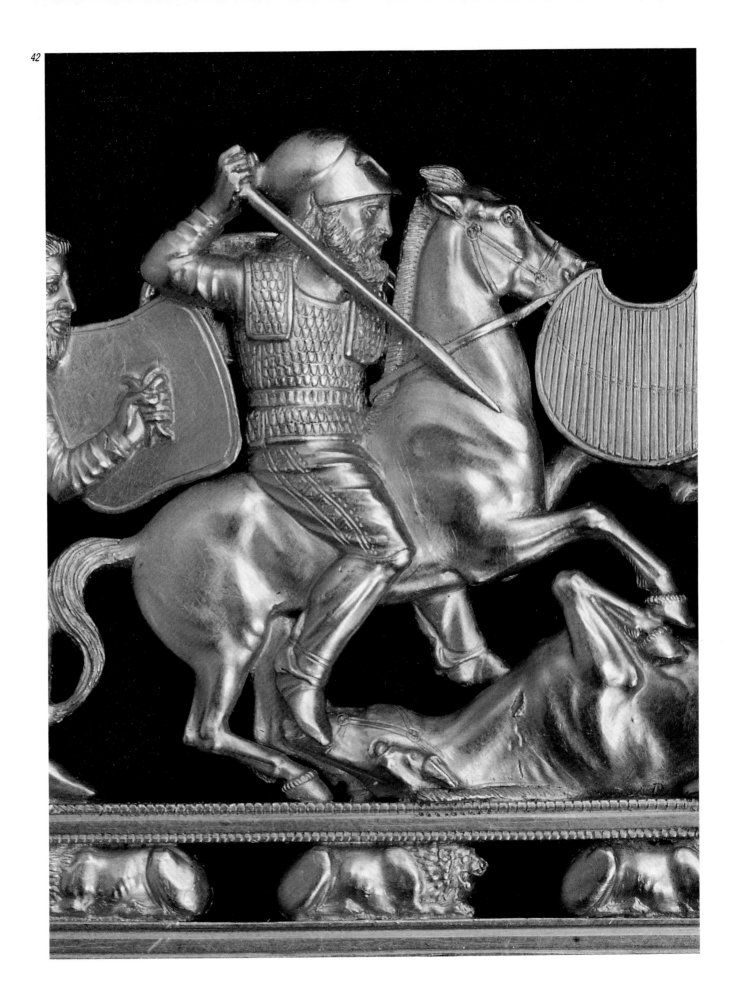

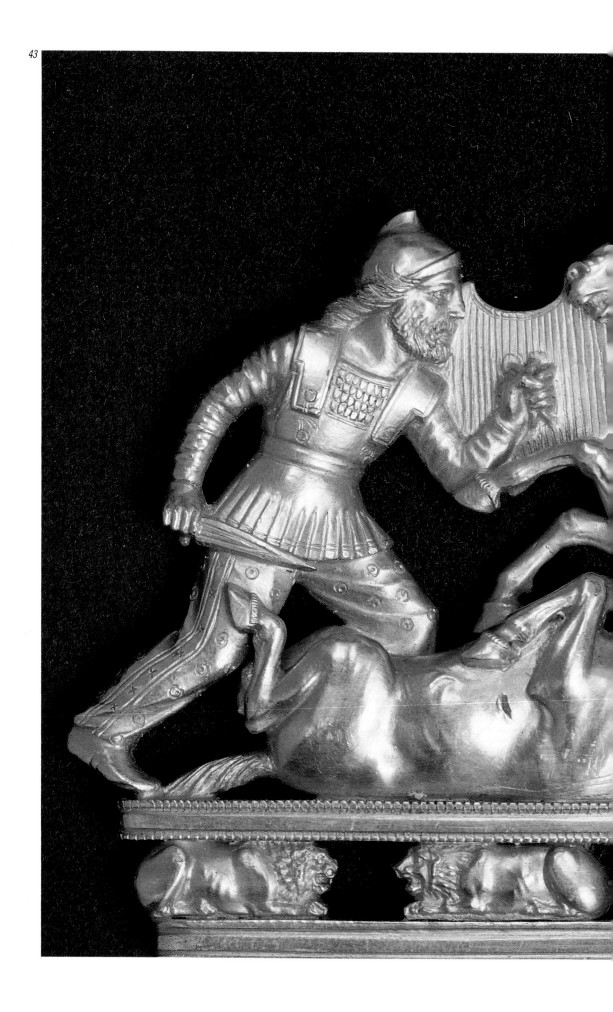

43

43. The back of the comb in fig. 41-42.

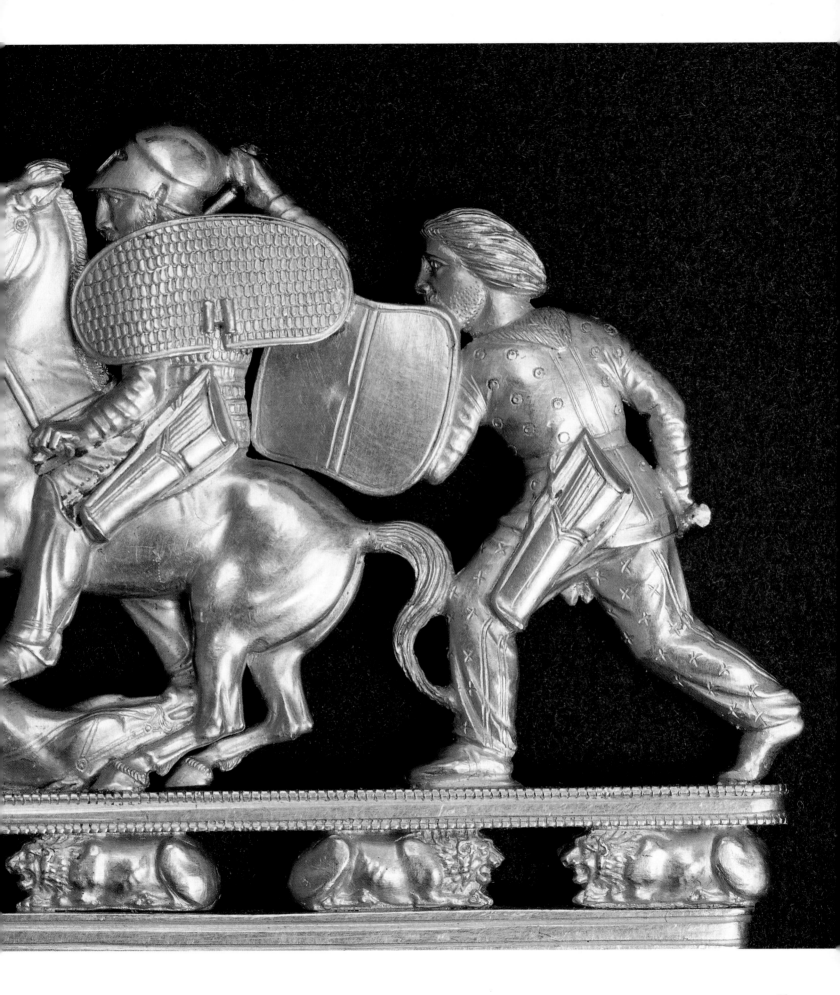

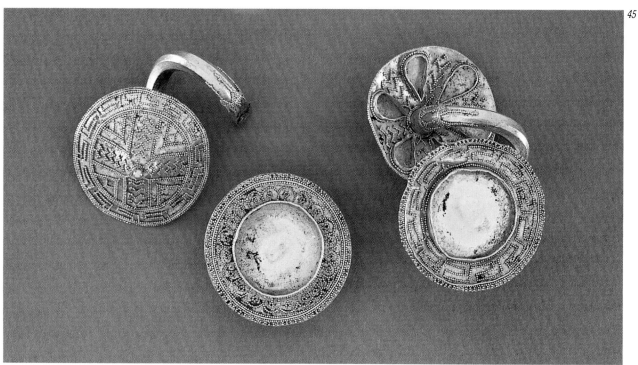

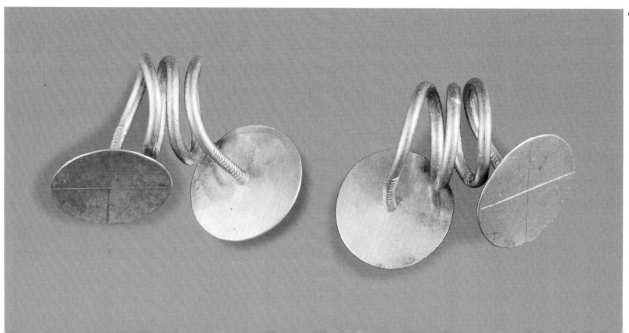

44. Earrings with disc terminals, 850-825 BC. Eretria, Archaeological Museum.

45. Earrings with granulated disc terminals, 8th century BC. Los Angeles, County Museum of Art.

46. Spiral earrings with disc terminals, 8th century BC. Oxford, Ashmolean Museum.

47. Spiral earrings with engraved herring-bone decoration, c. 750 BC. Corinth, Archaeological Museum.

48. Spiral earrings with engraved herring-bone decoration, c. 875-825 BC. Argos, Archaeological Museum.

49. Spiral earring with engraved herring-bone decoration, second half of 8th century BC. London, British Museum.

50. Spiral earrings with globules on the terminals, 6th century BC. London, British Museum.

47
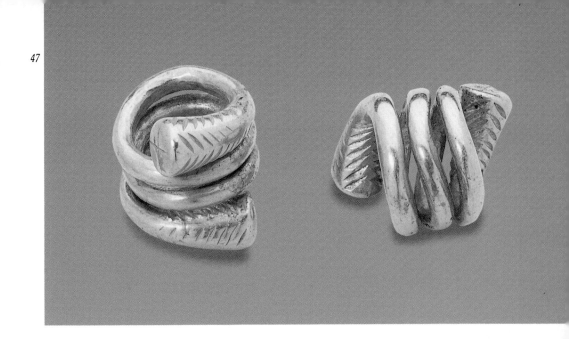

48
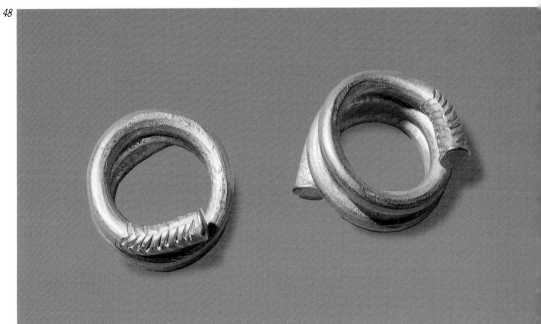

49
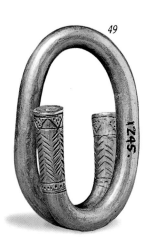

50
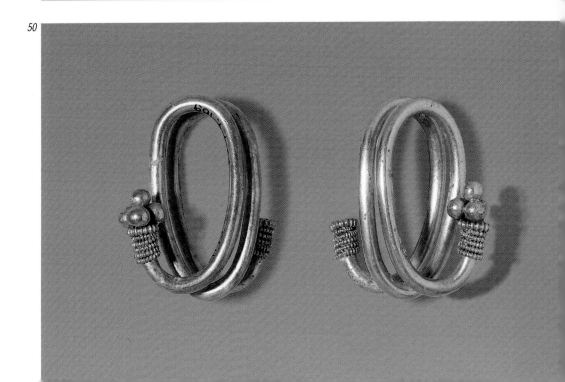

51. Long earring with disc terminals, second half
of 7th century BC. London, British Museum.

52. Long earring with griffin-head terminals, second half
of 7th century BC. Berlin, Antikenmuseum.

51

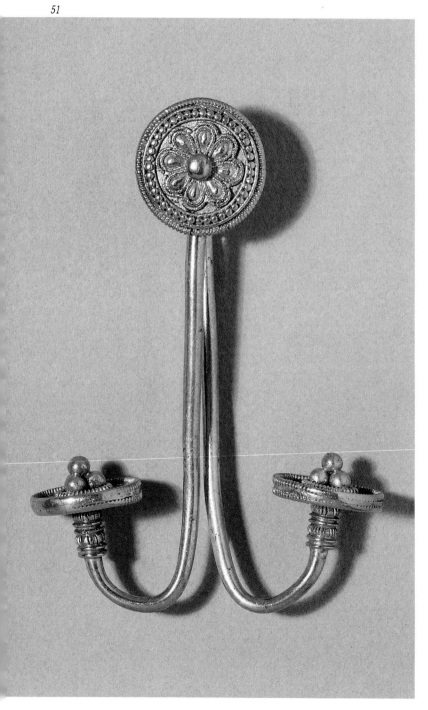

52

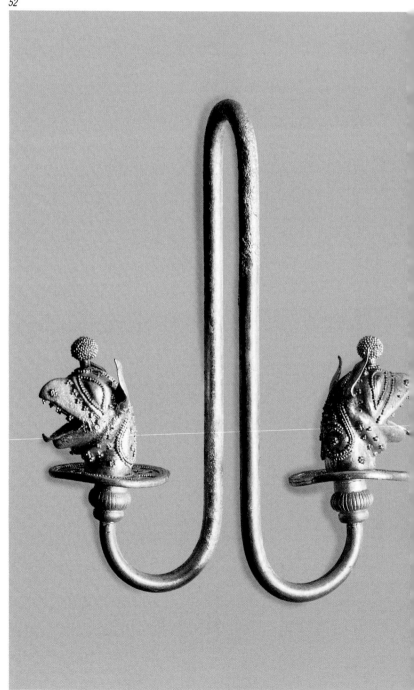

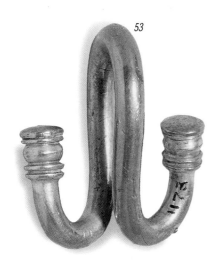

53

53. Earring with twisted terminals, second half of 7th century BC. London, British Museum.

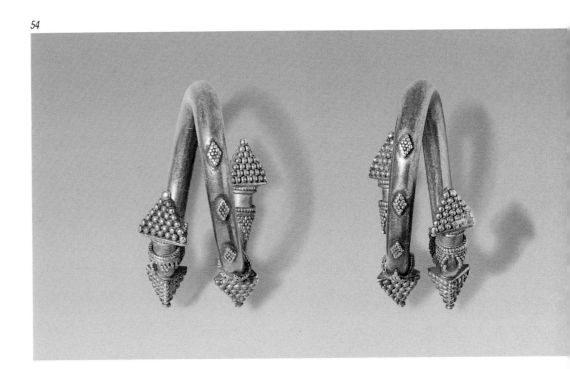

54

55

54. Earrings with twisted terminals and granulated pyramid ornaments, second half of 5th century BC. London, British Museum.

55. Earrings with granulated pyramid terminals, late 5th - early 4th century BC. Oxford, Ashmolean Museum.

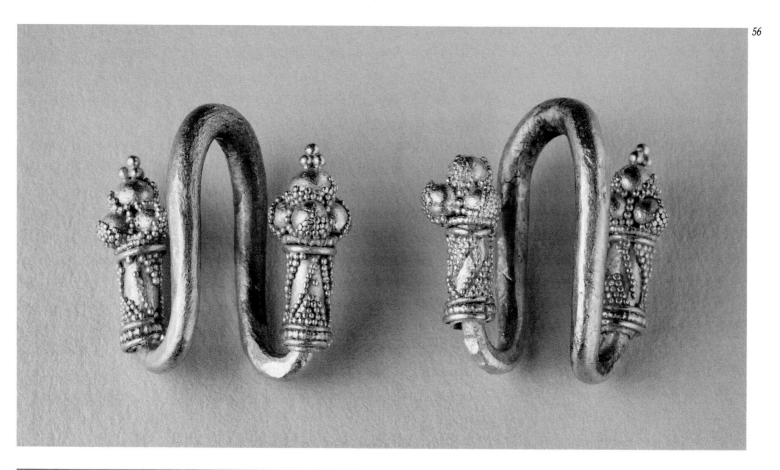

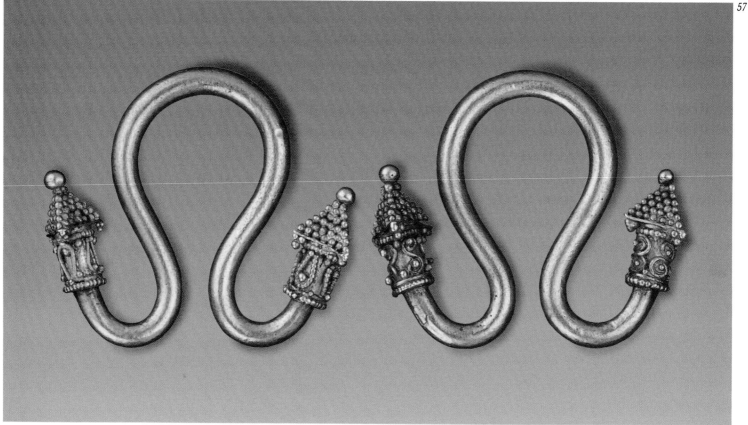

58. Omega-shaped earring with conical terminals, last quarter of 8th century BC. Athens, National Archaeological Museum.

58

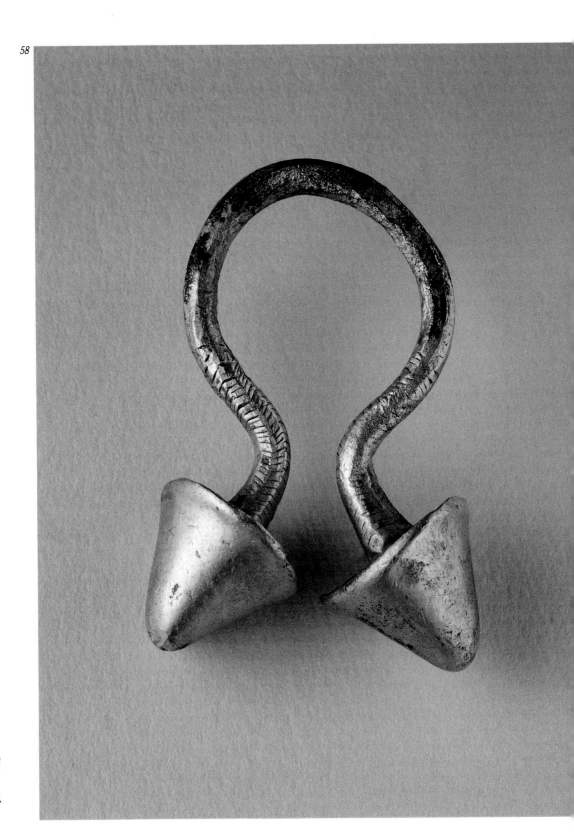

56. Earrings with twisted granulated terminals, late 5th century BC. Athens, National Archaeological Museum.

57. Omega-shaped earrings with granulated pyramid terminals, early decades of 5th century BC. Plovdiv (Philippoupolis), Local Archaeological Museum.

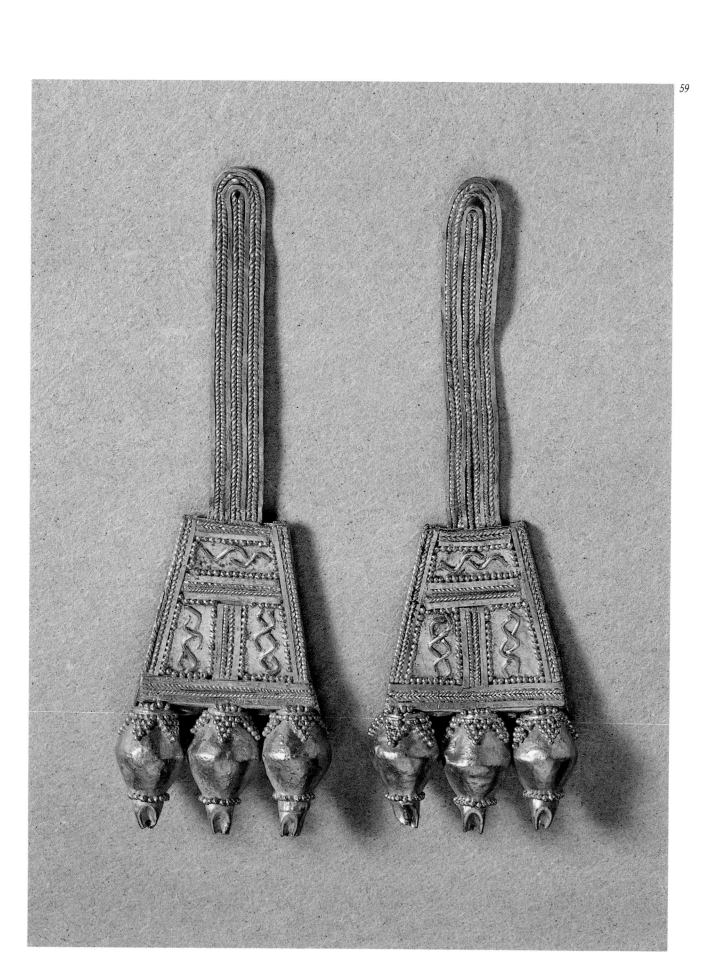

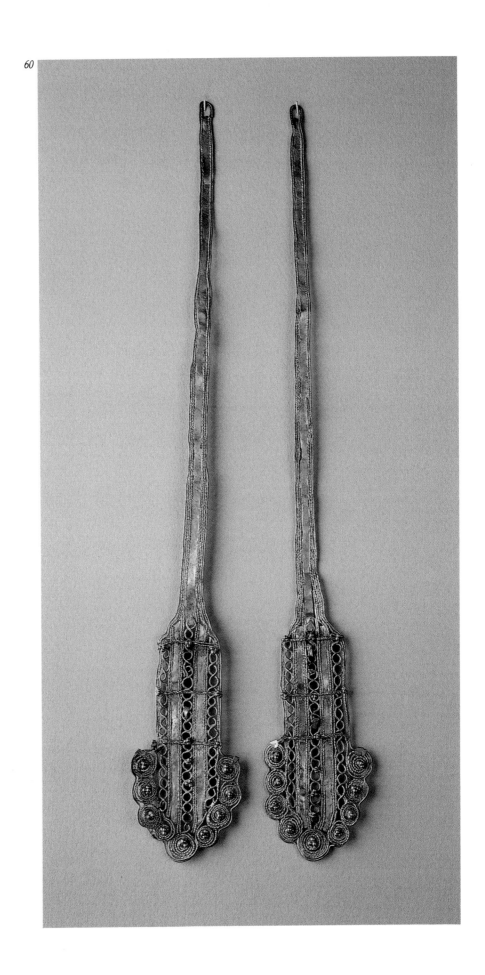

59. Band earrings with trapezoidal terminals, c. 850 BC. Athens, Museum of the Ancient Agora.

60. Band earrings with spiral ornaments on the terminals, second or third quarter of 6th century BC. Athens, National Archaeological Museum.

61. Band earrings with floral terminals, last quarter of 6th century BC.
Thessaloniki, Archaeological Museum.

61

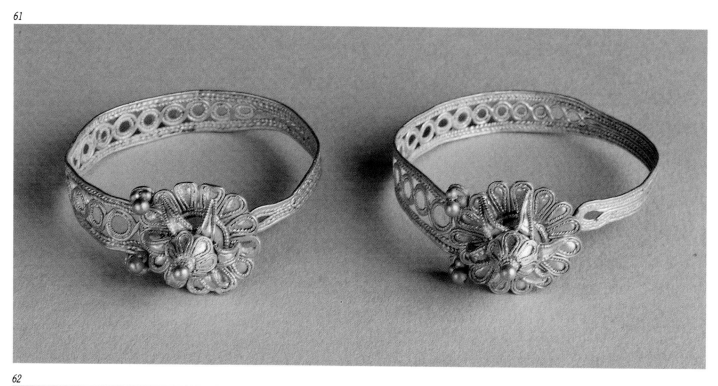

62

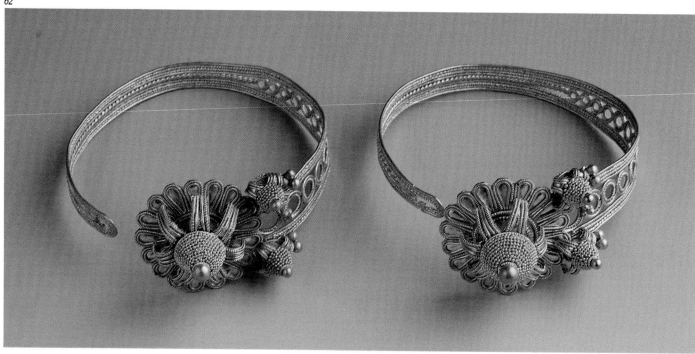

62-63. *Band earrings with floral terminals, c. 510 BC. Thessaloniki, Archaeological Museum.*

63

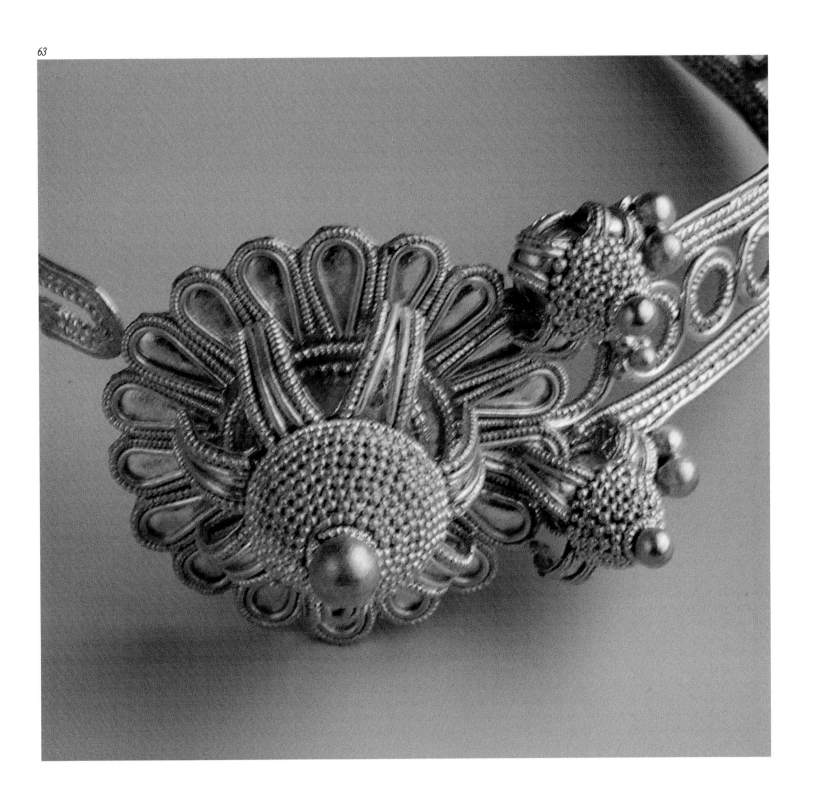

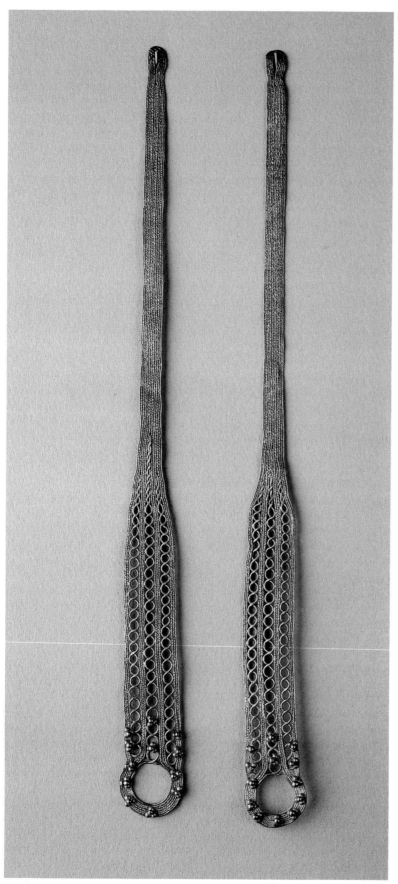

64. Band earrings with circular terminals, last quarter of 6th century BC. Athens, National Archaeological Museum.

65. Band earrings with wheel-shaped terminals, early 5th century BC. Thessaloniki, Archaeological Museum.

66. Double wire earrings with bilobe terminals, early 5th century BC. Athens, National Archaeological Museum.

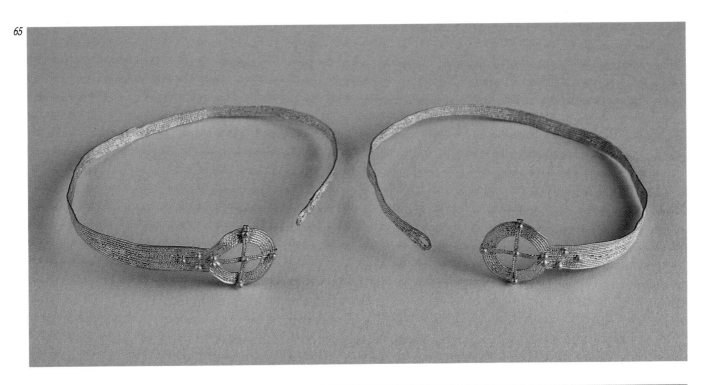

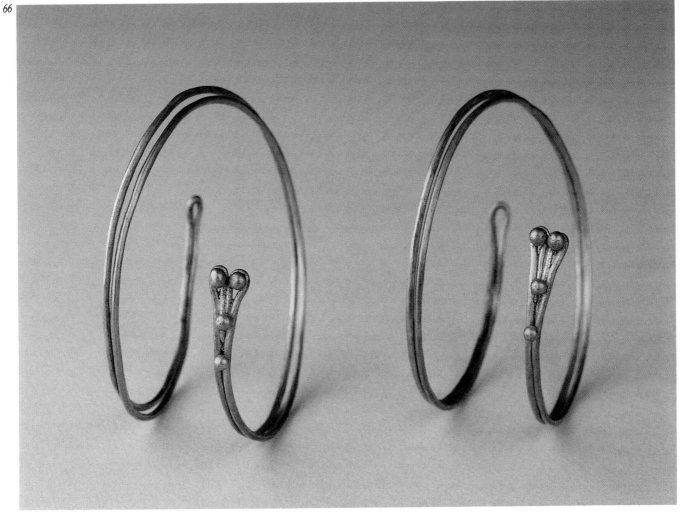

67

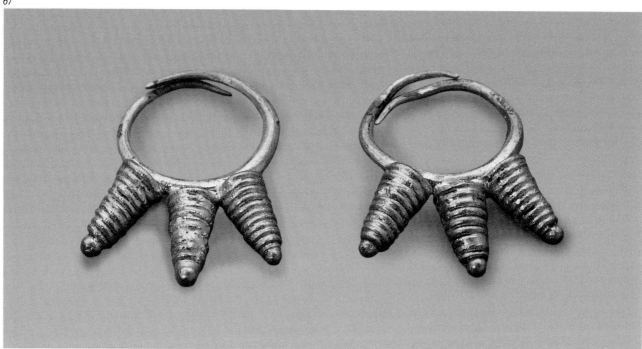

68

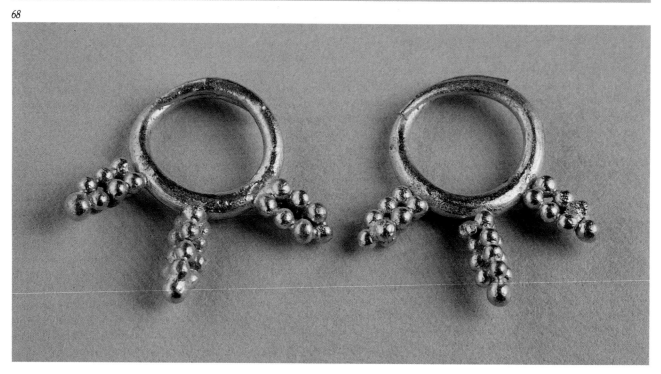

67. Earrings with three cones of coiled wire, 875-850 BC.
Eretria, Archaeological Museum.

68. Earrings with three granulated mulberries, 875-850 BC.
Eretria, Archaeological Museum.

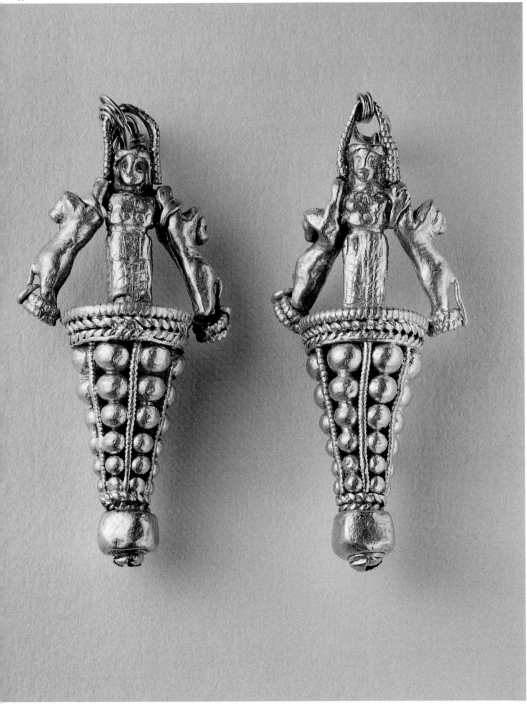

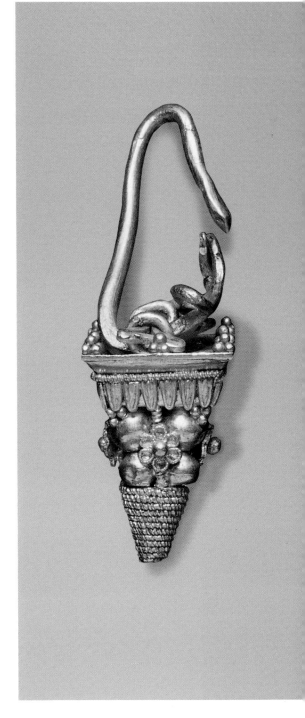

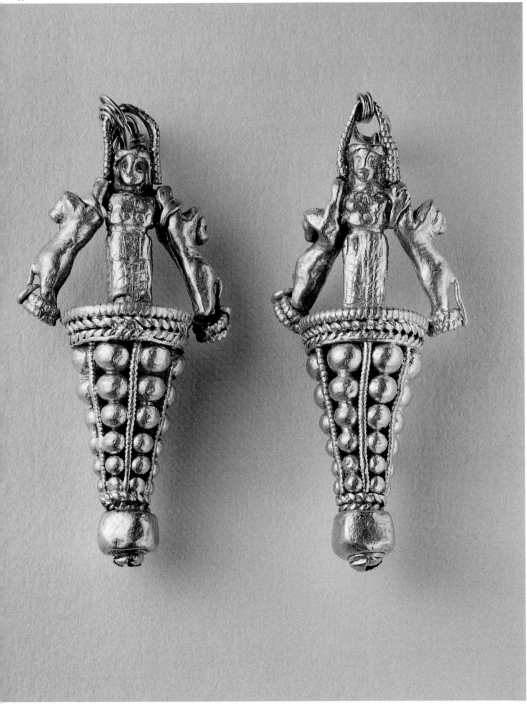

69. Earrings with conical pendant and Mistress of Animals, third quarter
of 7th century BC. Athens, National Archaeological Museum.

70. Earring with pyramidal pendant and snake, late 5th - first quarter
of 4th century BC. Athens, Benaki Museum.

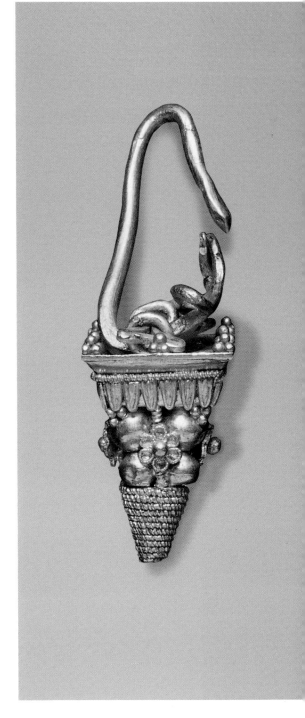

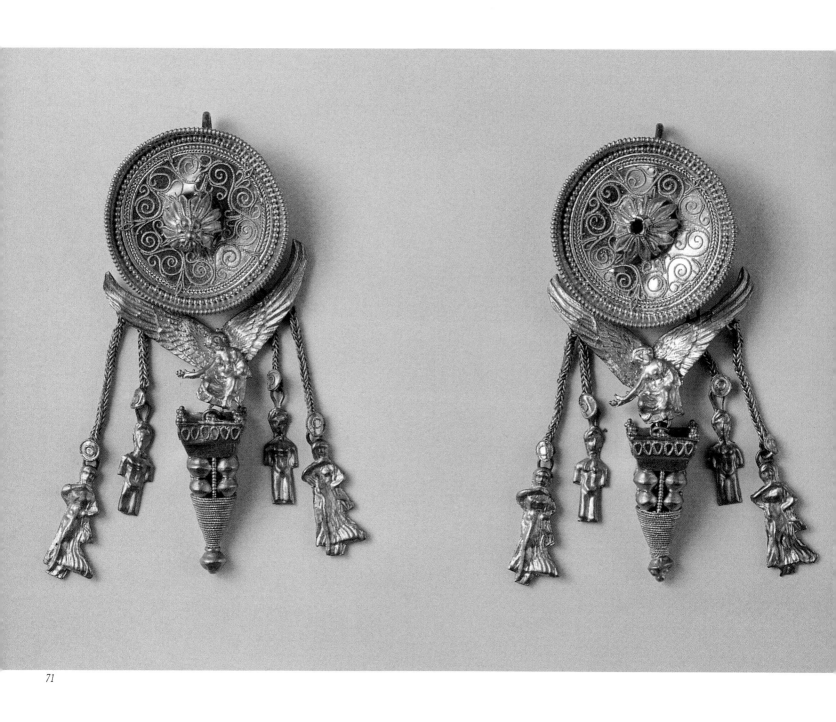

71

71. Earrings with pyramidal pendant and Nike playing knucklebones,
third quarter of 4th century BC. Berlin, Antikenmuseum.

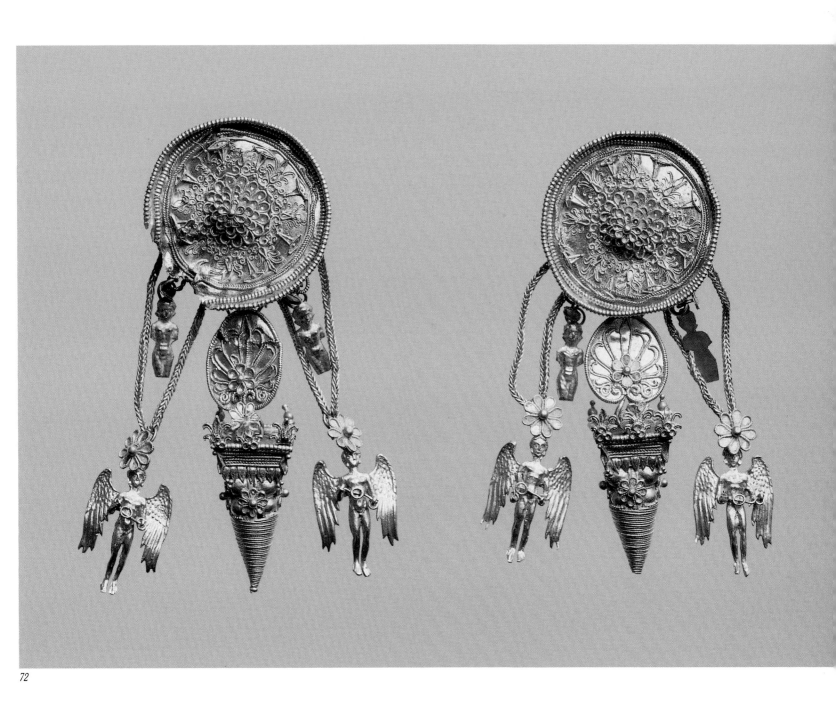

72. Earrings with palmette-crowned pyramidal pendant, last quarter
of 4th century BC. Berlin, Antikenmuseum.

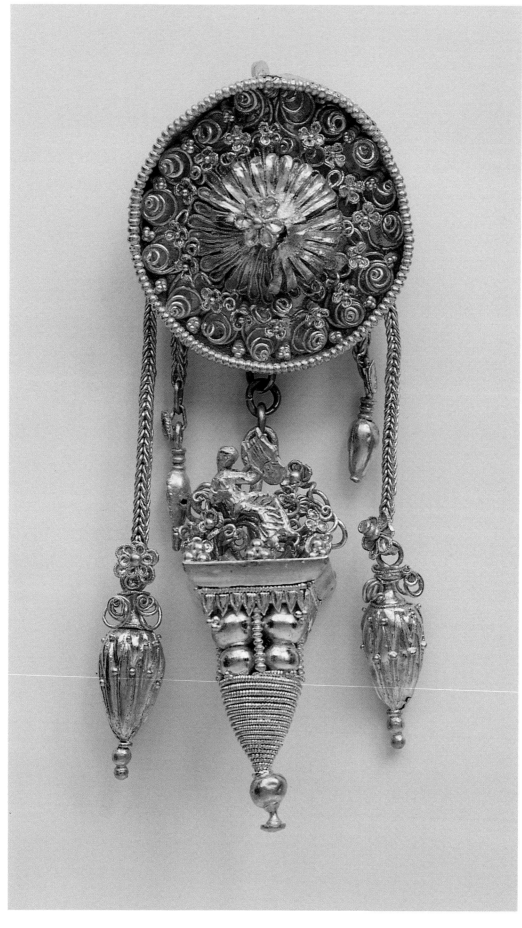

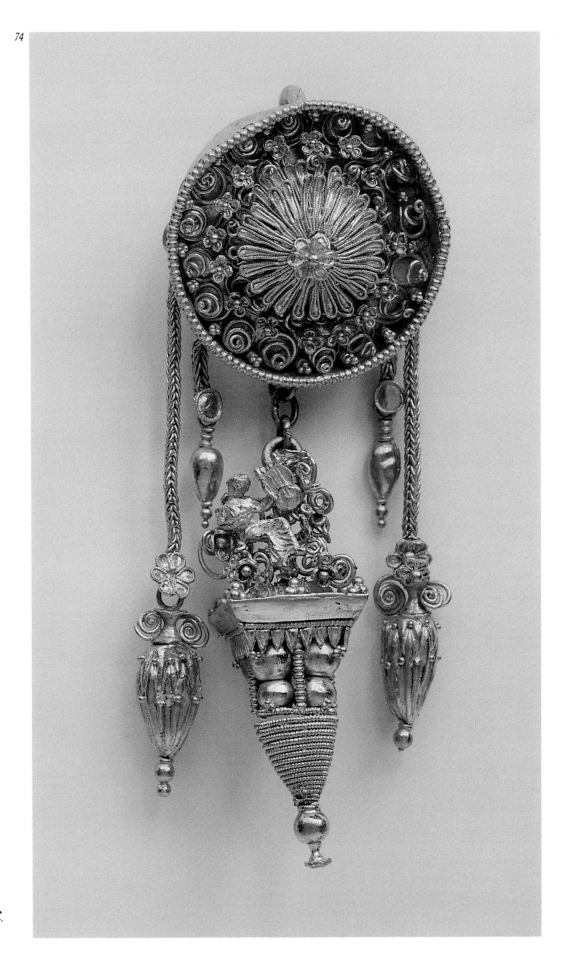

73-74. Earrings with pyramidal pendant and Muse, last quarter of 4th century BC. Athens, Benaki Museum.

75. Crescentic earrings, early 8th century BC. Athens,
National Archaeological Museum.

76. Earrings with the Rape of Thetis, second quarter
of 5th century BC. Athens, National Archaeological Museum.

75

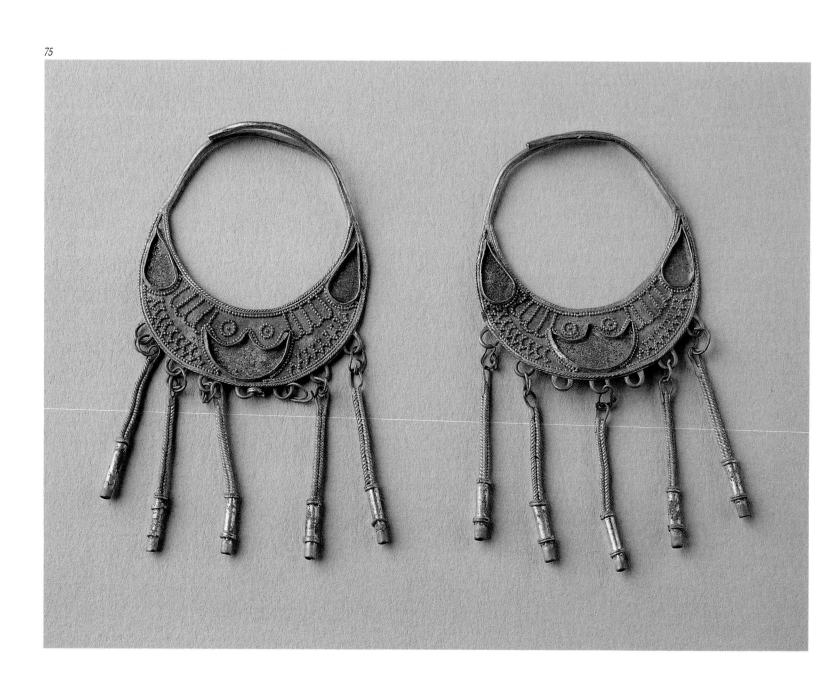

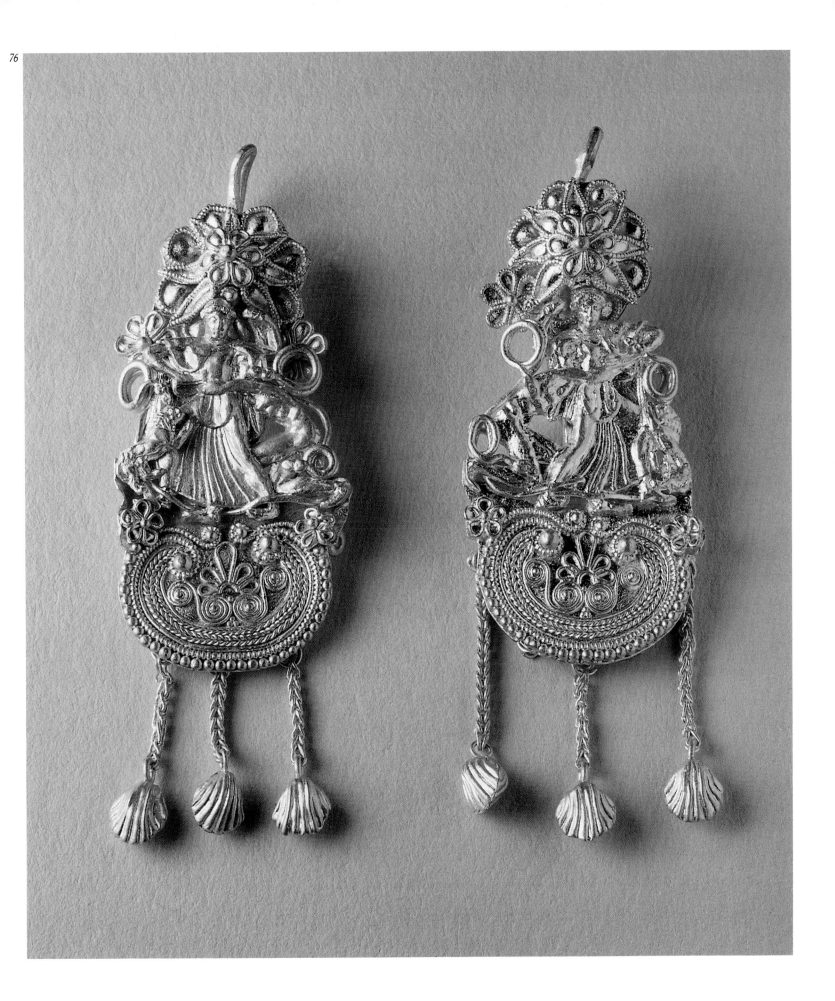

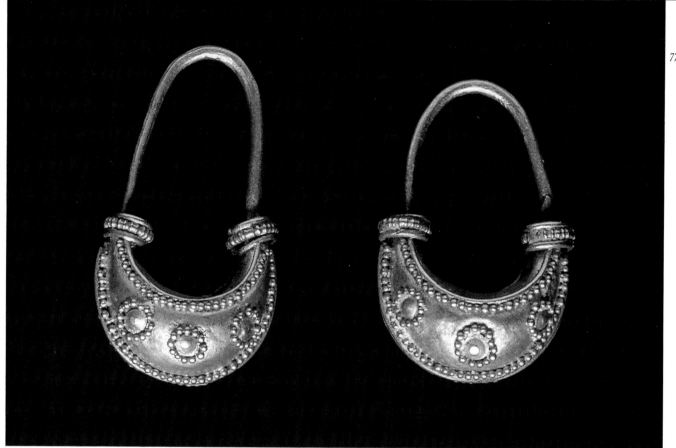

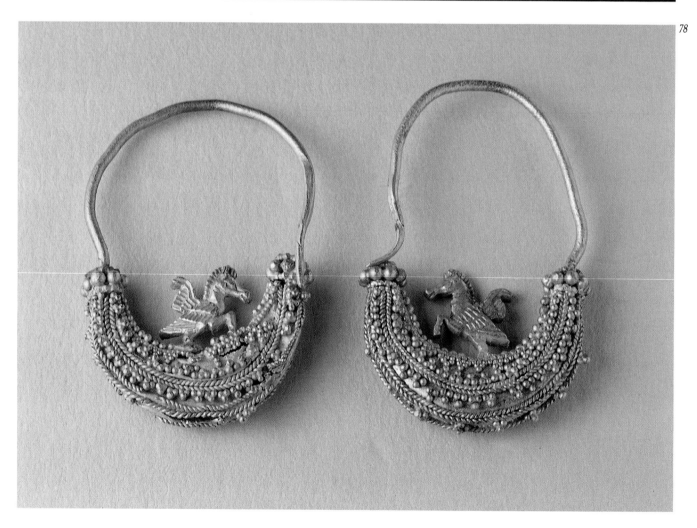

77. Boat-shaped earrings with granulated circles, late 6th century BC.
Athens, Benaki Museum.

78. Boat-shaped earrings with cock-horse, late 6th century BC.
Athens, National Archaeological Museum.

79. Boat-shaped earrings with siren and cockle-shell pendants,
late 5th century BC. London, British Museum.

79

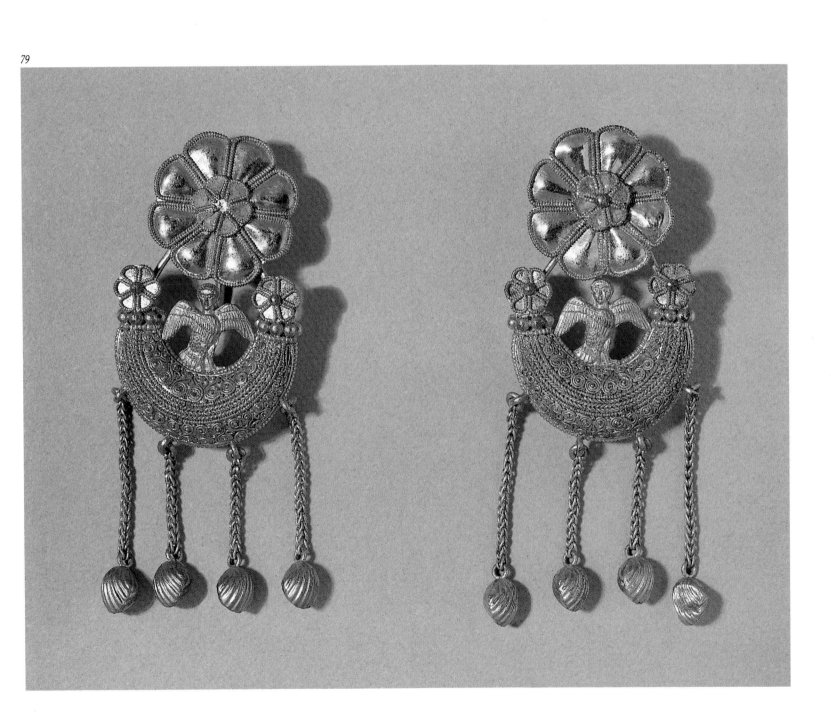

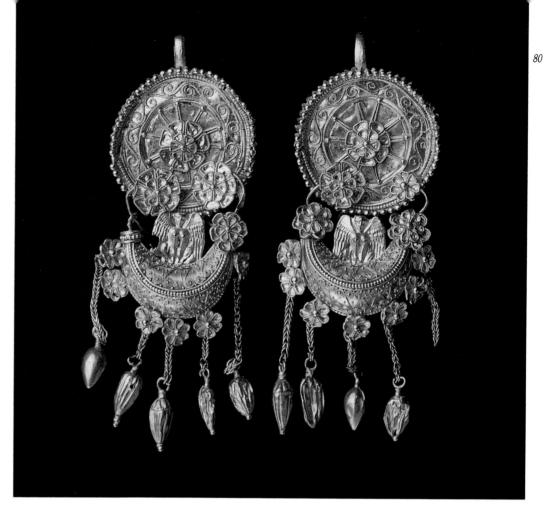

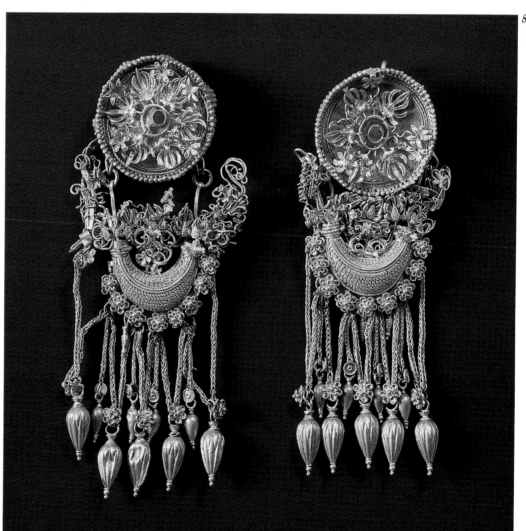

80. Boat-shaped earrings with siren and vase-shaped pendants, second quarter of 4th century BC. Vratsa, Local Historical Museum.

81. Boat-shaped earrings with three palmettes on a lyre-shaped ornament, c. 330 BC. Thessaloniki, Archaeological Museum.

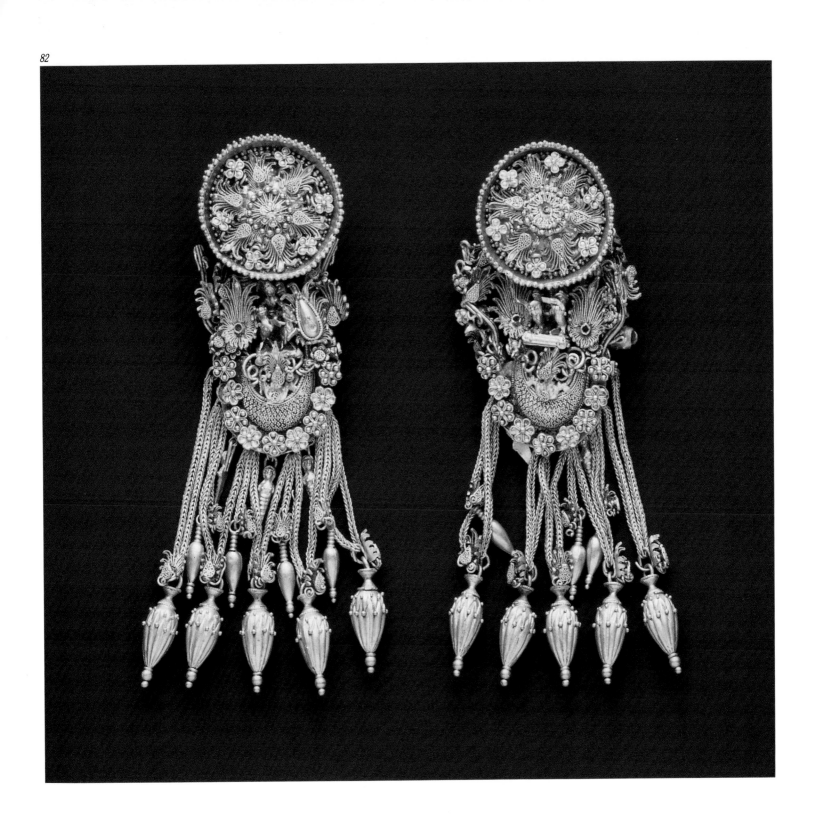

82. Boat-shaped earrings with Nike driving a two-horse chariot, last quarter of 4th century BC. New York, Metropolitan Museum of Art.

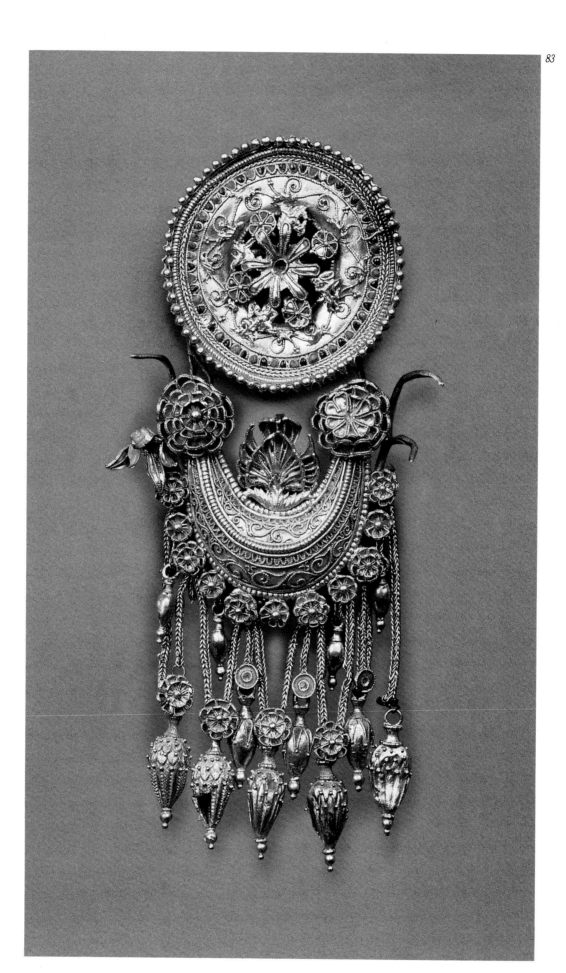

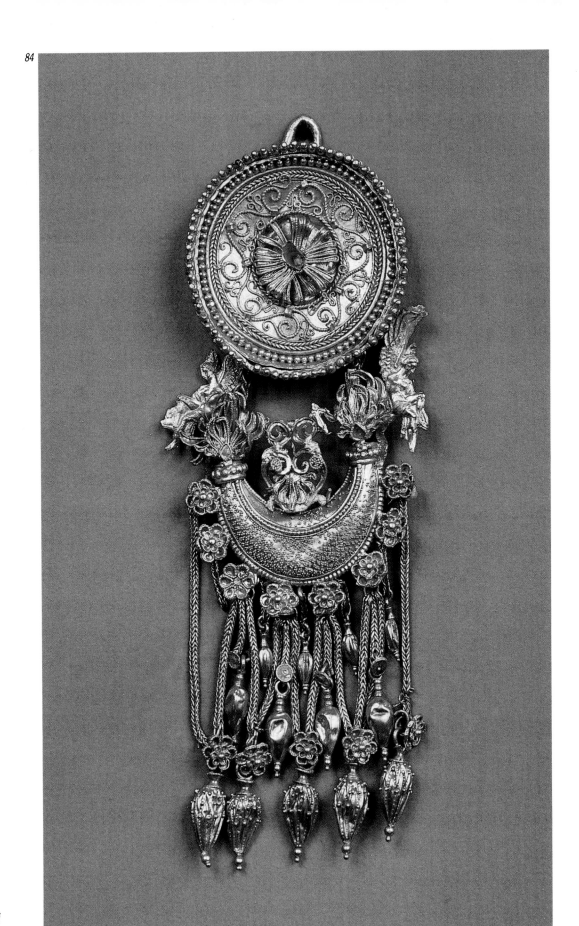

83. Boat-shaped earring with palmette in the hollow of the boat, 350-340 BC. Saint Petersburg, Hermitage State Museum.

84. Boat-shaped earring with two Nikai adjusting their sandal, c. 330 BC. Saint Petersburg, Hermitage State Museum.

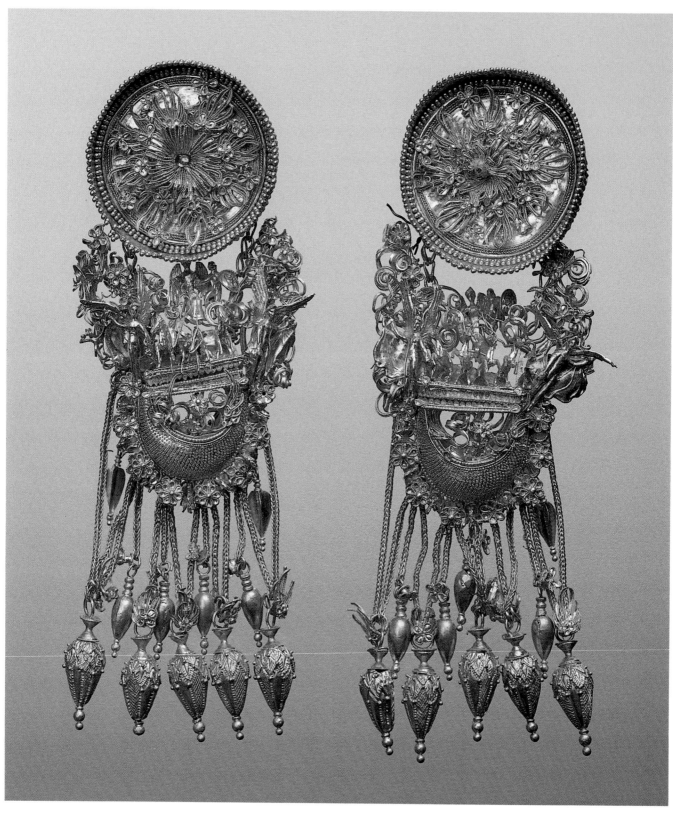

*85. Boat-shaped earrings with four-horse chariot, warrior, Nike and two Erotes,
late 4th century BC. Saint Petersburg, Hermitage State Museum.*

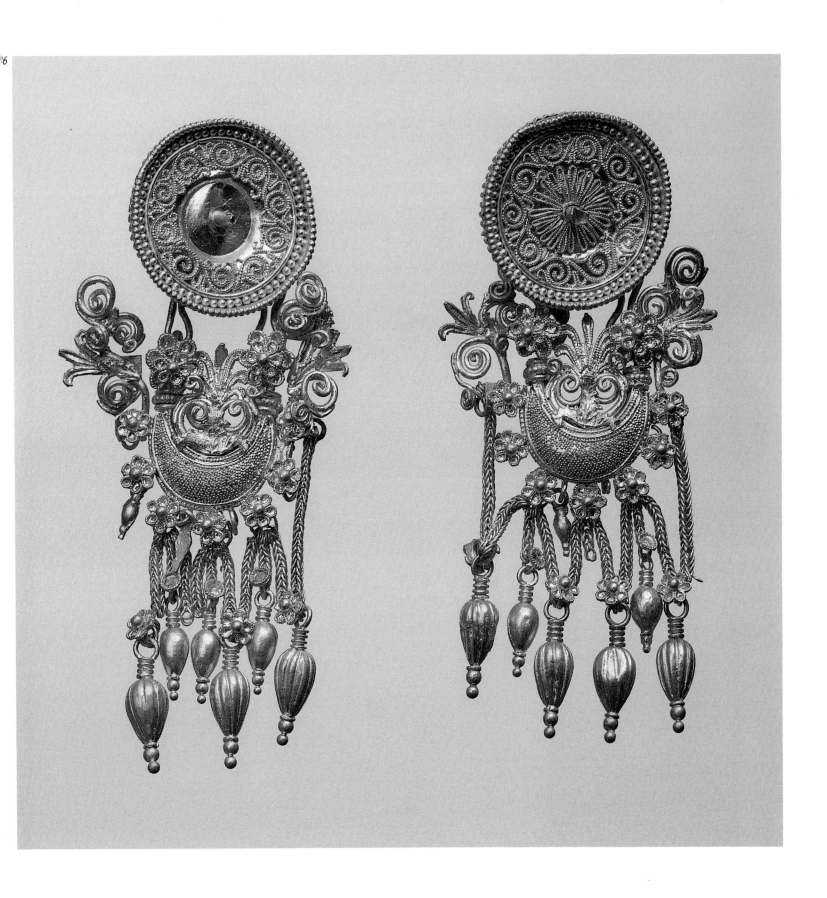

86. Boat-shaped earrings with palmette in the hollow of the boat, last quarter of 4th century BC. Saint Petersburg, Hermitage State Museum.

87. Boat-shaped earrings with hippocamp, c. 340-330 BC.
Volos, Archaeological Museum.

88. Boat-shaped earring with sitting Nikai, c. 330-320 BC.
Taranto, Museo Archeologico Nazionale.

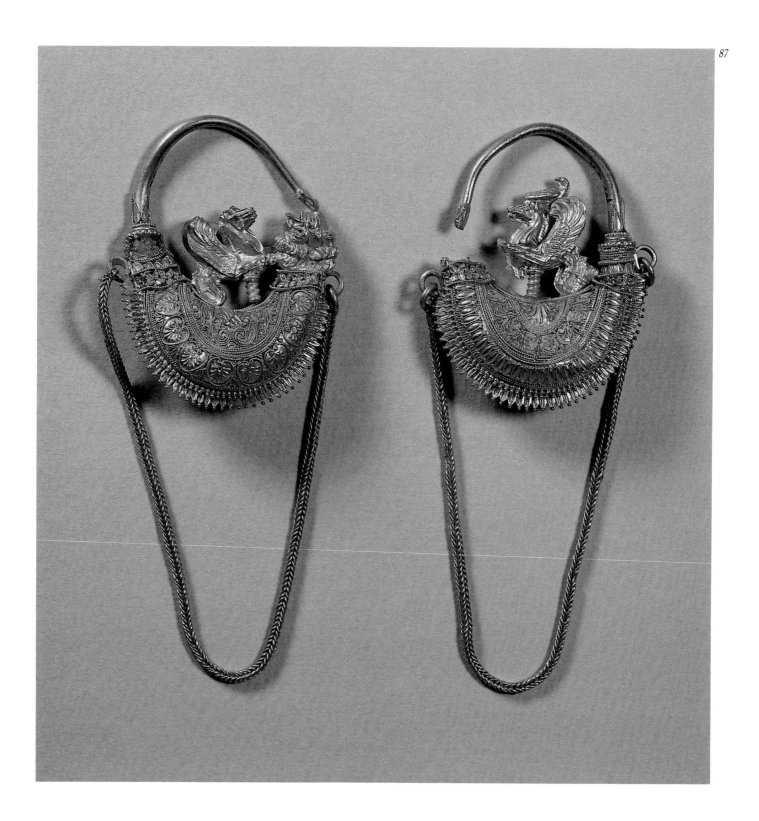

87

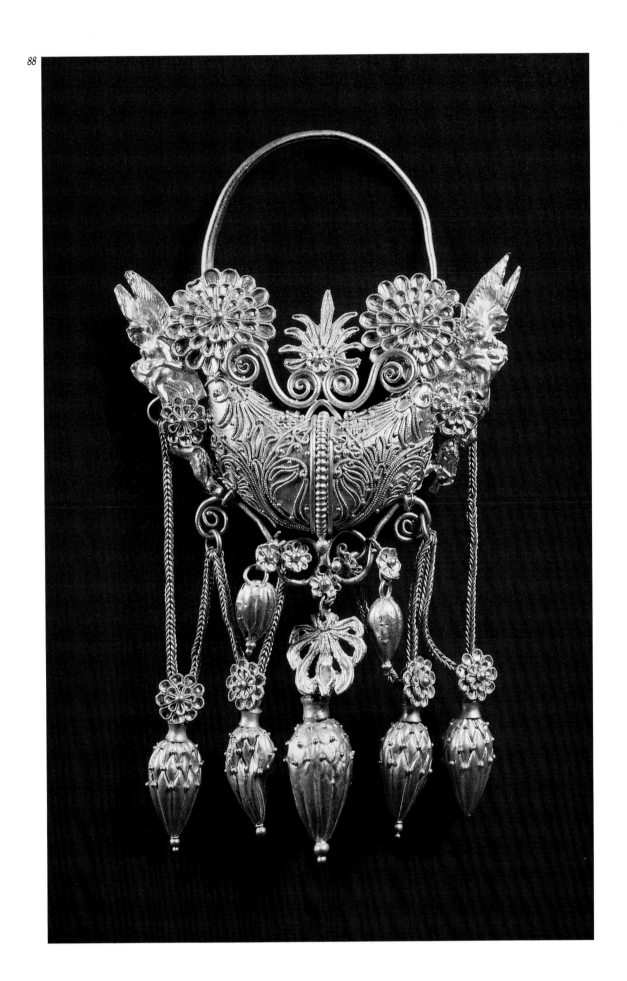

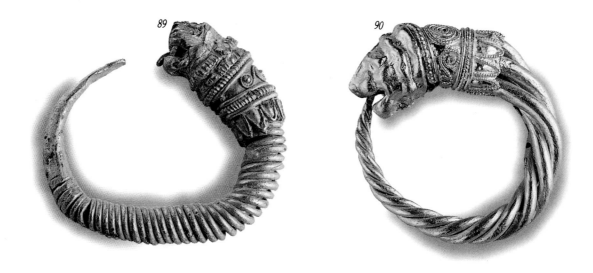

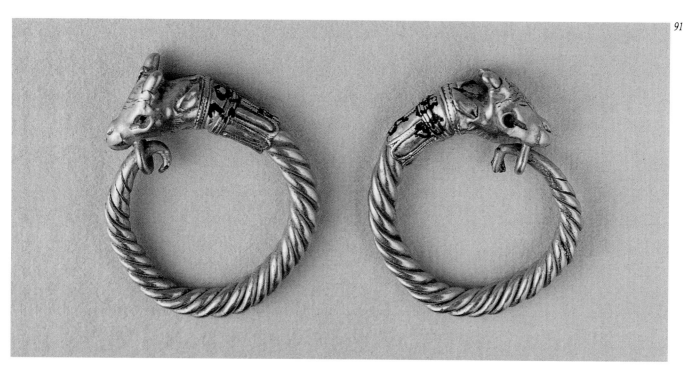

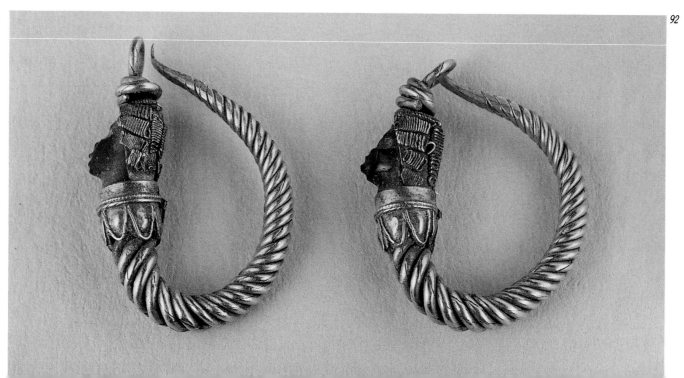

114

89. *Lion-head earring, c. 330 BC. Thessaloniki, Archaeological Museum.*

90. *Lion-head earring, c. 320 BC. Thessaloniki, Archaeological Museum.*

91. *Caprine-head earrings, second half of 3rd century BC. Athens, Canellopoulos Museum.*

92. *Negro-head earrings, c. 230 BC. Thessaloniki, Archaeological Museum.*

93. *Negro-head earrings, first half of 2nd century BC. Veroia, Archaeological Museum.*

94. *Lynx-head earrings, mid-2nd century BC. Veroia, Archaeological Museum.*

93

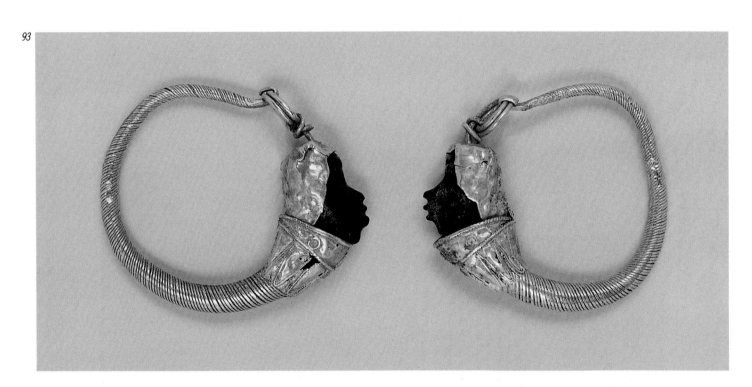

94

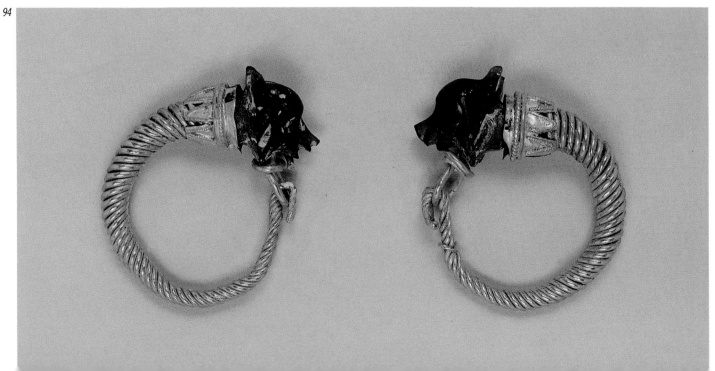

115

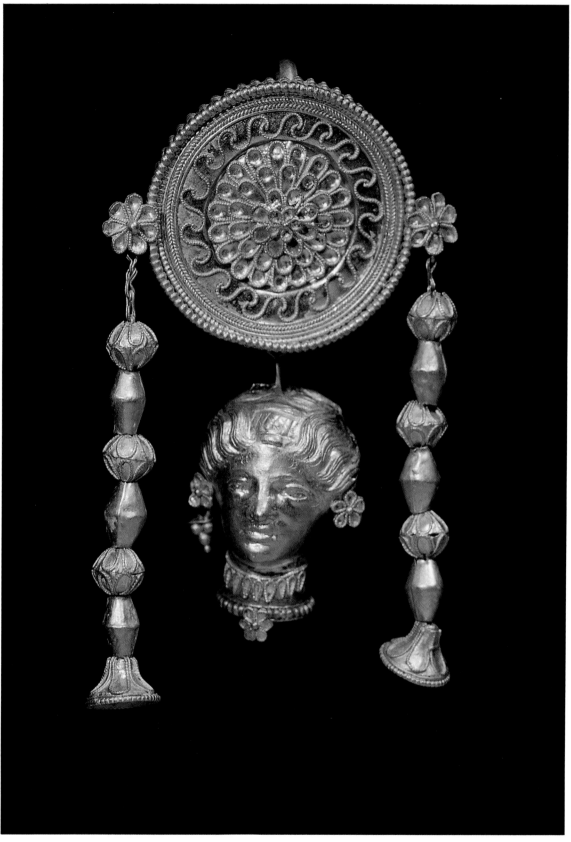

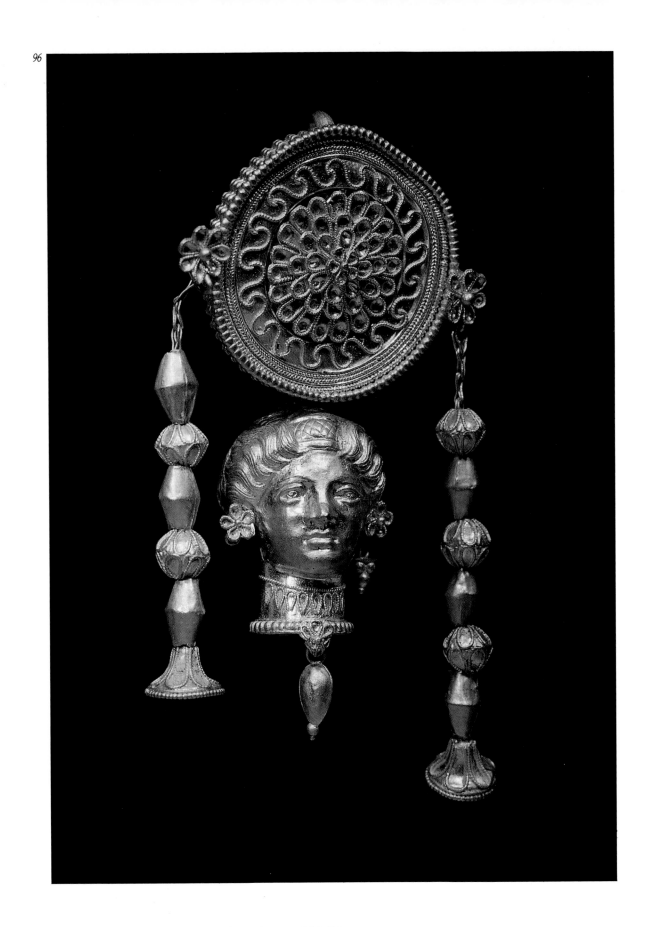

95-96. Earrings with female-head pendant, c. 350 BC.
Taranto, Museo Archeologico Nazionale.

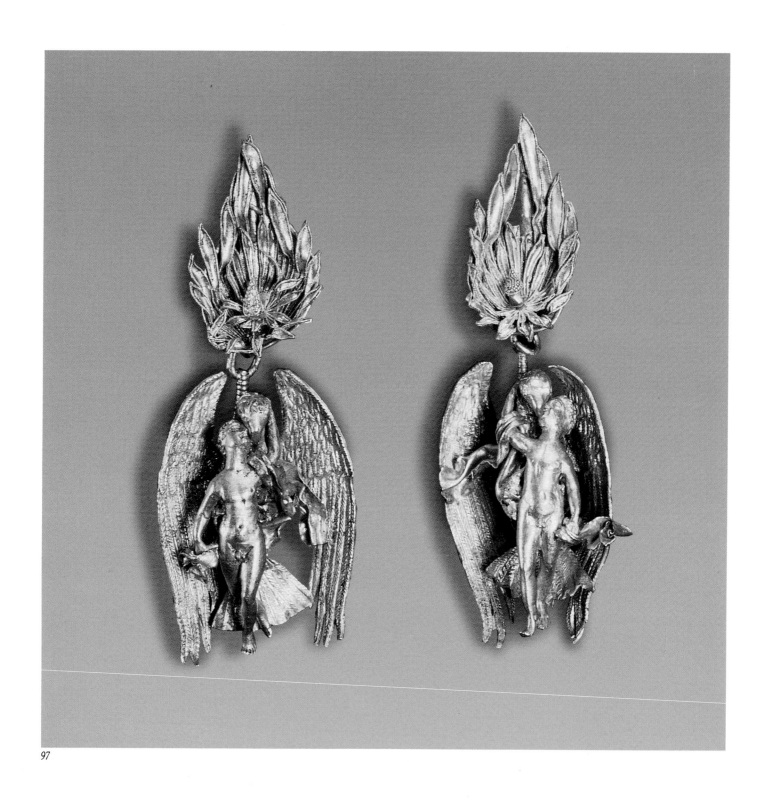

97

97. Earrings with the Rape of Ganymede, last quarter of 4th century BC.
New York, Metropolitan Museum of Art.

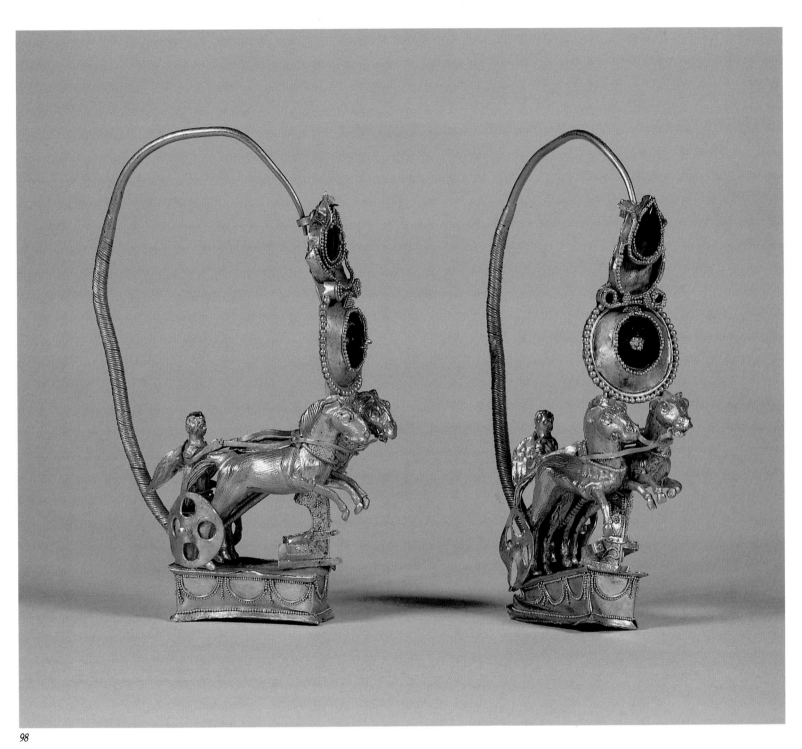

98. Earrings with Nike driving a chariot, mid-2nd century BC.
Volos, Archaeological Museum.

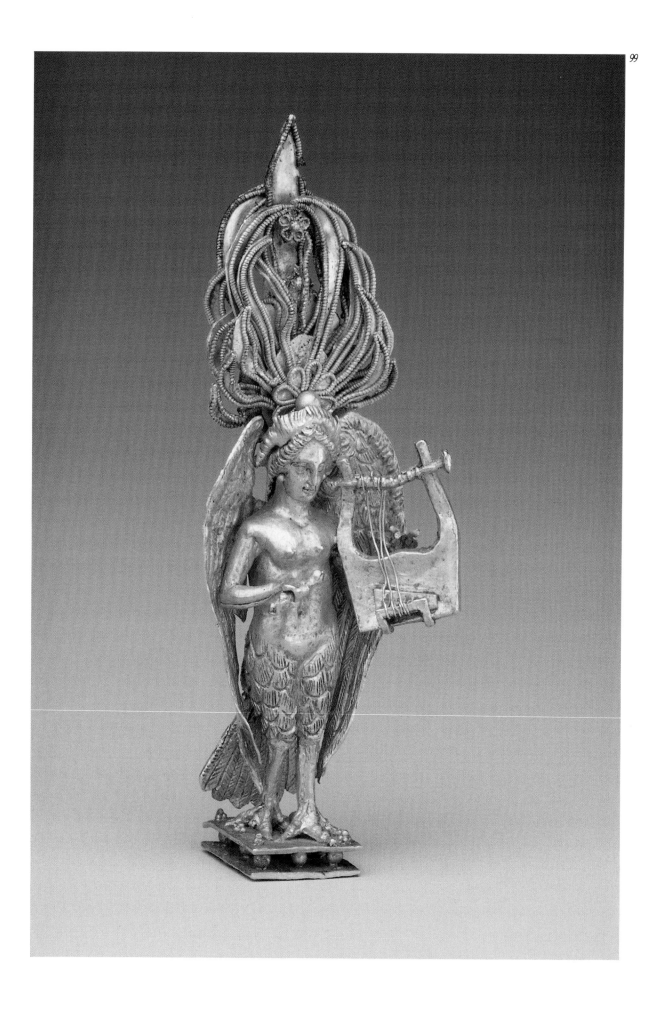

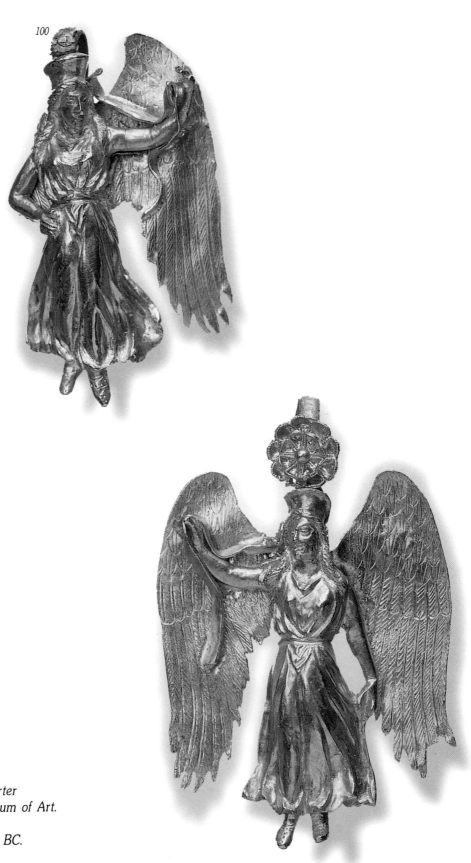

100

99. Earring with siren playing a kithara, last quarter
of 4th century BC. New York, Metropolitan Museum of Art.

100. Earrings with Nike holding a ribbon, c. 330 BC.
Saint Petersburg, Hermitage State Museum.

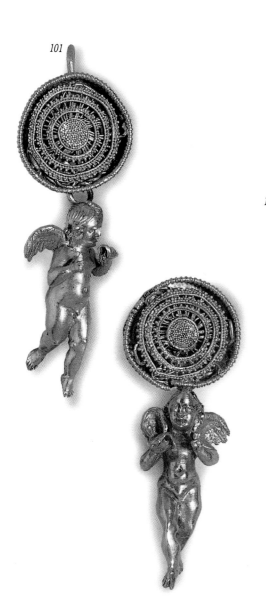

101. Earrings with Eros, late 4th - early 3rd century BC. London, British Museum.

102. Earrings with amphora-shaped pendants, second half of 2nd century BC. London, British Museum.

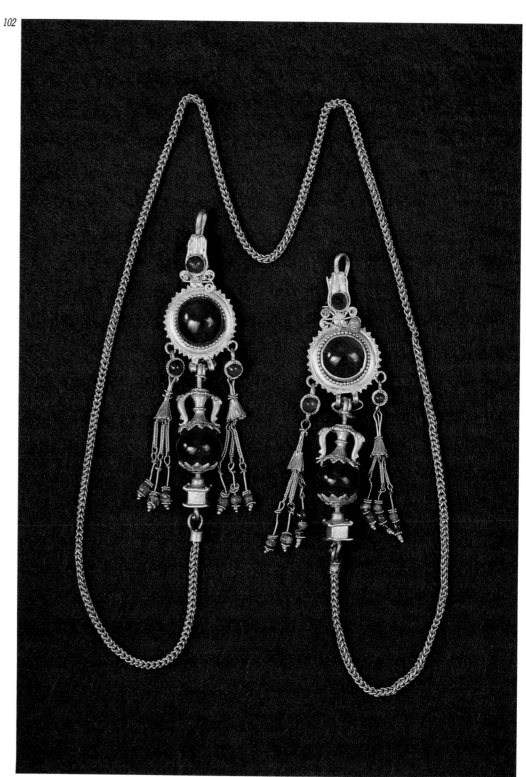

103. Earrings with goose pendants, first half of 2nd century BC.
Saint Petersburg, Hermitage State Museum.

103

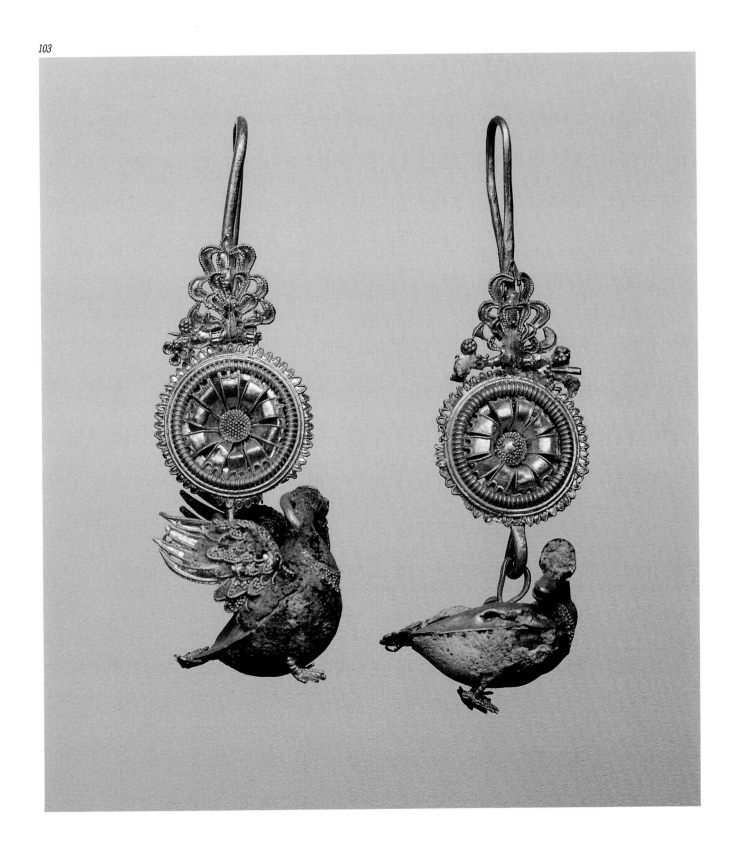

103. Earrings with goose pendants, first half of 2nd century BC.
Saint Petersburg, Hermitage State Museum.

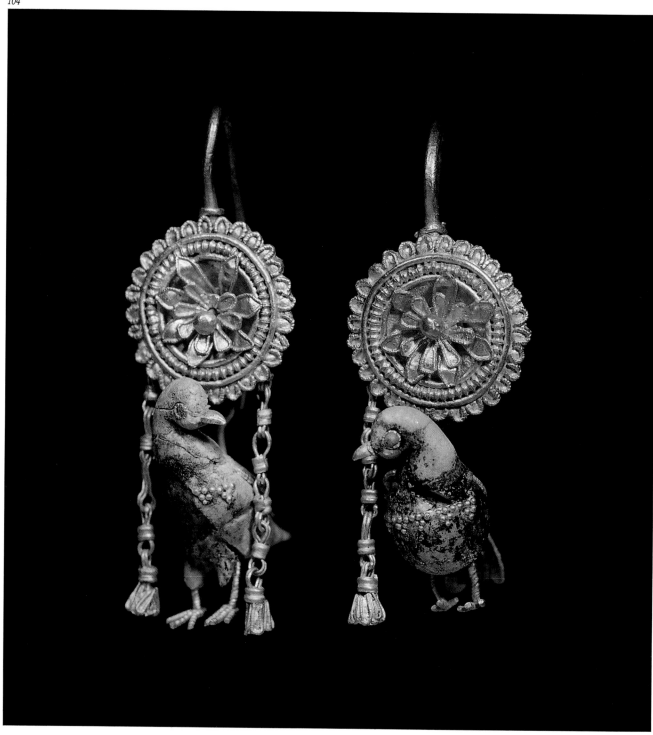

104. Earrings with dove pendants, 2nd century BC.
Taranto, Museo Archeologico Nazionale.

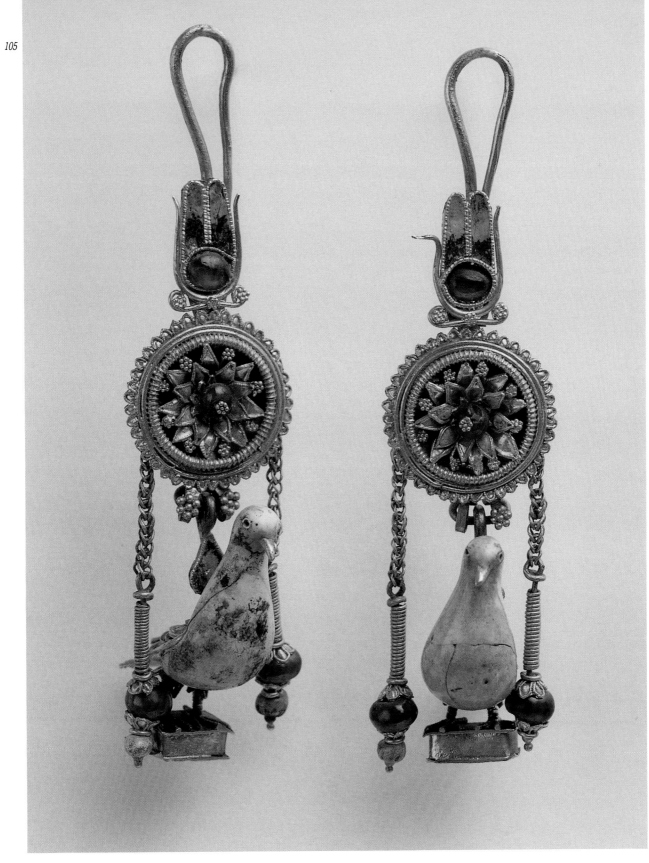

105. Earrings with dove pendants, second half of 2nd century BC.
Saint Petersburg, Hermitage State Museum.

*106. Four-spiral pendant, c. 800 BC. Athens,
National Archaeological Museum.*

*107. Chain necklace with pendant, c. 800 BC.
Herakleion, Archaeological Museum.*

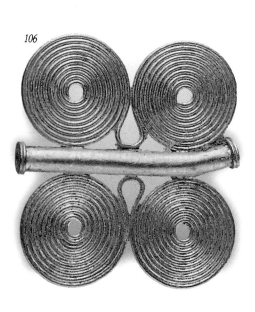

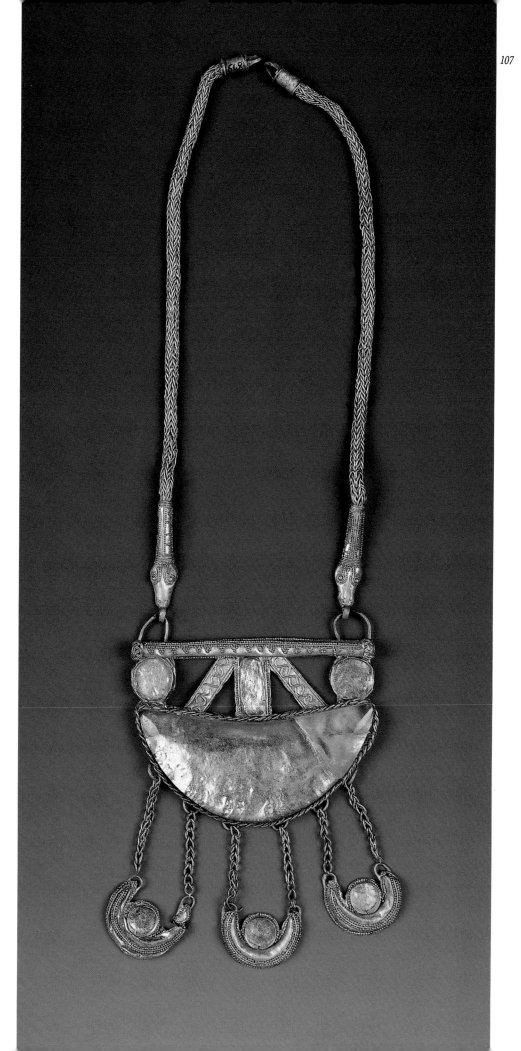

*108. Necklace with globular beads and cylindrical pendants,
8th century BC. London, British Museum.*

108

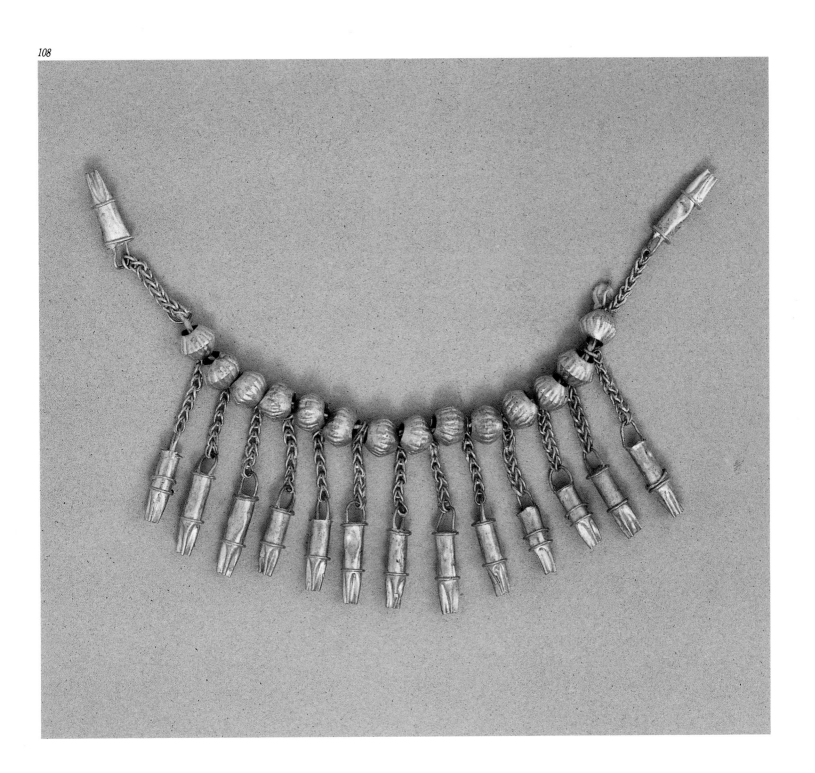

109. Three necklace pendants in the form of siren and daemonic bees, second half of 7th century BC. Copenhagen, Nationalmuseet.

110. One trapezoidal and four rectangular necklace plaques, c. 750 BC. Athens, National Archaeological Museum.

109

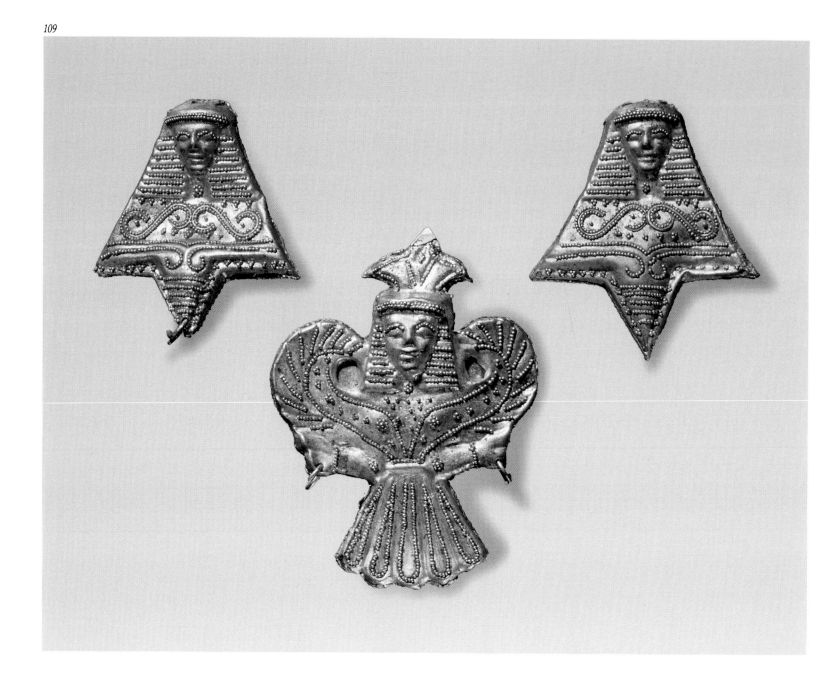

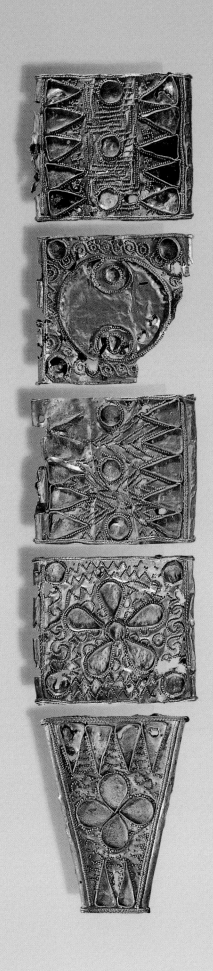

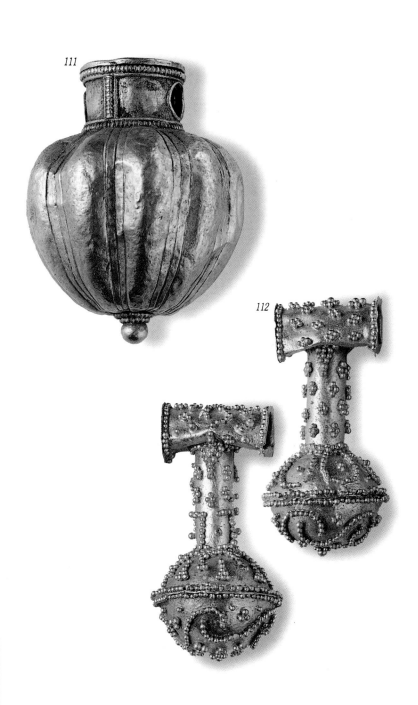

111. Vase-shaped pendant, last quarter of 7th century BC.
Athens, National Archaeological Museum.

112. Two spherical necklace pendants, late 7th century BC.
Athens, National Archaeological Museum.

111

112

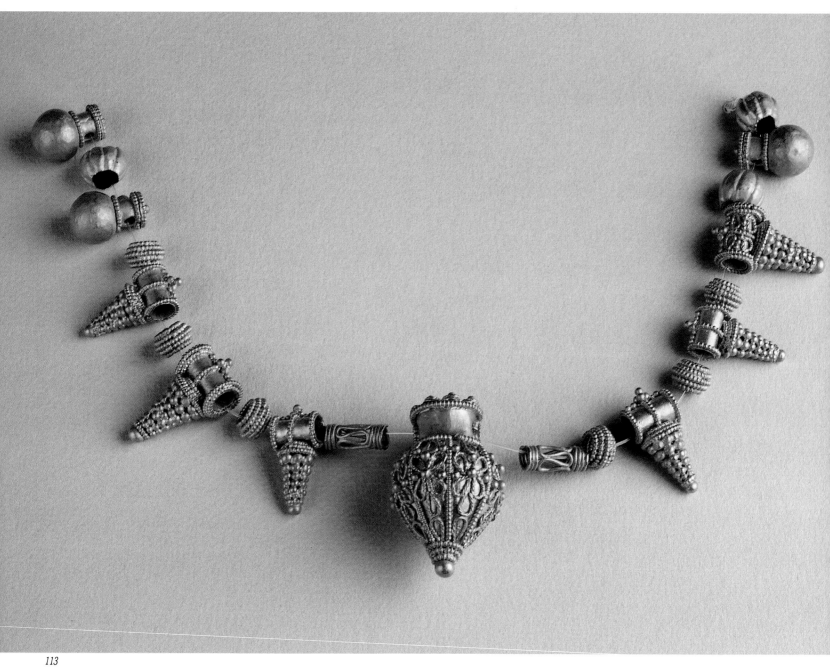

113

113. Necklace with conical pendants, c. 560 BC.
Thessaloniki, Archaeological Museum.

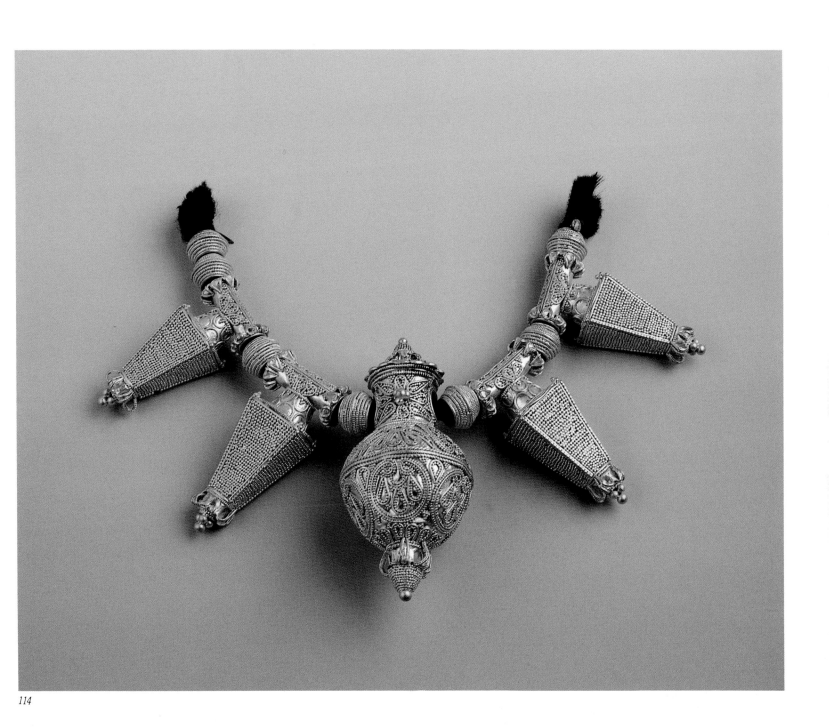

114. Necklace with pyramid pendants, c. 510 BC.
Thessaloniki, Archaeological Museum.

115. *Two schematic pomegranate pendants, c. 510-500 BC.*
Thessaloniki, Archaeological Museum.

116. *Necklace with vase-shaped and double-axe pendants,*
c. 510-500 BC. Thessaloniki, Archaeological Museum.

117. *Necklace with biconical beads and pomegranates,*
c. 510 BC. Thessaloniki, Archaeological Museum.

115

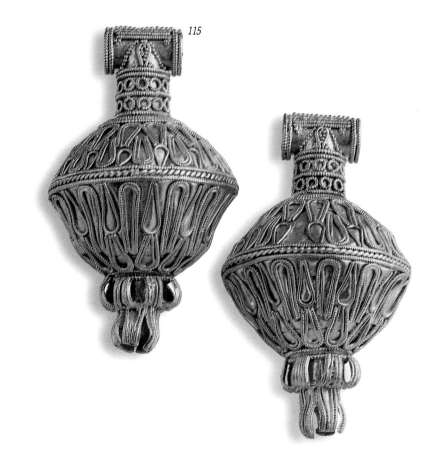

116

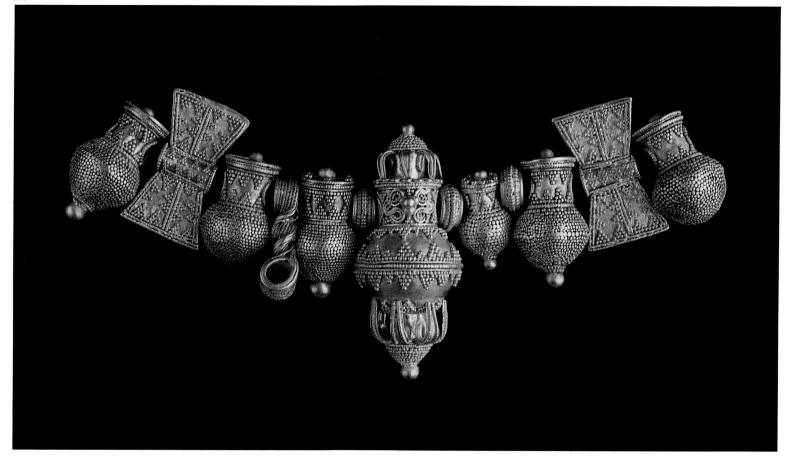

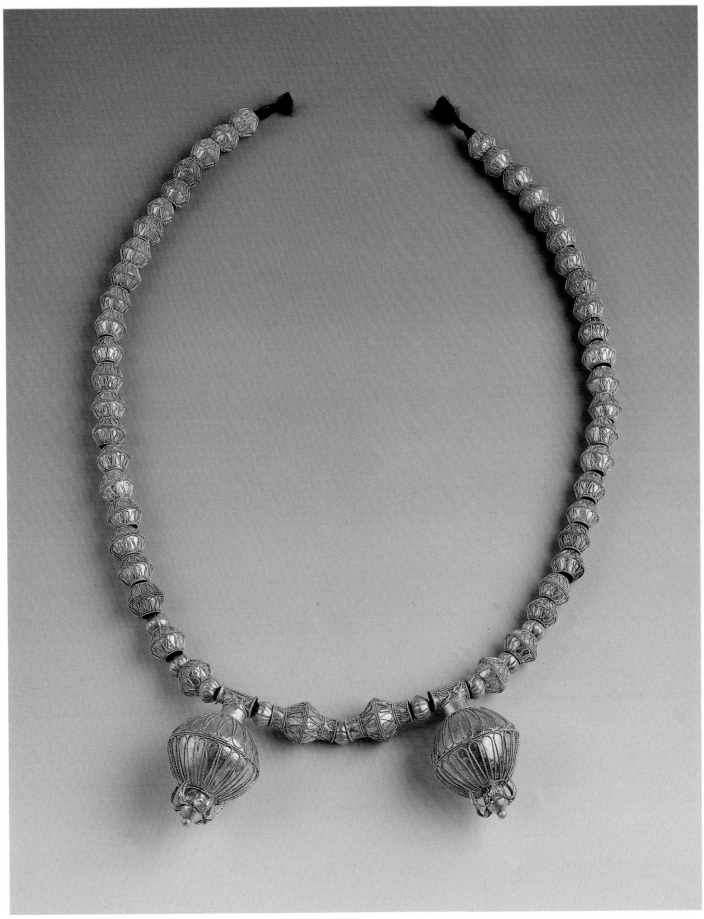

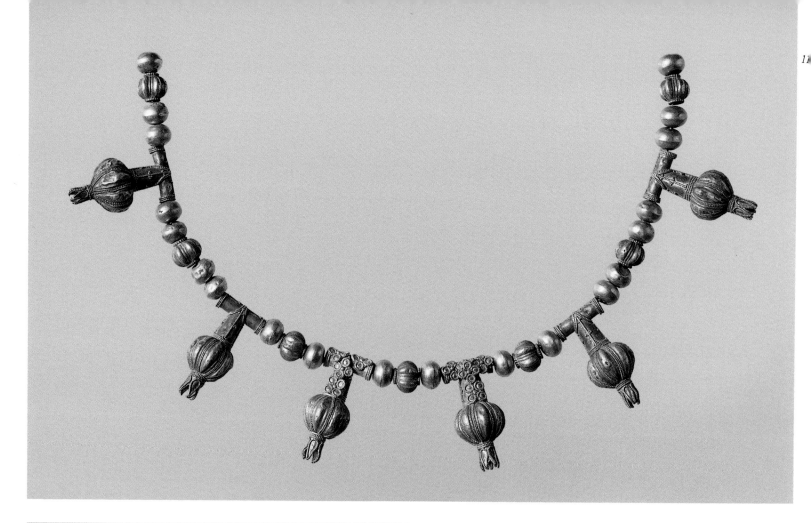

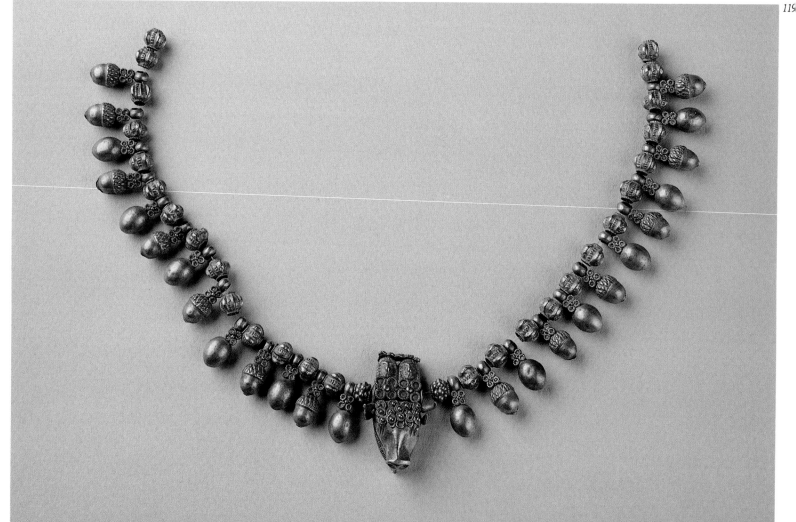

118. Necklace with pomegranates, late 6th century BC.
Berlin, Antikenmuseum.

119-120. Necklace with acorns and bull head, first quarter
of 5th century BC. Athens, National Archaeological Museum.

120

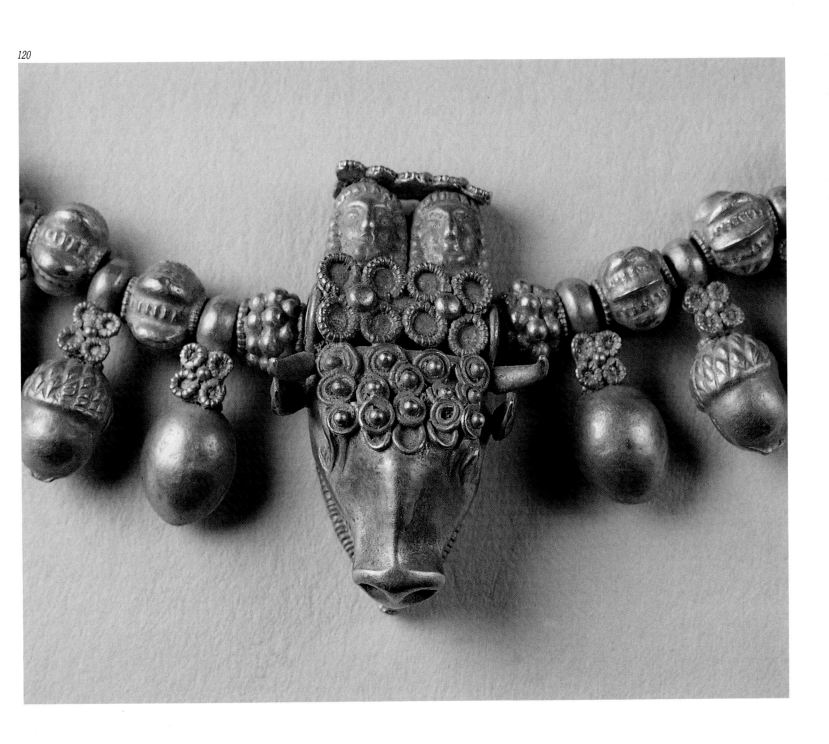

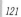

121

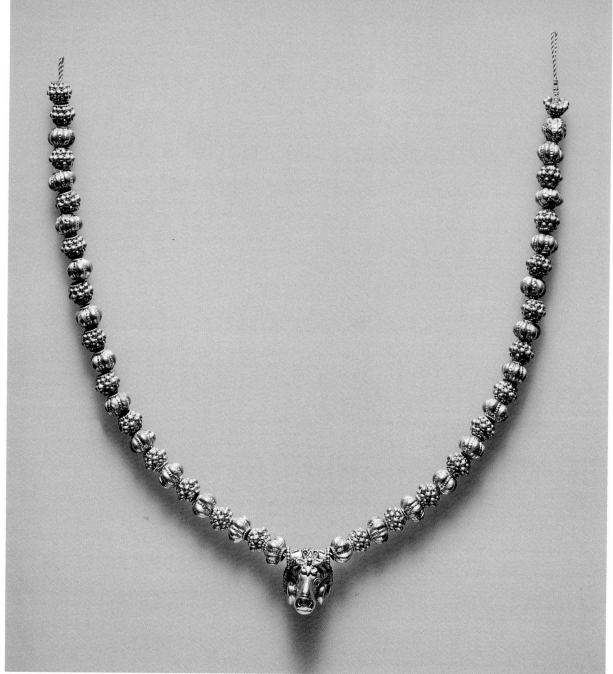

122

121. *Necklace with globular beads and ram head, second quarter of 5th century BC. Berlin, Antikenmuseum.*

122. *Section of a necklace with biconical and cylindrical beads, late 6th - early 5th century BC. Kavala, Archaeological Museum.*

123. *Necklace with cylindrical beads and Herakles knot, last quarter of 4th century BC. Amphipolis, Archaeological Museum.*

123

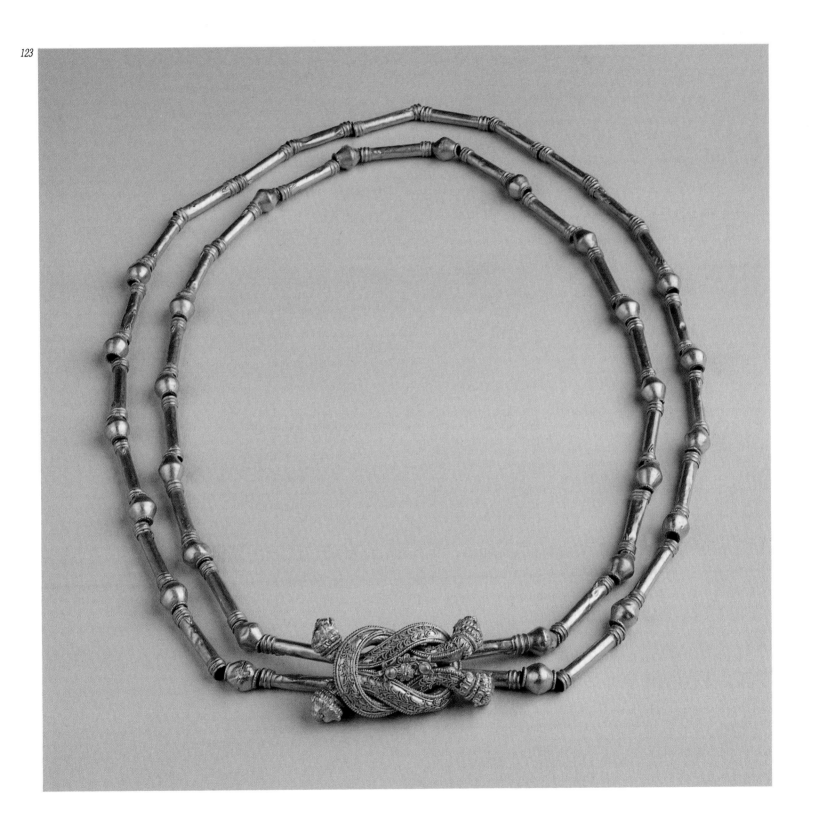

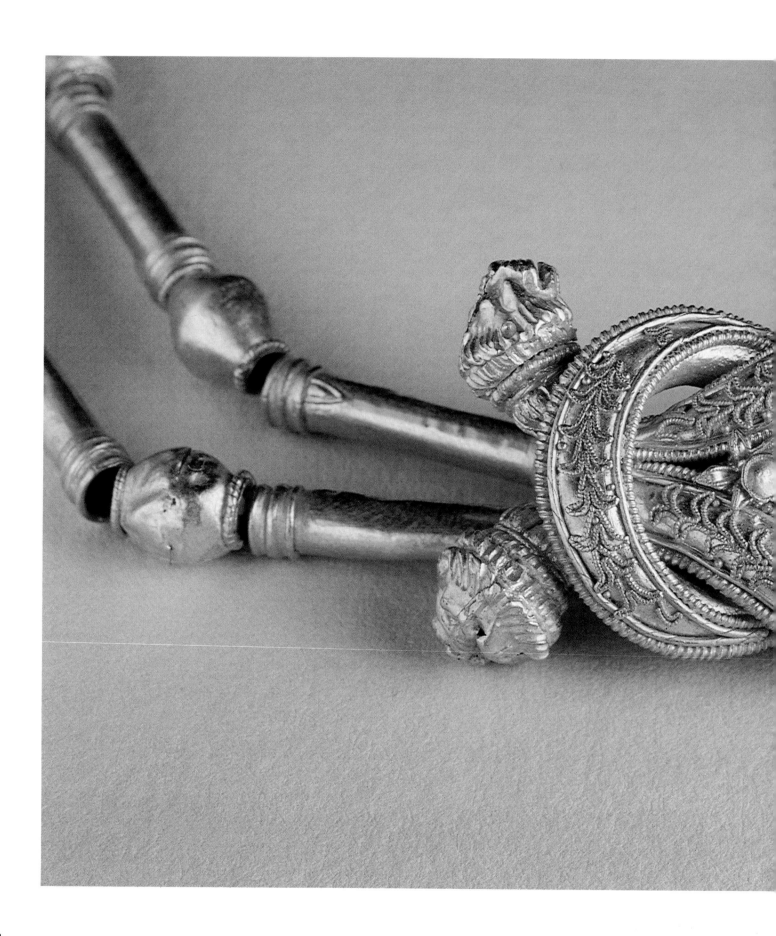

124. The central section of the necklace in fig. 123.

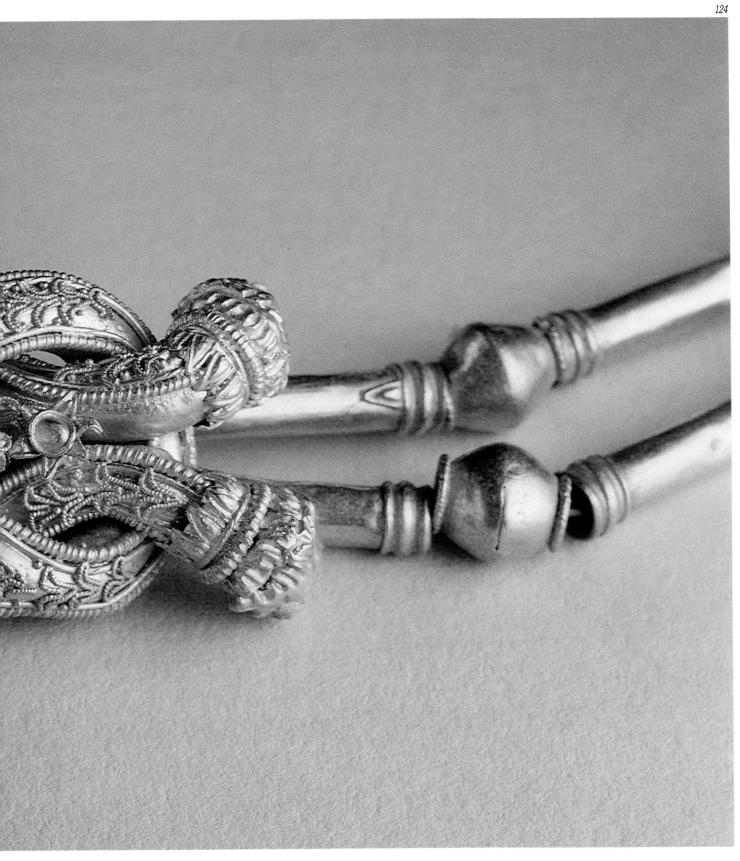

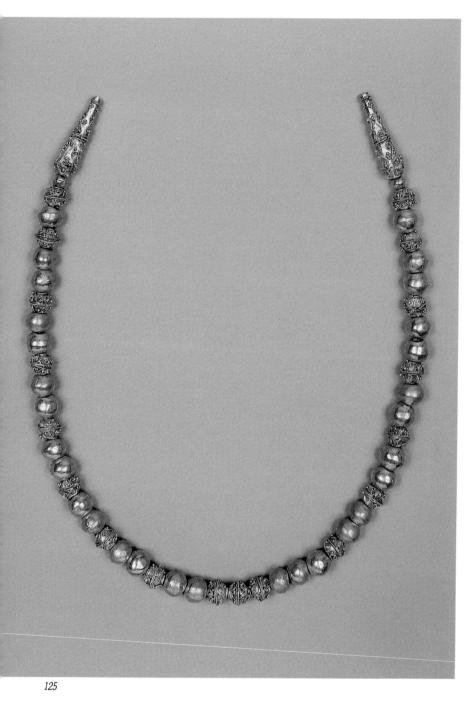

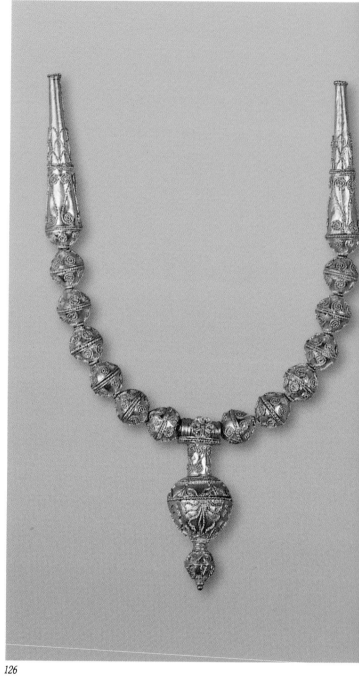

125

126

125. Necklace with globular beads, late 4th century BC.
Komotini, Archaeological Museum.

126. Necklace with globular beads and vase-shaped pendant,
late 4th century BC. Sofia, National Archaeological Museum.

140

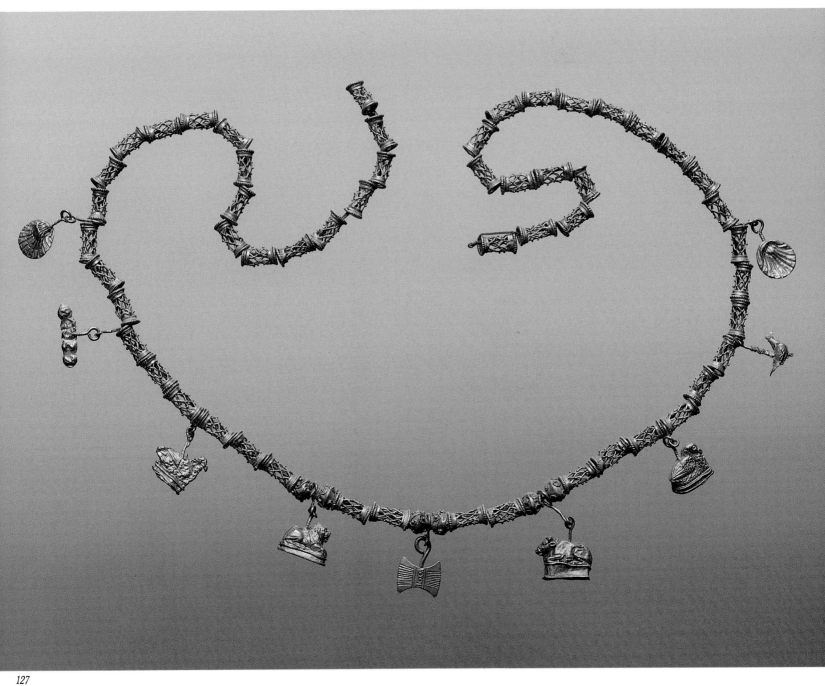

127

*127. Necklace with cylindrical reticulated beads and pendants,
late 3rd - early 2nd century BC. Saint Petersburg, Hermitage
State Museum.*

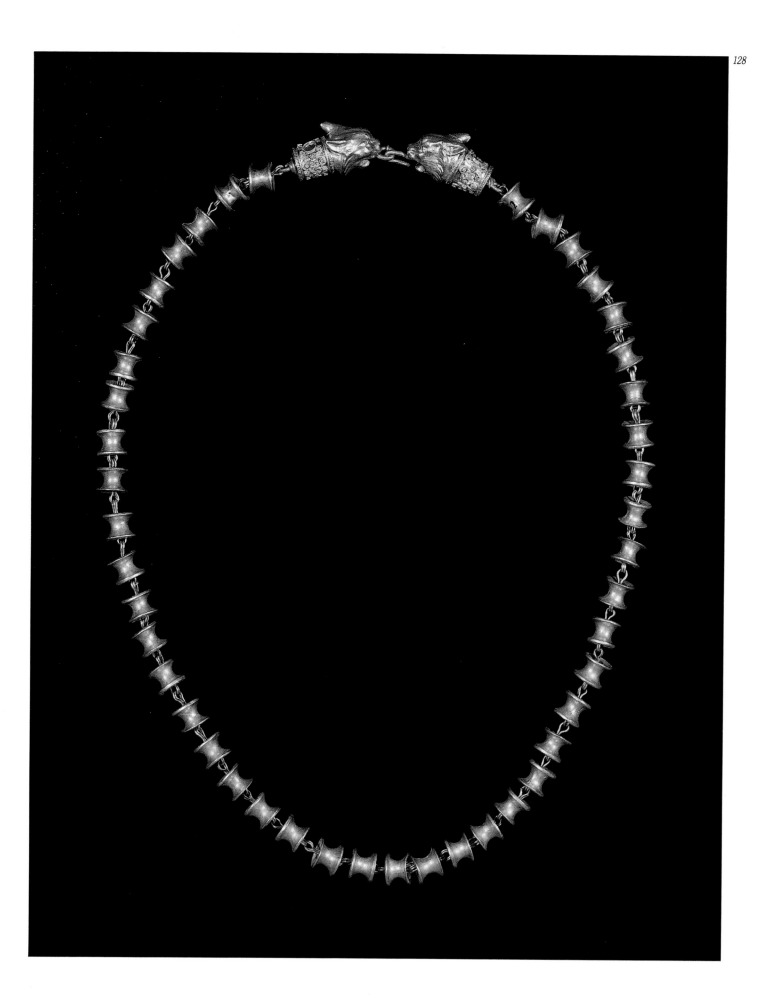

129

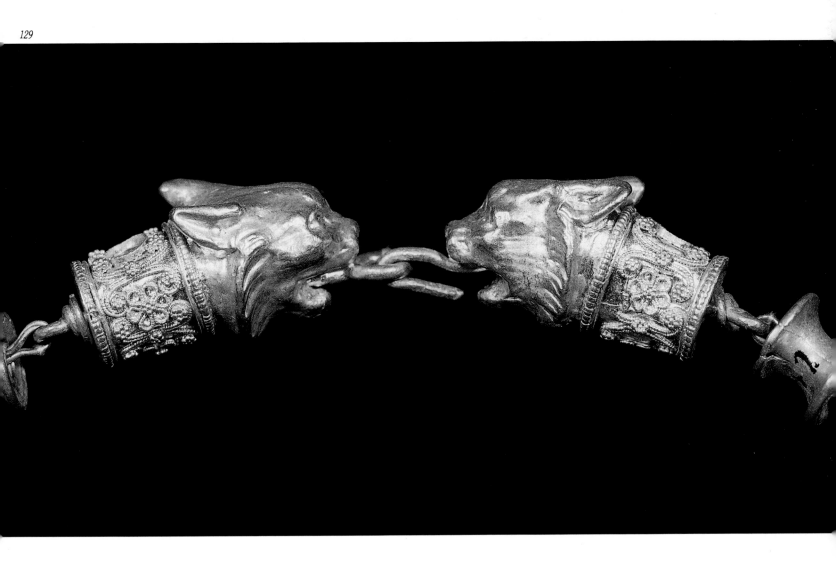

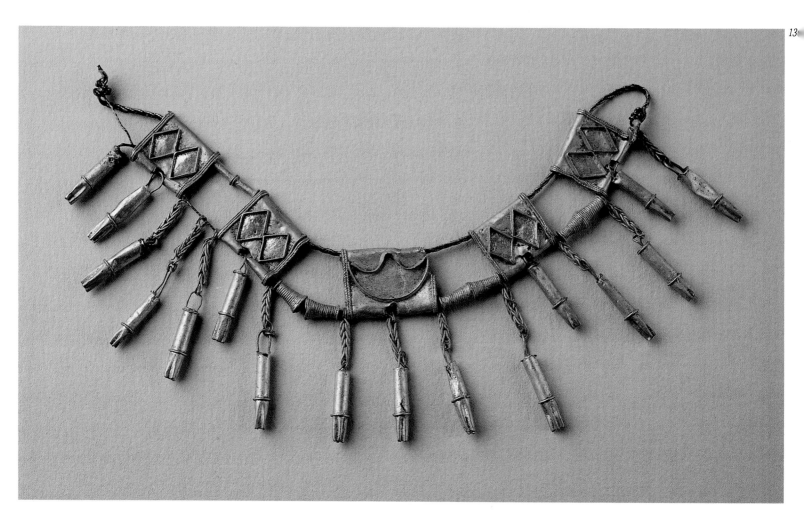

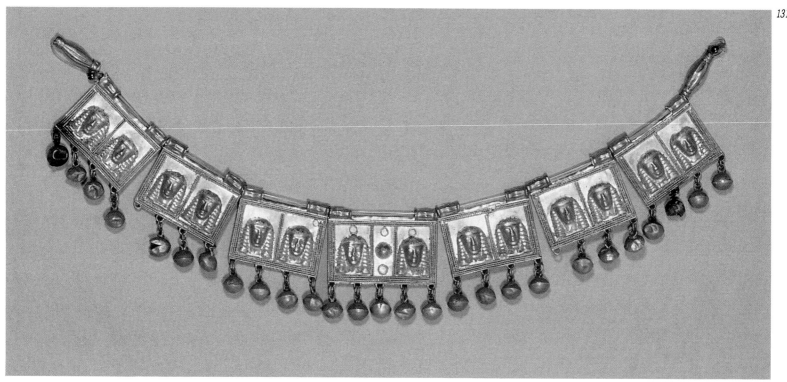

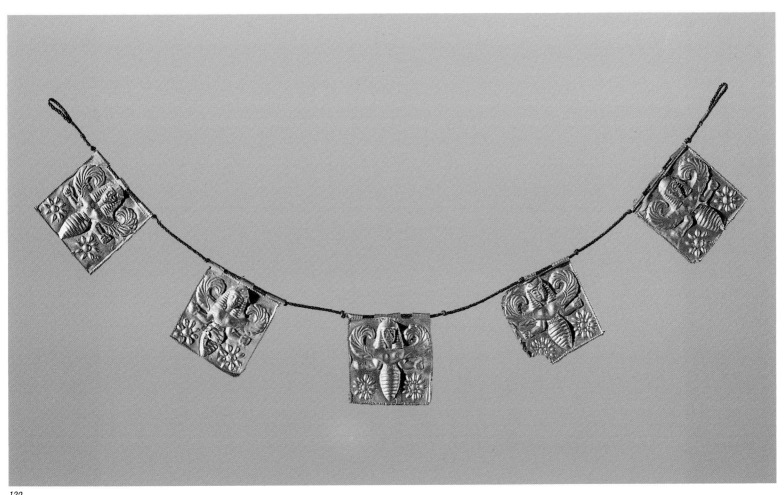

132

130. Necklace with gold plaques and cylindrical pendants,
c. 730 BC. Athens, National Archaeological Museum.

131. Seven necklace plaques with female heads, second half
of 7th century BC. London, British Museum.

132. Five necklace plaques with Melissa, second half
of 7th century BC. Berlin, Antikenmuseum.

133. *Seven necklace plaques with the Mistress of Animals, second half of 7th century BC. London, British Museum.*

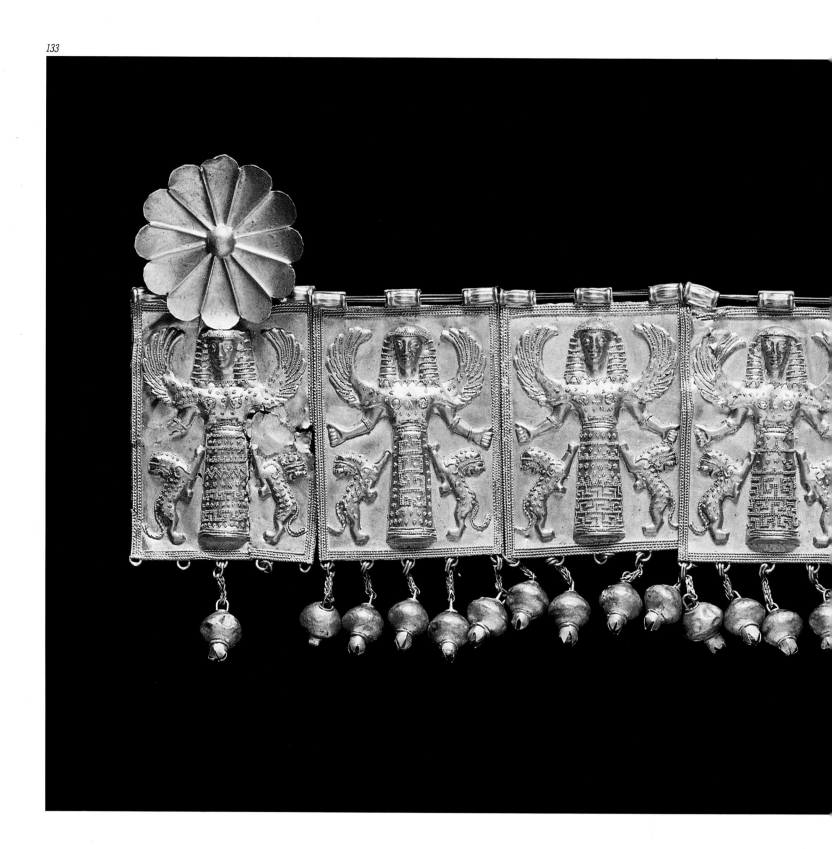

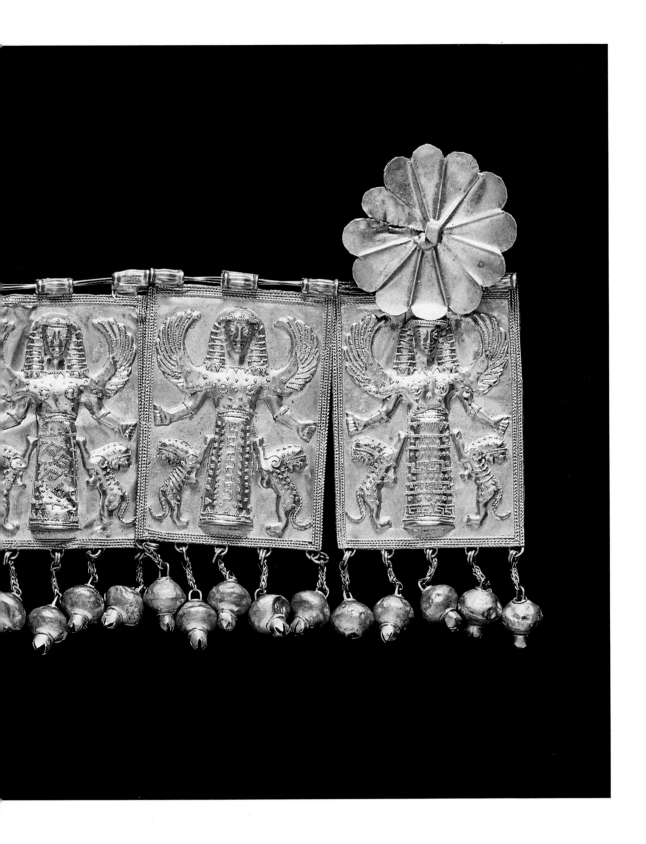

147

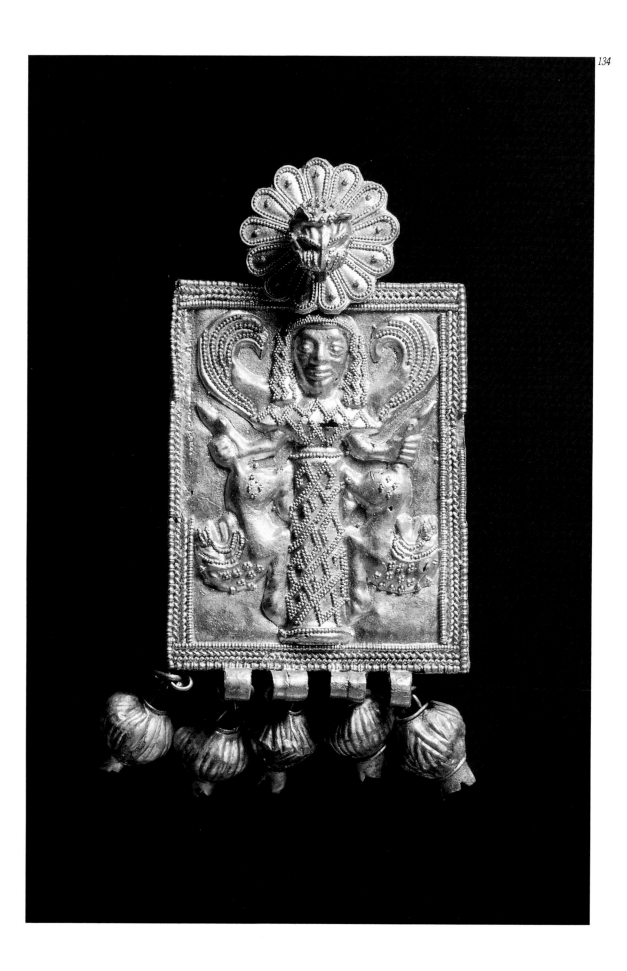

134. Necklace plaque with the Mistress of Animals, second half of 7th century BC. Berlin, Antikenmuseum.

135. Necklace with tongued plaques and wheat-grained pendants, c. 510 BC. Thessaloniki, Archaeological Museum.

135

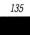

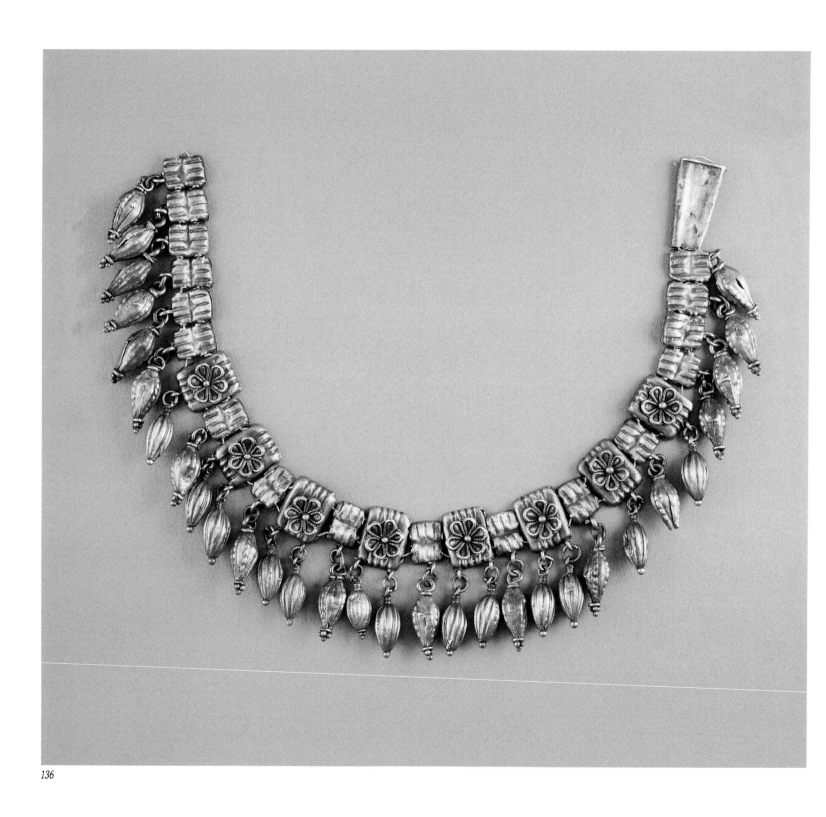

136

136. *Necklace with ribbed cylinders, decorated with rosettes,*
and vase-shaped pendants, late 5th - early 4th century BC. Oxford,
Ashmolean Museum.

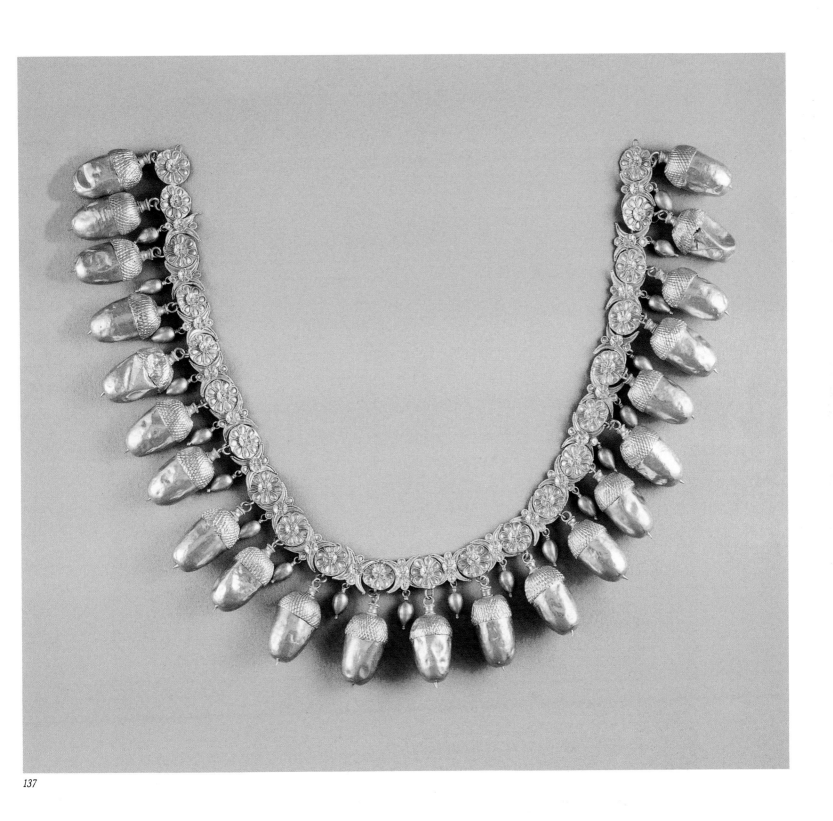

137

*137. Necklace with rosettes, lotus blossoms and acorns,
late 5th - early 4th century BC. Oxford, Ashmolean Museum.*

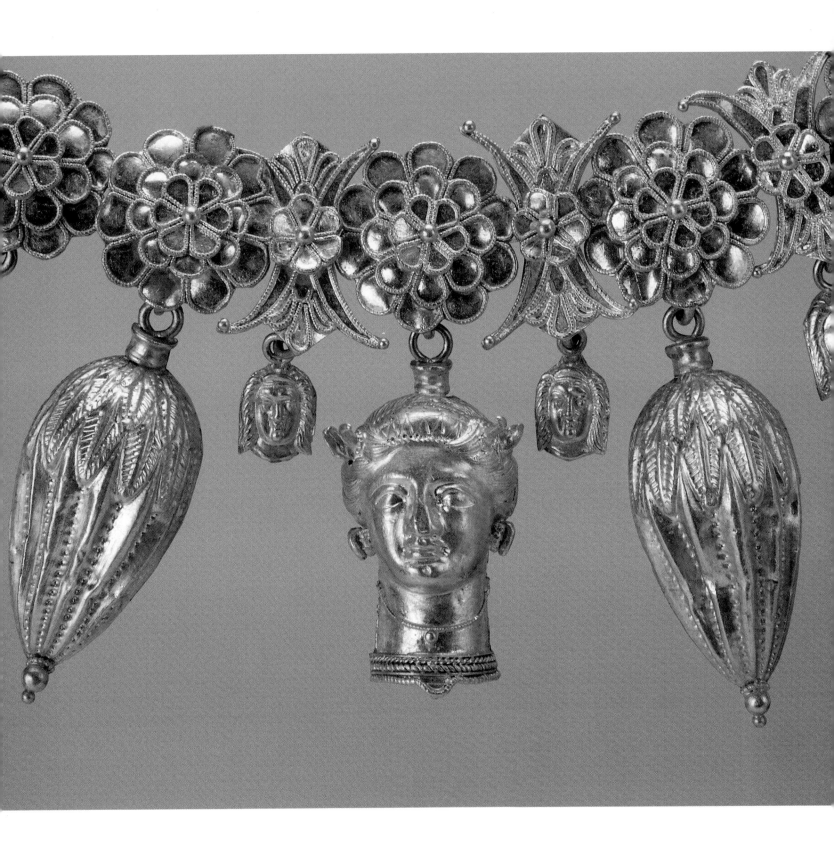

138-139. Necklace with rosettes, lotus blossoms, vase-shaped pendants and female heads, c. 350 BC. London, British Museum.

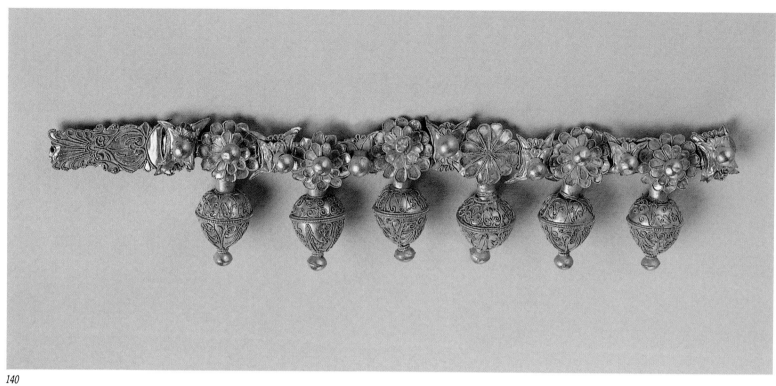

140

140. Section of a necklace with lotus blossoms, rosettes and vase-shaped
pendants, c. 330 BC. Volos, Archaeological Museum.

141. Necklace with lotus blossoms, bull head and vase-shaped pendants, last
quarter of 4th century BC. Saint Petersburg, Hermitage State Museum.

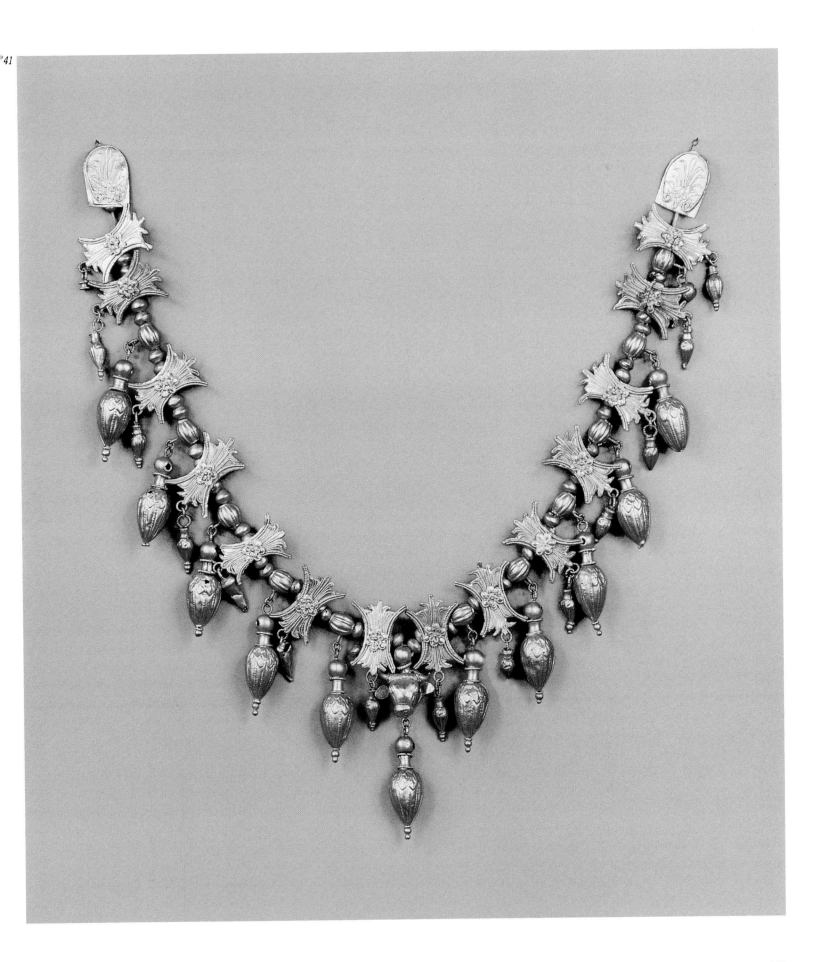

142-143. *Necklace with rosettes and double axes, late 3rd century BC (the two ornaments above the necklace are perhaps crowning finials from earrings). London, British Museum.*

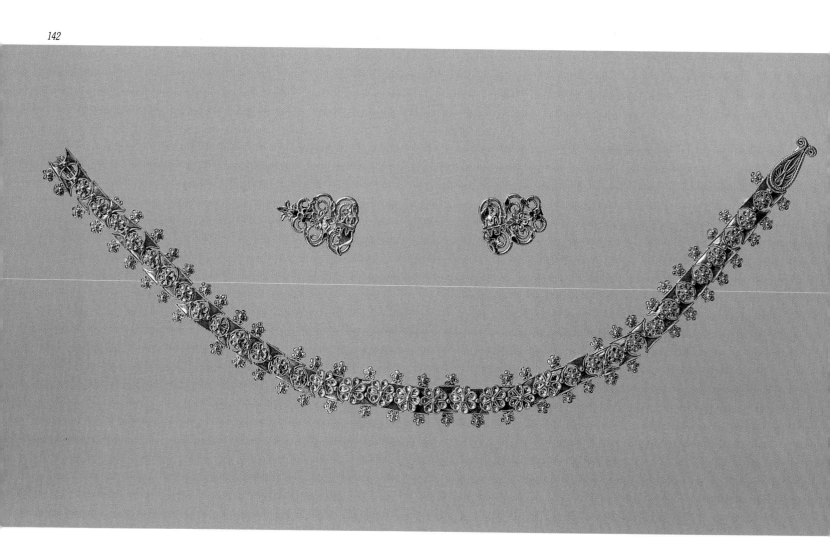

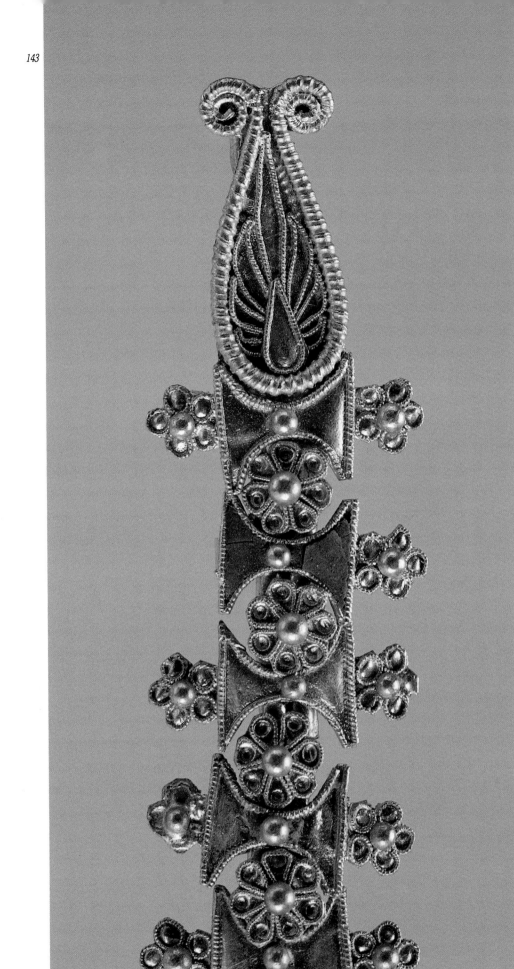

144-145. Necklace with rosettes and vase-shaped pendants,
c. 330 BC. Thessaloniki, Archaeological Museum.

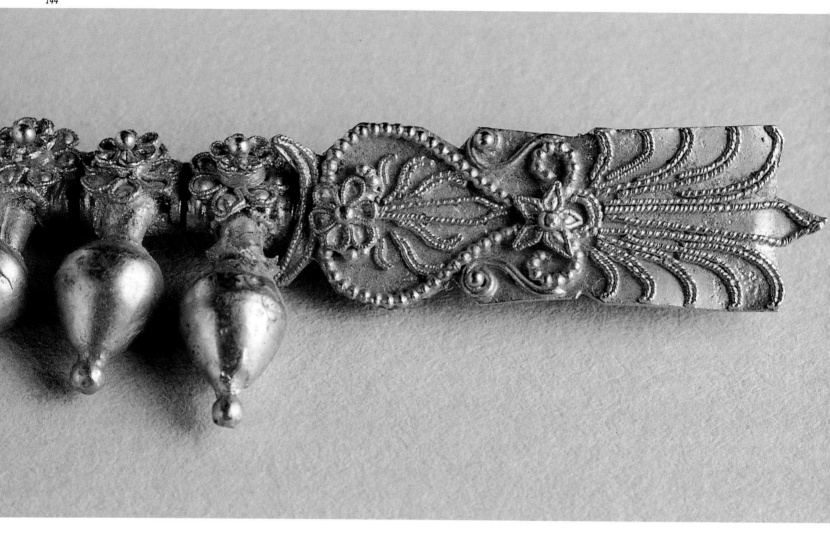

146. Necklace with chain strap and rosettes, second half
of 7th century BC. London, British Museum.

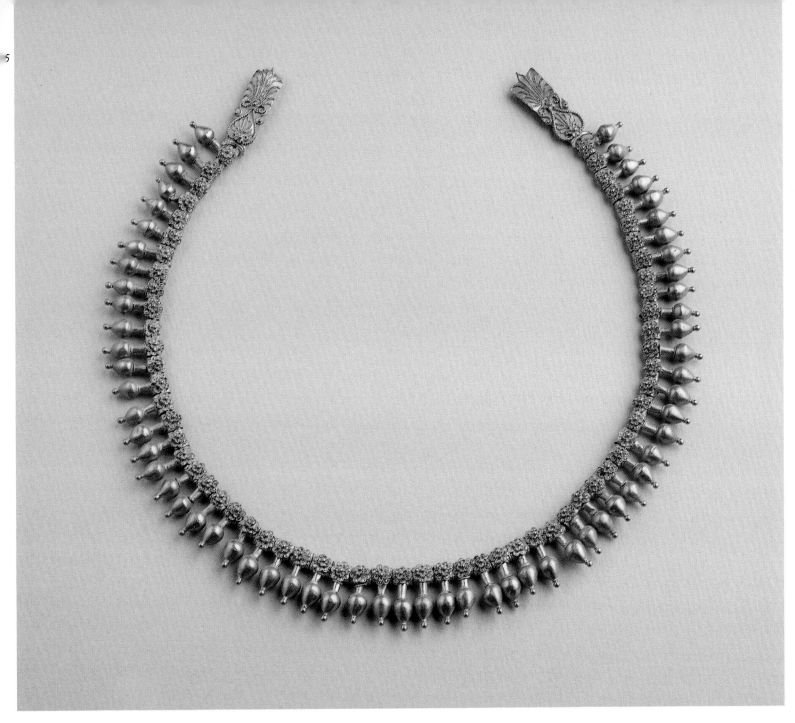

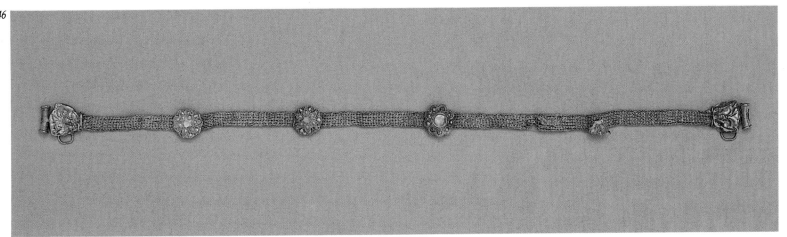

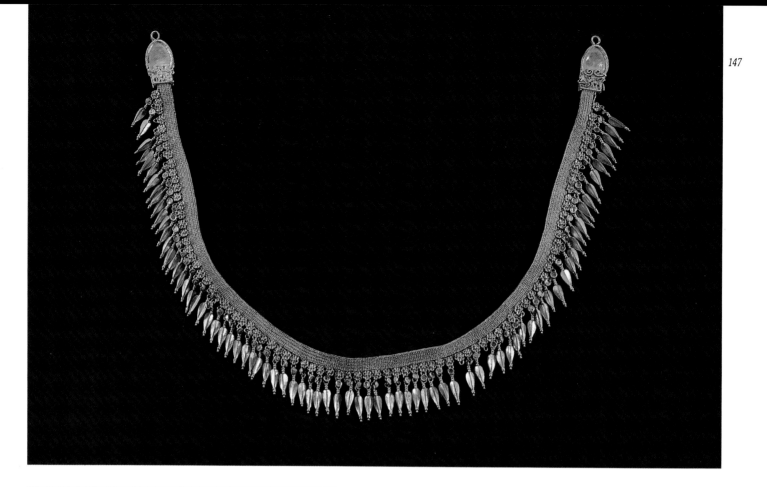

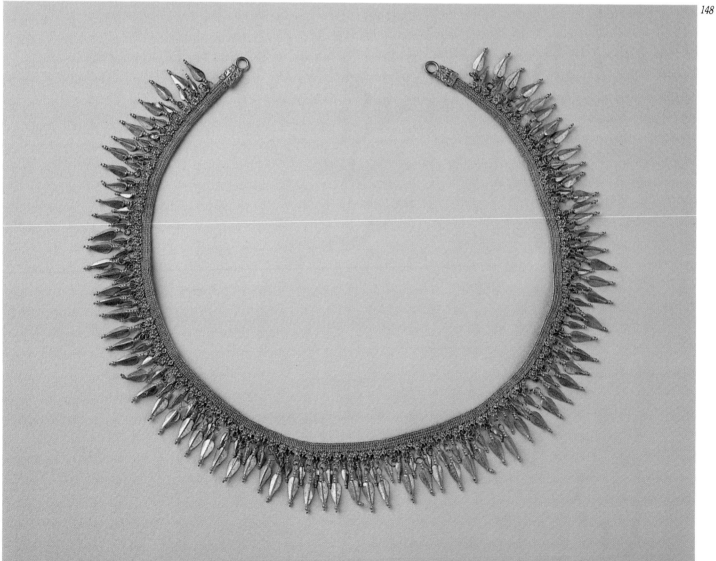

147. Necklace with chain strap and spear-heads, c. 330 BC.
Thessaloniki, Archaeological Museum.

148-149. Necklace with chain strap and spear-heads, 330-320 BC.
Athens, National Archaeological Museum.

149

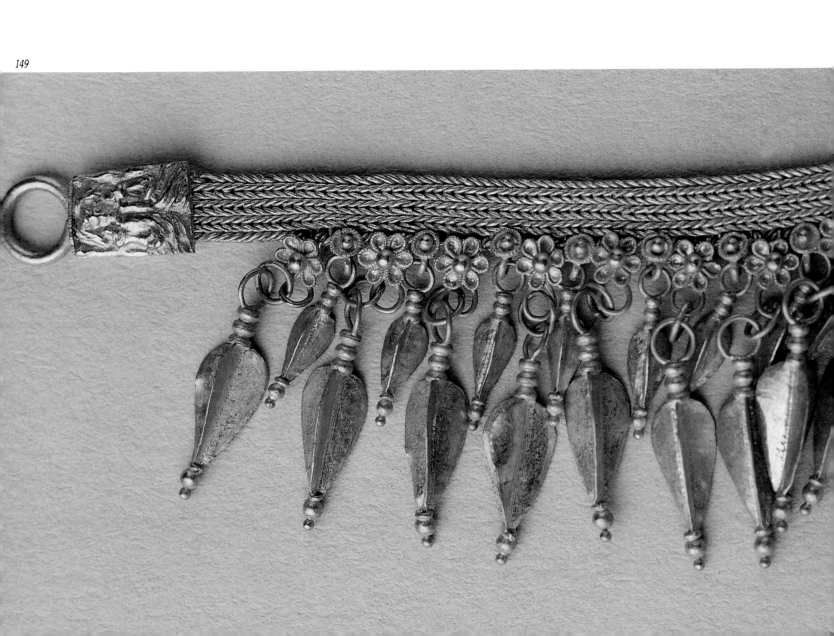

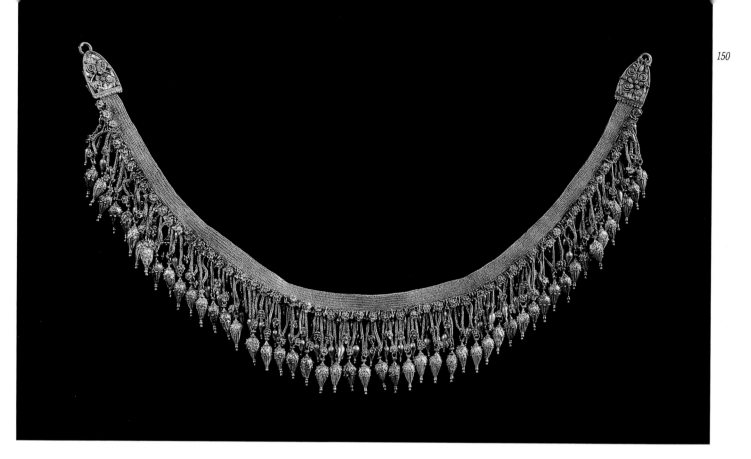

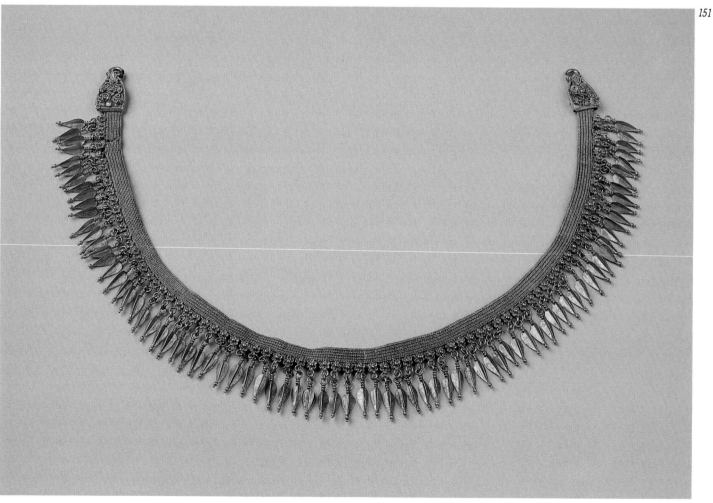

150. *Necklace with chain strap and vase-shaped pendants, last quarter of 4th century BC. Jerusalem, Israel Museum.*

151-152. *Necklace with chain strap and spear-heads, last quarter of 4th century BC. Athens, National Archaeological Museum.*

152

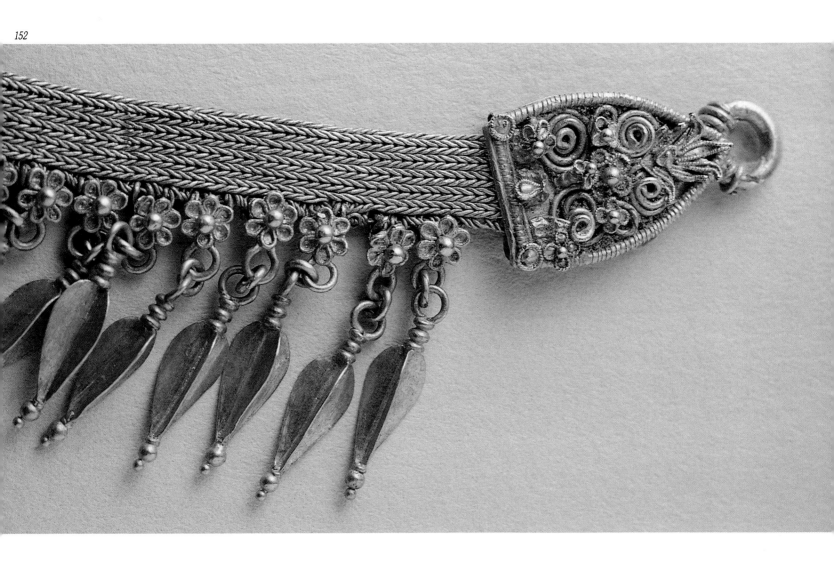

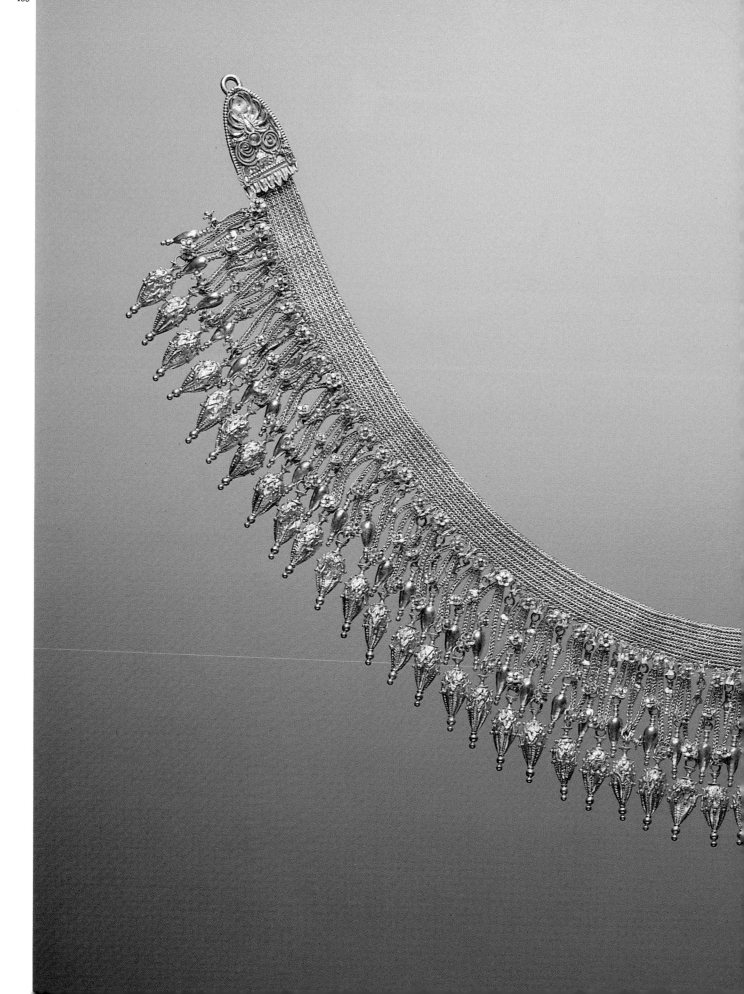

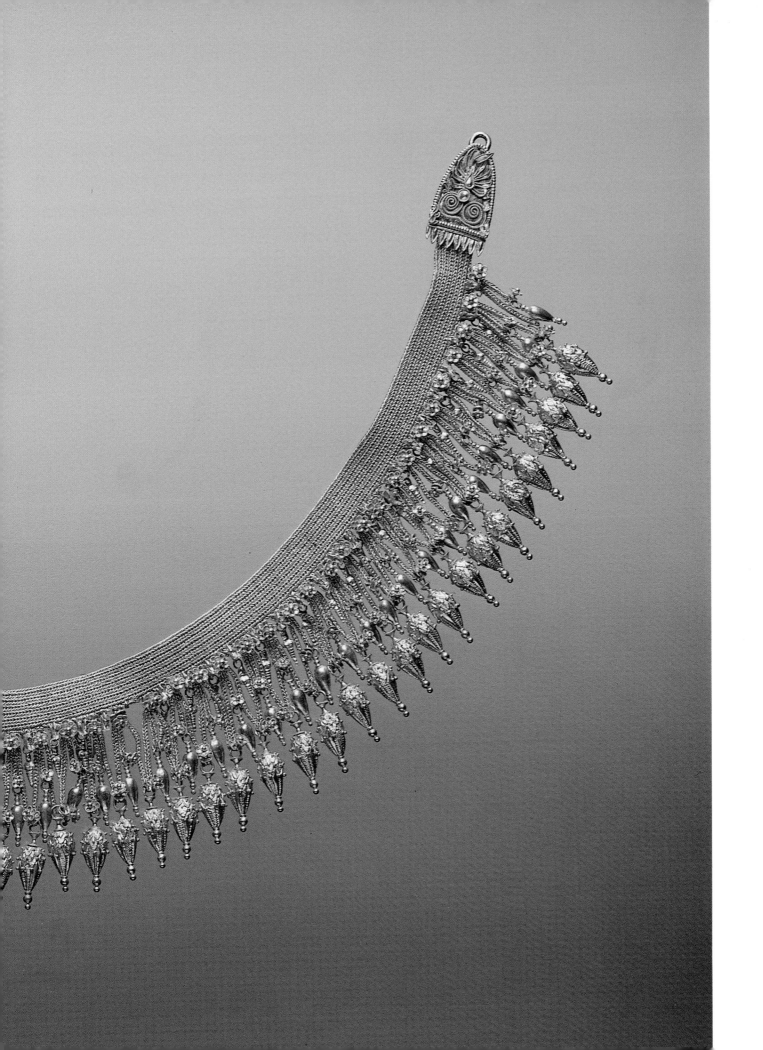

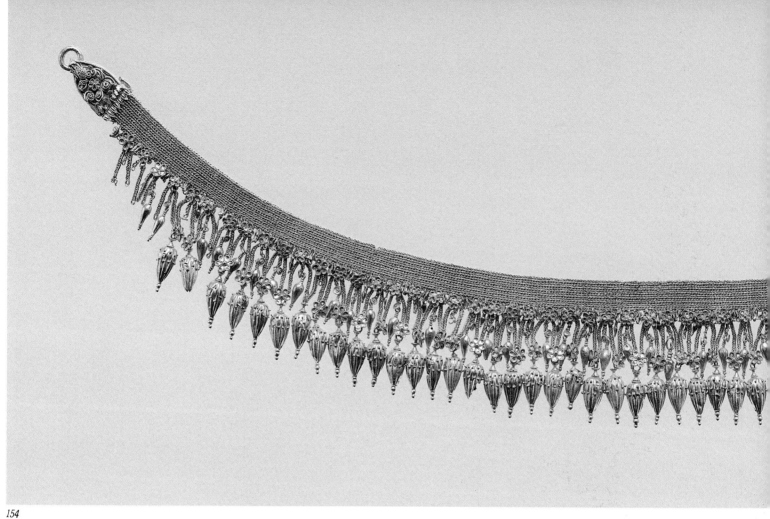

154

←

153. Necklace with chain strap and vase-shaped pendants, last quarter of 4th century BC. Saint Petersburg, Hermitage State Museum.

154. Necklace with chain strap and vase-shaped pendants, last quarter of 4th century BC. New York, Metropolitan Museum of Art.

155-156. Necklace with chain strap, vase-shaped pendants and garnets, early 2nd century BC. Athens, Benaki Museum.

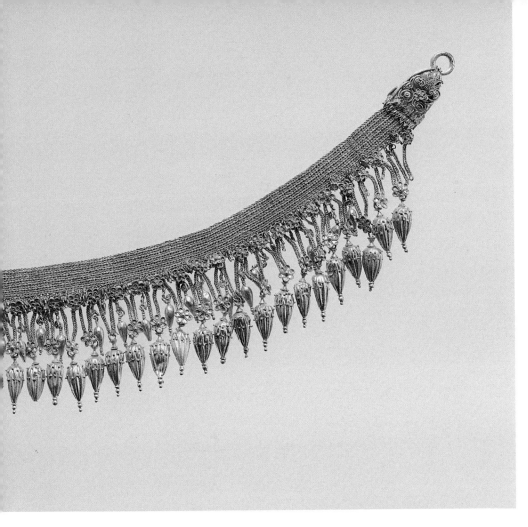

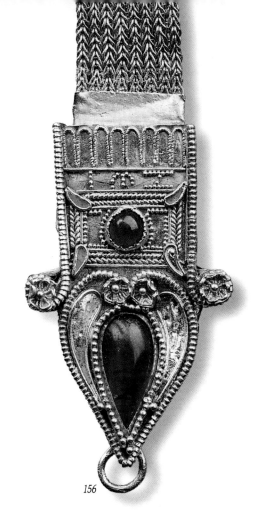

156

155

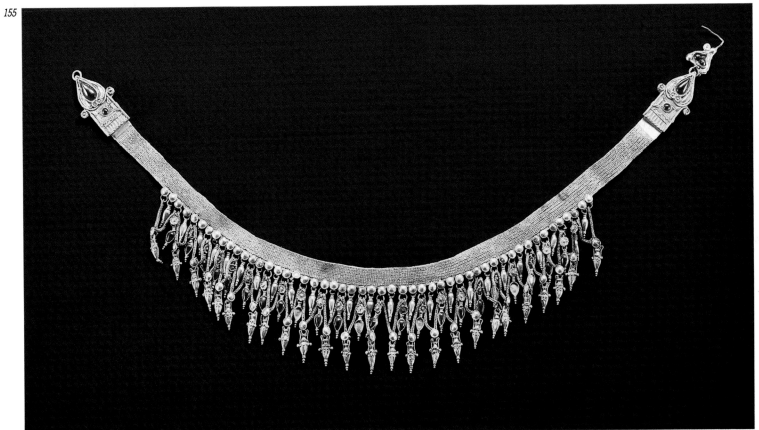

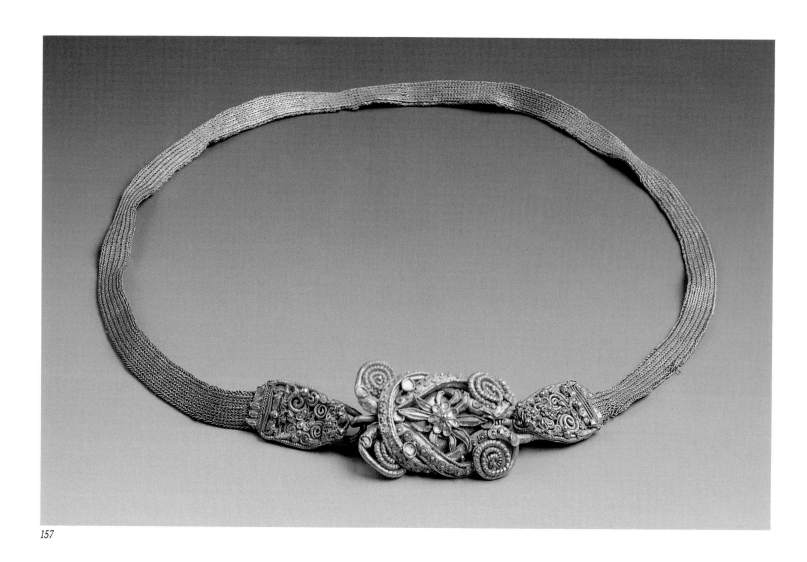

157

157. Necklace with chain strap and Herakles knot, late 4th - early 3rd century BC.
Saint Petersburg, Hermitage State Museum.

158-159. Necklace with two chain straps and Herakles knot, early 3rd century BC.
Saint Petersburg, Hermitage State Museum.

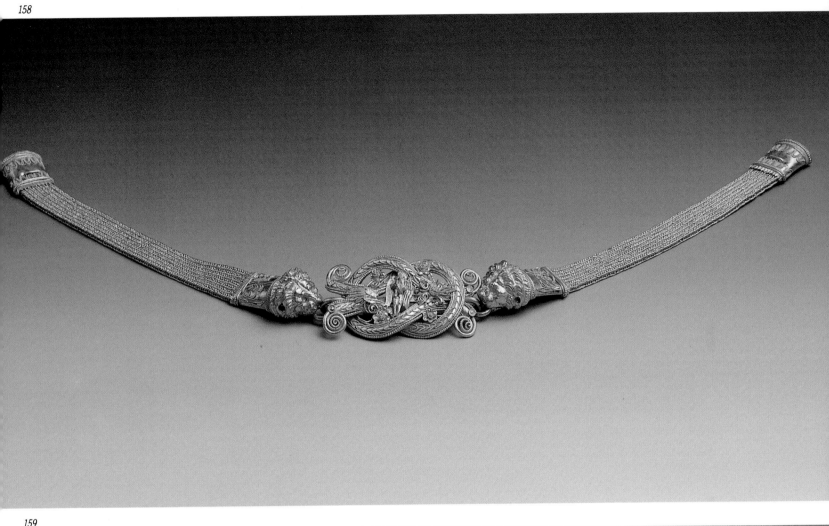

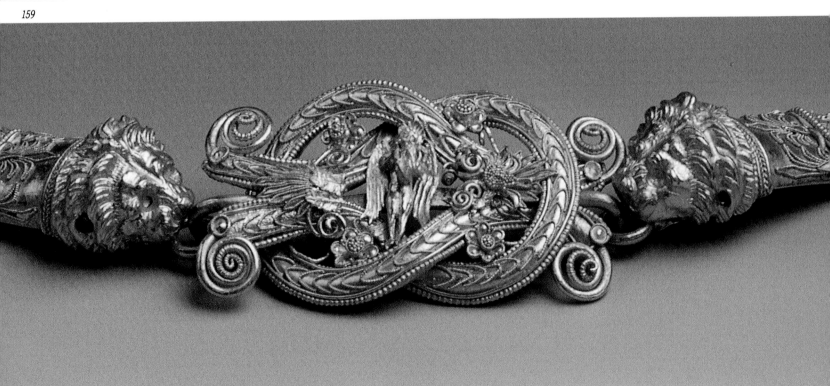

160. Necklace with two chain straps and Herakles knot, late 4th - early 3rd century BC.
Berlin, Antikenmuseum.

161. Chain necklace with bifurcate terminals and four snake heads, c. 510 BC.
Thessaloniki, Archaeological Museum.

160

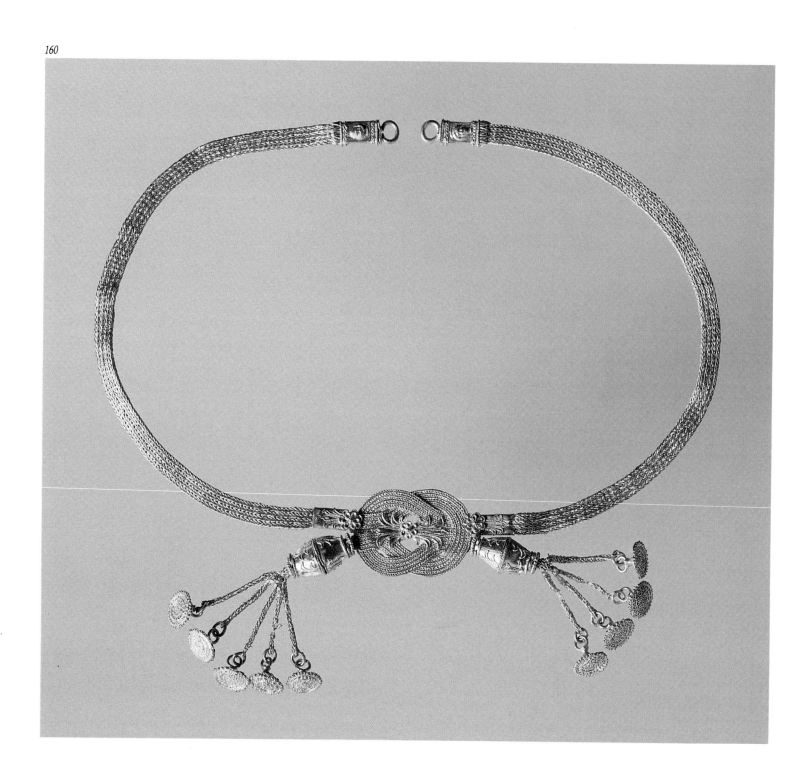

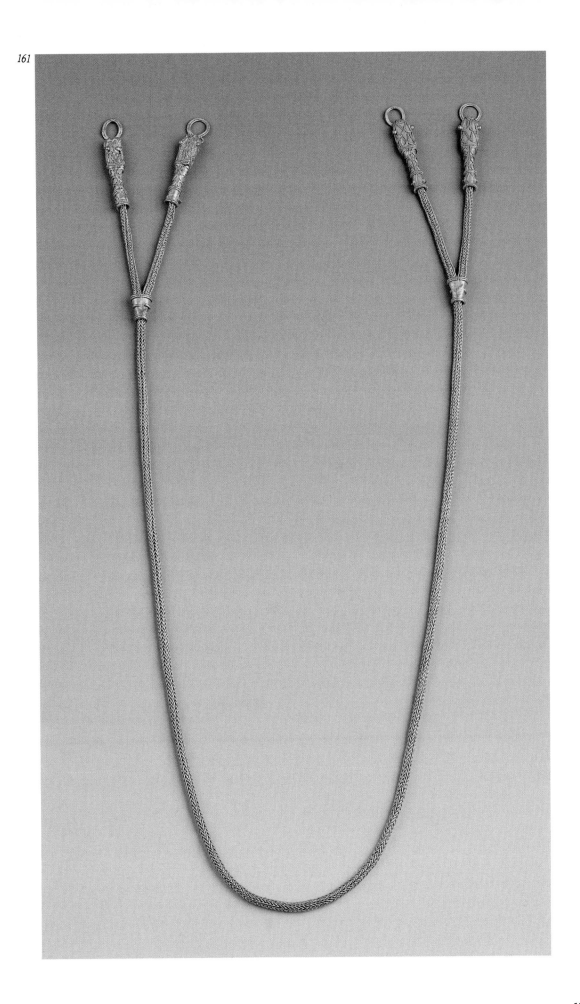

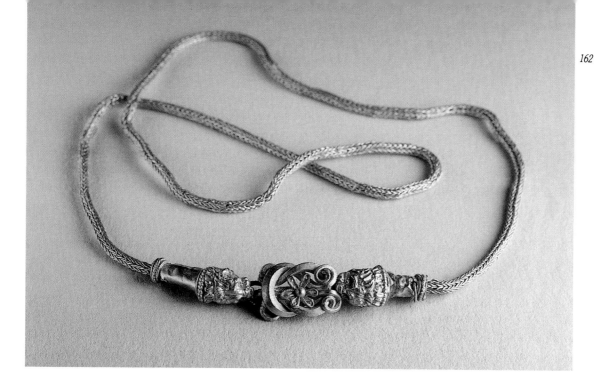

162

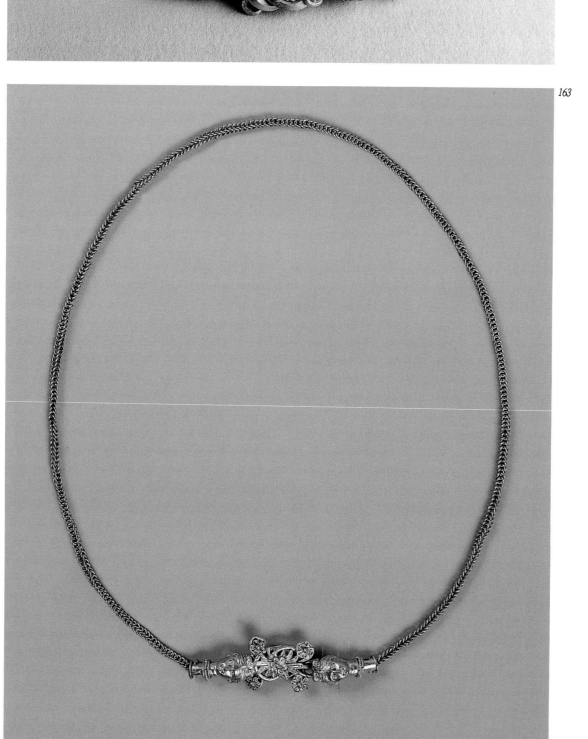

163

172

162. Chain necklace with Herakles knot and two lion heads, last quarter of 4th century BC. Amphipolis, Archaeological Museum.

163-164. Chain necklace with Herakles knot and two female heads, late 4th - early 3rd century BC. Komotini, Archaeological Museum.

164

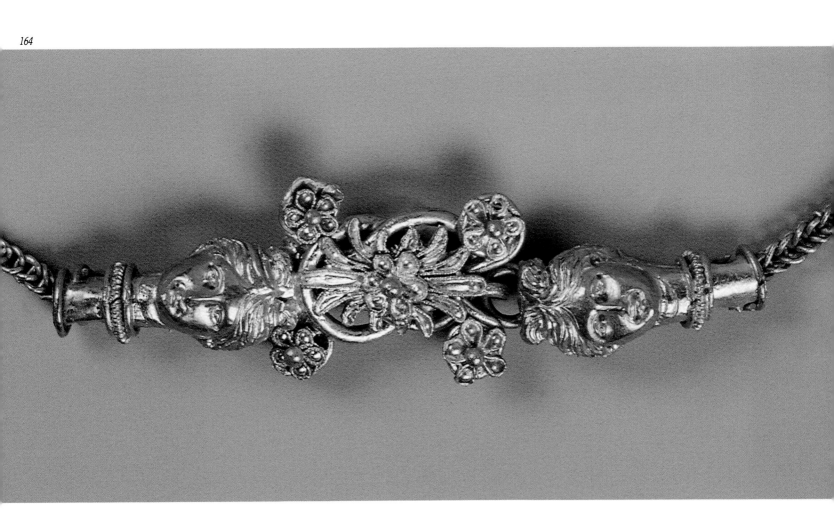

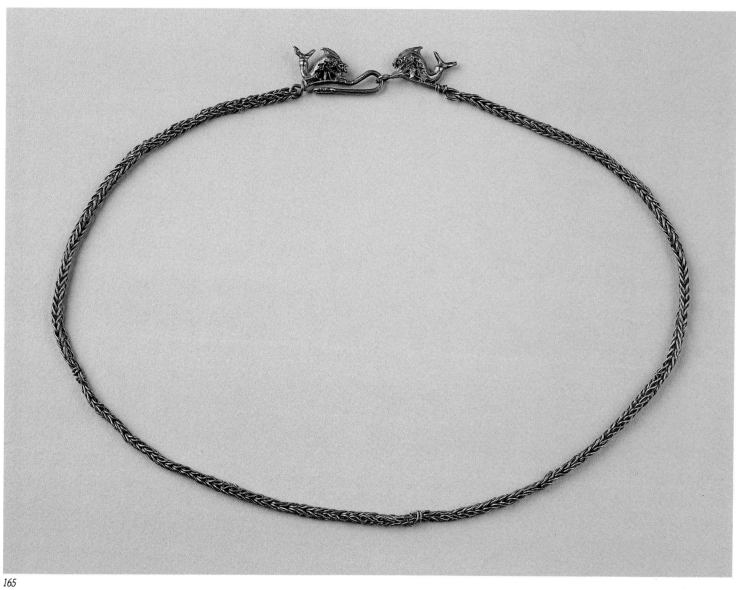

165

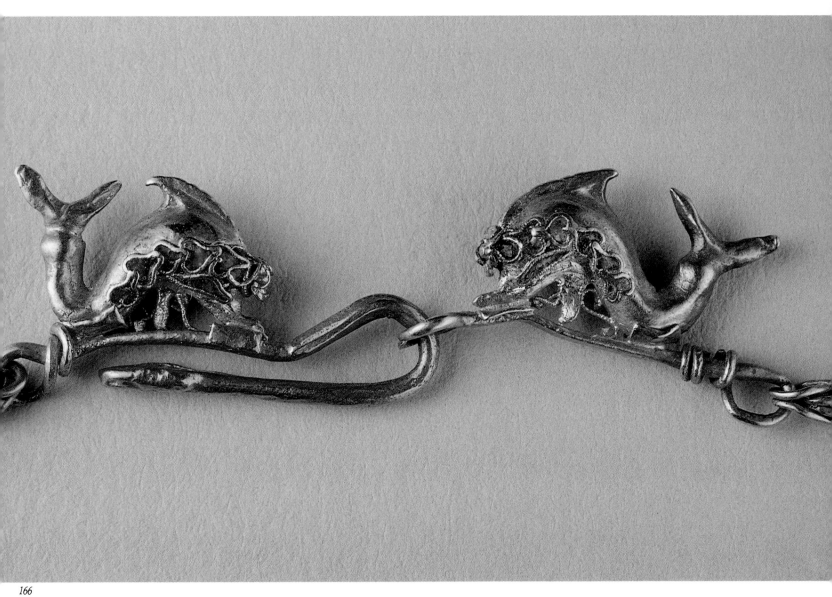

166

*165-166. Chain necklace with two dolphins, late 2nd century BC.
Athens, National Archaeological Museum.*

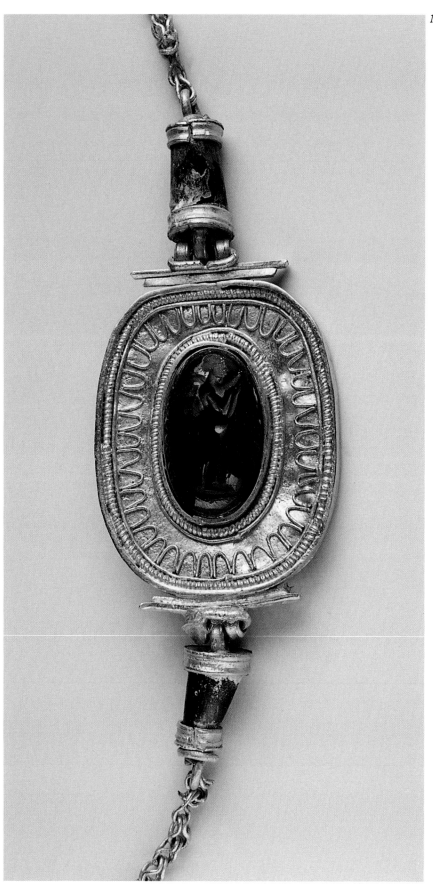

167. Chain necklace with gold-mounted medallion, early 2nd century BC. Thessaloniki, Archaeological Museum.

168. Necklace with two chains, bezel-set stones and lynx heads, second half of 2nd century BC. Saint Petersburg, Hermitage State Museum.

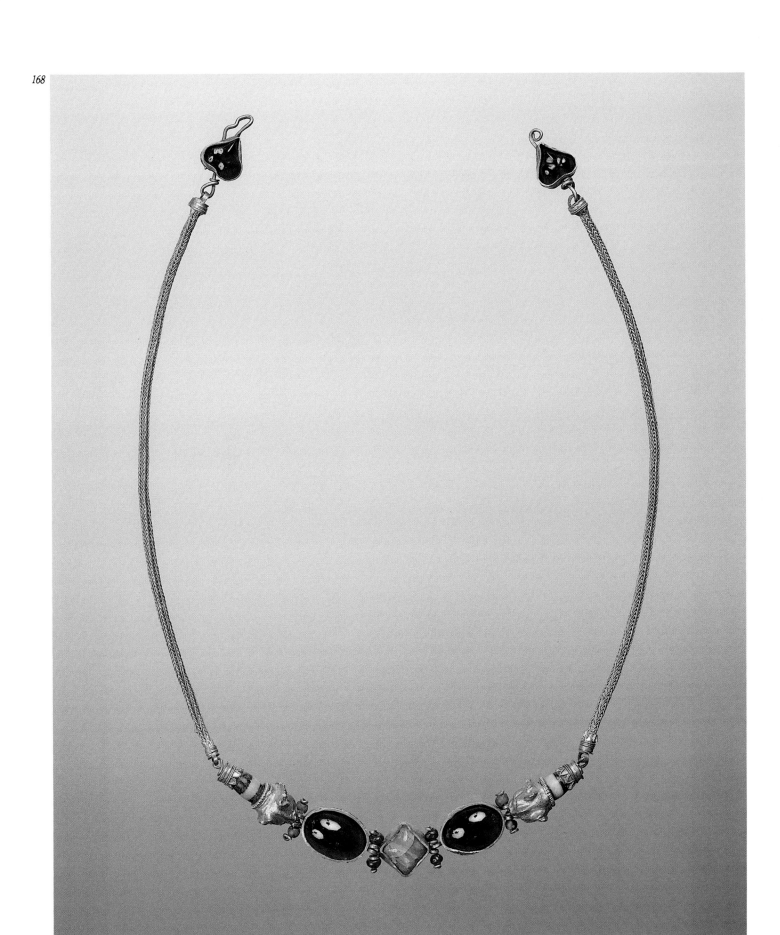

169. Pair of pins with pelicans, c. 800 BC. Herakleion,
Archaeological Museum.

170. Pair of pins with disc head, early 7th century BC. Herakleion,
N. Metaxas Collection.

171. Pair of silver pins with gold disc finial, c. 510-500 BC.
Thessaloniki, Archaeological Museum.

169

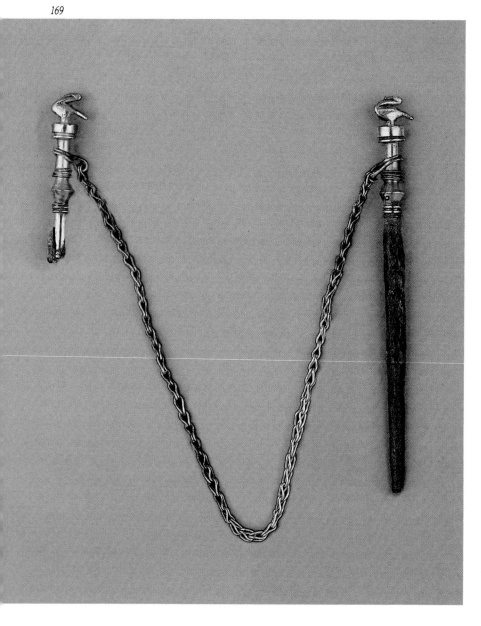

170

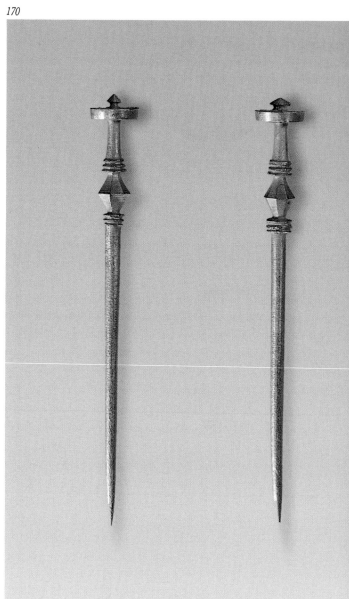

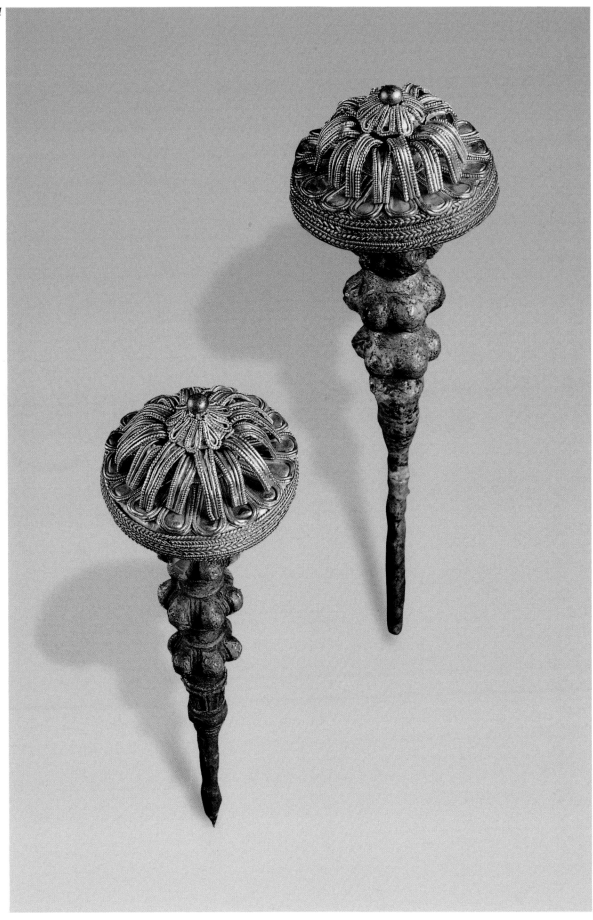

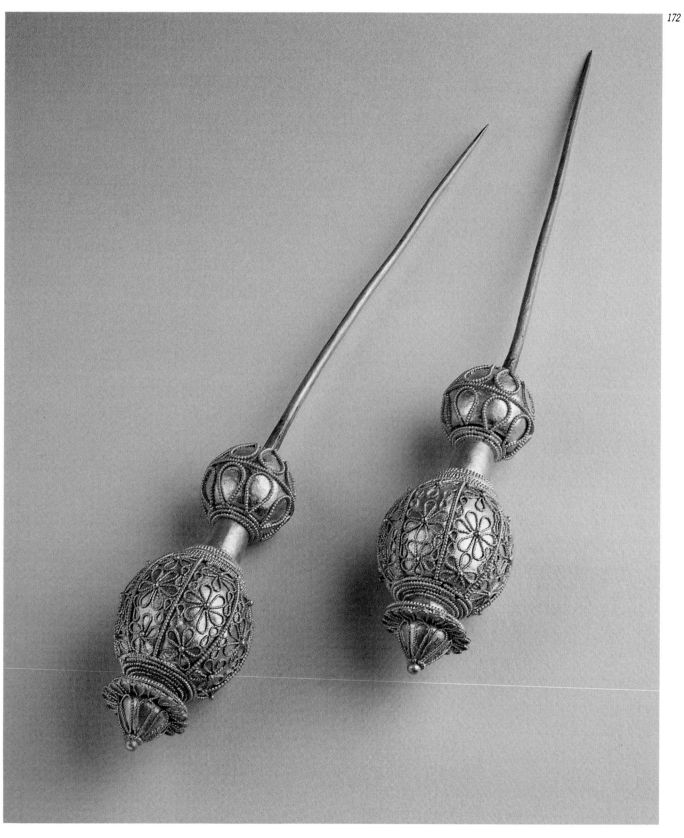

172. Pair of pins with two globular beads and disc finial, c. 560 BC.
Thessaloniki, Archaeological Museum.

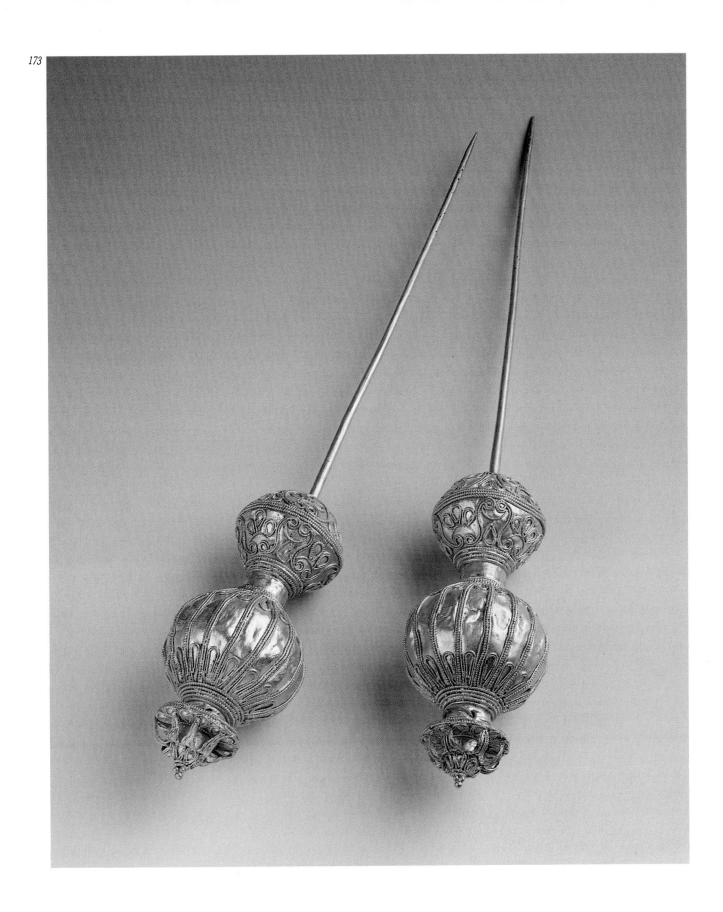

173. Pair of pins with two globular beads and disc finial, c. 510 BC.
Thessaloniki, Archaeological Museum.

174. *Pin with pomegranate head, 7th century BC.*
London, British Museum.

175. *Pin with poppy-capsule head, late*
7th century BC. Delos, Archaeological Museum.

176. *Pin with half-naked Aphrodite, 2nd century BC.*
London, British Museum.

177. Pin with tassel pendant, second half of 2nd century BC. Saint Petersburg, Hermitage State Museum.

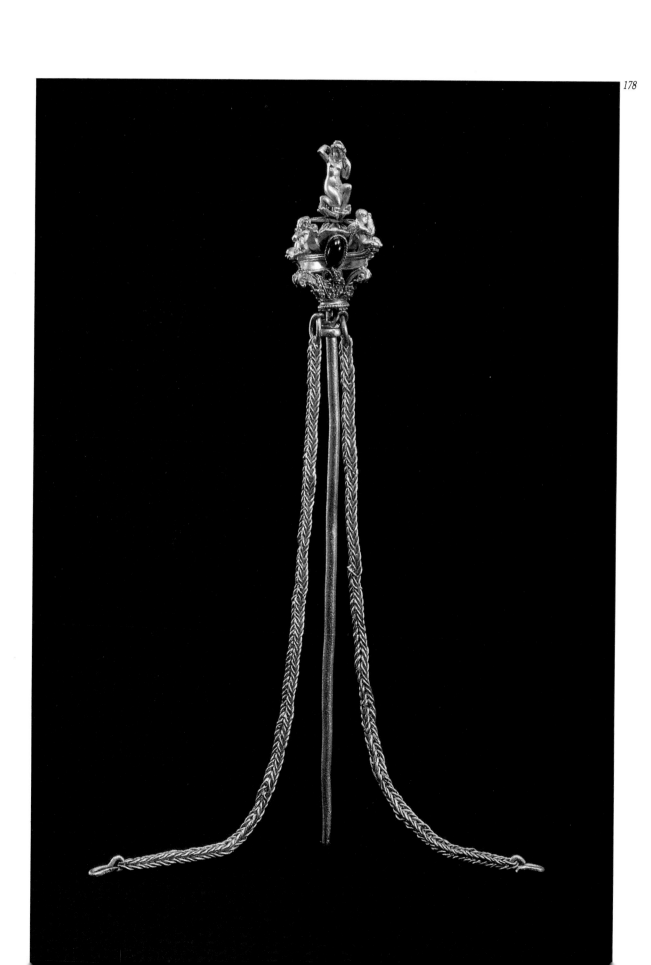

179

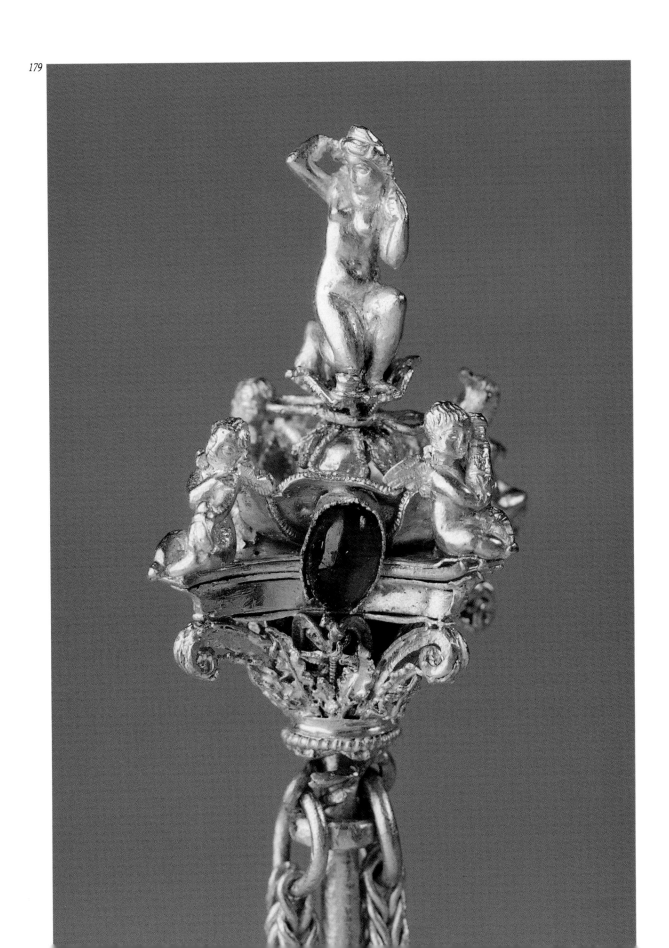

180. Fibula with leaf-shaped arch, c. 850 BC. Berlin, Antikenmuseum.

181. Two fibulae with representations on the catch-plate, c. 775-750 BC. London, British Museum.

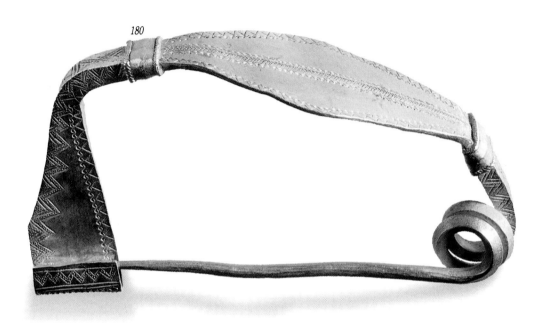

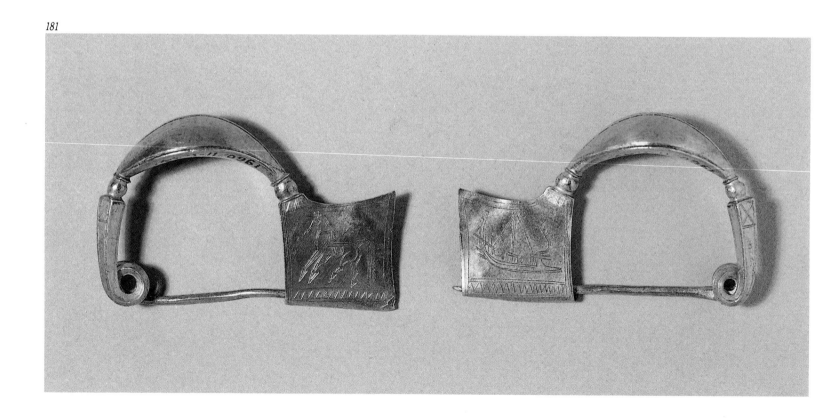

182. *Two arched fibulae with cylindrical beads, c. 510 BC. Thessaloniki, Archaeological Museum.*

183. *Two arched fibulae with Pegasos and lionskin, c. 330 BC. Thessaloniki, Archaeological Museum.*

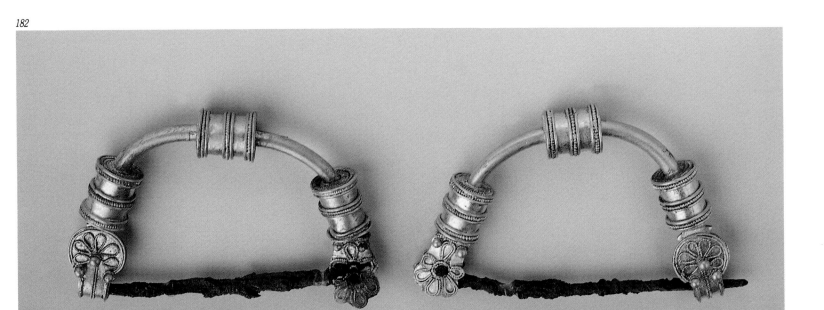

182

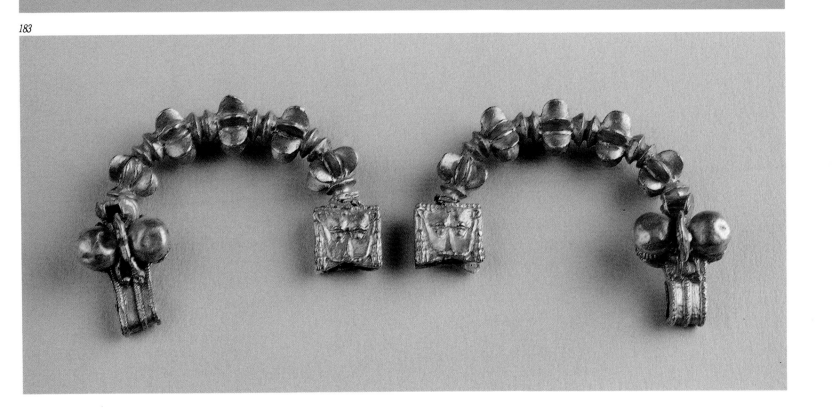

183

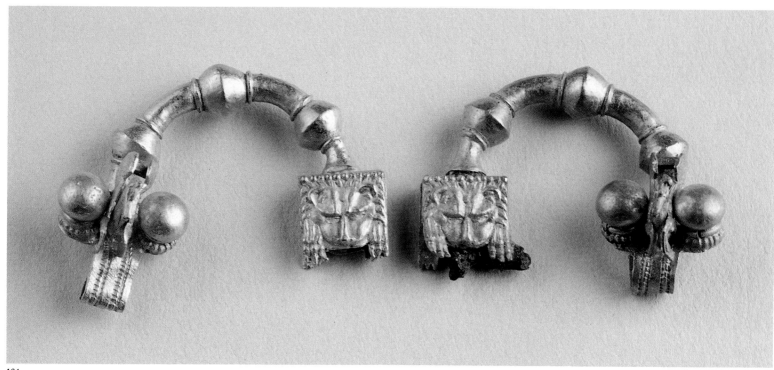

184

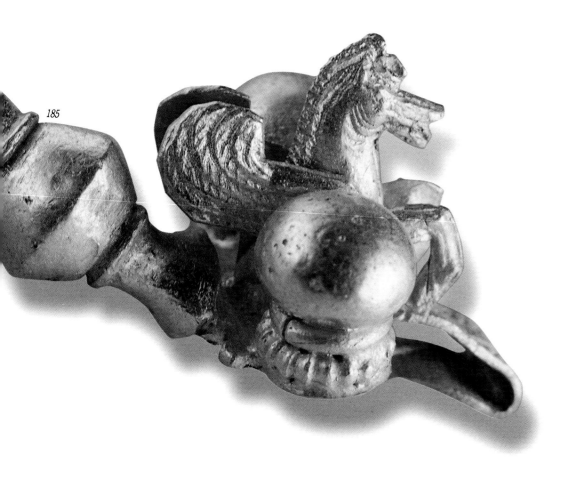

185

184-185. Two arched fibulae with Pegasos and lionskin, third quarter of 4th century BC. Thessaloniki, Archaeological Museum.

186. Arched fibula with horse protome, griffin and head of Herakles (back view), last quarter of 4th century BC. Berlin, Antikenmuseum.

187. Arched fibula with sphinx and head of Herakles (back view), last quarter of 4th century BC. Berlin, Antikenmuseum.

188. Fibula in the form of a hawk, second half of 7th century BC. Berlin, Antikenmuseum.

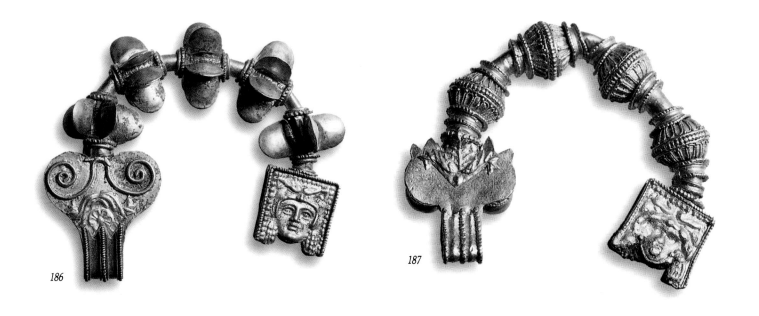

186

187

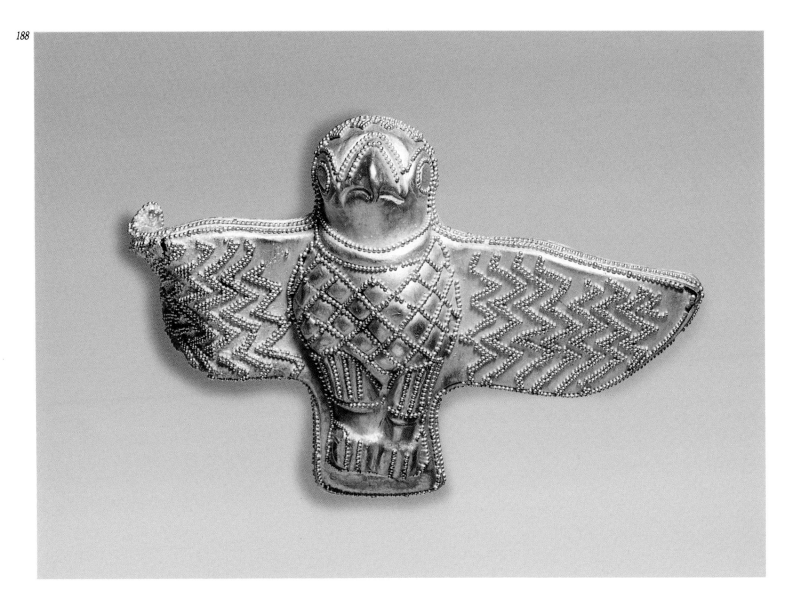

188

189

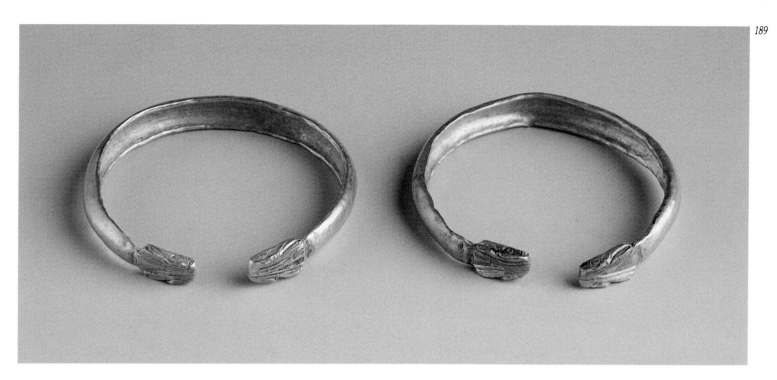

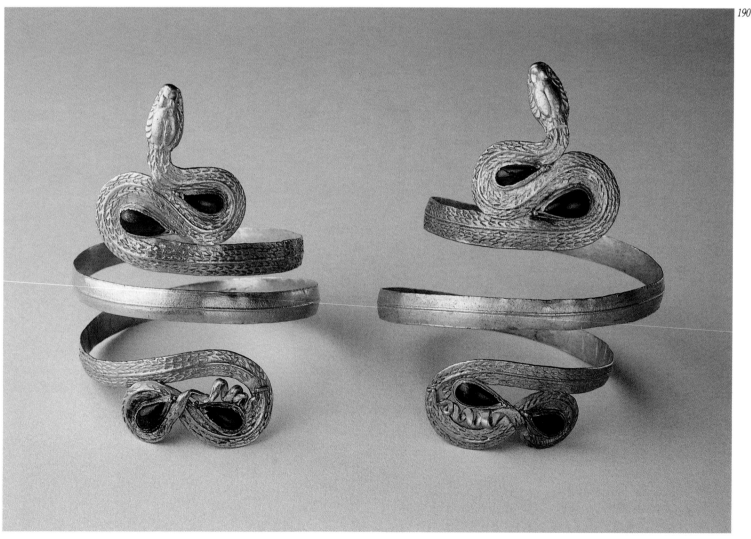

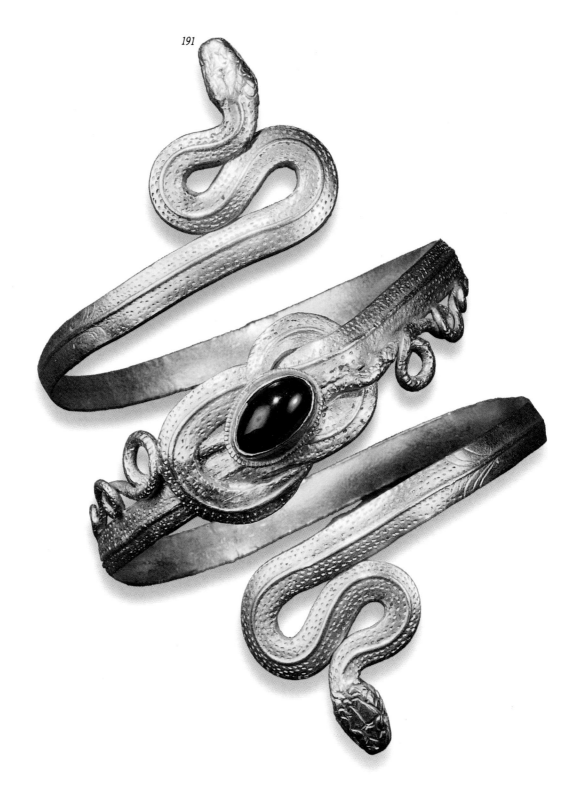

189. *Bracelets with snake-head terminals, 470-460 BC. Thessaloniki, Archaeological Museum.*

190. *Snake bracelets, late 3rd - early 2nd century BC. Athens, National Archaeological Museum.*

191. *Bracelet in the form of intertwined snakes, first half of 2nd century BC. Pforzheim, Schmuckmuseum.*

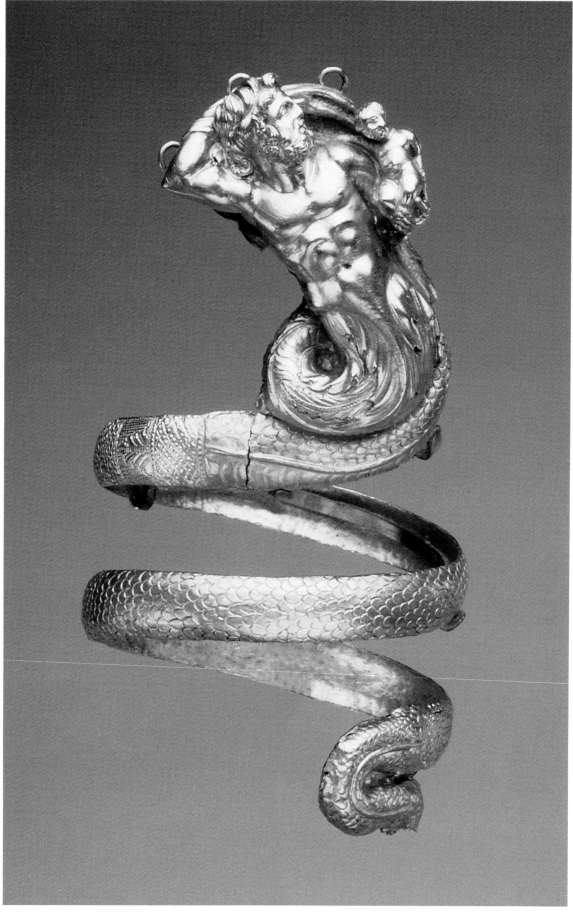

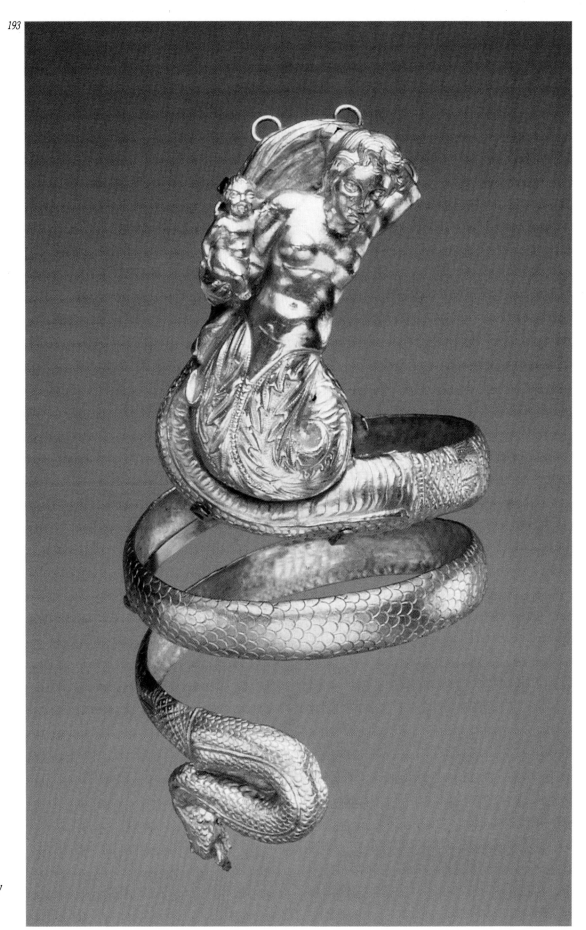

192-193. Bracelets in the form of a Triton and a Tritoness, early 2nd century BC. New York, Metropolitan Museum of Art.

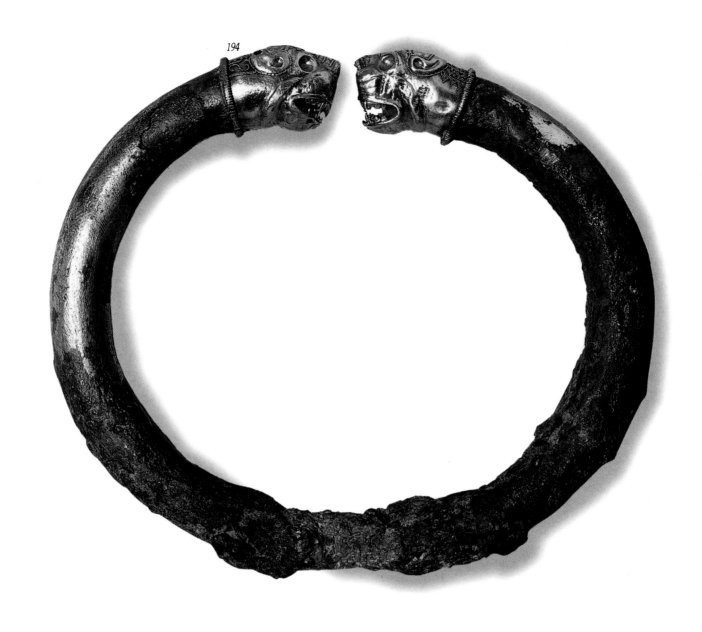

194. Bracelet with lion-head terminals, late 7th - early 6th century BC.
London, British Museum.

195-196. Bracelets with ram-head terminals, third quarter of 5th century BC.
London, British Museum.

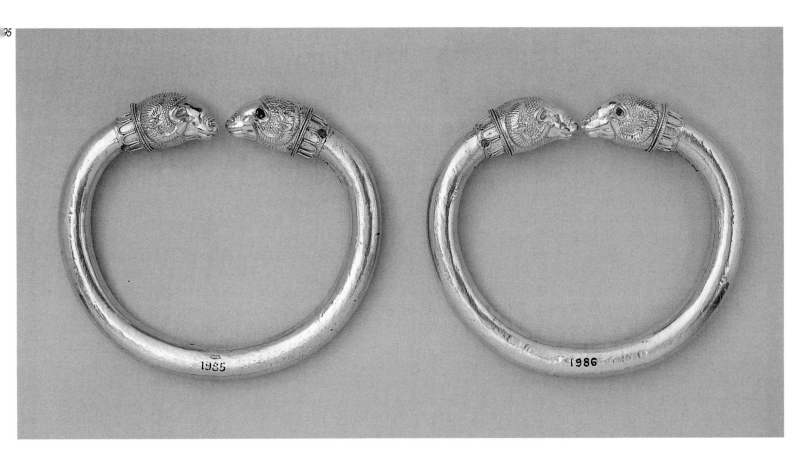

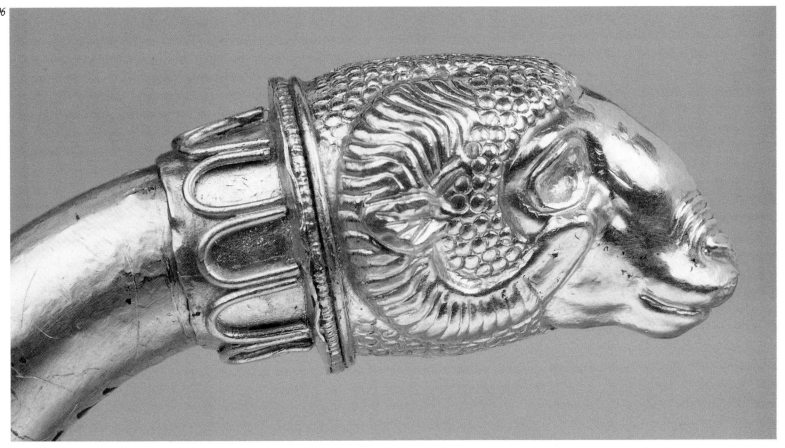

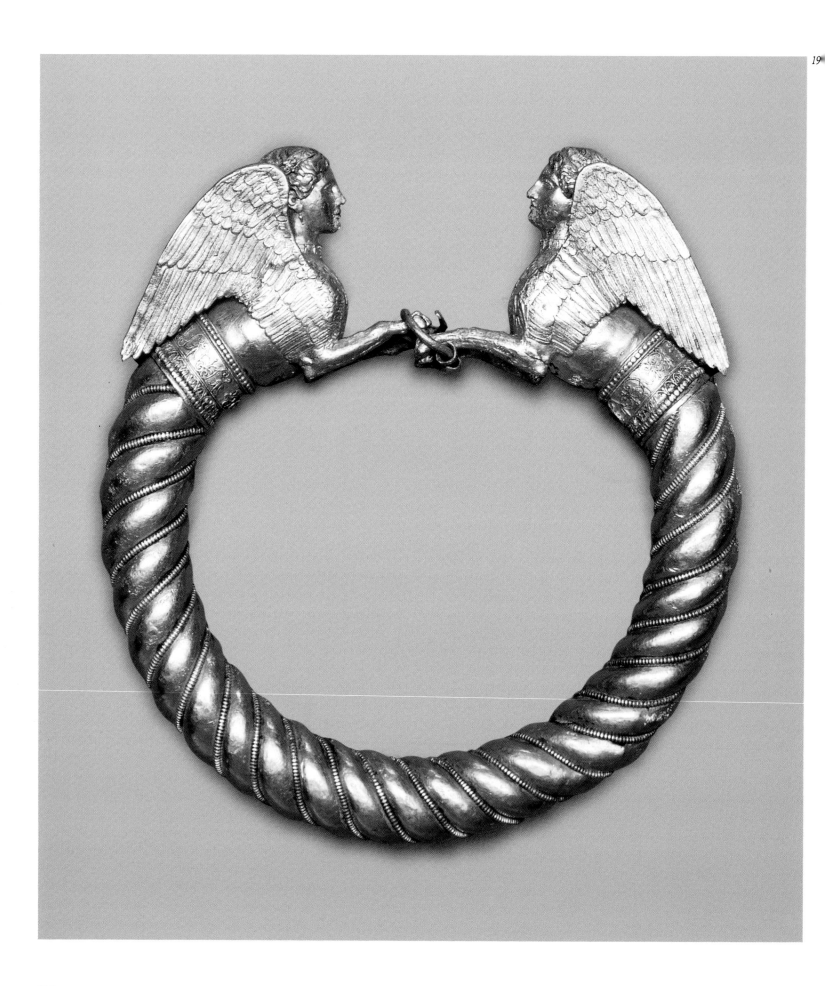

197. Bracelet with sphinx terminals, c. mid-4th century BC.
Saint Petersburg, Hermitage State Museum.

198. Rock crystal bracelets with gold ram-head terminals, last quarter
of 4th century BC. New York, Metropolitan Museum of Art.

198

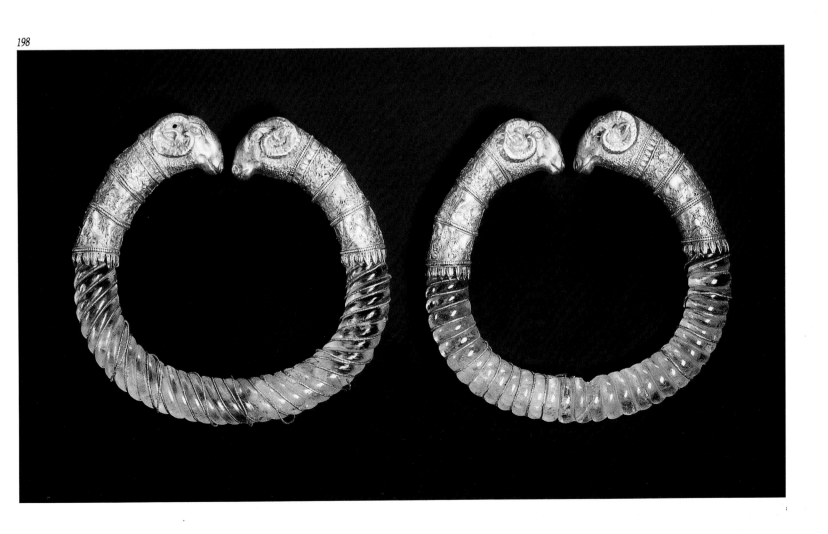

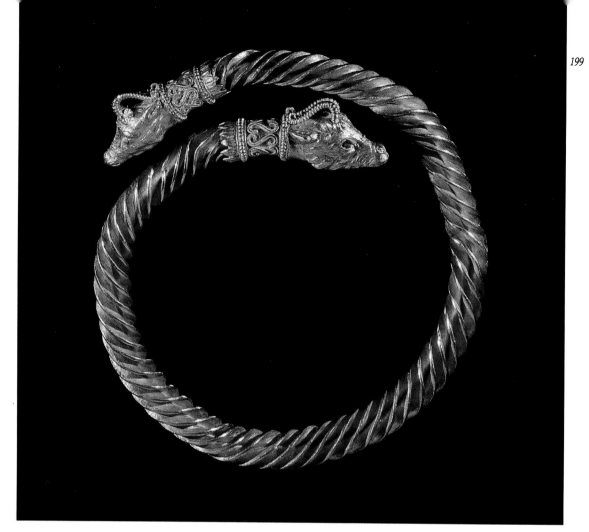

199

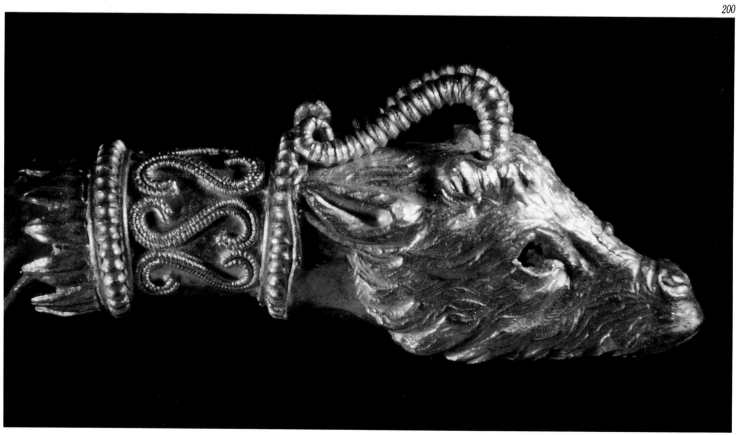

200

199-200. Bracelet with caprine-head terminals, early 3rd century BC.
Taranto, Museo Archeologico Nazionale.

201. Bracelets with horned lynx-head terminals, early 2nd century BC.
Thessaloniki, Archaeological Museum.

201

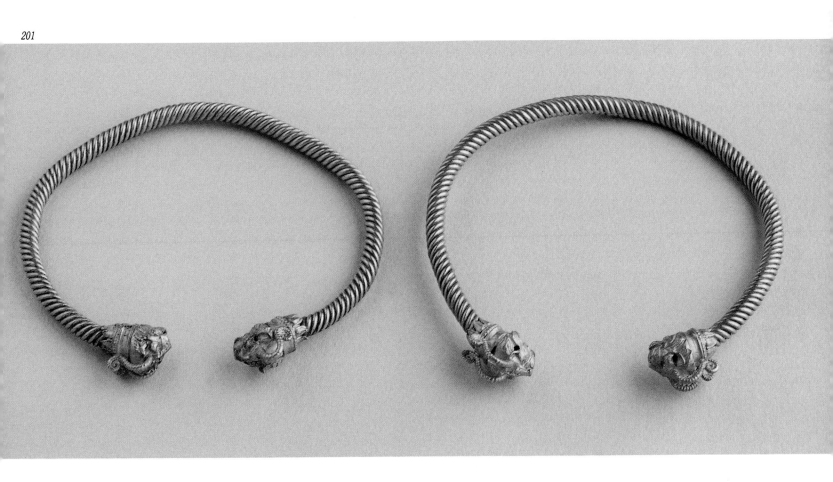

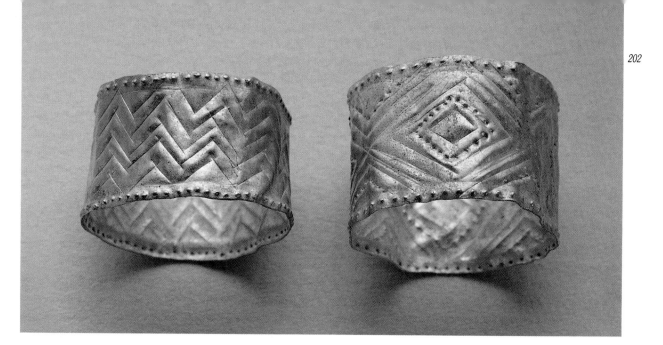

202

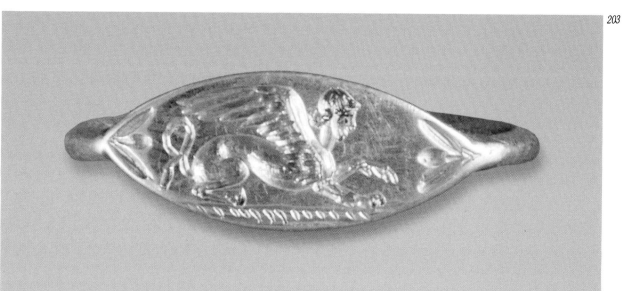

203

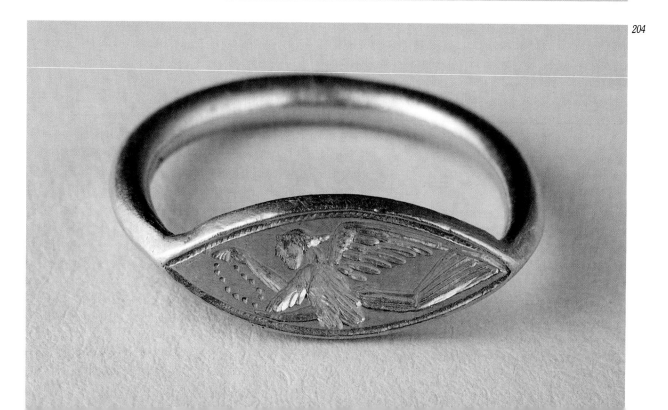

204

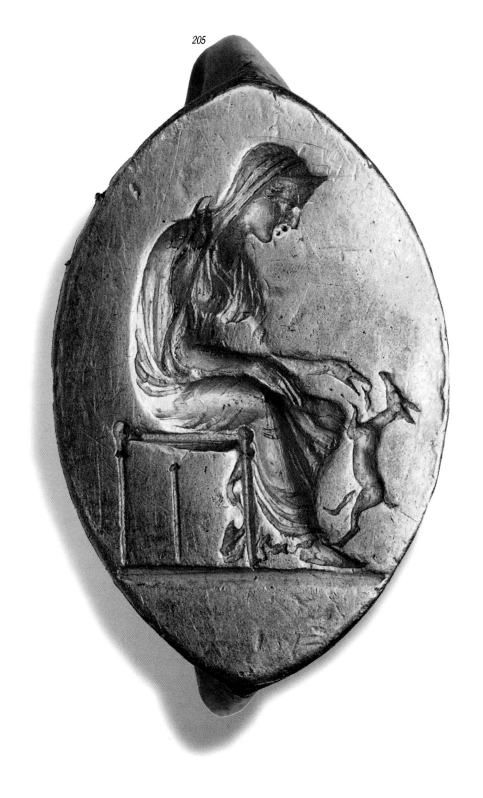

205

202. *Two band finger rings, c. 850 BC. Athens, Museum of the Ancient Agora.*

203. *Finger ring with sphinx, second quarter of 5th century BC. Oxford, Ashmolean Museum.*

204. *Finger ring with flying Nike, second quarter of 5th century BC. Athens, National Archaeological Museum.*

205. *Finger ring with seated female figure, last quarter of 5th century BC. Saint Petersburg, Hermitage State Museum.*

206. Finger ring with Aphrodite and Eros, first quarter of 4th century BC.
Saint Petersburg, Hermitage State Museum.

206

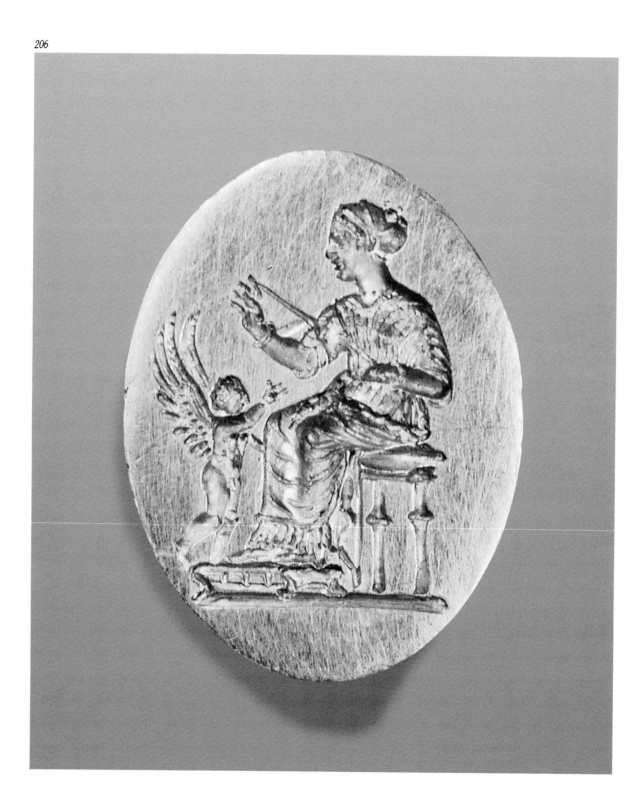

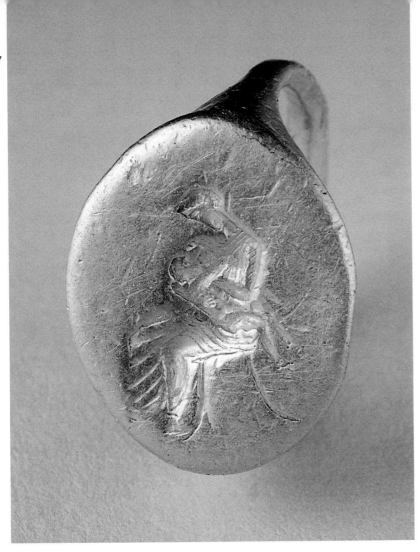

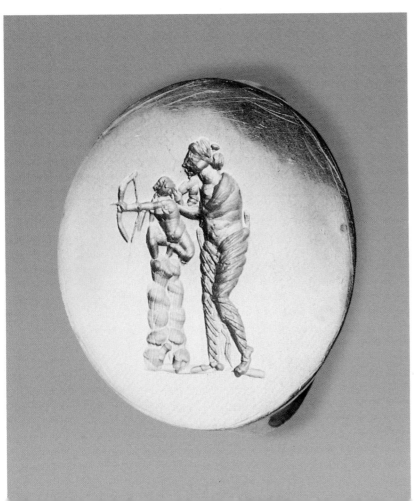

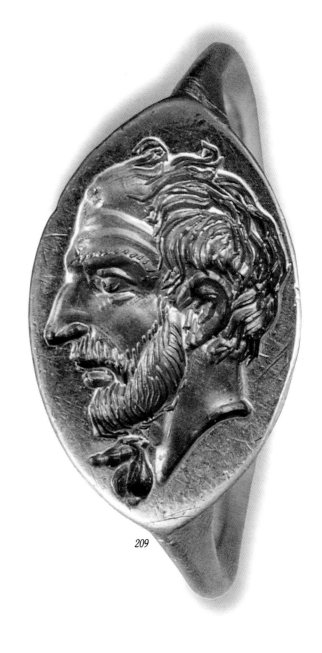

207. Finger ring with Kourotrophos, third quarter of 4th century BC. Thessaloniki, Archaeological Museum.

208. Finger ring with Aphrodite and Eros, last third of 4th century BC. Berlin, Antikenmuseum.

209. Finger ring with bearded head, last quarter of 5th century BC. Berlin, Antikenmuseum.

209

210. Gold hoop supporting a sealstone with a flying heron, engraved by Dexamenos of Chios, third quarter of 5th century BC. Saint Petersburg, Hermitage State Museum.

211-212. Finger ring with circular bezel, bearing a griffin on one face and a rosette on the other, early 5th century BC. London, British Museum.

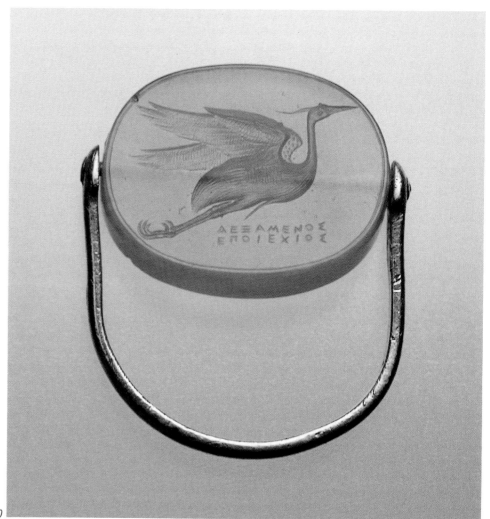

210

211

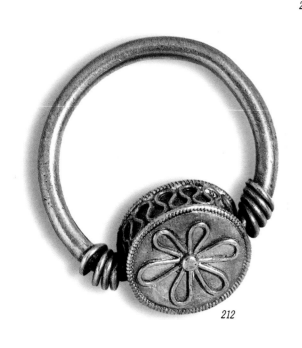

212

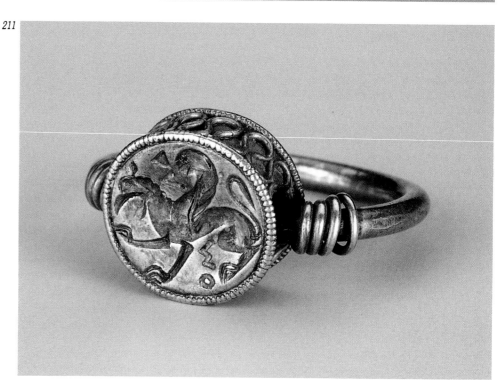

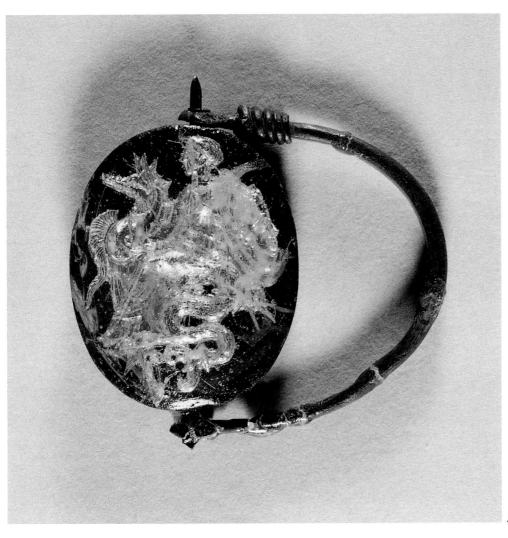

213. *Finger ring with Thetis bearing Achilles'*
weapons, third quarter of 4th century BC.
Volos, Archaeological Museum.

214. *Finger ring with bifacial palmette bezel,*
late 5th century BC. Berlin, Antikenmuseum.

213

214

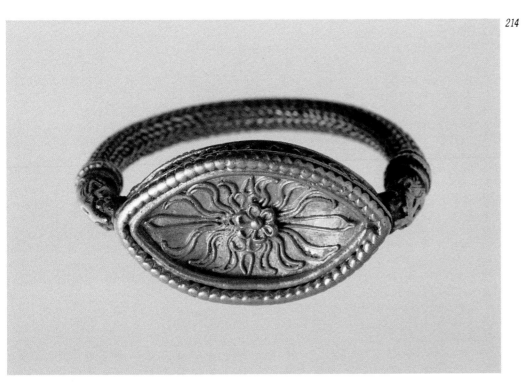

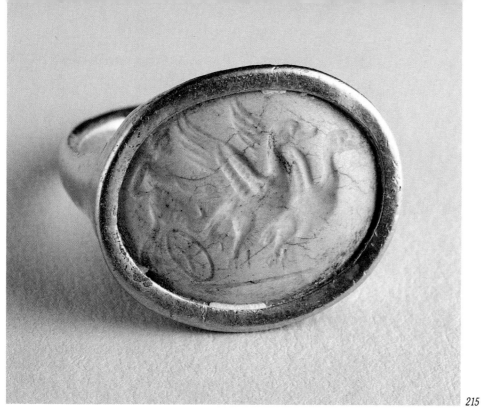

215. *Finger ring with Aphrodite on a chariot drawn by geese, third quarter of 4th century BC. Thessaloniki, Archaeological Museum.*

216. *Finger ring with Aphrodite carrying a shield and spear, late 3rd century BC. Boston, Museum of Fine Arts.*

217. *Finger ring with Herakles knot, early 3rd century BC. London, British Museum.*

218. *Snake ring, late 3rd - early 2nd century BC. Athens, National Archaeological Museum.*

215

216

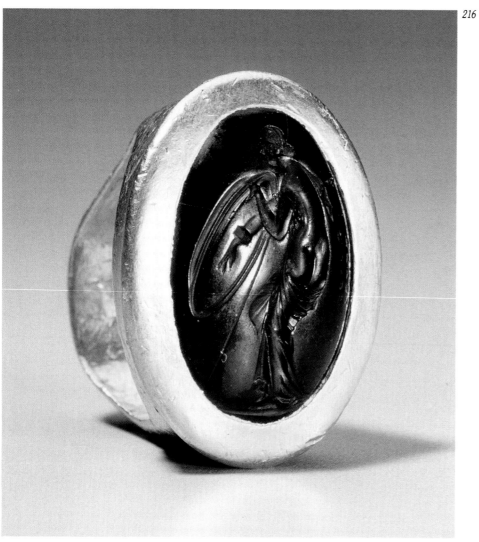

217

219. Finger ring with quatrefoil ornament of cloisonné enamel, second half of 2nd century BC. Saint Petersburg, Hermitage State Museum.

220. Finger ring with the inscription ΔΩΡΟΝ (gift), c. 480 BC. Thessaloniki, Archaeological Museum.

221. Finger ring with the inscription ΚΛΕΙΤΑΙ ΔΩΡΟΝ (to Kleita a gift), third quarter of 4th century BC. Thessaloniki, Archaeological Museum.

219

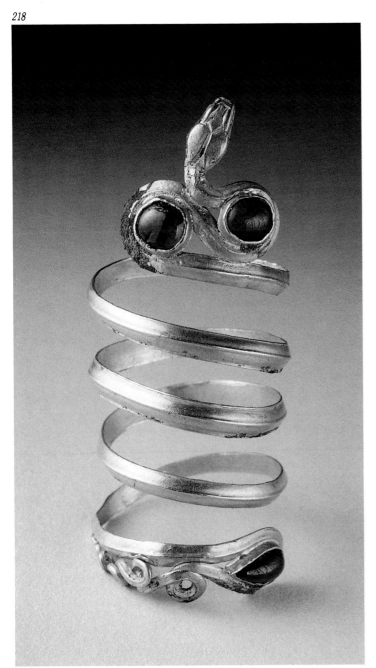

218

220

221

DESCRIPTIONS

1. Ivy wreath, mid-4th century BC.
Diam. of stem 18.5 cm. Tomb 3 of the Pappa tumulus, Sevasti,
Pieria. Dion, Archaeological Museum 2579.

Comprises two tubular stems of sheet gold. The ends
corresponding to the back of the head are crossed and
joined together with fine wire bindings in two places.
There is a gap between the front ends, which are con-
nected by two thick wires. From the two front terminals
spring two wire stalks, each bearing a cluster of ivy ber-
ries (corymb). The hollow, hemispherical berries are
fashioned individually from sheet gold and then soldered
to the others. The petioles of a total of thirty ivy leaves,
arranged in two groups of fifteen, are inserted in per-
forations in the stems. The striking verisimilitude of the
leaves suggests that the craftsmen perhaps used actual
ones as models. An impressive work with a fine sense of
decorative austerity. Ivy wreaths were not common
funerary offerings. In the general series of gold wreaths
of the 4th century BC the find from Sevasti is one of the
earliest examples.

M. Μπέσιος, *AEMΘ* 1, 1987, 212, figs 5 and 6. *Ancient Macedonia*
1988, no. 244. Similar to the wreath from Kastellorizo: *AΔ* 1, 1915,
Appendix, 62ff., fig. on p. 86. On ivy wreaths for funerary use: Blech
1982, 95ff. Here p. 26.

2. Flowering myrtle wreath, third quarter of 4th
century BC.
Max. diam. 18 cm. The antechamber of Macedonian tomb II (of
Philip) at Vergina. Thessaloniki, Archaeological Museum Bε70.

Comprises two tubular stems. The ends corresponding
to the back of the head are crossed and bound to-
gether with wire. The connection of the two front ends

is simpler. From each stem sprout five leafy shoots: in
one case only the lower section has survived. Of the eighty
leaves in all, some are directly attached to the stem and
others belong to the nine extant shoots. They imitate the
shape of natural myrtle leaves and have an engraved
midrib. The myrtle is in full bloom, its one hundred and
twelve surviving flowers consisting of a swollen hemi-
spherical floral receptacle – doubling as a conventional
calyx – covered by a five-petalled corolla of cut-out sheet
gold. Upon this a disc, like a multi-petalled rosette, vivid-
ly renders the plant's numerous stamens. On two of the
surviving flowers the stamens are rendered in a nat-
uralistic manner with wire filaments topped by globular
anthers. The central section of the wreath, that rested
on the forehead, is further enhanced by the convergence
of the elevated lateral branches and supplementary vari-
egated flowers with a radiate five-petalled rosette. One
of the loveliest and best preserved examples of its kind,
the Vergina myrtle wreath is a delightful piece in which
the accomplished craftsman has successfully combined
the rich 'world' of efflorescence with a refined feeling
for the decorative.

Ανδρόνικος 1984, 191, pls 40 and 154. Μπ. Τσιγαρίδα in *Αμητός*
1987, 907ff., pls 181-182. Cf. the wreath from Pydna: M. Μπέσιος
in *Οι Αρχαιολόγοι μιλούν για την Πιερία*, 1984 (1985), 54, fig. 7.
M. Μπέσιος - M. Παππά, *Πύδνα*, 1995, 105. On the form of natural
leaves and flowers of the myrtle bush see H. Baumann, *Die*
griechische Pflanzenwelt, 1986, 53, fig. 82. Here p. 26.

3. Oak wreath, last quarter of 4th century BC.
Max. diam. of stem 22 cm. The chamber of tomb III ('of the
Prince') at Vergina. Thessaloniki, Archaeological Museum Bε97.

Comprises a single tubular stem of sheet gold, the ends

crossed at the back and joined together with wire bindings in two places. The individual sheet-gold leaves are either attached directly to the hoop or to the foliate and fruit-bearing branches of the wreath. The pinnately cleft leaves are conventionally rendered, with a midrib and radiate impressed venation from either side. The acorns are fashioned from sheet gold and the cupule is enlivened with embossed dots. This wreath accompanied the deceased in the tomb, passed round the neck of a silver hydria containing his cremated bones. It is a less lavish version of the valuable oak wreath recovered from tomb II at Vergina (fig. 4).

Ανδρόνικος 1984, 217, figs 183-184. Ε.-Μ. Τσιγαρίδα in Σ. Δρούγου et al., *Βεργίνα, Η Μεγάλη Τούμπα. Αρχαιολογικός Οδηγός,* 1994, 64, 96. Here p. 26.

4. Oak wreath, third quarter of 4th century BC.
Max. diam. of stem 18.5 cm. The larnax in the chamber of Macedonian tomb II (of Philip) at Vergina. Thessaloniki, Archaeological Museum Βε17.

Comprises a tubular stem of sheet gold, the ends crossed at the back and joined together with fine wire binding. The hole at each end is covered by a gold-leaf bud with chased linear outline. The stem bears fifty-seven individual cut-out oak leaves attached with wire petioles, thirty-two branches with twelve to fifteen smaller leaves and stalks with sixty-eight preserved sheet-gold acorns with stippled cupule. Towards the back of the stem their stalks are arranged in threes, but their number increases somewhat towards the middle of the wreath, upon the forehead, where it seems acorns were concentrated in small groups of five or six. This wreath from Vergina is the most precious to have survived. Its preserved weight is 714 grammes, while the original was certainly greater. It was probably worn on the head of the deceased and snatched from the funerary pyre before cremation was complete.

Ανδρόνικος 1984, 170ff., fig. 137. *The Search* 1980, no. 173, col. pl. 36. Here p. 26.

5-6. Flowering myrtle wreath, c. 330 BC.
Max. diam. of stem 19.2 cm. Tomb Δ at Derveni, Thessaloniki. Thessaloniki, Archaeological Museum Δ1.

All the flowers are extremely crumpled because of the fineness of the sheet gold. The wreath comprises two tubular stems, the holes of which at the back are masked by a half-open bud cut from gold sheet, with incised details. The larger myrtle leaves are affixed directly to the stems, while the smaller ones belong to twelve foliate branches, six on each side of the wreath. To the total of one hundred and sixty leaves corresponds an almost equal number of peduncles, each with an inflorescence of five flowers, most of which are preserved (at least seven hundred). Each flower consists of a five-petalled rosette, on which is set another rosette with six very fine banded petals, synoptically rendering all the stamens and ending in a disc-shaped finial in place of the anthers. The anonymous goldsmith chose the midpoint of the wreath to express the superb quality of his art, creating a highly decorative composite flower (fig. 6). The following detailed description will perhaps convey the finesse of the workmanship: Penetrating the centre of a disc-shaped rosette is a tiny vertical tube supporting several successive wire rings, soldered to each of which are wire pedicels bearing, from the bottom upwards: twelve eight-petalled rosettes, twelve six-point stars, twelve enamelled ivy leaves, twelve quatrefoil rosettes, twelve enamelled discs, twelve quatrefoil stars and ten five-point stars. The whole represents an ornate myrtle flower of exquisite delicacy, whose stamens bear instead of anthers these tiny cut-out flowers of sheet gold bordered by extremely fine beaded wire. The hole at the top of the tube was probably inset with a precious stone, now lost. This wreath, with its abundance of flowers, was surely exceptionally impressive in its pristine state.

Χ. Μακαρόνας, ΑΔ 18, 1963, Χρονικά, 194 (its provenance is mentioned as tomb Γ). *Treasures* 1979, no. 239, pl. 31. Here p. 26.

7. Berry-bearing myrtle wreath, c. 320 BC.
Max. diam. of stem 21 cm. Tomb B at Derveni, Thessaloniki. Thessaloniki, Archaeological Museum B138.

Comprises two tubular stems, the back ends of which are joined together with careful wire bindings in two places. The hoop is provided with holes in which are inserted seventy-four individual leaves in groups of two or three, as well as eight tubular branches (one has not been mended) with eight leaves, four on either side of the wreath. The cut-out myrtle leaves with engraved midrib are convincing imitations of natural ones, wider towards the peduncle and pointed at the top. A peduncle with flower and a stalk with berry correspond to each group of individual leaves, while on each branch ternate berries alternate with ternate flowers. The corolla is rendered as a six-petalled rosette set on a hemispherical floral receptacle-calyx from which the stamens are absent. There are also peduncles bearing closed buds. The berries, like the flowers, are of sheet gold and the modelled protuberance at their tip bears a cruciform incision characteristic of natural myrtle berries. The midpoint of the wreath, over the forehead, is emphasized only by the convergence of the top branches. This wreath is one of the most faithful simulations of nature.

ARepLondon 1961/62, 15. Treasures 1979, no. 238. Ancient Macedonia 1988, no. 236. Here p. 26.

8. Olive wreath, second half of 3rd century BC.
Max. diam. 18 cm. Macedonian tomb I at Amphipolis. Kavala, Archaeological Museum M2403.

Preserved in very good condition on account of the thickness of the sheet gold. Comprises two tubular stems joined by wire binding at the front, while there was a wire loop for the ribbon tie at the back. The characteristic olive leaves, twenty-one on each side in ternate arrangement, have an engraved midrib and outline. Wider at the top, narrower and pointed towards the petiole, they have the same shape as the natural leaf. The midpoint of the wreath, above the forehead, is emphasized by a cabochon ruby in a gold mount. The Amphipolis wreath, vitally elegant in its simplicity, represents a type dominant in this region.

Δ. Λαζαρίδης, *ΠΑΕ* 1960, 71, pl. 56α. Idem, *Οδηγός Μουσείου Καβάλας*, 1969, 120, pl. 40α. *Treasures* 1979, no. 368. Cf. *Ancient Macedonia* 1988, no. 349. Here p. 26.

9-10. Band diadem with animal frieze, c. mid-8th century BC.
L. 38.5 cm, w. 3.4 cm. Kerameikos Cemetery, Athens. Paris, Musée du Louvre BJ93 (MNC 1291).

Of relatively thin sheet gold. Embossed decoration of two carefully executed meander patterns, left and right of a tripartite representation: in the middle a nonchalant recumbent ibex, flanked either side by the same savage scene of a lion pouncing upon an unsuspecting grazing deer. The inertia at the centre of the composition develops as if in a crescendo to the dramatic action at the sides. The conventional synchronism of two successive events – the calm grazing of the deers and the sudden violent attack by the lions – is a characteristic trait of Geometric art. There is no 'logical' connection and each figure is alone in its world, as if, for example, the ibex at the centre or the deer belong to other contexts. The integration of the figures into a closed unit is achieved through their proximity and their framing in the rectangular panel. The animal frieze was embossed in a larger mould with several zones, used for producing gold investments for wooden caskets. Fragments of such bands were found at Eleusis. The composite meander motif was produced in another mould. The clear symmetry and calculated precision in the arrangement of all the components, the spare narrative expression of even the dramatic element in the representation place the band among the loveliest examples of diadems of this class. The two holes at each end were for the cords with which it was tied at the back of the head.

Ohly 1953, 31, 84ff., 97ff., no. 12, pls 4, 1 and 7, 2. Coldstream 1979, 124, fig. 38c. Higgins 1980, 97, fig. 14. Here pp. 13, 19, 28, 36. On the stylistic problems: Ohly, op. cit., 105ff. I. Scheibler, *Symmetrische Bildform*, 1960, 18ff. with n. 49. B. Schweitzer, *Greek Geometric Art*, 1971, 189ff. Cl. Bérard, *Eretria III*, 44.

11. Band diadem with dancing women, c. 700 BC.
L. 15.5 cm, w. 3.5 cm. Corinth. Berlin, Antikenmuseum 31093.

The band bears an embossed representation of seven female figures 'dancing' towards the right, one leg to the fore. Clad in a long garment, their arms are outstretched touching and holding a branch between them. A motif of two concentric circles fills the space below the branches, a persistent feature in Geometric art, which is characterized by a *horror vacui*. Women dancing is a theme commonly encountered in Late Geometric vase-painting, often associated with a scene of *prothesis* (lying in state) of the dead. Whether the dance in these scenes is connected with certain rituals – as is believed, for example, for the procession of chariots during the *ekphora* (carrying for burial) of the dead – is not confirmed by the literary sources. The band seems to be intact, but the mould in which the gold sheet was hammered was evidently longer, judging from the incomplete circular ornament at the left edge. Because it is rather small and without holes for tying, it is presumed that it was affixed to a longer band of cloth or leather.

E. Kunze, *Gnomon* 21, 1949, 8. Greifenhagen 1970, 24, pl. 6, 1. Here pp. 19, 29. On dances associated with funerary rites: R. Tölle, *Frühgriechische Reigentänze*, 1964, 84ff. M. Wegner, *Musik und Tanz*, Archaeologia Homerica III, U, 44ff. Kurtz - Boardman 1971, 60. Cf. W. Burkert, *Griechische Religion*, 1977, 67. K. Branigan, *Dancing with Death*, 1993, 130ff.

12. Band diadem with applied rosettes, second half of 7th century BC.
L. 30.5 cm. Kameiros, Rhodes. London, British Museum 1160.

A band decorated with six embossed rosettes alternating with five concave applied ones, increasing in size from the ends towards the middle, where the largest is placed. The alternation of applied and embossed rosettes endows the piece with a vital aspect. Interpolated between them are stippled X-shaped motifs. A hole at each rounded end of the band was for the two fine cords with which it was tied at the back of the head. Fine and symmetrical, the diadem is one of the best examples of the type.

BMCJ 1911, no. 1160, pl. 13. Laffineur 1978, 109, 224, no. 168, pl. XX, 2. On diadems with applied rosettes: Amandry 1963, 222ff., no. 166, figs 126-129, pl. 34. Here p. 29.

13-18. Five rosettes from a diadem, second half of 7th century BC.
Diam. 4.6 cm. Melos. Athens, National Archaeological Museum Xp1177-1181.

The six-petalled rosettes are cut from rather thick gold sheet and their periphery delineated by twisted wire with a parallel row of granulation. On three of the rosettes each petal is embellished with another double six-petalled rosette, likewise meticulously outlined with wire and granulation. At their centre is a lion's head in two cases (figs 14, 15) and a bull's in the third (fig. 13). On the other two rosettes each petal is the base for the head of a griffin alternating with a bee (one missing), while at their centre is an eagle with outspread wings in one case (fig. 16) and a larger griffin head in the other (figs 17-18). The details on the floral and faunal ornaments and the filling motifs in the interstices are executed in rich fine ganulation. The ferocity of the lions and griffins is emphasized by their open mouth. This is the period when Oriental elements – a host of floral motifs and fantastic or other animals – were reaching Greece at an increasing pace and were incorporated in the jewellery produced in local workshops, particularly on Rhodes as well as other Aegean islands. The Melian rosettes will have been attached to a band of perishable material, since there is no trace on their reverse of them being soldered or joined to a metal one. They will have adorned a diadem, placed in a row like the much more frugal rosettes on that in figure 12.

Χρ. and Σ. Καρούζου, *Ανθολόγημα θησαυρών του Εθνικού Μουσείου*, 1981, 46ff, pls 38-40. Laffineur 1978, 85ff, 214ff, nos 117-121, pl. XV. Here p. 29. Cf. A. Lebessi, *BSA* 70, 1975, 175, pl. 25c. Deppert-Lippitz 1985, 106, fig. 54.

19-20. Band diadem with sphinxes and rosettes, second half of 7th century BC.
L. 22.8 cm. Kos. Athens, Benaki Museum 6242.

The right section of the diadem is missing. Of the applied cut-out rosettes (probably five) the one from the right end is missing. All are outlined with plain wire and two rows of granulation. The middle rosette is more ornate with liberal granulation on the petals and above all on the magnificent radiate nucleus. On the pairs of plainer rosettes flanking it left and right, an impressive, modelled ram head replaces the nucleus. The spaces between the rosettes are occupied by single sphinxes embossed on a separate cut-out sheet, while four identical sphinxes in a row, hammered in the same die as the others, frame the decoration of the diadem from the left. One rosette and four sphinxes on the right side will have completed this impressive piece, an outstanding product of a Rhodian workshop.

Laffineur 1978, 110ff., 222, no. 159, pl. XIX. *Gold of Greece* 1990, pl. 9. Here pp. 14, 29.

21. Diadem with embossed floral decoration, c. 320 BC.
L. 25.7 cm, h. in middle 8.6 cm. Tomb B at Derveni, Thessaloniki. Thessaloniki, Archaeological Museum B136.

Fashioned from rather thick sheet gold with curved outlines. The centrepiece is formed as a tall isosceles triangle with very pointed apex, upon which the central palmette of the embossed decoration is developed. Left and right of this motif are spiralling shoots, describing fields for floral ornaments. The edges of the band are incurved to hold a backing of the same shape, of hard material that has since perished, to which it was further secured by tiny silver rivets: the remains of one of these are preserved in one of the holes carefully opened on the periphery of the diadem, so as not to interfere with the decoration. According to one viewpoint, this ornament perhaps adorned the brow of a helmet.

Treasures 1979, 236, pl. 30. M. Pfrommer, *Jdl* 97, 1982, 142. *Oro dei Greci* 1992, 276, pl. 149, 3. Here pp. 29f.

22. Band diadem with embossed lyre-shaped motifs, 5th century BC.
L. 26 cm. Unknown provenance. Athens, Benaki Museum 1530.

The band is decorated with six embossed lyre-shaped ornaments, developed from the middle outwards in opposite directions and enclosing pairs of antithetic palmettes. The composition is closed at each end by a palmette. There are two holes for tying the diadem at the back. Fine workmanship and a rhythmical, elegant design.

Segall 1938, 21, no. 13, pl. 6. Here pp. 29, 30.

23-24. Diadem with embossed representations of Dionysos, Ariadne and Muses, last quarter of 4th century BC.
L. 36.8 cm. Said to be from Madytos. New York, Metropolitan Museum of Art 06.1217.1.

A band of embossed egg-and-dart pattern (Ionic cymatium) at once borders the pedimented diadem and frames the representation. Twelve figures are depicted in all, seated in the curves of two huge vegetal spirals springing from an acanthus bush in the middle and developing towards its ends. Dominating the central triangular section are the semi-reclining figures of Dionysos and Ariadne, each loosely holding the thyrsus, their heads turned towards one other. Ariadne wears a sleeved chiton and a himation covering her legs, Dionysos a girdled chiton and high boots (*kothornoi*). Facing the divine couple are ten female figures in two groups of five, characterized as Muses because they hold musical instruments. Flowers sprouting from the crest of the enormous vegetal spirals, birds below the figures and two insects in front of the central figures, perhaps alluding to cicadas – Plato's 'prophets of the Muses' (*Phaedr.* 262 D) –, complete the picture of a paradisal milieu: a milieu in which the linking of the Muses with Dionysos is comprehensible. Some scholars attribute a symbolic meaning to the representation of Muses, which is not unusual on jewellery of the period (figs 73-74). The Madytos diadem was found in a tomb and according to one view its female occupant appears as the tenth

Muse in the group depicted on her diadem.

Segall 1966, 22ff., pl. 40. Higgins 1980, 158, pl. 45C. Williams - Ogden 1994, no. 62. Here pp. 29, 34. Representation of Muses also on the Abydos diadem: Segall, op. cit., 22, fig. 1. On the symbolism of cicada representations: R. Böhme, *Jdl* 69, 1954, 49ff. R. Laffineur, *BCH* Suppl. XI, 1985, 255.

25. Band diadem with Herakles knot, late 4th - early 3rd century BC.
L. 35 cm. Grave at Amphipolis. Kavala, Archaeological Museum M185 (1263).

A plain sheet-gold band with an applied Herakles knot at the centre, the two antithetic interlocking loops of which are formed from curved tubular elements of sheet gold bordered by beaded wire. The ends of the loops and the middle of the knot are embellished with a six-petalled rosette. The central rosette still preserves traces of enamel. Regardless of its significance on other pieces of jewellery (see p. 14), the Herakles knot on this band diadem from Amphipolis was probably chosen for the apotropaic-protective quality attributed to it in popular belief.

Δ. Λαζαρίδης, *ΠΑΕ* 1956, 142, pl. 48β above. Idem, *Οδηγός Μουσείου Καβάλας*, 1969, 139, pl. 51 left. *Treasures* 1979, no. 388, pl. 53. *The Search* 1980, no. 88, col. pl. 12. Pfrommer 1990, 307, no. HK73. Here pp. 14, 29. Cf. Pfrommer, op. cit., pls 5, 8.

26-27. Diadem with lyre-shaped elements and Herakles knot with Eros, c. 320 BC.
L. 50.7 cm. Tomb Γ at Sedes, Thessaloniki. Thessaloniki, Archaeological Museum 5410.

The diadem comprises eight lyre-shaped ornaments, four on either side, orientated towards the centre. Each ornament is formed from two separate cylindrical stems of sheet gold. The basal join is concealed by acanthus leaves from which spring a palmette and a pair of internal volutes, as well as the spiralling wire stalks of two other palmettes that develop outside the lyre-shaped ornaments. At the top of the stems, which is open for inserting the bottom of the next ornament, two external volutes sprout from below the acanthus leaves, giving each ornament its characteristic shape. At the centre of the diadem is a Herakles knot formed from two antithetic interlocking lyre-shaped loops. Standing upon this is a winged Eros of sheet gold, holding a dove with outspread wings in each hand and flanked right and left by a palmette. Inserted on each of the terminals (fig. 27) is a lion head with a link in its mouth for tying the diadem at the back of the head. The Sedes diadem and a simpler, similar one from the Pangaion region, formerly in Berlin (before the Second World War), are among those pieces of jewellery that bespeak the wealth of artistic inspiration in Macedonian goldsmiths' workshops at that time.

N. Κοτζιάς, *AE* 1937, 876ff., figs 6-8. *Treasures* 1979, no. 318, pl. 46. Pfrommer 1990, 307ff., no. HK80, pl. 1, 1. Here pp. 14, 30. The Berlin diadem: Greifenhagen 1970, pl. 13, 6. Amandry 1963, 246, fig. 146. On the dating of the Sedes tomb see here no. 90.

28-29. Diadem with tendril scrolls and Herakles knot with Eros, last quarter of 4th century BC.
L. 50 cm. Said to be from Thessaly. Athens, National Archaeological Museum Στ339 (H. Stathatos Collection).

A diadem composed of three articulated sections: a middle one and a band-shaped one either side. On the two lateral sections a rather thick wire stem describes the frame which at once delimits and consolidates the decorative motif: a wire rinceau which spirals freely, without background, and with exceptional vitality towards the middle of the diadem. The points at which the spirals are soldered to the frame are masked by schematic palmettes and the points of their branching by acanthus leaves. From the crests of the spirals sprout bell-shaped flowers. The favourite theme of the age has been chosen for the central section of the diadem (fig. 28), the Herakles knot. This consists of two antithetic interlocking wire loops with spiral finials, so that the whole comprises two opposed lyre-shaped ornaments. Hanging from the knot are two tassels of three chains bearing schematic pomegranate pendants. The central section is completed above and below by another two pairs of spirals and embellished with acanthus leaves, bell-shaped flowers and schematic palmettes. Represented at the centre of the knot is a naked winged Eros, with

the lowered left hand and the raised right holding the edges of a himation passed behind his back. At the terminals there is a sidewise Omega-shaped loop for fastening the diadem at the back of the head. A refined and delicate creation of an accomplished goldsmith.

Amandry 1953, 77ff., 88, no. 217, fig. 45, pl. 31. Amandry 1963, 244. Pfrommer 1990, 301, no. HK15, pl. 29, 15. Here pp. 14, 22, 30.

30-31. The Vergina diadem, third quarter of 4th century BC.
L. 46.5 cm. The antechamber of Macedonian tomb II (of Philip) at Vergina. Thessaloniki, Archaeological Museum Βε75.

The left edge is missing. A complex ensemble of intricate vegetal spirals of sheet gold and variform flowers. The basic design consists of two rows of lyre-shaped devices in horizontal arrangement, orientated from the ends towards the central section of the diadem, the decorative element of which is a Herakles knot. From this spring two larger lyre ornaments, one of which unfurls above into three flaming palmettes and the other below into a tassel of four tiny chains ending in globular beads. All the points of branching of the numerous volutes are masked by meticulously wrought acanthus leaves and the overall effect is an orgiastic profusion of palmettes, buds and flowers in a dazzling diversity of forms, their details rendered in the finest filigree. All the buds and several blossoms are covered with sapphire blue enamel, chromatically enhancing this artistic masterpiece. The accomplished jeweller's penchant for the decorative reaches its climax in the addition of bees on many of the palmettes and of a diminutive dove nestling in the heart of the palmette above the Herakles knot (fig. 31). The diadem terminated left and right in a ribbed tube with lion-head finial that held the link for fastening it. In conception and execution this is one of the most exquisite examples of the Greek goldsmith's art.

Treasures 1979, no. 87. Ανδρόνικος 1984, 197, figs 158-159. Here pp. 14, 30.

32-33. Diadem with Herakles knot and chain straps, last quarter of 3rd century BC.
L. 51 cm. Perhaps from Thessaly. Athens, Benaki Museum 1548.

Comprises a composite central section and two chain straps on either side (for their manufacture see pp. 23, 24) with leaf-shaped terminals bearing the links for fastening the diadem. Dominating the central section is an impressive Herakles knot with sards held by gold band bindings in a mount with dentate edges (fig. 32). The band bindings are bordered by tongue pattern inlaid with alternating light green and sapphire blue enamel. The middle of the knot, where two antithetic palmettes join, is embellished with a rosette, while at the ends of its loops, at the point where they begin to straighten, are two smaller rosettes. The vertical frame on each side of the knot is decorated with tongue pattern, again picked out in blue and green enamel. These frames are linked by a hinge (small loops through which a vertical axis passes) to a trapezoidal section in the form of an anta capital with volutes at the top, which is also familiar from other pieces of jewellery (figs 34, 36-37, 147, 155-156). Enamelled tongue ornament emphasizes the band at the base of this section, as well as the frame around its central ornament, a palmette with red garnet nucleus. A similar palmette also adorns the leaf-shaped terminals of the chain straps. There were originally ten pendent tassels at intervals, consisting of tiny chains ending in globular beads of red, reddish white and green glass-paste. The diadem belongs to a special class and is perhaps the earliest of all, the most finely wrought and with clear tectonic articulation. Sumptuous and superb, it can be characterized as regal.

Segall 1938, 32ff., no. 28, pls 8-9. Amandry 1953, 120ff., 131, fig. 71 in the middle. Higgins 1980, 158 in no. 3, pl. 46. Pfrommer 1990, 301, no. HK17, pls 12, 3 and 29, 41. Here pp. 14, 23, 30, 39.

34. Central section of a diadem with Herakles knot, first quarter of 2nd century BC.
L. 23 cm. Perhaps from Thessaly. Athens, Benaki Museum 1549.

Comprises five parts with an impressive Herakles knot in its dominant middle section. The knot is set with sard

held in the mount by gold band bindings, as in the diadems in figures 32-33 and 36-37. At the centre is a large cabochon garnet 'eye' in a gold mount, framed laterally by two palmettes with an enamelled blue leaf at their nucleus, and above and below by two ivy leaves. The loops of the knot are embellished with four rosettes. The whole is closed on each side by a heavy gold frame, hinged (small loops through which a wire passes) to a trapezoidal ornament in the form of an anta capital, as in the corresponding sections in the aforementioned diadem. These trapezoidal sections are decorated with a square garnet in the middle, surrounded by four palmettes alternating with four rosettes. At the ends there are two inward-facing, modelled gold bull heads with link in the mouth for attachment to the trapezoidal elements and a garnet collar, connected most probably with a chain, as on an analogous piece in the same museum (no. 1550).

Segall 1938, 36ff., no. 29, pl. 10. Amandry 1953, 120, 131, fig. 71 below. Δελпβορριάς 1980, 27, fig. 13. Pfrommer 1990, 301, no. TK19, pl. 13, 1. Here pp. 14, 30. Diadem 1550 in the Benaki Museum: Pfrommer, op. cit., no. HK18, pl. 13, 2.

35. Diadem with Herakles knot and sheet-gold bands, late 3rd - early 2nd century BC.
L. 42.5 cm. Grave at Aetos, Ithaca. New York, Metropolitan Museum of Art 58.11.5.

Comprises a middle section with Herakles knot and four plain bands of sheet gold, extending in pairs to right and left of it. The knot, wrought entirely from sheet gold, the outlines emphasized by a simple and a spiral-beaded wire, is embellished with four seven-petalled rosettes and four round red garnets. At the centre are two antithetic palmettes with common nucleus, consisting of a diamond-shaped mount set with a garnet. Two virtually rectangular plaques function as transitional elements from the Herakles knot to the bands. These too are edged with spiral-beaded wire and decorated at the centre with a rosette upon a filigree palmette, with little discs at the corners and a filigree foliate ornament on the side towards the bands. Hanging from a loop at either end of the knot is a relief Silen head, from which hang three chain pendants

with bead finials, perhaps rendering pomegranates. The diadem illustrated here is the simplest form of a type of which some particularly opulent specimens are known, with chain straps and a member in the form of an anta capital on each side of the Herakles knot (figs 32-34, 36-37). The fragile bands of sheet gold on the Ithaca example indicate that it was perhaps specially made for funerary use, as was also a finger ring found with it. On the back of the diadem is an intriguing inscription with two female names in the genitive case: ΣΑΦΦΟΥ ΛΑΟΔΑΜΙΑΣ (OF SAPPHO OF LAODAMIA).

Amandry 1953, 120. Pfrommer 1990, 302ff., no. HK32, pl. 29, 43 (cf. also HK179, pl. 11, 3). Williams - Ogden 1994, no. 35 and ring no. 36. Here pp. 14, 23, 30. On relevant imitations see Παπαποστόλου 1990, 86ff., figs 2-5.

36-37. Diadem with Herakles knot and chain straps, late 3rd or early 2nd century BC.
L. 120 cm. Perhaps from Thessaly. Athens, National Archaeological Museum Στ353 (H. Stathatos Collection).

Comprises a central section with Herakles knot and two chain straps (on their manufacture see pp. 23, 24), the terminals of which have been lost. The tripartite central section consists of two trapezoidal ornaments in the form of an anta capital, flanking the middle device to which they are connected by hinges (small band links through which passes a rod of rather thick gold wire). The elongated plaques to which the loops of the hinge are soldered are embellished with lovely bead-and-reel wires and coloured stones or enamel in foliate mounts. The middle part is dominated by a Herakles knot fashioned from sheet gold forming mounts set with off-white glass-paste, their dentate periphery formed from rows of filigree leaves. The glass-paste pieces are held in place by two additional 'bindings' on each loop of the knot: two bands with foliate border on the right and two palmettes (one missing) on the left. A multi-petalled rosette at the centre of the knot, a rosette between two – possibly antithetic – palmettes with green nuclei at the ends of the left loop (these perhaps existed at the ends of the right one too), and pairs of enamelled rosettes upon wire spirals at the ends of the knot (the right ones are

preserved) complete its decoration. At the centre of the two trapezoidal members is a rectangle of off-white glass-paste set in a mount with dentate border and surrounded by twisted wires. One explanation for the unusually long straps is that they were wound twice around the head. The diadem's creator follows in the footsteps of the craftsman who fashioned the piece illustrated in figures 32-33. In its pristine state the diadem will have been particularly striking, enlivened by the coloured stones and the blue and green enamel inlays: nuclei of rosettes and palmettes, foliate ornaments on the articulations and discs at the corners of the trapezoidal devices or enamelled palmettes, bands and rosettes.

Amandry 1953, 118ff., no. 264, pl. 48. Pfrommer 1990, 301, no. HK20. Here pp. 14, 23, 30, 39.

38. Diadem in the form of a floral wreath, c. 200 BC.
L. 47.2 cm. Canosa, Southern Italy. Taranto, Museo Archeologico Nazionale 22.437.

Comprises two curved stems of equal size and semicircular section, joined in the middle by hinges (small loops through which a rod passes). Their borders are trimmed with bead-and-reel wire and the entire convex surface of the main face is covered with decoration imitating a natural floral wreath, represented interwound with a triple ribbon of sheet gold, initially enlivened with dark green enamel in the middle strand and light green on the outer ones. The wreath is lavishly embellished with variform flowers, picked out in white, green and blue enamel, with red receptacles and four to five stamens bearing white spherical anthers. The whole is complemented by banded scrolls, enamelled green leaves and occasional berries of red glass-paste on a gold wire stalk. The terminals of the diadem are decorated with a green oak leaf. Floral wreaths are also known of in terracotta in this period. The Canosa diadem, gold and polychrome with its profusion of flowers, is the most festive example known of this type.

Ori di Taranto 1987, 122ff., no. 54. Deppert-Lippitz 1985, 244, fig. 179. Guzzo 1993, 119, fig. 67, 292, fig. B1. Here p. 31. Terracotta floral wreaths: E. Breccia, La Necropoli di Sciatbi I, 1912, 166, figs 518-519, pl. 76, nos 240-241. Δ. Παντερμαλής, Μακεδονικά 12,

1972, 166, no. 6, pl. V, ε. Τύμβος Νικήσιανης 1992, 21, pl. 6, 6.

39. Diadem of curved sheet gold of semicircular section, with tendril scrolls, c. 350 BC.
L. 10.5 cm. Crispiano in the region of Taranto. Taranto, Museo Archeologico Nazionale 54.114.

The diadem, in the shape of a tube cut along its longitudinal axis, is curved to fit the head. Its outline is emphasized by beaded wire and embellished with wave pattern traced in wire. The entire convex surface is decorated in filigree technique with two rinceaux developing outwards from above a central acanthus bush with applied leaves of sheet gold. A palmette projects from each dip of the vegetal scrolls, while their ends terminate in a bell-shaped flower. From the shape of the gold sheet and other indications it is adduced that the diadem was probably intended to cover a core of circular or semicircular section, of perishable material – perhaps wood. Plain metal diadems of circular section are known from graves at Taranto. In any case, the diadem from Crispiano is unique of its kind, and if it was indeed associated with a core of circular or semicircular section, then it is the earliest example of a type that appeared later in several variants (figs 38, 40).

Ori di Taranto 1987, 118ff., no. 47. Deppert-Lippitz 1985, 195ff., fig. 144. Oro dei Greci 1992, 262, pl. 123, 1. Guzzo 1993, 121, fig. 68, 294, fig. VIII A1. Here p. 31. On the metal diadems from Taranto: Deppert-Lippitz, op. cit., 196. Ori di Taranto, op. cit., 119ff., nos 49-51.

40. Diadem with Herakles knot, second half of 2nd century BC.
Diam. 20 cm. Grave I in the Artjukhov Barrow near Phanagoreia, Taman peninsula, Euxine Pontus (Black Sea). Saint Petersburg, Hermitage State Museum Art. 1.

Comprises three articulated parts. The two outer ones, of semicircular section, are filled with black resin. Their grooved exterior is divided lengthwise by a zone decorated with wire scrolls. Similar ornaments, together with a leafy corolla, adorn the two decorative band rings framing the hinges, which join these two lateral sections of the diadem to the middle one. This is dominated by a

Herakles knot of sards set in gold mounts with dentate border and held in place with additional gold band bindings as on other diadems (figs 32-34, 36-37). At the centre of the knot is an eagle with outspread enamelled wings, carrying off a small winged Eros. The representation is a variation of the theme of the Rape of Ganymede (see fig. 97). All the surfaces bearing filigree decoration are enhanced with blue and pink enamel. Six tassels of chains and spiralling wires with garnet bead finials hang from spherical or heart-shaped sards in gold mounts. This is one of the last gorgeous diadems in the art of Greek goldwork.

Minns 1913, 405, 430, fig. 322. Hoffmann - Davidson 1965, 54 in no. 1, fig. 1f. Deppert-Lippitz 1985, 275. Pfrommer 1990, 309, no. HK99, pls 29, 32. Here pp. 14, 31.

41-43. Comb with battle scene, first half of 4th century BC.

H. 12.6 cm. Solokha Barrow, east bank of the river Dnieper, Ukraine. Saint Petersburg, Hermitage State Museum Dn1913.1/1.

Cast in solid gold, the comb comprises three architecturally structured parts: the handle which is formed as a pedimental composition, a frieze with five crouching lions defined above and below by two regulae, and a row of teeth arrayed like a colonnade. On the handle – bifacial like the lion frieze – is represented a battle scene with a Scythian horseman, followed left by a fellow warrior, attacking an adversary right, fighting on foot beside his slain steed. Though the struggle is not yet over, the imagery clearly suggests the victor: the elevated equestrian figure at the centre of the representation. Like the other figures he is clad in Scythian costume – a sleeved garment, baggy trousers (anaxyridai) and closed shoes – and wears a helmet of Corinthian type, a scaly cuirass and greaves. The gorytos hanging from his left shoulder is empty of bow and arrows, and his shield hangs on his back. In his left hand he holds the reins of his mount and with the right he thrusts his spear. His combatant's horse is dead. A wound on the right of the animal's neck is still bleeding (fig. 42), while another gapes next to the joint of the left foreleg (fig. 43). The enemy, now on foot, wearing a breastplate and a helmet of the so-called Phrygian type, defends himself, holding a pelta and a dagger, the sheath of which hangs at his left side. The horseman's companion, dressed in a leather Scythian corselet with the hood thrown behind, rushes against him. The individual details have been rendered with exceptional care and the anatomical modelling of the horses is meticulous. There is an immediacy and realism in the dynamic composition. Combs were quite common grave goods accompanying Scythian male burials. The Scyth client had probably specified the content of the scene on the Solokha comb, which was commissioned from a Greek workshop in the region, as borne out by its design and execution. It is the loveliest testimony of a Graeco-Scyth cultural symbiosis, which is, so to speak, epitomized by the central figure of a Greek horseman appropriately attired in Scythian garb.

Artamonov 1969, pls 147, 148, 150. G. Charrière, Die Kunst der Skythen, 1974, fig. 364. Gold der Skythen 1984, no. 51. Here p. 21. On combs in Scythian graves: V. Schiltz, Die Skythen und andere Steppenvölker, 1994, 135ff., figs 102-103, 325, 359.

44. Earrings with disc terminals, 850-825 BC.

Diam. of disc 1 cm. Lefkandi, Euboea. Eretria, Archaeological Museum 85.10A-B.

Comprise a bent wire the ends of which are inserted in a socket on the underside of the disc terminals of the earrings. Slightly conical and concave, these discs are fashioned from sheet gold. Similar earrings of bronze have been found at Corinth, Tegea, and with larger cones at Amphikleia and Perachora, of gold at Thebes and with decorated cones in Attica (fig. 45). In some instances the conical terminals are solid. The Lefkandi earrings constitute austere and early examples of a type which was more widely diffused mainly during the eighth century BC.

Coldstream 1979, 64, fig. 19d. Higgins 1980, 105, pl. 16D. Idem, Lefkandi I, 131, nos 17-18, pls 225, 231a. Oro dei Greci 1992, 97, 241, no. 39. Here p. 31 and for parallels p. 279f. On earrings with solid conical terminals: Higgins 1980, pl. 16E.

45. Earrings with granulated disc terminals, 8th century BC.
Diam. of terminals 2.8 and 2.7 cm. Unknown provenance. Los Angeles, County Museum of Art M.47.6.1.

Each earring comprises a rather thick stem and two disc terminals of sheet gold. The stem is twisted and its ends are decorated with granulated triangles. Of the two disc terminals on each earring, one is slightly conical while the other is flat with a central circular mount that originally held a bead, perhaps of amber or rock crystal, most probably convex at the top, so it too will have been somewhat conical in appearance. The conical terminals are richly ornamented in granulation: on the obverse a cruciform device encircled by meander pattern, and on the reverse six rows of herring-bone motif in radiate arrangement, alternating with an equal number of leaf-shaped mounts – originally set with stones –, forming a six-petalled rosette. On the flat terminals the circular mount is surrounded by meander pattern in one case and tongue pattern in the other. Their underside is decorated with a group of five granulated lines in the middle of which is the socket for the stem linking the two discs. These earrings constitute the luxurious Attic version of a type with disc-shaped and slightly conical terminals also known from other regions (fig. 44). The granulated motifs belong to the thematic repertoire of Geometric pottery and their combination with inlaid elements in another material, adopted from Oriental models, is one of the distinctive traits of Attic jewellery in the eighth century BC.

D.L. Carroll, *AJA* 74, 1970, 37ff., pls 9-10, figs 1-5. R. Higgins, *BSA* 64, 1969, 148ff., pls 39b-40. Higgins 1980, 98, no. 4, pl. 14C. Deppert-Lippitz 1985, 73ff., fig. 33. Here pp. 13, 31, 36.

46. Spiral earrings with disc terminals, 8th century BC.
Diam. of discs 1.6 cm. Corinth. Oxford, Ashmolean Museum 1927.1329.

Comprise a spiralling wire, each end of which is engraved with herring-bone pattern and soldered to a sheet-gold disc engraved with a cross on the upper face. Similar examples are also known from Perachora. The type of earrings with disc terminals is known from as early as the tenth century BC, as attested by an example with stippled decoration on the disc, from the Agrinion region. The earrings probably hung from a very fine wire link passed through the ear lobe.

Higgins 1980, 103, pl. 16A. Cf. *Perachora* I, 74ff., 184, pls 18, 4 and 84. Greifenhagen 1970, pl. 4, 7. Deppert-Lippitz 1985, 60, fig. 26. Here p. 31 and for the Agrinion earrings p. 279.

47. Spiral earrings with engraved herring-bone decoration, c. 750 BC.
H. 1.7 cm. Corinth. Corinth, Archaeological Museum 6091.

Fashioned from a rather thick, solid stem, coiled three times. The ends, distended and each facing in the opposite direction, are engraved lengthwise with herring-bone motif, that is two rows of oblique lines forming successive chevrons. A cross is engraved on the flat circular terminal, as known from similarly early earrings of another kind (fig. 46). The spiral will have hung from a link passed through the ear lobe.

Corinth XII, 250, no. 1999, pl. 107. Higgins 1980, 102. Deppert-Lippitz 1985, 60, figs 25 right and 29 above. Here p. 31. Cf. *Perachora* I, 185, no. 32, pl. 84. Ο. Αλεξανδρή, *AAA* 5, 1972, 169, fig. 78.

48. Spiral earrings with engraved herring-bone decoration, c. 875-825 BC.
Diam. 3 cm. Grave 12 in Danaos street, Argos. Argos, Archaeological Museum 3426, 3427.

Fashioned from a rather thick stem of circular section, coiled twice. The ends are slightly distended and decorated with engraved herring-bone motif (see also fig. 47). Researchers have repeatedly described such items of jewellery as hair rings, but they are too heavy and inflexible to have been used as such. The prevailing opinion that they are in fact earrings is supported by copious evidence. The earrings from Argos are the earliest examples of this type, which enjoyed great longevity as well as great variety in size and decoration of the terminals, depending on current fashion, yet maintained to the end its characteristic spiral form, with one (fig. 49) or more coils (figs 47, 50). The earrings will have hung with the

terminals upwards, from a link passed through the ear lobe.

Χ. Κριτζάς, ΑΔ 27, 1972, Χρονικά, 192, pl. 134α. Higgins 1980, 102. Here p. 31.

49. Spiral earring with engraved herring-bone decoration, second half of 8th century BC.
H. 3.2 cm. Myndos, Caria. London, British Museum 1245.

Comprises a solid stem wound in a single spiral. The slightly thicker ends are bent upwards and decorated with a zone of engraved vertical herring-bone motifs. The lower part of the zone is defined by a ring with a row of impressed dots, and the upper by a ring with stippled triangles. Earrings of this type, but with the ends arranged differently and decoration attuned to the spirit of the age (figs 53-56), continued to be produced into the fourth century BC. They will have hung with the ends pointing upwards, from a link passed through the ear lobe.

BMCJ 1911, no. 1245, pl. 14. Higgins 1980, 119, no. 2. *Oro dei Greci* 1992, 112, 247, no. 63. Here p. 31.

50. Spiral earrings with globules on the terminals, 6th century BC.
H. 3 cm. Kameiros, Rhodes. London, British Museum 1174/75.

Comprise a rather thick stem, coiled twice. The ends, bent upwards, are encircled by six parallel beaded wires, and the terminals surmounted by four globules in pyramidal arrangement. This is a somewhat anachronistic example of a type whose development can be traced from the ninth century BC (fig. 48). Nevertheless, the decoration of the ends is relatively novel of its kind. Known from an example in Basle, of the seventh century BC, several variations of it are encountered later on earrings of the fifth (fig. 56) and even the fourth century BC. Beautiful ornaments, combining an old form with a newer decorative conception, the Kameiros earrings, like the others of this type, will have hung with the terminals pointing upwards, from a link passed through the ear lobe.

BMCJ 1911, nos 1174/75, pl. 12. Higgins 1980, 113, pl. 18B.

Laffineur 1978, 155 and for the Basle earring no. 217, pl. XIV, 2. Fourth-century BC earrings: Greifenhagen 1975, pl. 39, 1. Deppert-Lippitz 1985, 179, fig. 125. Here p. 31.

51. Long earring with disc terminals, second half of 7th century BC.
H. 5.9 cm. Kameiros, Rhodes. London, British Museum 1166.

Comprises a rather thick stem forming a long loop. The ends, bent upwards, are sheathed by a cylinder of successive rings and crowned by a disc embellished at the centre by four globules in pyramidal arrangement surrounded by beaded wire. Another disc, decorated with an eight-petalled rosette, covers the top of the earring. This is a simple variation of an island (fig. 52), mainly Rhodian, type. It will have hung from a fine link passed through the ear lobe.

BMCJ 1911, no. 1166, pl. 12. Laffineur 1978, 140ff., no. 208, pl. XXV, 1 right. Higgins 1980, 113, pl. 18C. Here pp. 23, 32.

52. Long earring with griffin-head terminals, second half of 7th century BC.
H. 6 cm. Melos. Berlin, Antikenmuseum Gl141 (Misc. 1845 S.94).

Comprises a rather thick stem, doubled over to form a kind of long loop. The ends, bent upwards, are encircled by a tripartite ring supporting a horizontal disc. Arising from the disc is the daemonic head of a griffin, the modelled details of which are picked out in wire and superb quality granulation which also covers entirely the horn on the monster's brow. This is a wonderful example of the goldsmith's art in the Aegean islands, representing the final stage in the evolution of a type that developed primarily on Rhodes and which can be traced back to the Late Geometric period.

Greifenhagen 1975, 46, pl. 38, 8. Laffineur 1978, 140ff., no. 203, pl. XXIII, 4. Here pp. 14, 32 and for Late Geometric examples p. 280.

53. Earring with twisted terminals, second half of 7th century BC.
H. 2.6 cm. Rhodes. London, British Museum 1173.

Comprises a rather thick stem folded into a kind of loop,

the terminals of which are bent upwards and turned in opposite directions. Each terminal is embellished with a bead-and-reel ring. This is an early Rhodian example of a type of earrings with twisted terminals that enjoyed wide distribution and persisted into the fourth century BC, with variations in the decoration of the terminals (see figs 54-56).

BMCJ 1911, no. 1173, pl. 12. Laffineur 1978, 155, no. 209, pl. XXV, 1 left. Higgins 1980, 113, pl. 18A. Cf. *Emporio* 1967, 222, nos 361 and 373, fig. 144. Higgins, op. cit., 21D. 4th-century BC earrings: Deppert-Lippitz 1985, 179, fig. 124. Here p. 32 and for parallels p. 280.

54. Earrings with twisted terminals and granulated pyramid ornaments, second half of 5th century BC.
H. 2.1 cm. Said to be from Kyme, Aeolis. London, British Museum 1585/86.

Comprise a rather thick gilded bronze stem folded into an open loop, the two terminals of which are bent upwards and turned in opposite directions. Each terminal is topped by a pyramid of excellent quality granulation. There is a similar granulated ornament on the underside of the curvature formed by the bent ends of the stem, while its sides are decorated with three added rhomboid motifs in granulation and a ring with pendent triangles. The earrings represent the most masterly example of this kind of decoration, variations of which are also known from Xanthos, Cyprus and Duvanlij in Bulgaria, while a very early plain example was recovered at Emporio on Chios.

BMCJ 1911, nos 1585/86, pl. 26. Higgins 1980, 126, pl. 25E. Williams - Ogden 1994, no. 47. Cf. Filow 1934, 133, no. 6, fig. 155, 1-2. P. Demargne, *Xanthos* I, 32ff., pl. 4, no. 2102. Pierides. 1971, 31, pl. 20, 9. From Chios: *Emporio* 1967, 222, no. 364, fig. 144, pl. 91. Here p. 32.

55. Earrings with twisted pyramid terminals, late 5th - early 4th century BC.
H. 3.4 cm. Necropolis of Nymphaion, Crimea. Oxford, Ashmolean Museum 1885.483.

Comprise a gilded bronze stem folded into a loop, the ends of which are bent upwards as far as the top of the loop and twisted in opposite directions. Each end is sheathed by a cylinder decorated in filigree technique and crowned by granulated pyramidal finials. The earrings from Nymphaion belong to an advanced phase of the type of earrings with twisted terminals (see fig. 53). The decoration – filigree cylinder and pyramidal finial – was popular on earrings in the regions of Thrace and the northern shore of the Euxine Pontus (see fig. 57), while a pyramidal finial is also encountered on a pair of earrings said to have been found at Kyme in Aeolis (fig. 54).

Higgins 1980, 126, pl. 24C. Vickers 1979, 10, 42, pl. 11c. Here p. 32. Cf. Greifenhagen 1970, 43, pl. 20, 6-7. T. Hackens, *Catalogue of the Classical Collection. Classical Jewelry. Museum of Art, Rhode Island*, 1976, 58ff., no. 18. Williams - Ogden 1994, no. 93.

56. Earrings with twisted granulated terminals, late 5th century BC.
H. 2 cm. Unknown provenance. Athens, National Archaeological Museum Στ294 (H. Stathatos Collection).

Comprise a stem of circular section folded into a loop, the ends of which are bent upwards and turned in opposite directions. Each terminal is sheathed by a cylinder decorated with granulated triangles and crowned by four globules in pyramidal arrangement, likewise embellished with granulated triangles. The apex of the terminals is set off by four granules, also forming a pyramid. The earrings constitute the development of an earlier type, the decoration of which underwent certain variations over time (see figs 53-55).

Amandry 1963, 198ff., nos 115/6, fig. 104, pl. 30. Here p. 32. On the crowning elements cf. Laffineur 1978, 140ff., no. 217, pl. XIV, 2 left.

57. Omega-shaped earrings with granulated pyramid terminals, early decades of 5th century BC.
H. 3.6 cm. Muschovitza tumulus, Duvanlij, southern Bulgaria. Plovdiv (Philippoupolis), Local Archaeological Museum 1538.

Comprise a rather thick wire stem folded into an open loop or Omega. The ends are sheathed by a cylinder decorated in filigree technique and crowned by a granulated pyramid terminal. Earrings of this type, a vari-

ation of those with twisted ends (figs 53-56), were widely distributed from the sixth century BC, primarily in Macedonia where they are mainly encountered in silver, a few in bronze and very rarely in gold, more often with snake-head finials. Pyramid terminals were preferred during the fifth century BC, particularly in the regions of Thrace and the northern shore of the Euxine Pontus. A pair of earrings from Nymphaion in the Crimea has terminals decorated in a similar manner (fig. 55). Omega-shaped earrings were worn hanging from a link passed through the ear lobe.

Filow 1934, 88, no. 7, fig. 109 right. *Gold der Thraker* 1979, 89, no. 159 (there is an error in the bibliographical reference and the figure is of earrings no. 167). Here p. 32 and for other examples in gold p. 280.

58. Omega-shaped earring with conical terminals, last quarter of 8th century BC.

H. 4 cm. Levidi, Attica (Kantza area). Athens, National Archaeological Museum Στ297 (H. Stathatos Collection).

Comprises a thick stem folded into an open loop or Omega. Each end, directed sideways and downwards, is engraved with herring-bone pattern and topped by a sizeable cone. The closest parallels for such terminals are encountered on Geometric earrings from Olympia, Perachora, Lousoi in Arcadia and Pherrai in Thessaly. The ends of Geometric earrings of other types (figs 46-48) are likewise engraved with herring-bone motif. The earring in the Stathatos Collection remains the unique example of the singular Omega-shaped type until the sixth century BC, when earrings of similar form but with different ends in terms of direction and decoration enjoyed wide distribution for a long period (see fig. 57). Ornaments of this type were worn hanging from a fine link passed through the ear lobe.

Amandry 1953, 139, no. 278, pl. 52. Amandry 1963, 255 in no. I 278. Philipp 1981, 115, in no. 394. Here pp. 13, 32, 36 and for examples of another type with similar conical terminals p. 280.

59. Band earrings with trapezoidal terminals, c. 850 BC.

L. 6.5 cm. Grave to the NW of the Areopagos, south of the Agora. Athens, Museum of the Ancient Agora J148.

Comprise a strap and a trapezoid plaque of sheet gold. The strap is formed from three twisted wires. Two of these wires, longer than the third and each twisted in the opposite direction, so as to form a kind of braid together, are folded at the end of the strap, forming a loop, and brought backwards, thus surrounding the third, central wire which is doubled over. Interposed between the central wire and the outer ones is a plain flat wire, just like that which surrounds the whole of the strap. The trapezoid plaques are divided by two zones of rows of granulation and wires, into three fields bearing a guilloche. Soldered to the bottom are three pomegranates with granulated triangles or leaves on their upper part. The earrings from the Agora are for the period under consideration the earliest examples in Greece of composite jewellery featuring filigree decoration and granulation, for which reason some scholars have suggested they were made by a Phoenician goldsmith or were imported from Cyprus. However, techniques are soon learnt by adept craftsmen, and since both the decorative conception and motifs are purely Attic, and such examples are unknown from the East, a problem only arises if the earrings are not attributed to an Attic workshop. The straps, reported to have been found folded, must originally have formed a circle, as in the Archaic band earrings of Macedonia (figs 61-62, 65). It should be noted that earrings with one terminal emphasized are a quintessentially northern artistic idiom.

E. Smithson, *Hesperia* 37, 1968, 111ff., no. 77, pls 30, 32. Coldstream 1979, 56, fig. 13. J.N. Coldstream, *Hesperia* 64, 1995, 397ff., pl. 99a-b. Boardman 1970, 108. Kurtz - Boardman 1971, 62. Hampe - Simon 1980, 198ff., figs 320- 321. Higgins 1980, 97ff., pl. 13D-E. Deppert-Lippitz 1985, 58ff., fig. 24. J. Boardman, *OxfJArch* 9, 1990, 178. Here pp. 14, 22, 23, 32, 36, 226-227 on no. 75, 238 on no. 108.

60. Band earrings with spiral ornaments on the terminals, second or third quarter of 6th century BC.
L. 23.5 cm. Macedonia. Athens, National Archaeological Museum Στ175 (H. Stathatos Collection).

Comprise a strap narrower in one section and wider in the other. The narrow section is made from a sheet-gold band bordered by one plain and two twisted wires, forming a loop at one end. The wider section is made from two bands alternating with three zones of wire guilloche, defined right and left by twisted wires, which end forming nine spiral ornaments decorating the tongue-shaped terminal. This wider section is consolidated widthwise by three reinforcing bindings of two twisted wires. Groups of four globules in pyramidal arrangement embellish the spiral ornaments, the bindings and the medial guilloche. The straps formed a circle, as on the examples found at Sindos and Toumba, Thessaloniki (figs 61-62, 65). Soldered to the back of the medial guilloche is a hook to which the loop at the narrow end of the strap was fastened. The earrings in the Stathatos Collection give the impression that they are among the earliest examples of their kind.

Amandry 1953, 42ff., nos 65/66, fig. 22d, pl. 15. On earrings of this type: R. Laffineur, *BCH* 103, 1979, 217ff. A. Despini in *Ancient Macedonia* IV, 1986, 162ff. Here pp. 22, 32.

61. Band earrings with floral terminals, last quarter of 6th century BC.
Diam. 4 cm. Grave 48, Sindos. Thessaloniki, Archaeological Museum 8045-8046.

Comprise a filigree band with a gradually tapering plain wire guilloche framed by three wires terminating in a link at the narrow end. The eyes of the guilloche are embellished with a tiny circle of spiral-beaded wire and the broad terminal of the band is decorated with a composite flower, based on a cut-out rosette, its petals outlined with plain and spiral-beaded wire. At the centre is a tube, the top of which is cut vertically in six places to form an equal number of petals, unfurling downwards and likewise outlined with double wires. At the nucleus of the blossom is a conical rosette. The ends of the band next to the flower bear four globules in pyramidal ar-

rangement. Preserved on the back of rosette 8045 is a hook that fastens in the link at the narrow end of the band. The earrings perhaps hung from this hook or more probably from a fine link passed through the ear lobe.

Σίνδος 1985, no. 512. A. Despini in *Ancient Macedonia* IV, 1986, 159ff., pl. 2a. Here pp. 22, 32, 44.

62-63. Band earrings with floral terminals, c. 510 BC.
Diam. 5.7 and 5.5 cm. Grave 67, Sindos. Thessaloniki, Archaeological Museum 7975.

Similar to the earrings in figure 61 but more ornate. The nucleus of the flower consists of a granulated cone with a globule at the apex. The ends of the band beside the rosette are embellished with two smaller flowers identical to the large one, and four globules in pyramidal arrangement. The earrings were found close to the skull of the deceased woman in the position of the ears, as were the other related examples from the Sindos cemetery. These are the most precious and elaborate earrings of this category.

Σίνδος 1985, no. 321. A. Despini in *Ancient Macedonia* IV, 1986, 159ff., pl. 2c. *Oro dei Greci* 1992, 268ff., no. 143, 4. Here pp. 22, 32, 44.

64. Band earrings with circular terminals, last quarter of 6th century BC.
L. 19 cm. Macedonia. Athens, National Archaeological Museum Στ169 (H. Stathatos Collection).

Comprise a band with a wide and a narrow end, wrought entirely in filigree technique. The basic decorative element is the plain wire guilloche utilized in three zones at the broad end. The guilloches are framed and separated by four groups of three wires that unite to form a loop at the narrow end of the band and describe a circular terminal at the wide. This terminal and the contiguous section of the band are decorated with groups of four globules in pyramidal arrangement. The earrings formed a circle, just like those from Sindos and Toumba, Thessaloniki (figs 61-62, 65). This pair is a plain yet elegant example of band earrings.

Amandry 1953, 42, nos 59/60, fig. 22b, pl. 14. Here pp. 22, 33.

65. Band earrings with wheel-shaped terminals, early 5th century BC.
Diam. 5.5 cm. Grave at Toumba, Thessaloniki. Thessaloniki, Archaeological Museum 753 (5432).

Comprise a band of fourteen parallel beaded wires gradually decreasing in number. At the narrow end is a small loop. At the wide end the band bifurcates to form a circular terminal bearing a cross of two double wires, its ends embellished with globules as is the contiguous end of the band. A second, similar but badly damaged pair of earrings in the Thessaloniki Museum (inv. no. 754), was recovered from the same cluster of Late Archaic graves uncovered at Toumba, Thessaloniki. An unpretentious example of the category of Macedonian band earrings.

Θεσσαλονίκη 1986, 94, fig. 78. Here pp. 32ff. On the Toumba graves:. Χ. Μακαρόνας, Μακεδονικά 1, 1940, 476. Θεσσαλονίκη 1986, 88ff., figs 70-80. For comparanda see here p. 280.

66. Double wire earrings with bilobe terminals, early 5th century BC.
Diam. 5 and 5.3 cm. Unknown provenance, perhaps Macedonia. Athens, National Archaeological Museum Στ181 (H. Stathatos Collection).

Each earring comprises a doubled spiralling wire, the two ends of which are curved to form a bilobe, quasi heart-shaped terminal decorated with four globules. There are very few examples of earrings of this class in gold, the majority are of silver. The origins of earrings with only one end emphasized are sought in examples from Central Europe. Direct ancestors of double-wire earrings are a certain type that appeared in Greece in Late Mycenaean times and continued into the Geometric period, the duration of which was much greater in Macedonia than in Southern Greece. The earrings in the Stathatos Collection are perhaps of Macedonian provenance. The examples known so far from this region date back to the Late Archaic period, such as a silver pair from Toumba, Thessaloniki and another from Epanomi. On these last the suspension loop that passed through the ear lobe is preserved.

Amandry 1963, 197ff., nos 110/111, pl. 30. R. Laffineur, *BCH* 104, 1980, 358 n. 61. Here p. 33. Toumba earrings: Θεσσαλονίκη 1986, 94, no. 755. Epanomi earrings: Μ. Τσιμπίδου-Αυλωνίτη, *AEMΘ* 3, 1989, 322ff., fig. 8. For other comparanda here p. 280.

67. Earrings with three cones of coiled wire, 875-850 BC.
H. 1.5 cm. Lefkandi, Euboea. Eretria, Archaeological Museum.

Comprise a tapered wire hoop with crossed ends at the top. Soldered to the bottom are three conical appendages fashioned from coiled wire. Filigree technique was perhaps used here because it was easier than granulation which was more usual for conical pendants (see fig. 68). Though the wire of the hoop is fine and could pass through a hole pierced in the ear lobe, the crossed terminals constitute an obstacle and it is quite possible that these earrings also hung from a link passed through the ear lobe.

M.R. Popham - E. Touloupa - L.H. Sackett, *BSA* 77, 1982, 217 (nos 40-41), 236, pls 17 and 30b, and *Antiquity* 56, 1982, pl. 23c. *Oro dei Greci* 1992, 97, 240, no. 38. Here pp. 22, 33.

68. Earrings with three granulated mulberries, 875-850 BC.
Diam. 1 cm. Grave at Lefkandi, Euboea. Eretria, Archaeological Museum 8644.

Comprise a tapered wire hoop with crossed ends at the top. Soldered to the bottom are three 'mulberries' formed from three vertical rows of granules. These appendages are exceptionally interesting because they perhaps represent the earliest examples of granulation to appear in Greece after the Late Mycenaean period. The type of earring with a mulberry appendage is known from the sixteenth century BC, with parallel development in Syria, Cyprus and Crete. There is a Late Mycenaean earring with four mulberry-shaped appendages in the Benaki Museum and the craftsman of the earrings examined here was probably connected with such a tradition. The 'τρίγληνα μορόεντα' mentioned in the Homeric epics (*Iliad* XIV 183, *Odyssey* xviii 298), that Eurydamas, one of the suitors, is ready to offer Penelope, were perhaps of this form. The number of

pendants may well have been associated with locality and workshops, since Lefkandi is the provenance of another similar pair of earrings with three appendages, though these are fashioned in filigree technique (fig. 67).

Lefkandi I, 171 (nos 10-11), 221, pl. 231d. Higgins 1980, 106, pl. 16C and *BSA* 77, 1982, 236. Deppert-Lippitz 1985, 63, fig. 28. Here pp. 24, 33, 36 and for precursory forms with one pendant p. 284. The Late Mycenaean earring 2089 in the Benaki Museum: *BCH* 62, 1938, 448, pl. 48, no. 5.

69. Earrings with conical pendant and Mistress of Animals (Potnia Theron), third quarter of 7th century BC.
H. 4.3 cm. Argos. Athens, National Archaeological Museum Στ309 (H. Stathatos Collection).

Each earring comprises a cone, the upper part of which is covered by a circular sheet encircled by a ring of one beaded and one 'rope' wire, on which stands a Mistress of Animals (*Potnia Theron*). The cone is fashioned from six columns of globules diminishing in size towards the bottom, to which is attached a pomegranate finial of sheet metal with the characteristic crinkled surface of the fruit. The Mistress of Animals, a daemonic figure with power over Nature and protective qualities, is here clad in a girdled peplos bearing the same engraved decoration front and back: two rows of three circles above and net pattern below. The goddess has long hair dressed in the so-called Daedalic manner and wears a diadem. Resting on her shoulders are the forepaws of two lions, rampant on a circular pedestal, the head turned outwards. The facial features of both the goddess and the beasts are cursorily rendered. The beaded wire loop above the shoulders of the figure was used for the suspension of the jewel, probably from a link passed through the ear lobe (the little wire links are a later addition for display purposes). The Argos earrings occupy an important place in the history of the evolution of this class of jewellery (see figs 70-74).

Amandry 1953, 29ff., nos 43/44, pl. 10. Higgins 1980, 103, no. 4. Philipp 1981, 121. Here pp. 14, 23, 33, 280, cf. also the conical pendants in fig. 113.

70. Earring with pyramidal pendant and snake, late 5th - first quarter of 4th century BC.
H. 3.5 cm. Unknown provenance. Athens, Benaki Museum 1573.

Comprises a suspension hook and a pyramidal pendant with conical end. The upper part of the pendant is decorated with a series of leaves reminiscent of an Ionic cymatium. The conical finial is completely coiled with dense parallel rows of wire. The middle section of each side comprises four coarse globules with a six-petalled – formerly enamelled – rosette in the middle. The ornament is crowned by the daemonic figure of a coiled snake, the upper body of which forms the suspension hook of the earring. The clean lines and austere aesthetic of this piece place it among the earliest and most imposing examples of the type in gold.

Segall 1938, 62, no. 52, pl. 20. Deppert-Lippitz 1985, 126, fig. 74. *Gold of Greece* 1990, pl. 16. Here p. 33.

71. Earrings with pyramidal pendant and Nike playing 'knucklebones' (astragalizousa), third quarter of 4th century BC.
H. 5.7 cm. Kalymnos. Berlin, Antikenmuseum Misc. 10823 a-b.

Comprise a disc masking the suspension hook and five pendants. The disc is embellished with a rosette encircled by a zone of vegetal spirals and lotus buds in fine, calligraphic filigree technique. The main one of the five pendants, typical of this class of earrings, is the middle pyramid that serves as a pedestal for a sheet-gold winged figure of Nike, poised to throw spherical *pentobols* held in her right hand. Hanging from chains are another four sheet-gold pendants: two dancing girls, in a type familiar from terracotta figurines of the fourth century BC, and two *plangones*, nude female figures to the knees, best known from terracotta grave goods and fourth-century BC funerary stelae. The *astragalizousa* is likewise directly related to a much beloved coroplastic type, most probably crystallized in the first half of the fourth century BC, perhaps deriving from a painted model: the representation of Pandareos' daughters, wards of Aphrodite according to myth, who were painted by the great Polygnotos 'playing knucklebones' in

the Netherworld, in his famous painting of Nekyia at Delphi. In general the game of knucklebones, played also by Eros, was associated with Aphrodite and its representation alludes to life in the Netherworld. The Kalymnos earrings are crafted in a delicate manner with particular attention to the modelling of the figures, especially that of Nike.

Greifenhagen 1975, 50, pl. 40, 4, col. pl. III, 15. Hoffmann - Davidson 1965, no. 20. Higgins 1980, 162, pl. 48D. Cf. the earrings: Williams - Ogden 1994, nos 49-50. Here pp. 15, 34. On the type of the *astragalizousa*: B. Neutsch, *Studien zur vortanagräisch-attischen Koroplastik*, 1952, 54ff. On the meaning of the figures playing knucklebones: E. Buschor, *Grab eines attischen Mädchens*, 1962, 60. On *plangones*: Segall 1966, 25ff., 38.

72. Earrings with palmette-crowned pyramidal pendant, last quarter of 4th century BC.
H. 6.4 cm. Kyme, Aeolis. Berlin, Antikenmuseum Gl165/6 (Misc. 7035).

Comprise the disc concealing the suspension hook and five pendants, the central one of which is pyramidal – a typical element of earrings of this class (see figs 70-71) – with conical finial. The multi-petalled four-tier rosette at the centre of the disc is surrounded by a finely-wrought wreath of filigree palmettes alternating with bell-shaped flowers. The pyramidal pendant is crowned by small palmettes and rosettes, as if there were a garden upon it, culminating in a large enclosed palmette articulated in the system of suspending the cone from the disc. Also hanging from the disc are two *plangones*, as in the earrings in figure 71, and below these, from two chains, two Erotes 'turning the wryneck' (jynx), a magic wheel which turned with the tautening or loosening of two strings, thus attracting the person desired. The theme belongs basically to the cycle of Aphrodite (see fig. 206). In general, there exist in this vivid figurative ornament imperceptible hints that are more overtly expressed in another analogous example in the Benaki Museum (fig. 73), on which the female figure with the lyre is represented as a Muse in a transcendental setting.

Greifenhagen 1975, 49, pl. 40, 1. Idem, *Schmuck der alten Welt*, 1979, 36. Hoffmann - Davidson 1965, no. 19. Higgins 1980, 162. Here pp. 33, 34.

73-74. Earrings with pyramidal pendant and Muse, last quarter of 4th century BC.
H. 5.1 cm. Unknown provenance. Athens, Benaki Museum 2101.

Comprise a disc, to which the suspension hook is soldered, and five pendants. The disc is very lavishly decorated with an impressive double multi-petalled rosette at the centre (cf. figs 84 and 85) and the remaining surface covered with a host of tiny rosettes and vegetal scrolls. The same floral milieu is developed upon the pyramidal pendant, as if creating a garden in which sits a female figure of sheet gold with embossed details. She wears a chiton and himation, and holds a lyre that characterizes her as a Muse. Representations of Muses are quite a frequent theme on jewellery of this period – such as the boat-shaped earrings from Madytos and Chersonesos in the Crimea, and diadems too (figs 23-24) –, as well as featuring in other artistic genres from even earlier, alluding to a beautiful and resplendent place beyond this world. The other four pendants flanking the pyramid are vase-shaped: two small and plain, and two large with embossed foliate decoration and two volutes beside the neck imparting the form of an amphora. The earrings in the Benaki Museum are most probably from an East Ionian workshop.

BCH 63, 1939, 288, pl. 52b. AA 1940, 143, fig. 16. Δελήβορριάς 1980, 24, fig. 8. *Gold of Greece* 1990, pl. 25. Here pp. 15, 33, 34. On the earrings from Madytos see Williams - Ogden 1994, no. 63 and from Chersonesos Pfrommer 1990, 204ff., pl. 27, 5-6. On the meaning of the representation of a Muse in general see E. Buschor, *Grab eines attischen Mädchens*, 1962, 57.

75. Crescentic earrings, early 8th century BC.
H. 6.2 cm. The so-called Isis Tomb at Eleusis. Athens, National Archaeological Museum A10960.

The main body of the earring is a stout gold sheet in the shape of a crescent moon, extravagantly decorated in granulation technique: tongue pattern and zigzag cover the interstices between three shallow mounts, the middle one of which has the distinctive shape of a *pelta*, a specific type of shield. The mounts, formed from flat wire, were originally set with stones, possibly amber or rock crystal. Seven short chains (two are missing

from each earring), formed from three twisted parallel wires soldered together, end in a tiny cylindrical finial originally inserted in a small globular amber bead (one was preserved *in situ* when the earrings were discovered in the tomb). The cylinder with the bead and its separate lower section rendered a pomegranate, as possibly on two Attic necklaces (figs 108, 130. Cf. the pomegranates fig. 59). A pair of similar earrings found at Eleusis, another at Anavyssos and a single earring now in the British Museum are all products of Attic workshop provenance with Eastern influences.

Α.Ν. Σκιάς, *AE* 1898, 106, pl. 6.6. Higgins 1980, 98, pl. 13G. Deppert-Lippitz 1985, 71ff., fig. 32 above. Here pp. 13, 14, 22, 23, 34, 36, 238. Parallels: R. Higgins, *BSA* 64, 1969, 145ff., pl. 35. Ν. Βερδελής - Κ. Δαβάρας, *ΑΔ* 21, 1966, Χρονικά, 98, pl. 95α.

76. Earrings with the Rape of Thetis, second quarter of 5th century BC.

H. 4.8 cm. Grave at Eretria. Athens, National Archaeological Museum Χρ928.

Comprise three separate parts: a triple rosette that partially masks the suspension hook, a modelled representation in the middle and, lastly, a non-typical *pelta*-shaped device ornately embellished with twisted and beaded wires and a palmette springing from a pair of S-shaped volutes. Five short chains hang from the *pelta* (two are missing from each earring) and each ends in a cockle pendant, identical to those encountered on other jewellery from Eretria (see fig. 79). Represented in the middle section of the earring is a bifacial rape scene: a fleeing female figure struggles to escape the embrace of a male half-kneeling beside her back leg. A lion in front of her and three coiled wire snakes assist the interpretation of the scene: it is the rape of Thetis by Peleus. The myth relates that the enamoured King of Phthia, eponymous hero of Pelion, lay in wait for Thetis and abducted her one night with full moon. In her effort to escape the mortal groom, the goddess metamorphosed successively into fire, a lion, snakes and water. Finally, thanks to Peleus' persistence, she remained a woman and so he fathered Achilles. The motif of motion and the drapery of the goddess's garment bring to mind sculpted works, such as the well-known 'fleeing maiden' of Eleusis and other related statues in the Severe Style. The figure of Peleus is comparable with the terracotta 'Melian' reliefs. The earrings are unique in terms of subject and were crafted by a highly accomplished Eretrian goldsmith with restive spirit, a credit to the long tradition of the workshops in the region.

Παπαβασιλείου 1910, 78, pl. ΙΣΤ, 1. S. Casson *JIAN* 20, 1920/21, 89ff., pl. II, 2-3. Χρ. and Σ. Καρούζου, *Ανθολόγημα θησαυρών του Εθνικού Μουσείου*, 1981, 47ff., pl. 42. E. Walter-Karydi, *AA* 1994, 363ff., fig. 9. Here p. 34. Eleusis kore: B. Sismondo Ridgway, *The Severe Style in Greek Sculpture*, 1970, 26, figs 36-37. Melian reliefs: P. Jacobsthal, *Die melischen Reliefs*, 1931, 23ff., nos 14-15, fig. 2, pl. 8.

77. Boat-shaped earrings with granulated circles, late 6th century BC.

H. 2.3 cm. Unknown provenance. Athens, Benaki Museum 1532.

Comprise a boat-shaped body of sheet gold and a wire suspension hook. Both faces of the boat are decorated with three circles in granulation technique encircling a central boss, thus giving the impression of stippled rosettes. The curvilinear outline of the ornament is described in granulation, while the horn-shaped ends are surrounded by a ring with horizontal central groove in which is placed beaded wire. Circles formed from beaded wire constitute part of the decoration on some necklace pendants (figs 115, 118-120). The earrings in the Benaki Museum are a modest early example of a type of Eastern provenance that appeared at Ephesos during the seventh century and in the rest of Greece in the sixth century BC.

Segall 1938, 22, no. 15, pl. 4. Blanck 1976, 23 n. 9, fig. 5a, 1. *Gold of Greece* 1990, pl. 11. Here p. 34. On boat-shaped earrings: Amandry 1963, 218 n. 3. Higgins 1980, 125ff. Pfrommer 1990, 197ff.

78. Boat-shaped earrings with cock-horse (hippalektryon), late 6th century BC.

H. 3.5 cm. Spata, Attica. Athens, National Archaeological Museum Στ237 (H. Stathatos Collection).

A boat-shaped body is formed from slightly convex cutout crescents of sheet gold. On both faces of the orna-

ment a row of double twisted wires frames the upper and the lower outline, while another row in the middle, following the curve of the boat-shaped body, divides the surface into two decorative zones. On each row of wires are dependent granulated triangles. The horn-shaped ends of the boat are encircled by a ring formed by larger granules. The middle of the hollow of the boat is occupied by a three-dimensional sheet-gold figure of a cock-horse (*hippalektryon*), an imaginary animal half horse, half bird, with engraved details. The earrings from Spata are for the present the earliest example of a particular type of boat-shaped earrings that developed apace, mainly during the fourth century BC (figs 79-86).

Amandry 1953, 140, nos 282/83, pl. 52. Miller 1979, 8, pl. 3c. Higgins 1980, 125. Here p. 34.

79. Boat-shaped earrings with siren and cockle-shell pendants, late 5th century BC.
H. 6 cm. Eretria. London, British Museum 1653/54.

Comprise a rosette covering the suspension hook and a boat-shaped body of sheet gold. The nucleus of the rosette is a smaller one, originally with enamelled petals – perhaps alternating blue and green. All the leaves are outlined in beaded wire. A row of three twisted wires framed by two beaded ones divides the surface of the boat into two zones, both decorated with a dense pattern of S-shaped volutes, upright and in pairs. The horn-shaped ends are ringed by an annulet of globules crowned by a rosette. The space between them is entirely filled by a diminutive gold-sheet siren with outspread wings and embossed details on the obverse. Hanging from the bottom of the boat are four short chains, each holding a hollow cockle-shell, as on the earrings in figure 76. The earrings with siren are not only an exceptionally dainty piece of jewellery but also occupy an important place in the evolutionary course of ornaments of this type. In relation to the preceding examples (fig. 78) the decoration of the surface in two zones remains, but the suspension of the boat from the rosette, the decoration of its horn-shaped ends (with smaller rosettes), and the addition of the chains with the

pendants are new elements which henceforth became standard for earrings of this kind.

BMCJ 1911, nos 1653/54, pl. 30. Miller 1979, 8, pl. 3d. Higgins 1980, 125, pl. 24E. Deppert-Lippitz 1985, 149ff., fig. 128. Williams-Ogden 1994, no. 9. Here p. 34.

80. Boat-shaped earrings with siren and vase-shaped pendants, second quarter of 4th century BC.
H. 7.5 cm. Grave at Vratsa, NW Bulgaria. Vratsa, Local Historical Museum B60.

Each earring consists basically of a disc covering the suspension hook and a boat-shaped body. As on the earlier earrings from Eretria (fig. 79), the boat is decorated in two zones with similar filigree volutes. Here too there are two rosettes on the horn-shaped terminals and the three-dimensional figure of a siren. Among the new elements are the garland over the convex surface of the boat, with seven rosettes from which hang chains with vase-shaped pendants, as well as the suspension disc which now includes a two-tier rosette flanked by a zone of filigree rinceaux. The disc is encircled by a complex granular band, henceforth a permanent element of earrings of this type. In contrast to the refined and richer sense of East Greek goldsmithing, to which Bulgarian scholars turned initially for the stylistic classification, the form and workmanship of the Vratsa earrings point rather to workshops in the northern coastal cities of the Euxine Pontus (cf. fig. 83), where Eretrian goldsmiths may well have worked in the fifth century BC, as has been observed also for certain pieces of jewellery from Nymphaion in the Crimea (see p. 246 in no. 137).

I. Venedikov - T. Gerassimov, *Thrakische Kunst*, 1973, 78, 346, fig. 196. Hoddinott 1975, 79, pl. 51. *Gold der Thraker* 1979, no. 296. Deppert-Lippitz 1985, 181ff. Pfrommer 1990, 197ff., pl. 31, 6. Here pp. 34, 37, 38. On the jewellery from Nymphaion: Vickers 1979, 42 in pl. XIa-b.

81. Boat-shaped earrings with three palmettes on a lyre-shaped ornament, c. 330 BC.
H. 9.5 cm. Grave Z at Derveni, Thessaloniki. Thessaloniki, Archaeological Museum Z8.

Like the preceding examples the earrings consist basic-

ally of a disc covering the suspension hook and a boat-shaped body. The rosette, typical of these items of jewellery, has fallen from the middle of the disc. Developed around its position is a floral wreath of six sheet-gold, free, flaming palmettes alternating with an equal number of rosettes. The boat-shaped body preserves the division into two decorative zones now covered in granulation in rows of lozenge motifs. The hollow of the boat is occupied by a composite lyre-shaped device comprising two pairs of S-shaped volutes upholding three fine, double flaming palmettes with foliate granular nucleus, surrounded by lotus buds and leaves. Two like single palmettes adorn the horn-shaped terminals of the boat, together with an elaborate ensemble of wire rinceaux and rosettes that develops freely beyond the bounds of the boat up to the height of the suspension disc. On the lower part of the boat nine rosettes mask the points of attachment of the nine chains ending in vase-shaped pendants, five large with ribbed body and foliate decoration, and four small and plain. Even smaller vases with horizontal grooves on the main face hanging directly from links between the rosettes survive, two on one earring and four on the other. Of the latter four, one has two globules on the wider upper part, revealing that the craftsman was cognizant of pendants in the form of a bee-woman (figs 82, 153).

X. Μακαρόνας, ΑΔ 18, 1963, Χρονικά, 194, pl. 229ϐ (they are mentioned as coming from the contents of the tomb E). *Treasures* 1979, no. 257, pl. 34. *The Search* 1980, no. 138, col. pl. 11. Pfrommer 1990, 201ff., pl. 31, 8. Here pp. 34, 37, 38.

82. Boat-shaped earrings with Nike driving a two-horse chariot, last quarter of 4th century BC.
H. 6.6 and 6.7 cm. Western Asia Minor. New York, Metropolitan Museum of Art 48.11.2-3.

The two principal elements of the earrings, the boat-shaped body and its suspension disc, are literally drowned in the effusive wealth of rosettes and ornate palmettes with impressive granulated nuclei. Behind the garland formed by the rosettes on the lower section of the boat, hangs the rich mesh of chains bearing larger and smaller vase pendants, and three miniature figures

in the form of a bee-woman, also encountered on a pair of earrings from Madytos and a contemporary necklace (fig. 153). The disc, standard element for the suspension of the main body of such pieces of jewellery, maintains its independence, while the boat-shaped body has virtually disappeared in the midst of the elaborate and intricate efflorescent assemblage. Within this riot of flowers that represents perhaps the extreme delicacy of the goldsmith's art, a new element appears that marks the beginning of the final phase (fig. 85) of earrings of this type: hovering within a transcendental environment between disc and boat is the apotheotic representation of a conventional two-horse chariot (*biga*) driven by a Nike. This is the period when the chariot with a Nike appears also as a three-dimensional pendant, as indicated by another type of earring now in Boston (cf. the later fig. 98). The earrings from western Asia Minor are a precious work of rare technical dexterity.

A. Oliver, *BMetrMus N.S.* 24, 1965/66, 272ff., figs 8-9. Pfrommer 1990, 240, pls 28, 2 and 31, 15. Williams - Ogden 1994, no. 70. Here pp. 15, 35, 37, 38. Madytos earrings: Pfrommer, op. cit., pls 26, 14 and 31, 14. Williams - Ogden, op. cit., no. 63. On the Boston earring see here pp. 234-235 in no. 98.

83. Boat-shaped earring with palmette in the hollow of the boat, 350-340 BC.
H. 9.5 cm. Grave at Kul Oba, near Pantikapaion (Kerch), Crimea. Saint Petersburg, Hermitage State Museum KO6.

One of the earrings from a pair discovered, it comprises a boat-shaped body and the suspension disc. The spare leaf-shaped rosette at the centre of the disc is surrounded by smaller rosettes alternating with four diminutive gold-sheet Nereids riding dolphins and bearing one of Achilles' weapons – cuirass, shield, helmet and greaves (see also fig. 213). The whole is framed by rinceaux and a zone of enamelled leaves that is defined by beaded and twisted wires. The surface of the boat is decorated with wire vegetal spirals in two zones, separated by another zone of enamelled leaves – as on the disc – and framed by beaded wires. From its lower section, behind a garland of eleven rosettes, hang chains bearing vase pendants in three sizes. The horn-shaped

terminals of the boat are embellished with four-tier rosettes, while the hollow is occupied by a double flaming palmette springing from an acanthus bush, which has replaced the daemonic figure on earlier pieces (figs 78-80). The uppermost palmette and most of the rosettes of the decoration are covered in light blue enamel, endowing the piece with a lively aspect. The Kul Oba earrings constitute a representative example in the development of this type.

Segall 1966, 20, pl. 21b. Artamonov 1969, 68, pls 221-223. Blanck 1976, 23, fig. 5b, 7. Pfrommer 1990, 201ff., 283, no. FK153, pl. 27, 1. Williams - Ogden 1994, no. 88. Here pp. 34, 37, 38.

84. Boat-shaped earring with two Nikai adjusting their sandal, c. 330 BC.
H. 9 cm. Grave at Kul Oba, near Pantikapaion (Kerch), Crimea. Saint Petersburg, Hermitage State Museum KO7.

Of the same type as the preceding examples. The decoration of the suspension disc remains in the earlier tradition with a conventional multi-petalled rosette at the centre surrounded by rinceaux (cf. fig. 83). The hollow top of the boat is occupied by a lyre-shaped device, as on the earrings from Derveni (fig. 81), though here it is more complex, embellished with lotus buds (one has survived) and very possibly crowned by a palmette, perhaps the same as the flaming palmettes atop the horn-shaped terminals of the boat. The decoration on the body, a typical pattern of granulated lozenges, is now developed mainly in one zone. The ornament includes figures modelled in the round, as on earlier pieces (figs 78-80), but in a different place – at the sides of the boat – and possibly with a different meaning. These are two winged Nikai, untying or adjusting their sandal with one hand, sitting left and right of the chains hanging from the disc. A later work of an old, experienced and highly accomplished craftsman.

Reinach 1892, 64, no. 4, pl. 19, 4. Artamonov 1969, 74, pl. 304. Blanck 1976, 23ff., fig. 7. Pfrommer 1990, 202, pl. 27, 4. Williams - Ogden 1994, no. 89. Here pp. 15, 34, 37, 38.

85. Boat-shaped earrings with four-horse chariot, warrior, Nike and two Erotes, late 4th century BC.
H. 9 cm. The cemetery at Theodosia on the SE coast of the Crimea. Saint Petersburg, Hermitage State Museum F1.

Flaming palmettes alternating with rosettes surround a popular ornament in this northern region of the Euxine Pontus, the virtually linear, multi-petalled rosette at the centre of the disc (see figs 83, 84, 86). Suspended from the disc is the characteristic boat-shaped body, which is completely covered with rows of miniscule granulated lozenges and embellished towards the bottom with the typical garland of rosettes, behind which hang chains bearing palmette, rosette and vase pendants. Essentially the boat has been transformed from a dominant element and bearer of a daemonic figure (see figs 78-80, 87), into a peculiar pedestal, the two horn-shaped terminals of which support the cymation-bearing base of a diminutive modelled group: a quadriga driven by a Nike and transporting a nude warrior with shield, while two Erotes flank the representation against a background of vegetal spirals, palmettes and rosettes that compose the decoration between the boat and the suspension disc. These earrings from Theodosia, together with other related ones with a quadriga driven by a Nike or Helios, constitute the *finale maestoso* in the long and illustrious history of this type (see figs 78-80, 83, 81, 84, 82).

L. Stephani, *CRPétersbourg* 1865, 38. Rosenberg 1918, 18, figs 29-30. Segall 1966, 25. Blanck 1976, 23, fig. 5b, no. 8. Deppert-Lippitz 1985, 183, fig. 120, nos 5 and 5a. Pfrommer 1990, 205, 288, no. FK170, pls 28, 1 and 31, 12. Here pp. 15, 35, 37, 38 and for parallels pp. 35 and 281.

86. Boat-shaped earrings with palmette in the hollow of the boat, last quarter of 4th century BC.
Great Bliznitsa, Taman peninsula, Euxine Pontus (Black Sea). Saint Petersburg, Hermitage State Museum BB114.

Comprise the disc concealing the suspension hook and the boat-shaped body with pendants. At the centre of the disc is a multi-petalled filigree rosette (missing from one earring), circumscribed by a zone of spiral wire motifs. In the hollow of the boat are three acanthus

leaves, from which springs a palmette whose base is formed from two large and two small volutes. On the horn-shaped terminals a rosette and scrolls with trefoil ornament mask the suspension wires from the disc. Soldered behind the typical row of rosettes on the convex end of the boat are the chains bearing two rows of vase-shaped pendants in two sizes, above which is a third one of even smaller vases with flat back. The decoration of the discs recalls that of earlier earrings of the third quarter of the fourth century BC (figs 83-84), but the shape of the boat, which is of limited dimension, as well as its decoration with a single zone of granulated lozenges, are comparable with later examples (figs 82, 85). The earrings from Great Bliznitsa may well be the work of an old and proficient goldsmith.

L. Stephani, *CRPétersbourg* 1869, 6, 18, pl. I, 12. Pfrommer 1990, 273, no. FK132, pl. 27, 2-3. Here pp. 35, 37, 38.

87. Boat-shaped earrings with hippocamp, c. 340-330 BC.
H. 4 and 4.3 cm, with the chain 8.4 and 8.7 cm. Grave A at Omolion, Thessaly. Volos, Archaeological Museum M49-50.

Both sides of the boat-shaped body are extravagantly decorated with filigree motifs. Multiple rows of granulation, together with rows of plain and twisted wires define two decorative zones on each side. On one side the enclosed palmettes of the lower zone dominate. On the other, the plain row of foliate motifs of the lower zone is enlivened by palmettes alternating with lotus blossoms in the upper one. An elaborate granulated ring, a typical element of earrings of this class, stresses the convex contour of the lower part of the pieces. Wedged in the upper part of the boat is a three-dimensional winged figure of a sheet-gold hippocamp, on which a bird perches (missing from one earring). In front of the legs of each hippocamp is a disproportionately large, inverted lion head which adorns one terminal of the boat (one is missing). The suspension hook ends in a snake head. A chain hangs from the two horn-shaped terminals of the boat. The Omolion earrings feature neither a suspension disc nor pendants – known from other pieces (figs 79-86). They continue the old tradition of boat-shaped earrings

(figs 77-78) and are among the loveliest examples of this class.

Δ. Θεοχάρης, *ΑΔ* 17, 1961/62, Χρονικά, 176, pl. 198α. Miller 1979, 7ff., pls 2-3a-b. Deppert-Lippitz 1985, 180, pls XIV-XV. Higgins 1980, 125. Here p. 35.

88. Boat-shaped earring with sitting Nikai, c. 330-320 BC.
H. 9.9 cm. Taranto. Taranto, Museo Archeologico Nazionale 110.090.

Hanging from a wire suspension hook is the characteristic boat-shaped ornament bearing numerous pendants. Both sides of the boat are divided into two sections by a column of three wires and decorated in filigree technique with palmettes and bell-shaped flowers. Its hollow is occupied by a pair of horizontal double volutes, from which springs a palmette with a rosette nucleus. Each of the two horn-shaped terminals of the boat is obscured by a large triple rosette, on the outside of which is a sitting figure of a winged Nike, clad in a long himation and reportedly holding a swan in her embrace. Below each Nike a smaller rosette conceals the suspension hook of the two extreme chains bearing vase-shaped pendants, and soldered below these is a sheet-gold dove. The remaining chains with pendants hang from another pair of double volutes attached to the bottom of the boat. There are smaller rosettes above the vase-shaped pendants. The earring is one of the most luxurious pieces of jewellery recovered from the cemeteries of ancient Tarentum in Magna Graecia. The type is also preserved in terracotta jewellery from the same region.

Ori di Taranto 1987, 154ff., no. 68. Deppert-Lippitz 1985, 183, col. pl. XVII. Guzzo 1993, 90, 251, fig. 43. Here p. 35.

89. Lion-head earring, c. 330 BC.
H. 2.2 cm. Grave H at Derveni, Thessaloniki. Thessaloniki, Archaeological Museum H4.

The tapering hoop is formed from a wire wound round a wooden core, still visible today. The wide end is fitted into a decorative cylindrical collar terminating in a lion

head. The animal is rendered with its mouth open and the tongue hanging out between two canine teeth. The increase of volume at one end is gradual, in contrast to most of the later examples in which the excessive size of the lion head detracts from the aesthetic impact. By displacing the mane behind, the craftsman was able to model all the plastic volumes of the feline head, which are either absent or neglected on other examples. Stylistically this diminutive work displays affinity with corresponding relief animals on the famous bronze krater from Derveni, the decoration of which is imbued with the spirit of Classical art of the fourth century BC. The Derveni earring is not only one of the best proportioned examples of the type, but also one of the earliest, as corroborated by the pottery found in the same grave.

Treasures 1979, no. 268. Here p. 35. On the pottery found in grave H: X. Μακαρόνας, *ΑΔ* 18, 1963, Χρονικά, 194 (referred to as finds from grave Z). G. Kopcke, *AM* 79, 1964, 33, no. 52. Βοκοτοπού-λου 1990, 25. On the animals on the bronze krater: E. Γιούρη, *Ο κρατήρας του Δερβενίου*, 1978, pls 10 and 49.

90. Lion-head earring, c. 320 BC.
Diam. 2.2 cm. Grave Γ at Sedes, Thessaloniki.
Thessaloniki, Archaeological Museum 5418.

An open hoop with lion-head finial. The hoop consists of four loosely twisted wires tapering gradually towards one end which has a pointed terminal. The wide end is inserted in a cylindrical collar decorated with three S-shaped volutes of twisted wire and a zone of ovolos on the side of the hoop. It ends in a relatively massive lion head with embossed details. The Sedes earring is one of the few early examples of the kind. It was found together with a gold eighth of a stater of Philip II, a clay pyxis and a skyphos that date the find.

N. Κοτζιάς, *AE* 1937, 882, fig. 14 right. *Treasures* 1979, no. 321, pl. 45. Deppert-Lippitz 1985, 223 (erroneous data on the coin). Pfrommer 1990, 150ff., 371, no. OR235, pl. 23, 4. Here p. 35. On the pyxis: G. Kopcke, *AM* 79, 1964, 28, 66, no. 23. *Ελληνικός Πολιτισμός* 1993, no. 272. Z. Kotitsa, *AA* 1994, 38, 48 with n. 156. On the skyphos: *Agora* XII, 1, 258 in no. 327. *Ελληνικός Πολιτισμός*, op. cit., no. 273. On the coin: *Τύμβος Νικήσιανης* 1992, 49.

91. Caprine-head earrings, second half of 3rd century BC.
Diam. 1.9 and 2 cm. Unknown provenance. Athens, Canellopoulos Museum 288.

Comprise a hoop ending in a caprine head. The hoop is formed from gold wires twisted together and ends at the narrow end in a pointed terminal, bent to secure the fastening. Its thick end is inserted in a ring with tongue pattern towards the hoop, affixed to which is a zoomorphic head of sheet gold. Details of the animal's features are denoted in relief, the hair is engraved, the tiny ears and plain horns are added, while the eyes were inlaid in the sockets. A much commoner type of terminal on earrings of this type is the antelope head with long antlers of beaded or spool wire that renders the transverse grooves of the natural ones. Such earrings have been found throughout the Mediterranean basin and the conception of the type can be traced back to the art of the Achaemenids. The caprine head is rare and is sometimes confused with that of the antelope, which may well have been the source of inspiration of the Greek goldsmith who fashioned these pieces. Despite their small scale, the earrings in the Canellopoulos Museum are a vital work displaying exceptional care in the depiction of details.

R. Laffineur, *BCH* 104, 1980, 398, no. 84, fig. 90. Here p. 35. Cf. Pfrommer 1990, 354, no. OR6, pl. 24, 12 top right.

92. Negro-head earrings, c. 230 BC.
H. 2 and 2.3 cm. The chamber of the Macedonian tomb at Aghios Athanasios, Thessaloniki. Thessaloniki, Archaeological Museum 10822.

Comprise a hoop ending in a negro head. The hoop is formed from a group of plain wires coiled around some stable core, in order to give the desired shape. It tapers towards one end where there is a pointed terminal. At the thick end is a ring of sheet gold, one edge of which has been crimped as a foliate ring with wire outlines. Inserted on the ring is the head of a negro, summarily carved from deep red garnet or sard yet with the facial features distinctive of the race. The tightly curled hair is rendered in a particular manner: single, very fine gold

wires coiled and then compressed are placed in rows one below the other. Wedged into the crown of the head is one end of the wire that forms the link for fastening the earring. Considered to be one of the earliest earrings with negro head, this is one of the most interesting examples of the type which, according to recent research, is of Macedonian conception.

Φ. Πέτσας, ΑΔ 22, 1967, Χρονικά, 399, pl. 303δ and Μακεδονικά 9, 1969, 168, pl. 75α. Treasures 1979, no. 329, pl. 44. Pfrommer 1990, 185, 388, no. OR459, pls 30, 60. Π. Θέμελης, Γ΄ Επιστημονική Συνάντηση για την Ελληνιστική Κεραμεική. Θεσσαλονίκη 1991, 1994, 155 with n. 32. Here p. 35.

93. Negro-head earrings, first half of 2nd century BC.
Diam. 2 cm. Grave at Veroia. Veroia, Archaeological Museum 1115.

Comprise a hoop ending in a head of a negro. The hoop was formed by coiling plain wires around a core. The narrow end is pointed and forms a hook. The wide one is inserted in a ring band decorated with wire roundels and long radiate leaves. Fitted to the upper terminal of the hoop is a negro head, roughly carved from red garnet or sard but with pronounced facial features, particularly the protruding jaw, everted lips and broad nose. The mass of hair is indicated cursorily in gold sheet on which embossed dots render the tight curls. A link on the crown of the head was used for fastening the earring. Negro-head earrings are a late variation of the type with lion-head terminal and were popular in Macedonia. In general negroes constituted a recurring theme in Hellenic art. The ancient Greeks used the blanket term 'Αἰθίοπες' (Ethiopians) for the dark-skinned peoples, a word already encountered on the Mycenaean tablets from Pylos.

Treasures 1979, no. 70, pl. 12. Pfrommer 1990, 185 n. 1157, 388ff., no. OR462. Here p. 35. On Ethiopians and the reference to them in the Pylos tablets: F.M. Snowden, Blacks in Antiquity, 1970, 1, 15, 102.

94. Lynx-head earrings, mid-2nd century BC.
Diam. 1.7 cm. Grave at Veroia. Veroia, Archaeological Museum M1207.

Comprise a hoop formed from plain wires coiled carefully around a core. The hoop tapers progressively to-wards one end which is bent to form a hook for fastening. The wider end is inserted in a collar band decorated with a ring of radiate leaves. Fitted to the outward side of the collar and carved in deep red sard is the head of a lynx, a wild animal with long jaw whiskers (see figs 128-129, 201). Its gleaming eyes led the ancient Greeks to believe it was possessed of supernatural powers. Sard was widely used in ancient jewellery even from the Late Bronze Age, the main source being India. The Greeks probably obtained the stone via Sardis, capital of Lydia, from which its name is derived.

Κ. Τσάκαλου-Τζαναβάρη, ΑΔ 37, 1982, Χρονικά, 300. Ancient Macedonia 1988, no. 320. Here p. 35. On sard: Furtwängler 1900, 385ff. Boardman 1970, 375.

95-96. Earrings with female-head pendant, c. 350 BC.
H. 6 cm. Crispiano, region of Taranto. Taranto, Museo Archeologico Nazionale 54.115A-B.

Comprise a disc concealing the suspension hook and three pendants. Dominating the surface of the disc is a large, multi-petalled rosette circumscribed by a zone of running spiral and concentric zones of plain, twisted and beaded wires, encircled by a granulated ring. The central pendant is a female head of sheet gold with embossed details and added ornaments. The hair is drawn around a fillet with engraved checkerboard decoration, visible above the forehead, while in the ears are earrings with rosettes from which hang pyramid pendants of granulation (two missing) and around the neck is a necklace with conical wire pendants rendered as leaves. Last, at the bottom of the neck is another necklace rendered in beaded wire with a central vase-shaped pendant (one missing) hanging from a rosette. The heads are framed by two strings of alternating biconical and spherical beads embellished with filigree leaves. The earrings were perhaps found together with the Crispiano diadem (fig. 39). The heads recall analogous pendants on the necklace in the British Museum (figs 138-139), said to have been found at Taranto. Earrings of similar type have also been found at Pantikapaion in the Crimea, as well as at other sites in the northern region of the Euxine Pontus.

Higgins 1980, 128, pl. 25B. *Ori di Taranto* 1987, no. 73. *Oro dei Greci* 1992, 158, 263, no. 123, 2. Guzzo 1993, 93, 251, fig. 44. Here p. 35. On similar earrings see Williams - Ogden 1994, no. 103.

97. Earrings with the Rape of Ganymede, last quarter of 4th century BC.
H. 5.5 cm. Near Thessaloniki. New York, Metropolitan Museum of Art 37.11.9-10.

The principal ornament of the earrings is a three-dimensional group of an eagle with Ganymede, hanging from an elaborate flaming palmette with granulated foliate nucleus and sheet-gold leaves edged with beaded wire. The group of two figures is cast, apart from the wings and tail of the eagle, and Ganymede's himation, which are of sheet gold. With unparalleled expressive impact, the miniscule sculpture represents the abduction of the blond son of Tros, mythical King of Troy, by the eagle of Zeus. The majestic bird, with its wonderful wings outspread, grasps in its legs the body of the comeliest of mortals, whom he carries up to Olympos. Ganymede, naked and holding a himation that passes behind his body, raises his one forearm and fondles the eagle's head. The gesture of tender embrace so overtly rendered leaves no doubt that it is Zeus himself in the guise of the eagle. Though the gifted creator of this miniscule group was perhaps inspired by the bronze sculpture by the Athenian Leochares, he nevertheless rendered the myth in his own personal manner. The representation here perhaps has another content: on funerary monuments the Ascent to Olympos symbolized the transition to another life from that on earth, to that among the immortals. This significance can be detected in the representations of certain other pieces of jewellery of the period (see p. 15). The Thessaloniki earrings occupy a special place among the loveliest works of the goldsmith's art.

G. Richter, *BMetrMus* 32, 1937, 290ff., figs 2 and 4. B. Segall, *BMusFA* 40, 1942, 50ff. Segall 1966, 27, pl. 45. Higgins 1980, 129, 164, pl. 48A. Deppert-Lippitz 1985, 226, fig. 163. Williams - Ogden 1994, no. 31. Here pp. 15, 35, 235 in no. 99. On the myth of Ganymede in ancient art see H. Ζερβουδάκη, ΑΔ 33, 1978, Μελέται, 36 with n. 77.

98. Earrings with Nike driving a chariot, mid-2nd century BC.
H. 8.6 cm. Grave near Pelinnaion, Trikala. Volos, Archaeological Museum M194-195.

Comprise a two-horse chariot (*biga*) driven by a winged Nike. The group, wrought from sheet gold, stands on an elongated plinth, embellished with filigree and granulated garlands, a typical element of many earring pendants from the second century BC onwards. The facial features and the clothing of the figure, as well as the seat of the chariot, are summarily rendered. The four-spoke wheels are connected by an axle of spiral-beaded wire also used for the pole of the vehicle. The horses gallop with their forelegs raised, beneath which the prow of a ship with high figurehead was chosen as a support, on both sides of which the apotropaic 'eye' – typical in this position – is rendered in granulation. Above the horses' heads and the suspension disc, that consists of a large circular 'eye' with blue glass-paste set in a gold mount edged with beaded wire, is a composite ornament. It constitutes a variant of the so-called Isis crown (see pp. 236 and 237. in nos 102 and 105), which is rendered conventionally with a leaf-shaped red stone in a gold mount, set above a crescentic mount, which was originally inlaid with a precious stone or glass-paste. This ornament, like the Isis crown, is a frequent crowning finial for earrings from the second century BC. According to one viewpoint, the goldsmith who crafted this type of earring had in mind some related monument set up to commemorate some victory on land and at sea. The ship-shaped support below the horses is certainly strange and anyway unique. It may well allude to a transcendental chariot that crosses land and sea. An analogous interpretation has also been proposed for the representation of a Nike driving a chariot, on another earring now in Boston. Chariots are known too from earrings of another type, where they are, however, incorporated in the decorative ensemble (figs 82, 85).

Δ. Θεοχάρης - Γ. Χουρμουζιάδης, *AAA* 3, 1970, 211, fig. 1. Miller 1979, 42ff., 61ff., no. Pel. J 4, pls 24c-d, 25. Deppert-Lippitz 1985, 262, col. pl. XXV, also with variations of the Isis crown with pls 195-197. The Boston earring: B. Segall, *BMusFA* 40, 1942, 50ff., figs 1-

3. Deppert-Lippitz 1985, 226, fig. 164. Interpretative problems: Segall, op. cit., 52ff. B. Schweitzer, *Platon und die bildende Kunst der Griechen*, 1953, 64ff. Here pp. 15, 35, 229 in no. 82.

99. Earring with siren playing a kithara, last quarter of 4th century BC.

H. 4.4 cm. Unknown provenance. New York, Metropolitan Museum of Art 08.258.49.

Comprises a magnificent double flaming palmette concealing the suspension hook, and the imposing figure of a standing siren stepping on a rectangular plinth. This hybrid figure, conceived in the fertile imagination of ancient peoples as a woman from the waist upwards but with the wings, tail and legs of a bird, is represented here as a mythical musician, as known on other monuments. It is fashioned from sheet gold in two pieces, the front and the back, while the wings, tail and legs are added and the details of the plumage chased. Also made of separate pieces of sheet gold are the plectrum the figure holds in the right hand, and the kithara with the side pieces, the resonator below and the cross-piece above, between which three of the seven strings of the instrument are still preserved. The strange musician wears a diadem and earrings, and the exquisitely tender female countenance contrasts sharply with the bestial legs. Some scholars attribute the piece to the same workshop as the Ganymede earrings (fig. 97). Sirens, daemonic winged figures, were regarded by the ancient Greeks as friendly and beneficient beings who stood by man in the life after death, which is why they were so often represented in sepulchral art. Some scholars have characterized sirens with musical instruments as Muses of the Netherworld.

B. Segall, *BMusFA* 40, 1942, 50ff., figs 4 and 6. Williams - Ogden 1994, no. 19, cf. also no. 114. Here pp. 15, 35, 251-252 in nos 158-159. On Muses of the Netherworld: E. Buschor, *Die Musen des Jenseits*, 1944.

100. Earrings with Nike holding a ribbon, c. 330 BC.

H. 4.8 cm. The Pavlovskij kurgan near Pantikapaion (Kerch), Crimea. Saint Petersburg, Hermitage State Museum Pav. 3.

Comprise a double rosette (missing from one earring), partially disguising the suspension hook, and a pendant in the form of a Nike. The Nikai have long hair falling in front on the shoulders and wear a polos, a girdled chiton and shoes on which all details are rendered even the soles. They hold a fillet in their raised hand, to which they turn the summarily rendered face. The figures are hollow and probably cast, the details worked by hand and suitable chisels. The raised arms and the wings are added. The hook on one earring had been broken and repaired in antiquity. It was perhaps then that the rosette and the wing from one Nike were lost. The earrings from the Pavlovskij kurgan are considered among the earliest examples of a class of Hellenistic earrings with a three-dimensional, usually winged, figure hanging from a rosette. Of these ornaments the most popular were those featuring Eros (see fig. 101). The placing to the fore of one leg of each Nike and the lower part of the pleated chiton that wafts behind attest the craftsman's desire to represent the figures in motion, as bearers of a distinguishing attribute, a victor's fillet (see concerning the representation of Nike p. 263 in no. 204).

Segall 1966, 26, 27, pl. 44. Deppert-Lippitz 1985, 188, 203, 222, 226, fig. 162. Pfrommer 1990, 251 with n. 2063. Williams - Ogden 1994, no. 107. Here pp. 15, 35.

101. Earrings with Eros, late 4th - early 3rd century BC.

H. 4.2 cm. Kyme, Aeolis. London, British Museum 1889/1890.

Comprise a disc covering the suspension hook and a pendant in the form of a small Eros. The decoration of the disc is apportioned in three concentric zones with granulated triangles in radiate arrangement, surrounding a central granulated nucleus as on the pendants of the necklace in figure 160. The little Eros is represented in flight and said to be holding a writing tablet. His hair on the forehead is gathered in a braid falling behind and the face is merry. On one figure the left leg is drawn behind, while the left arm is to the fore together with the corresponding part of the body that turns towards the projected right leg. Thus it is developed in space as a diminutive three-dimensional sculpture. On the other figure the correspondences are exactly the opposite. In general the rhythm of the movement and the plasticity

of the modelling, both of the face and the body, have been rendered with a care unusual in a host of similar examples. These earrings are among the best early examples of a type that was extremely popular throughout the Hellenistic period in numerous variations.

BMCJ 1911, nos 1889/1890, XXXVff., pl. 33. Higgins 1980, 163, pl. 47B. Here pp. 15, 35. On early examples see Greifenhagen 1975, 19, fig. 1. Δ. Τριαντάφυλλος, AA 29, 1973/74, 809, pl. 5978 (necklaces figs 125, 163-164 illustrated here are from the same tomb). Παπαποστόλου 1990, 110, 118ff., no. 25, fig. 25. On the type of the infant Eros: H. Döhl, Der Eros des Lysipp, 1968, 76ff., 85ff., 91ff.

102. Earrings with amphora-shaped pendants, second half of 2nd century BC.
H. 7 cm, l. of chain 43.3 cm. Unknown provenance, perhaps Egypt. London, British Museum 2331.

The disc at the top of the earring is dominated by a round, gold-mounted garnet circumscribed by a ring of granulated triangles and topped by the so-called Isis crown. The last is an ornament of Egyptian provenance that here preserves the typical elements: volutes supporting a pair of sheet-gold horns that themselves frame a round garnet from which spring two feathers. The central pendant of the earrings consists of an amphora-shaped device, the body of which is a deep red spherical garnet flanked above and below by two rings of granulated triangles. Its handles are two full-bodied miniscule gold dolphins. The whole stands on a rectangular plinth, a typical element of certain pendants of this period (fig. 105). Left and right hang two complex tassels of beads of coloured semiprecious stones. Attached to the plinth is a chain that joins the two earrings and which hung down on the chest. Both the amphora-shaped pendants and the disc with the Isis crown are elements that appeared on earrings of the second century BC. The specimens shown here are among the most finely wrought of the kind.

BMCJ 1911, no. 2331, pl. 51. E. Levy, BCH 92, 1968, 530, fig. 6. Deppert-Lippitz 1985, 261ff., col. pl. XXXI. Pfrommer 1990, 233 n. 1712. Here p. 35. On the Isis crown: Higgins 1980, 154. Deppert-Lippitz, op. cit., 262. With analogous crowning finial and chain are the earrings 1562 in the Benaki Museum: Gold of Greece 1990, pl. 37.

103. Earrings with goose pendants, first half of 2nd century BC.
H. 5.1 cm. Grave near Pantikapaion (Kerch), Crimea. Saint Petersburg, Hermitage State Museum P1845.1.

Comprise a complex ornament with a disc partially covering the suspension hook, and a pendant in the form of a goose. On the disc is a rosette with a granulated nucleus and leaves, once picked out in blue enamel, surrounded by a wreath of cut-out leaves and crowned by a high two-tiered palmette whose nucleus is covered by a central acanthus leaf, while its base is formed from two lateral leaves together with rosettes. Below the disc hangs the small goose, fashioned in white enamel, while the gold wings – preserved on only one earring – were covered with blue enamel and the smaller feathers with gold granules. On one earring the goose ruffles its feathers and turns its head ready to preen the left side. In both cases the geese wear two gold necklaces, one with triangular pendants and the other with spherical beads. Miniature winged creatures entirely of enamel as earring pendants are an innovation of the second century BC, known mainly from the northern shores of the Euxine Pontus and Southern Italy.

L. Stephani, CRPétersbourg 1870/71, 204, pl. VI, 13-4. N. Kondakof - J. Tolstoi - S. Reinach, Antiquités de la Russie Méridionale, 1891, 60ff., fig. 77. Minns 1913, 397, fig. 291. Here pp. 35, 248.

104. Earrings with dove pendants, 2nd century BC.
H. 3.7 and 3.5 cm. Taranto. Taranto, Museo Archeologico Nazionale 6.430A-B.

Comprise the suspension disc and three pendants, the middle one of which is a dove. On the disc is a two-tier rosette within a circle of triple wire surrounded by a foliate wreath. The dove, made of enamel, turns its head prettily to the side. The wings and their feathers, as well as the tail feathers, are outlined in gold wire, which also surrounds the bird's round eyes. Likewise of gold are the beak, the necklace of granulated triangles and the legs of spiral-beaded wire. The lateral pendants flanking the dove consist of double wire links forming chains ending in a bell-shaped flower. The Taranto earrings are one of the charming examples with enamel birds that de-

veloped in this period, primarily in Magna Graecia and the northern shores of the Euxine Pontus.

Ori di Taranto 1987, 169ff., no. 85a-b. Guzzo 1993, 104, fig. 57. Here p. 35.

105. Earrings with dove pendants, second half of 2nd century BC.
H. 6.5 cm. Artjukhov Barrow near Phanagoreia, Taman peninsula, Euxine Pontus (Black Sea). Saint Petersburg, Hermitage State Museum Art. 40.

Comprise a suspension disc and three pendants, the middle one of which is in the form of a dove. The disc is surrounded by a wreath of small cut-out leaves and decorated by a triple rosette, once with enamelled radiate leaves and a garnet nucleus. Above the disc is the so-called Isis crown, consisting of two gold horns framing a round sard at the base with two enamelled feathers above. Below the disc hangs the principal ornament of the earring, an enamel dove with white body and green wings and tail. The beak, eyes and legs are of gold. The bird stands upon a rectangular plinth and is flanked right and left by a chain ending in a garnet bead. The dove was the best loved of all birds in the art of jewellery, as well as on funerary stelae where it is frequently encountered. This preference is attributed to the bird's association with Aphrodite, but beyond any symbolism this association implicates, the dove of all winged animals familiar to man, it is the one that then too evoked the greatest tenderness and sympathy.

L. Stephani, *CRPétersbourg* 1880, 74ff., pl. III, 4-5. Minns 1913, 430, fig. 321. Higgins 1980, 164, pl. 48B. Pfeiler-Lippitz 1972, 110, 115. On the symbolism of the dove: Αικ. Κώστογλου-Δεσποίνη, *Προβλήματα της παριανής πλαστικής του 5ου αιώνα π.Χ.*, 1979, 113ff. Here p. 35.

106. Four-spiral pendant, c. 800 BC.
W. 2 cm. Anavyssos, Attica. Athens, National Archaeological Museum Χρ1520.

The pendant comprises a lengthwise cylindrical bead the ends of which are surrounded by double wire, and a pair of spirals soldered above and below it. Each pair of spirals is formed from a single wire, the two ends of which are coiled while the middle section forms a small arc, so that the whole is spectacle-shaped. Four-spiral ornaments of this kind, with variations in the arrangement of the spirals, are known from Mycenaean times. Single ones, such as that from Anavyssos, were most probably used as medallions. Several together formed a necklace, as attested by relevant finds from Lefkandi on Euboea, the Idaean Cave in Crete and in all likelihood some similar four-spiral ornaments from Skyros.

Ν. Βερδελής - Κ. Δαβάρας, *ΑΔ* 21, 1966, 98, pl. 95α. Higgins 1980, 100. Necklace from Lefkandi: *ARepLondon* 1986/87, 13 jacket photograph. Here pp. 13, 36 and other parallels p. 281.

107. Chain necklace with pendant, c. 800 BC.
L. 36 cm, w. of pendant 6.8 cm. Grave at Tekes, Knossos. Herakleion, Archaeological Museum X648.

Comprises two cord-chains (for their manufacture see p. 23f.) terminating in snake heads from which hangs a half-moon pendant of sheet gold. The pendant is framed by three pairs of braided wire, thus forming a mount in which a rock crystal is set. Added ornaments above the crescent, together with one rectangular and two disc mounts, once set with amber, create a complex whole. Hanging below from three pairs of chains are an equal number of sheet-gold crescents with granulated border and a circular mount that was perhaps inlaid with amber. The rectangular and circular mounts are made of gold sheet bordered by flat wire. The necklace was found in a grave along with other pieces of jewellery. The motifs and the shape of the pendants are common in Syro-Palestinian art, which led to the jewellery being attributed to a foreign workshop established in Crete. According to another viewpoint, however, the presence of Cretan elements as well in the jewellery ensemble can only be explained satisfactorily by their creation in a Cretan workshop receptive to Oriental influences. That is, the phenomenon that runs also through Greek art in the ensuing years can be ascertained in this piece.

J. Boardman, *BSA* 62, 1967, 63, 68, no. 1, pls 7 and 10. A. Lebessi, *BSA* 70, 1975, 173ff. Eadem, *Στήλη. Τόμος εις μνήμην Ν. Κοντολέοντος*, 1980, 94 n. 32. Higgins 1980, 109, pl. 17C. Deppert-Lippitz 1985, 66, col. pl. II. Here pp. 14, 22, 23, 36, 40, 252 in no. 161.

108. Necklace with globular beads and cylindrical pendants, 8th century BC.
H. of pendants 3 cm. Possibly from Attica. London, British Museum 1960.11-1.20-21 (Elgin Collection).

The necklace is composed of fourteen globular beads alternating with tiny chains from which hang cylindrical pendants. The beads are of sheet gold and embellished with parallel impressed grooves. The cylindrical pendants are compressed at the bottom into four folds. From their similarity in form to two earring pendants from Eleusis (fig. 75), it can be assumed that the upper section of the cylinders surrounded a sphere of material that has perished. Thus each pendant assumed the form of a pomegranate, as on the earrings from Eleusis and most probably the necklace from Spata (fig. 130). Indeed, these may well be pieces from the same workshop. Pomegranate pendants with crinkled cylinder below are known in Attica from the ninth century BC (fig. 59), while others, suspended from four-spiral beads of an eighth-century BC necklace, were discovered recently in the Idaean Cave, Crete.

R. Higgins, *BMQ* 23, 1960-1, 103, nos 20-21, pl. 47, b3. Deppert-Lippitz 1985, 78, fig. 37. Here pp. 13, 14, 37, 226-227 in no. 75. Pendants from the Idaean Cave: Sakellarakis 1988, 182ff., figs 18-20.

109. Three necklace pendants in the form of siren and daemonic bees, second half of 7th century BC.
H. 3.7 and 2.7 cm. Perhaps from Rhodes. Copenhagen, Nationalmuseet 861.

The pendants are made from two gold sheets of the same shape: the back one is plain, while the front has embossed details complemented by granulation. Represented in a conventional manner are a siren and two other daemonic female figures with the body of an insect, identifiable with those on some necklace plaques (fig. 132), which are interpreted as Melisses. On all three pendants the faces and the hair framing them are triangular in shape, characteristic of the age, and the details stressed by rows of granules. A granulated rosette on the neck occupies the place of a medallion and two rows of granules above the forehead perhaps denote the hair

line or a simple diadem band instead of the diadem in other cases (figs 131, 133-134). The lotus ornament, crowning the head of the siren, along with the typological assimilation from the waist upwards with figures such as the Mistress of Animals and the bees on the Rhodes plaques (figs 132-134), place her in the same daemonic world as the other figures. Rows of granules render the arrangement and shape of the feathers on the wings and tail of the siren, as well as the segments on the lower body of the daemonic bees. The wings on the latter, like the general form of the body, are totally schematized, perhaps in order to distinguish them from the siren. A link at the very bottom of one woman-bee and one on each of the siren's arms indicate that beads or pomegranates or other additional ornaments hung from these, as from the contemporary plaques (figs 131, 133-134). The three together perhaps constituted an ensemble, maybe with beads as spacers between. Three similar ornaments with bee representation were found together with the spherical pendants in figure 112, in a grave on Thera.

Laffineur 1978, 55, 119ff., 123ff., 176, 229, nos 193-194, pl. XXII, 3, 6. Deppert-Lippitz 1985, 102, fig. 52. *Oro dei Greci* 1992, 115, 248, no. 70. Here pp. 14, 37, 244-245 in no. 132. Of Thera: E. Pfuhl, *AM* 28, 1903, 225ff., 228ff., pl. 5, 1-3.

110. One trapezoidal and four rectangular necklace plaques, c. 750 BC.
Dimensions of the rectangles 3 x 3.5 cm, of the trapezoid 4 x 3 x 1.5 cm. Eleusis, Attica. Athens, National Archaeological Museum Χρ147 (3524-3538).

All the plaques are fashioned from rather thick sheet gold framed on the four sides with twisted wires. Flat band wire soldered perpendicular to the sheet forms mounts for inlaid amber, as the surviving traces indicate. Surrounded by a row of granules, these are triangular, round and even leaf-shaped, forming a rosette on two plaques, while one has the schema of the so-called Dipylon shield. The field between the inlaid ornaments is filled with diverse motifs executed in rich granulation. Each sheet is rolled top and bottom to form tubes through which passed the cords holding the plaques as

an ensemble. The bottom tube is cut in three places, perhaps in order to hang some pendants, as in the case of the necklace from Spata (fig. 130). On the back of the two lateral sides of all the plaques there is a column of three loops of flat wire, probably for sewing them onto a cloth fillet or directly onto the garment on the chest. The form of the necklace, that is the position of the component plaques, can be presumed. The trapezoidal plaque together with a second identical one, now lost, evidently constituted the terminals of the piece of jewellery, while that with the Dipylon shield probably belongs in the middle, corresponding to the Spata necklace, the middle plaque of which is embellished with a *pelta*. The plaque with the rosette and a like one that has not been found flanked the middle one or were adjacent to the trapezoidal ones. The number seven for necklace pendants is probably not fortuitous, since it is encountered in other instances too (see figs 131, 133). Five, seven and twelve 'χρυσία' (*chrysia*) are mentioned in inscriptions as elements of a piece of jewellery dedicated under the name 'ὄχθοιβος' (*ochthoibos*). One such ornament was worn by the statue of Athena Polias on the Acropolis, while 'ὄχθοιβοι' are mentioned as *ex-votos* in the sanctuary of Artemis at Brauron as well. From the interpretation of the word 'ὄχθοιβος' it has been deduced that these pieces of jewellery were sewn onto a special band on the hem of the chitons. The Eleusis plaques may well have constituted an 'ὄχθοιβος'. Similar ones have been found at Brauron and at Exochi on Rhodes. The type of such necklaces can be traced back to Syro-Palestinian models.

Δ. Φίλιος, *AE* 1885, 179ff., pl. 9, 3-4. B. Segall, *BMusFA* 41, 1943, 46, pl. 2d. Bielefeld 1968, 56. Higgins 1980, 99, pl. 15 B-F. *Oro dei Greci* 1992, 242, no. 47. Here pp. 13, 23, 36, 38, 244 in no. 130. Brauron plaques: *Tὸ Ἔργον*, 1962, 31, fig. 37. Exochi: Friis Johansen 1957, 78, 170, no. Z47, figs 178, 180. On 'ὄχθοιβος' and 'χρυσία': Blanck 1974, 29, 31ff., 36.

111. Vase-shaped pendant, last quarter of 7th century BC.
H. 2.8 cm. Argos. Athens, National Archaeological Museum Στ318 (H. Stathatos Collection).

Fashioned from sheet gold. The body is divided by triple vertical incisions into elliptical swollen fields like melon slices. The cylindrical neck, pierced for the suspension cord, is flanked by a plain and a beaded wire. Above the neck a foil disc in place of a lid is decorated with an embossed rosette. The arrangement of the vertical grooves on the body of the ornament and the rosette at the top infer that the goldsmith had a poppy capsule in mind. However, in overall shape it belongs in the class of vase-shaped pendants that were commonplace for several centuries, worn either singly as medallions or several together as necklace elements. The remains of a carbonized substance (possibly wood) on the inside of the Argos pendant perhaps constituted the core over which the sheet gold was formed.

Amandry 1953, 30ff., no. 45, pl. 10. Philipp 1981, 370 n. 730. Here pp. 37, 40.

112. Two spherical necklace pendants, late 7th century BC.
H. 2 cm. Grave on Thera. Athens, National Archaeological Museum Xp1065.

Comprise a globular bead joined to a vertical cylinder, united in T shape with a horizontal one, through which the suspension cord passed. The pendants are formed from gold foil with rich granulated decoration over their entire surface. The cylinders bear lozenge motifs of four granules. Around the middle of each bead is a zone of two rows of granules, probably masking the seam between its two hemispherical sections. There are two rows of triangles on the upper section of one bead and a row of tongue ornaments with granulated nucleus on the other. The lower hemispherical section of both is decorated with sigmoid scrolls and random granulated triangles. Pendants of this type could be worn singly as medallions. Those of Thera are particularly important since they are at the beginning of a T-shaped suspension

system that was very popular in the sixth century BC, mainly in the workshops of Macedonia and Eretria (figs 115, 117-118). The pendants were found together with three others in the form of daemonic bees (cf. fig. 109).

E. Pfuhl, *AM* 28, 1903, 227, nos 4-5, pl. 5, nos 4, 8 and 7, 9. G. Pinza, *Materiali per la etnologia antica Toscano-Laxiale* I, 1915, 406, fig. 339 e, f. Higgins 1980, 115. Here p. 37. Cf. *Tocra* 1966, 156, no. 1, fig. 71, pl. 104.

113. Necklace with conical pendants, c. 560 BC.
H. of middle pendant 3 cm. Grave 28, Sindos. Thessaloniki, Archaeological Museum 8091.

The necklace comprises: 1) A central vase pendant partitioned by beaded wire into eight vertical fields, the middle of which is occupied by a quatrefoil rosette. A hole in the neck was for the suspension cord. 2) Six conical granulated pendants attached above to a cylindrical member, decorated on the obverse with leaves of spiral beaded wire. 3) Three vase-shaped pendants with plain globular body. 4) Eleven small beads, three of gold foil with parallel grooves, six of five parallel beaded wires and, last, two openwork cylindrical ones entirely fashioned in filigree. The relatively coarse granulation and the shape of the pendants recall the conical appendages of two earlier earrings from Argos (fig. 69). The Sindos necklace is one of the earliest of this kind and perhaps marks the initial installation in Macedonia of goldsmiths working in filigree and granulation techniques, who created the Archaic jewellery tradition in the workshops of this region.

Σίνδος 1985, no. 429. *Oro dei Greci* 1992, 268, no. 143, 2. Here p. 37.

114. Necklace with pyramid pendants, c. 510 BC.
H. of middle pendant 5.7 cm. Grave 67, Sindos. Thessaloniki, Archaeological Museum 7964/65, 7967γ.

Comprises a middle vase-shaped pendant, four pyramid pendants attached to a horizontal tube at the top, and seven spacer beads consisting of parallel beaded wires. Intricate patterns in filigree and granulation embellish the entire surface of the middle pendant: alternating upright and inverted lotus ornaments on the upper part of the biconical body and enclosed inverted trefoil ornaments on the lower. On the obverse of the neck is an eight-petalled rosette. Crowning the whole is a flower with downward furling petals and granulated conical centre, while a like flower on the bottom gives the ornament the form of a pointed-bottom vase. The pyramid pendants, completely covered with fine granulation, end in a similar flower, while the cylinders are decorated above with filigree tongue and foliate motifs and granulated triangles. One of the most precious and finely worked pieces of jewellery recovered from the Sindos cemetery, this necklace is an outstanding work from a local workshop.

Σίνδος 1985, no. 325. Here pp. 24, 37.

115. Two schematic pomegranate pendants, c. 510-500 BC.
H. 6 cm. Grave 20, Sindos. Thessaloniki, Archaeological Museum 7944.

Wrought from sheet gold decorated on the body with four dense rows of leaves described by a plain and a beaded wire. The neck is decorated with two rows of filigree roundels. The pendants give the impression of vases, but the double flower on the bottom perhaps belies the goldsmith's intention of rendering pomegranates in a form analogous to that of the pendants on another necklace from Sindos (fig. 117). Like those, the pendants no. 7944 may have belonged to a larger ensemble, perhaps to the necklace in figure 116 which comes from the same grave, or possibly to another with beads of perishable material that have not survived.

Σίνδος 1985, no. 149. Here p. 37.

116. Necklace with vase-shaped and double-axe pendants, c. 510-500 BC.
H. of middle pendant 3.6 cm. Grave 20, Sindos. Thessaloniki, Archaeological Museum 7939-7943.

The necklace consists of: 1) A middle pendant that is basically vase-shaped. The globular body is embellished with four rows of granulated triangles, while the neck is

decorated with two filigree volute ornaments. The whole culminates in a flower with drooping radiate petals and a granulated nucleus. The finial at the bottom is the same. 2) Six vase-shaped granulated beads, four of which, with a globule at the bottom, are in the form of a pointed-bottom vase. 3) Two beads in the scheme of a double axe, with granulated triangles on the main side and a cylinder in the middle for the suspension cord. 4) Three small beads formed from three beaded and two plain wires. A double loop formed from sheet gold, to which are soldered parallel plain and beaded wires, perhaps held the ends of the suspension cord. The morphological diversity of the beads and the relative asymmetry in their arrangement are traits frequently encountered on the finds from Sindos. Nevertheless the overall effect is elegant and pleasing.

Σίνδος 1985, no. 148. Here pp. 37, 247-248 in nos 142-143 and 240 in no. 115 above.

117. Necklace with biconical beads and pomegranates, c. 510 BC.

H. of pomegranates 6.2 cm. Grave 67, Sindos. Thessaloniki, Archaeological Museum 7962/63 and 7966/67.

The necklace consists of: 1) Two large pendants rendering schematic pomegranates, decorated with filigree leaves in two zones. At the bottom a flower with upwards furled petals renders decoratively the finial of the natural fruit. 2) Forty-six biconical beads with the same decoration as the pendants. 3) Two biconical beads just like the others but with cylindrical extension at either end. 4) Nine smaller spacer beads with parallel horizontal grooves. All the beads and pendants are of sheet gold. Though biconical beads were common throughout Greece at this time, their shape has an especially long tradition in bronze jewellery in Macedonia. The necklace is impressive mainly on account of its size, for worn round the neck it would cover the chest down to the abdomen.

Σίνδος 1985, no. 323. Oro dei Greci 1992, 269, no. 143, 5. Here p. 37. Cf. R. Vasić, The Chronology of the Early Iron Age in Serbia (B.A.R. Suppl. Series 31, 1977), 35ff., 66, pl. 54, 4.

118. Necklace with pomegranates, late 6th century BC.

L. 27 cm. H. of pomegranates 3.3 cm. Eretria. Berlin, Antikenmuseum Gl11 (Misc. 8399).

Consists of plain and ribbed globular beads and six pomegranate pendants, all of gold sheet. Each pomegranate consists of a relatively large grooved bead with vertical elliptical bulges, flanked by two twisted wires. At the bottom a calyx of pointed sepals renders the corresponding detail of the fruit. Soldered to the top is a vertical tube joined to a horizontal one through which the suspension cord passed. The main face of the tubes on the two middle pendants is decorated with four rosettes formed from four tiny roundels of beaded wire and a globule at the nucleus. The necklace is a characteristic example of the art of Eretrian goldsmiths in Late Archaic times.

Greifenhagen 1975, 15, pl. 4, 1. Blanck 1974, 78ff., 125ff., fig. 8, cf. pl. 1 (K8, K10a). Deppert-Lippitz 1985, 118ff., fig. 66. Here pp. 37, 40, 42, 227 in no. 77, 239-240 in no. 112.

119-120. Necklace with acorns and bull head, first quarter of 5th century BC.

L. 23 cm. H. of bull head 3 cm. Grave at Eretria. Athens, National Archaeological Museum Xρ10.

Comprises small pendants in the form of laurel berries, alternating with acorns with engraved lattice cupule. Each fruit is attached to a short vertical tube with a link-bead at the top through which the suspension cord passed. Each tube is masked in front by a four petalled rosette with circular leaves of beaded wire and a globule at the nucleus. Between the pendants are spacer beads bearing six bulges framed by a row of embossed dots. The middle of the necklace (fig. 120) is enhanced by a bull-head pendant modelled in detail: parallel incisions for the gnathic whiskers, tiny appliqué ears and horns, and three rows of four and five spiral curls on the brow. Atop the bull head is a horizontal tube for the suspension cord, embellished in front with two quatrefoil rosettes of circular petals and a globule at the centre. Above the tube are two added female heads, the top of which is covered by a plaque of five pairs of

filigree roundels, each two pairs of which form rosettes like those described above. A quality product of one of the active Eretrian workshops.

K. Kuruniotis, *AM* 38, 1913, 309, pl. 15, 3. Higgins 1980, 129, pl. 26C. Deppert-Lippitz 1985, 120, fig. 68c. Here pp. 37, 227 in no. 77. Cf. the necklace Kuruniotis, op. cit., 306ff., pl. 15, 1.

121. Necklace with globular beads and ram head, second quarter of 5th century BC.
L. 26.5 cm. H. of pendant 1.6 cm. Eretria. Berlin, Antikenmuseum Gl15 (Misc. 8398).

Comprises alternating granulated and grooved beads bearing six perimetric elliptical bulges, flanked by a row of embossed dots. In the middle of the necklace hangs a ram-head pendant of sheet gold with modelled and engraved details. The brow is adorned with a large two-tier rosette. The back of the head is covered by a round sheet surrounded by a circlet with two rows of granules, while soldered to the top is a horizontal tube for the suspension cord. The use of an animal head to emphasize the middle of the necklace is one of the Late Archaic innovations that evidently had an important impact on Eretrian goldsmiths in the ensuing years.

Greifenhagen 1975, 15, pls 4, 2 and 5, 1-2. Higgins 1980, 129 n. 28. Deppert-Lippitz 1985, 120, fig. 69. Here pp. 36, 37.

122. Section of a necklace with cylindrical beads, late 6th - early 5th century BC.
L. of biconical bead 7.7 cm. L. of cylinders 4.7-4.8 cm. Region of Amphipolis (Ennea Hodoi). Kavala, Archaeological Museum M1353 - M1356.

Comprises one biconical and three cylindrical beads, all of sheet gold. The biconical bead, decorated with pointillé ribs flanking incised successive acute-angle triangles, probably constituted the middle of the necklace. The entire surface of the cylindrical beads is covered by very fine engraved lines forming a careful system of stacked triangles. Both bead shapes are survivals from earlier periods. This is an early example of necklaces with cylindrical beads, variations of which were widespread from the second half of the fourth century BC onwards (figs 123-124).

Ancient Macedonia 1988, no. 204. Here p. 37. On the biconical bead cf. E.A. Garnder, *BSA* 23, 1918/19, 19, fig. 10. S. Casson, *BSA* 24, 1919/21, 15. Amandry 1953, 47ff., no. 95, pl. 18. On the cylindrical beads cf. Φ. Ζαφειροπούλου, *ΑΔ* 19, 1964, Μελέται, 89, pl. 55ε-στ. R. Laffineur, *BCH* 104, 1980, 394ff., no. 77, fig. 83.

123-124. Necklace with cylindrical beads and Herakles knot, last quarter of 4th century BC.
L. of cylindrical bead 1.9 cm. Macedonian tomb in the region of Amphipolis (Tsagezi). Amphipolis, Archaeological Museum 3413.

Comprises forty-one cylindrical beads alternating with small biconical ones edged with beaded wire. The ends of the cylindrical beads are reinforced by a sheet-gold collar bearing three modelled annulets. Soldered below this at one end of each bead is a decorative foil foliole (fig. 124). The necklace incorporates a Herakles knot formed from two entwined antithetic loops of lightly compressed tubes, the outline of which is emphasized by one plain and one spiral-beaded wire. A row of schematic lotus blossoms wrought in extremely fine beaded wire embellishes their surface. The middle of the knot is covered by two eight-petalled rosettes flanked right and left by two six-petalled radiate ones with circular nucleus once inlaid with coloured material (enamel). The four ends of the knot terminate in three-dimensional lion heads with embossed details enhanced by additional engraving on the double mane and the wrinkles of the muzzle. The join with the ends of the knot is masked by a spiral-beaded wire and a foliate ring. The Amphipolis necklace is one of the most meticulously executed early examples of the type.

Χ. Μακαρόνας, *Μακεδονικά* 1, 1940, 495. Amandry 1963, 247 in no. I 223/227, fig. 148. Pfrommer 1990, 308, no. HK82, pl. 1, 3-4. Williams - Ogden 1994, in no. 65. Here p. 37. On similar beads with leaflet: Amandry 1953, no. 227, fig. 50, pl. 33. T.L. Shear Jr., *Hesperia* 42, 1973, 131, pl. 27f. R. Laffineur, *BCH* 104, 1980, 394, no. 76, fig. 81. Deppert-Lippitz 1985, 210ff., fig. 149b.

125. Necklace with globular beads, late 4th century BC.
L. 25 cm. Grave at Abdera. Komotini, Archaeological Museum 1570.

Comprises twenty-nine plain globular beads and eighteen globular ones decorated profusely with filigree double S-shaped volutes enlivened by granules. The same decoration is repeated in three zones on the club-like terminals of the piece. Globular beads occur in all periods. In all probability a string of globular beads was one of the primitive forms of necklace worn from earliest times, since the sphere is a dominant shape in nature, very often occurring in berries. The specific type of the Abdera necklace was very popular, with some variations, in the last quarter of the fourth century BC (see also fig. 126). The dating of a similar necklace from Bulgaria to the fifth century BC is based on an erroneous indication of provenance.

Δ. Τριαντάφυλλος, ΑΔ 29, 1973/74, Χρονικά, 809, pl. 598β. *Treasures* 1979, no. 423, pl. 59. *The Search* 1980, no. 59. Here pp. 36, 37. On an early example see Williams - Ogden 1994, no. 102. Bulgarian necklace: *Gold der Thraker* 1979, no. 165 (the reference there is erroneous). Deppert-Lippitz 1985, 145, 164, fig. 95.

126. Necklace with globular beads and vase-shaped pendant, late 4th century BC.
L. 38 cm. Mal-Tepe, Bulgaria. Sofia, National Archaeological Museum 6426-6428.

Comprises a central vase-shaped pendant, twelve globular beads and two inordinately large club-shaped terminals. All the elements of the necklace are decorated with filigree spiral motifs. The central pendant displays some affinity to the pendants of a necklace from Omolion in Thessaly (fig. 140) and the globular beads together with the terminals are akin to those on the necklace from Abdera (fig. 125). These comparanda point to a provincial workshop for the Mal-Tepe necklace, which is nevertheless of interest on account of its findspot.

B. Filow, *BIBulg* 11, 1937, 76ff., 113, nos 1-2, fig. 84, 1-2. *Gold der Thraker* 1979, no. 323. *Oro dei Greci* 1992, 146, 259, no. 115. M. Pfrommer, *IstMitt* 36, 1986, 67 with n. 48. Here p. 37.

127. Necklace with cylindrical reticulated beads and pendants, late 3rd - early 2nd century BC.
L. 62 cm. Grave at Pantikapaion (Kerch), Crimea. Saint Petersburg, Hermitage State Museum P1838.3.

The necklace consists of cylindrical beads of filigree mesh embellished with granulation. The ends of each bead are reinforced with one plain and one beaded wire. From the middle section of the necklace, where three pairs of globular beads are interposed – probably not belonging to it –, hung a total of nine pendants: three in the form of a bird (dove, owl and a third indeterminate, perhaps an eagle), two in the form of a couchant lion and bull on a plinth, two in the form of cockle-shells and one double-axe-shaped, which is probably the imitation of a bifacial comb as emerges from other examples. The penultimate left elongated object is unrecognizable: however, other analogous pendants have been interpreted as amulets, phylacteries with incantations on a tiny papyrus scroll or a rolled metal sheet. Necklaces with beads and pendants of this type mainly date from the second century BC, although cylindrical beads of open-work filigree in simpler form are already known from the sixth century BC (see fig. 113).

Reinach 1892, 52, no. 3, pl. 12, 3. Deppert-Lippitz 1985, 218, fig. 155. Here p. 37. Other examples: Pfeiler-Lippitz 1972, 109, pl. 32, 1. *The Search* 1980, no. 73. A. Δάφφα-Νικονάνου, *Μακεδονικά* 25, 1985/86, 190ff., no. 4, pl. 58. On comb-shaped and elongated pendants see Greifenhagen 1975, pls 24, 1 and 34, 18. F. Vandenabeele - R. Laffineur, *Cypriote Stone Sculpture*, 1994, 143ff. with nn. 29-30, pl. 43f.

128-129. Necklace with spool-shaped beads and lynx heads, late 2nd century BC.
L. 49 cm. Grave at Patras. Patras, Archaeological Museum 2141.

Comprises spool-shaped beads incorporating a chain that passes through them. The ends of the necklace terminate in two gold-sheet cylinders holding two lynx heads (fig. 129). Each cylinder is abundantly decorated with four pairs of opposed double volutes of double beaded wire. Granulated rosettes cover the convoluted finials of the volutes, as well as the middle of them, as a binding on each pair. The space between the

pairs is filled with a six-petalled rosette. The two three-dimensional lynx heads, which are the principal decorative element of the piece, are fashioned from gold sheet with embossed and engraved details, mainly on the characteristic jaw whiskers. The link and hook for fastening the necklace are accommodated in their open mouth. This is one of the loveliest necklaces of a Hellenistic type that was frequently combined with precious or semiprecious stones already from the third century BC.

Ι.Α. Παπαποστόλου, ΑΔ 33, 1978, Μελέτες, 357ff., pl. 109β-γ. Here pp. 37, 233 in no. 94. Cf. Pfrommer 1990, 310, no. HK106, pl. 9, 5 and 321, no. TK9, pl. 16, 2(1). Μ. Μπέσιος - Μ. Παππά, Πύδνα, 1995, 110.

130. Necklace with gold plaques and cylindrical pendants, c. 730 BC.
L. 10 cm. Grave at Spata, Attica. Athens, National Archaeological Museum Χρ1041.

Comprises five rectangular sheet-gold plaques rolled top and bottom to form tubes through which passed the two cords holding the five parts in an ensemble. Shallow mounts of fine flat wire soldered vertically to the sheet were originally inlaid: twin lozenges on the outside plaques and a *pelta*-shape in the middle one. The plaques are separated from each other by two cylindrical spacer beads above and one grooved biconical bead below. Corresponding to each plaque are three short chains from which hang tiny vertical tubes, pinched at the bottom to form four folds. It is probable that a globular bead of another material was passed on the top of the cylinder, giving the pendant the form of a pomegranate, as in the case of the Eleusis earrings (fig. 75). Indicative of this reconstruction is the form of the cylinders, which is almost identical to that on the Eleusis specimens. The Spata necklace is one of the earliest pectoral ornaments with plaques (see figs 110 and 131-135) that were sewn to the garment or affixed with fibulae or pins probably from as early as this period.

Αλ. Φιλαδελφεύς, ΑΔ 6, 1920/21, 138, no. 1, fig. 10 below. Coldstream 1979, 126, fig. 39b. Higgins 1980, 99, pl. 15A. Deppert-Lippitz 1985, 77, fig. 36. Here pp. 13, 14, 36, 37, 38, 238 in no. 108, 240 in no. 110.

131. Seven necklace plaques with female heads, second half of 7th century BC.
Dimensions 1.8 x 2.2 cm. Kameiros, Rhodes. London, British Museum 1103.

Rectangular plaques with two horizontal tubular loops at the top through which passed the cord that held them to form a necklace. Soldered to each plaque are two separate sheets, each bearing an embossed female head with the typical hairstyle of the period, its characteristic shape emphasized by horizontal rows of granules. Each figure wears a diadem and a necklace, also indicated by granulation. The pairs of heads are inscribed in a rectangular frame of twisted wires arranged in a braid pattern. The middle of the necklace is enhanced by a larger plaque on which the two heads are separated by a vertical strip defined by two pairs of wires and decorated with a rosette. Four globular beads hang from the six plaques, and five from the middle one. The ensemble probably comprised a pectoral necklace that will have been fastened to the garment with fibulae or pins. The embossed heads are an iconographic theme derived from Oriental models that was familiar in jewellery of the second half of the seventh century BC, particularly in Rhodes and the Cyclades, and even earlier in Crete. The heads on the Kameiros plaques perhaps represent, as part of the whole, a female deity, such as the Mistress of Animals who features on related ornaments (figs 133-134).

BMCJ 1911, no. 1103, pl. 11. A. Lebessi, BSA 70, 1975, 176ff. Laffineur 1978, 20ff., 56ff., 198, no. 31, pl. V, 1-2. Here pp. 14, 23, 24, 38.

132. Five necklace plaques with Melissa, second half of 7th century BC.
Dimensions 2.7 x 2.5 cm. Rhodes. Berlin, Antikenmuseum Misc. 8946.

Of sheet gold and bearing three tubular loops at the top, for the cord which held them as an ensemble. All the elements of the decoration, including the border on all four sides, are embossed in a hollow die. Represented is a figure that is female from the waist upwards and an insect from the waist downwards. The wings are de-

veloped curved in the upper corners of the sheet, while two rosettes occupy the empty field in the lower corners. This is a daemonic figure – hybrid like the sirens and the sphinxes –, the human part of which, with its sickle-shaped wings and the typical schema of the arms, is identified with the corresponding section of the Mistress of Animals (figs 133-134). It has been associated with the cult of Artemis Ephesia, whose symbolic animal was the bee – represented on the coinage of Ephesos from the sixth century BC –, yet elements diagnostic of an identification with the goddess are absent. It may well be an earlier nature deity comparable to the *Potnia Theron*, perhaps a *Potnia Melissa* (Mistress of Bees), which was amalgamated with other divinities in historical times, during which Nymphs *trophoi* (nurses) and seeresses, as well as the priestess of various deities were referred to as Melisses. An analogous bee is also represented on cut-out necklace pendants (fig. 109). An echo of these figures are the miniscule pendants in the form of a woman-bee that hang from certain fourth-century BC earrings and necklaces (figs 82, 153).

Greifenhagen 1970, 29, pl. 9, 6. Laffineur 1978, 51ff., 177, 193, no. 6, pl. II, 3 below. Here pp. 14, 37, 38. On the interpretation see *EAA* IV, 993ff., fig. 1185 s.v. *Melissa* (S. de Marinis). Hampe - Simon 1980, 209ff., fig. 325. R. Lullies, *JdI* 97, 1982, 113ff., fig. 11. Κ. Δαβάρας, *AE* 1984, 77ff. R. Laffineur, *BCH* Suppl. XI, 1985, 255ff. n. 70, fig. 8. *LIMC* II, 629 s.v. *Artemis.*

133. Seven necklace plaques with the Mistress of Animals (Potnia Theron), second half of 7th century BC.
H. 4.2 cm. Kameiros, Rhodes. London, British Museum 1128-1130.

The plaques belonged to a necklace that was probably worn as a pectoral ornament. On each is soldered a separate gold sheet bearing an embossed representation of the Mistress of Animals. The goddess's hands are outstretched as if holding the leash of the lion flanking her either side, in a gesture typical of figures of this class. Clad in a long garment and bedecked with diadem, necklace and bracelets, the *Potnia Theron* is winged. The jewellery, the details on the hair, the wings and the patterns on the dress are rendered in fine granulation, as is the stippled pelt of the animals which thus rather resemble panthers. Each plaque is framed by four rows of twisted wires. At the top are three tubes for the suspension cord, while from the bottom hung five short chains with pomegranate pendants. Attached to the top of each terminal plaque is a twelve-petalled rosette of cut-out gold sheet. In addition to the meticulous workmanship and refined sense of the decorative, notwithstanding the smallness of the plaques, the representations display a monumentality that distinguishes the necklace as outstanding among other Rhodian pieces of this type.

BMCJ 1911, nos 1128-1130, pl. 11. A. Lebessi, *BSA* 70, 1975, 175ff. Laffineur 1978, 17ff., 33ff., nos 56-58, pls V, 2 and VII, 5-6. Here pp. 14, 23, 24, 38.

134. Necklace plaque with the Mistress of Animals (Potnia Theron), second half of 7th century BC.
Dimensions 3.7 x 3 cm. Rhodes. Berlin, Antikenmuseum Misc. 8943.

A rectangular plaque with embossed image of a winged Mistress of Animals holding two lions by the tail. The goddess wears a long richly decorated garment and a band diadem with triangular finials. The diadem, the hair, the curvacious contours on the wings, the motifs on the dress and certain details on the lions are all executed in fine granulation. The entire representation is inscribed within a rectangular frame of twisted and spiral beaded or spool wires. Soldered to the top is a rosette embellished with rich granulation; at its nucleus is an exergue lion head and on the back a hook for fastening the ornament. At the bottom of the plaque are five loops, from which hang ribbed foil beads of pomegranate shape. Together with a second identical plaque, the ornament perhaps framed a pectoral necklace similar to that in figure 133.

Greifenhagen 1970, 28, pl. 9, 1.5.7. Laffineur 1978, 12ff., 18, 192ff., no. 3, pl. I, 3-4. Here pp. 14, 23, 24, 38, 40. On a second like plaque see Laffineur, op. cit., 209, no. 91, pl. XI, 1.

135. Necklace with tongued plaques, c. 510 BC.
L. 15 cm. Grave 67, Sindos. Thessaloniki, Archaeological
Museum 7972.

Comprises fifteen sheet-gold plaques with three cut-out
tongue-shaped finials top and bottom, bordered with
beaded wire and separated lengthwise by a zone of three
beaded wires. Corresponding to each plaque is a grain
of wheat pendant hanging from the middle 'tongue'.
The plaques were threaded onto two cords, one top
and one bottom, that passed through the loops at each
corner on the back. The ends of the cords, probably
tied together at either end of the necklace, facilitated
fastening it to the garment with fibulae or pins. Pectoral
necklaces with plaques appeared sporadically in the
eighth century BC (figs 110, 130) and became very
popular in the seventh, particularly in the islands and
above all on Rhodes (figs 131-134). The fashion was
short-lived, however, and the Sindos necklace is a rare
instance for the sixth century BC.

Σίνδος 1985, no. 315. Here p. 38.

*136. Necklace with ribbed cylinders, late 5th - early
4th century BC.*
L. 25 cm. Grave at Nymphaion, Crimea. Oxford, Ashmolean
Museum 1885.502.

The necklace consists of 'plaques' formed by corrug-
ated cylinders pressed along the middle in such a way
that a horizontal tube for the cord of the necklace is
formed top and bottom. The compressed cylinders,
placed one next to the other, form a kind of strap. At the
bottom of each are wire loops from which hang ribbed
pendants reminiscent of barley grains. The larger cylinders
are decorated with a rosette. Similar necklaces are also
known from Cyprus. 'Plaques' of this form were later
placed on the back of members forming the band of the
necklace (see p. 247f. in nos 140, 142-145).

Vickers 1979, 41, pl. 10a. Higgins 1980, 129, pl. 27A. Idem in
Studies in the History of Art 10, 1982, 141ff., fig. 2. Deppert-
Lippitz 1985, 143, fig. 92. Here p. 38. On those from Cyprus: R. Laf-
fineur, *Amathonte* III (*Études Chypriotes* VII, 1986), 50, 70,
nos 258 and 421, figs 61 and 98. Williams - Ogden 1994, nos
166, 178.

*137. Necklace with rosettes, lotus blossoms and
acorns, late 5th - early 4th century BC.*
L. 31 cm. Grave at Nymphaion, Crimea. Oxford, Ashmolean
Museum 1885.482.

Comprises a row of rosettes alternating with pairs of
antithetic lotus blossoms. A small rosette decorates the
centre of the larger ones and the lotus blossoms. From
the large rosettes hang strikingly large acorns with en-
graved reticulated cupule, and from the lotus blossoms
small pendants reminiscent of grains of wheat. The ros-
ettes were probably enlivened with inlaid coloured
enamel. A necklace fragment from Temir Gora (near
Pantikapaion in the Crimea) is of similar form. Affin-
ities with certain pieces of jewellery from Eretria led to
the suggestion that the Nymphaion necklace was per-
haps produced in an Eretrian workshop. Austere in its
form, it constitutes the earliest example of a series of
such necklaces with rosettes and lotus blossoms.

Blanck 1974, 126, fig. 13. Vickers 1979, 41ff., pl. 11a-b. Higgins
1980, 129, pl. 27B. Deppert-Lippitz 1985, 144, fig. 93. M. Pfrom-
mer, *IstMitt* 36, 1986, 65ff., pl. 20, 6. On the fragment from Temir
Gora: Miller 1979, 11, pl. 5a. Pfrommer, op. cit. Cf. Williams - Ogden
1994, no. 94. Here p. 38.

*138-139. Necklace with rosettes, lotus blossoms,
vase-shaped pendants and female heads, c. 350 BC.*
L. 32 cm. Said to be from Taranto, Southern Italy. London,
British Museum 1952.

The necklace comprises a garland of three-tier rosettes
alternating with pairs of antithetic lotus blossoms in its
central section. From the lotus blossoms hang miniature
relief female heads, and from the rosettes large ribbed
vase-shaped pendants with foliate decoration alternat-
ing with three-dimensional female heads adorned with
earrings and necklace. Two of these heads have a pair of
tiny zoomorphic ears and elegant miniscule horns above
the temples, and therefore in all probability represent Io,
the beautiful priestess of Hera Argeia, with whom Zeus
fell in love and who was turned into heifer by the angry
goddess. Behind the lotus blossoms and the rosettes are
double tubes for stringing the elements. The club-shaped
terminals and the penultimate globular beads do not

belong to the original necklace but have been added in recent times. Perhaps the most impressive example of its type, the Taranto necklace is contemporary with the earrings in figures 95-96 and slightly later than a similar piece found at Pantikapaion, from which hang heads of a river god instead of the relief female ones.

BMCJ 1911, no. 1952, pl. 35. Higgins 1980, 129, fig. 28. D. Williams, *RM* 95, 1988, 77ff., 94, pl. 31, 3-4. Guzzo 1993, 201 with figure. Williams - Ogden 1994, no. 135. Here pp. 37, 38. Necklace from Pantikapaion: Williams - Ogden 1994, no. 94. On miniature relief female heads cf. Becatti 1955, 193, no. 362, pl. 92.

140. Section of a necklace with lotus blossoms, rosettes and vase-shaped pendants, c. 330 BC.
L. 15.5 cm. Omolion, Thessaly. Volos, Archaeological Museum M36-M48, M55.

Preserved are one of the necklace terminals and six pairs of antithetic lotus blossoms alternating with two-tier rosettes, from which hang an equal number of vase-shaped pendants. Soldered to the back of the lotus blossoms and rosettes is a double ribbed cylinder through which passed two cords on which the necklace elements were strung, as in other examples (figs 142-145). The tube behind the necklace terminal is longer but single. The body of the vase-shaped pendants, divided into two sections by a horizontal zone of one spiral and two plain wires, is decorated in filigree technique with enclosed upright palmettes above and inverted ones below. The surviving necklace terminal is decorated with one enclosed and one freely developed filigree palmette on a gold-sheet plaque, exactly as on a necklace from Derveni, Thessaloniki (figs 144-145), though the workmanship is less careful than on the Macedonian piece. The Omolion necklace belongs to a series that had perhaps appeared in the fifth century BC and enjoyed considerable popularity during the fourth. The basic elements of the series are the antithetic lotus blossoms, while the pendants vary (figs 137-139) and the rosettes are sometimes replaced by beads (fig. 141).

Miller 1979, 10ff., 54, no. Hom. J 2, pl. 4a-f. Pfrommer 1990, 213, no. FK16 n. 1403. *Oro dei Greci* 1992, 161, 264, no. 125, 2. Here pp. 37, 38.

141. Necklace with lotus blossoms, bull head and vase-shaped pendants, last quarter of 4th century BC.
L. 45 cm. Grave at Karagodeuashkh, Kuban region, Euxine Pontus (Black Sea). Saint Petersburg, Hermitage State Museum 2492/2.

Comprises antithetic lotus blossoms like those in the necklaces of figures 137-140, though here rendered in a stylized, desiccated manner, and melon-shaped beads between plain globular ones, in the position of the rosettes in the previous examples. Large vase-shaped pendants with foliate decoration hang from the melon-shaped beads and small plain ones from the lotus blossoms. The mid-point of the necklace is enhanced by an expressive three-dimensional bull head with appliqué ears and horns, and another vase-shaped pendant hanging from its muzzle. The terminals are tongue-shaped plaques bearing filigree palmettes, a usual device in contemporary necklaces.

Artamonov 1969, 80ff., pl. 319. Deppert-Lippitz 1985, 167ff., fig. 116. M. Pfrommer, *IstMitt* 36, 1986, 66, 69, pl. 21, 1. Here pp. 37, 38.

142-143. Necklace with rosettes and double axes, late 3rd century BC.
L. 22.5 cm. Unknown provenance. London, British Museum 1951.

The necklace comprises thirty-six double-axe-shaped elements enamelled in green, alternating with seven-petalled rosettes perhaps originally enamelled in blue. The mid-point of the necklace is emphasized by nine larger rosettes. Smaller five-petalled rosettes are soldered top and bottom of the axes. Of the two terminals one is preserved, consisting of a lyre-shaped ornament formed from spiral-beaded wire enclosing a filigree palmette. Behind the necklace elements are double threading tubes. Two other ornaments purchased together with the necklace do not belong to it as was initially thought. Comprising three pairs of volutes developed upon a trefoil acanthus bush, the central leaf of which is covered with green enamel and the two lateral ones with blue, and crowned by a palmette, they may have been earring finials (cf. fig. 103). The necklace combines various early motifs such as the double axes (see fig. 116), with later ones such as the rosettes utilized as 'beads', known

from the necklaces with lotus blossoms (figs 137-140). However, the form of its terminal points to a date well after the fourth century BC, to which the necklaces with lotus blossoms belong.

BMCJ 1911, no. 1951, pl. 35. Pfrommer 1990, 256, fig. 43d and for the form of the terminal 257, fig. 43m-n. Williams - Ogden 1994, no. 15. Here pp. 23, 38.

144-145. Necklace with rosettes and vase-shaped pendants, c. 330 BC.
L. 31.7 cm. Grave Z, Derveni, Thessaloniki. Thessaloniki, Archaeological Museum Z2.

Comprises a garland of rosettes with a vase-shaped pendant hanging from each. The rosettes are two-tier, five-petalled on seven-petalled, and soldered onto corrugated cylinders pressed latitudinally so that the cord passed through top and bottom, as in other examples (figs 140-143). Each terminal of the necklace (fig. 144) is a thick gold-sheet plaque decorated with two palmettes, one enclosed and the other free, eleven-petalled, as on the Omolion necklace (fig. 140), but superior in quality. The palmette petals are executed in spiral-beaded wire. At the heart of the enclosed palmette is a six-petalled rosette and of the free one a five-petalled. A modest variation of the necklaces with lotus blossoms and rosettes (figs 137-140), the piece is the work of an accomplished craftsman.

Χ. Μακαρόνας, ΑΔ 18, 1963, Χρονικά, 194, pl. 229β (cited as coming from grave E). *Treasures* 1979, no. 254, pl. 37. Miller 1979, 11ff. Here pp. 37, 38. A similar necklace from Pydna: Μ. Μπέσιος - Μ. Παππά, Πύδνα, 1995, 106, fig. A. A section of another: M.S. Ruxer - J. Kubczak, *Greek Necklace of the Hellenistic and Roman Ages,* 1972, 244, pl. XXI, 2.

146. Necklace with chain strap and rosettes, second half of 7th century BC.
L. 22.3 cm. Grave at Kameiros, Rhodes. London, British Museum 1176.

Broken in two places, the strap comprises fine cross-linked loop-in-loop chains (on the method of manufacture see p. 23f.). The ends are decorated with sheet-gold plaques bearing an embossed lion head on the main face. The chain strap was decorated at regular intervals with applied rosettes – probably five –, one of which is missing. The surviving four are two-tier, bordered and embellished with wires and granulation, and had an inset nucleus. A vertical tube at the edge of each lion head was used for fastening the necklace to the garment on the chest, probably with fibulae. A wire loop at the side of the lion head was perhaps added for hanging decorative pendants. This fine, severe work of a Rhodian workshop is the earliest example of a necklace with a chain strap. An intact piece exactly like it, from Makry Langoni on Rhodes, disappeared from the local museum during the Second World War.

BMCJ 1911, no. 1176, pl. 12. Laffineur 1978, 155ff., no. 218, pl. XXV, 8-10. Here pp. 23, 39. The necklace now lost: Laffineur, op. cit., 155ff., 237, no. 229. Chain straps with lion-head terminals: Segall 1966, 9, 11, pl. 4, 14. Williams - Ogden 1994, no. 121. Cf. here figs 158-159.

147. Necklace with chain strap and spear-heads, c. 330 BC.
L. 34 cm. Grave Z, Derveni, Thessaloniki. Thessaloniki, Archaeological Museum Z1.

Comprises a chain strap and a row of pendants in the shape of three-flanged arrow-shaped heads. These pendants have been identified as those referred to as 'lance-heads' ('λογχία') in the epigraphic lists of the dedications to the sanctuary of Delos. The strap is formed from four cross-linked loop-in-loop chains (on the manner of manufacture see p. 23f.). Soldered to its bottom edge are eighty-six wire loops, masked by an equal number of six-petalled rosettes. From each loop hangs a ring with circular bezel, originally inlaid with blue enamel (now lost in many places), and a spear-head (six are now missing). Each end of the strap is inserted in a box-like plaque of gold sheets with tongue-shaped terminal. On the obverse of the terminals is a heart-shaped ornament of beaded wire, enclosing a palmette of cloisonné enamel, now lost. Below the heart-shaped ornament is a rectangular section with a six-petalled rosette at the centre, flanked by two double volutes, the top of which develops beyond the bounds of the rectangle. A

kind of anta capital of sofa type was thus created, that constituted the base of the enclosed palmette. On the right terminal of the necklace this decoration is carelessly executed, possibly indicative of a later intervention. Spare and elegant, the Derveni necklace is one of the early examples of the type.

X. Μακαρόνας, ΑΔ 18, 1963, Χρονικά, 194, pl. 229a (cited as coming from grave E). *Treasures* 1979, no. 253, pl. 37. *Oro dei Greci* 1992, 276, no. 149, 6. Here pp. 23, 30, 39, 215 and 251 in nos 32-33 and 155-156 respectively. On the term 'λογχία' see Blanck 1974, 40ff., 91ff.

148-149. Necklace with chain strap and spear-heads, 330-320 BC.
L. 34 cm. Corinth. Athens, National Archaeological Museum Xp1050.

Comprises a chain strap and two rows of pendants in the shape of three-flanged arrow heads, the so-called 'λογχία' (lance-heads), in two sizes. The strap is formed from three fine, cross-linked loop-in-loop chains (on the manner of manufacture see p. 23f.). At the lower edge seventy-nine six-petalled rosettes alternate with seventy-eight discs. The rosettes mask the points of suspension of the larger spear-heads and the discs those of the smaller ones. The leaves of the rosettes and the discs were originally inlaid with blue enamel. The ends of the strap (fig. 149) are inserted in a rectangular box-like plaque of rigid gold sheet, the main face of which is decorated with an embossed head of a lionskin, analogous with that observed on contemporary fibulae (figs 183-184). The necklace was found at Corinth buried with a hoard of gold staters of Philip II of Macedon and Alexander the Great, mainly from the Pella and Amphipolis mints. This might indicate that it was fashioned in the workshop of a Macedonian goldsmith.

Corinth XII, 256ff., no. 2055, pl. 109. Amandry 1953, 79ff., figs 46-47. G. Roger Edwards - M. Thompson, *AJA* 74, 1970, 343ff., pl. 88. Here pp. 23, 39. On necklace terminals with lionskin: Segall 1966, 26, pl. 44. Williams - Ogden 1994, no. 106.

150. Necklace with chain strap and vase-shaped pendants, last quarter of 4th century BC.
L. 34.3 cm. Said to be from Trebizond (Trapezous). Jerusalem, Israel Museum 91.71.347 (N. Schimmel Collection).

The strap is formed from fine cross-linked loop-in-loop chains (on the manner of manufacture see p. 23f.), from which hang numerous vase-shaped pendants in three sizes. The large- and medium-size pendants hang from double chains, the top and bottom of which are covered by rosettes. The upper rosettes, which form a kind of garland at the lower edge of the strap, alternate with miniature protomes of Pegasos, as on the necklaces from Theodosia and Madytos (figs 153-154) and on another with pendent spear-heads from Great Bliznitsa on the Taman peninsula. The small vase-shaped pendants hang from the Pegasos protomes. The necklace ends in two tongue-shaped plaques exquisitely embellished with a granulated rosette in the middle of four filigree volutes. The lower two volutes sprout from acanthus leaves and the upper two branch from the lower, forming with them a lyre-shaped ornament (visible primarily on the left terminal) that constitutes the base of the palmette which is its finial. Similarly decorated terminals exist on other necklaces (figs 151-152, 154, 157), but on the example from Trebizond the conception is original, integrating the individual motifs and organizing them in a comprehensible representation. One of the most precious pieces of jewellery of its kind, the necklace is imbued with that sense of profusion characteristic of Greek workshops in the eastern territories.

The Search 1980, no. 62 and col. pl. 15. Deppert-Lippitz 1985, 170, col. pls XII-XIII. Here pp. 23, 37, 39. On the necklace from Great Bliznitsa see Williams - Ogden 1994, no. 123.

151-152. Necklace with chain strap and spear-heads, last quarter of 4th century BC.
L. 30 cm. Thessaly. Athens, National Archaeological Museum Στ340 (H. Stathatos Collection).

Comprises a chain strap and a row of pendants in the shape of three-flanged arrow heads, that are identified as the 'λογχία' (lance-heads) mentioned in the inscriptions. The strap is formed from five fine, cross-linked loop-

in-loop chains (on the manufacture see p. 23f.). At the bottom edge a garland of eighty-one rosettes, originally inlaid with blue enamel, masks the points of articulation of an equal number of spear-heads. Each end of the strap is inserted in a box-like plaque covered by a sheet-gold tongue (fig. 152) with rich decoration: In the bottom corners there are two roundels and above them follows a row of three tiny acanthus leaves, the outer ones combined with two rosettes and the middle with a leaf-shaped nucleus. A pair of double S-shaped scrolls is embellished with three miniscule rosettes between the volutes and a larger one in the middle of them. The decoration terminates in a palmette wedged between the two top volutes. The goldsmith here has created a version of an ornament analogous to that in figure 150. The strap with a row of spear-heads constitutes a modest example of the type, in contrast to its elaborate terminals that are more suited to heavier necklaces (cf. those in figs 150, 154). In relation to the last ones the Thessalian piece is perhaps slightly later, as is the necklace from Pantikapaion wich has similar but clumsier terminals (fig. 157).

Amandry 1953, 79ff., no. 218, pl. 32. Amandry 1963, 247, no. I 218. Here pp. 23, 39.

153. Necklace with chain strap and vase-shaped pendants, last quarter of 4th century BC.
L. 33 cm. Theodosia, Crimea. Saint Petersburg, Hermitage State Museum F2.

The strap comprises fine cross-linked loop-in-loop chains (on the manner of manufacture see p. 23f.). A garland of rosettes along its bottom edge masks the points of articulation of the pairs of chains from which hang large vase-shaped pendants with foliate decoration, while smaller, and plainer ones, hang a little higher up. Alternating with the rosettes are miniscule protomes of Pegasos, as on the necklaces in figures 150 and 154, from which are suspended tiny figures, known from other contemporary pieces of jewellery (fig. 82), with the upper body of a woman and the lower of an insect. This is a schematic rendering of a daemonic hybrid figure – like the sirens and sphinxes – better understood from earlier

pieces (fig. 132), perhaps a *Potnia Melissa* (Mistress of Bees). The ends of the strap are inserted in a tongued box-like plaque, the main face of which is decorated with a palmette. Discovered together with the earrings in figure 85, the necklace is a skilful ornament, mainly of interest for the diversity of its decorative elements.

Reinach 1892, 53, pl. 12a, nos 4 and 4a. Amandry 1963, 209 with n. 3. Deppert-Lippitz 1985, 170, fig. 120, nos 4 and 4a. Pfrommer 1990, 288, no. FK170. Here pp. 23, 37, 39, 228-229 in no. 81.

154. Necklace with chain strap and vase-shaped pendants, last quarter of 4th century BC.
L. 32.3 cm. Said to be from Madytos. New York, Metropolitan Museum of Art 06.1217.13.

The strap comprises six cross-linked loop-in-loop chains (on its manufacture see p. 23f.). Attached to the bottom edge is a long row of rosettes alternating with miniscule Pegasos protomes (see also figs 150, 153). The rosettes conceal the point of articulation of the short chains from which hang vase-shaped pendants in two rows: in the lower larger and richly decorated, in the upper – slightly higher – smaller and simpler. Close to the edge of the strap is a third row of vase-shaped pendants, with flat back, hanging from the Pegasos protomes. The terminals of the necklace consist of two tongued plaques, at the base of which a band of seven cut-out leaves covers the join with the chain strap. Their surface is decorated with two pairs of volutes with a five-petalled rosette between. Arising from the volutes is a palmette with granulated nucleus, while below them a row of cut-out leaves occupies the position of an acanthus bush. A more comprehensible and logically designed version of this decoration can be seen on a necklace said to come from Trebizond (fig. 150). The goldsmiths of the necklace from Thessaly (figs 151-152) and of another from Pantikapaion (fig. 157) rendered variations of it.

E. Robinson, *BMetrMus* I, 1905/1906, 118ff. Segall 1966, 22, 24, pl. 40. Williams - Ogden 1994, no. 64. Here pp. 23, 37, 39.

155-156. Necklace with chain strap, vase-shaped pendants and garnets, early 2nd century BC.
L. 35 cm. Perhaps from Thessaly. Athens, Benaki Museum 1554.

Comprises a chain strap (on its manufacture see p. 23f.) from which hang two rows of vase-shaped pendants and a third row of amphoras. The points where the pendants or their chains join the bottom edge of the strap are concealed by discs. The bigger vase-shaped pendants, in the middle row, are particularly prominent, since they consist of a red garnet mounted in gold. The ends of the strap are inserted in two rectangular box-like plaques in the form of an anta capital, familiar from other pieces of jewellery (figs 32-37) as well as indicated at the terminals of earlier necklaces (fig. 147). The plaques culminate in a schematic trefoil palmette, the outer leaves of which were enamelled in green, while the larger middle leaf as well as a round eye in the middle of the anta capital were inset with red garnet. Written in gold grains in a tiny, oblong green-enamelled space at the base of the anta capital is the name ΖΩΙΛΑC, the first three letters of which are on the left terminal of the necklace (fig. 156) and the last three on the right. The first three letters also occur on two superb bracelets (figs 192-193), while the name appears in full on another pair of bracelets (fig. 190). It may be the name of the goldsmith in the nominative case or, according to another view, the name of its lady owner in the genitive case. A heart-shaped ornament soldered to the right terminal bears the fastening hook (cf. fig. 168). Of fine workmanship, this precious necklace is one of the last examples of the type with vase-shaped pendants.

Segall 1938, 40, no. 34, pls 12 and 24. Amandry 1953, 109, 110 in nos 247/8 and 252, fig. 67a. *Gold of Greece* 1990, fig. 18. Pfrommer 1990, 216, 255ff., fig. 43p. Here pp. 23, 37, 39. On the heart-shaped ornament see Pfeiler-Lippitz 1972, 117 with n. 90. Miller 1979, 28.

157. Necklace with chain strap and Herakles knot, late 4th - early 3rd century BC.
L. 41 cm. Hadji Mouschkai, Pantikapaion (Kerch), Crimea. Saint Petersburg, Hermitage State Museum P1840.29.

The chain strap (on its manufacture see p. 23f.) termin-

ates in two tongue-shaped plaques elaborately decorated in a manner comparable to that of the necklaces in figures 150-152 and 154, but less skilfully executed in comparison to them. The two antithetic intertwined loops that form the Herakles knot (on this see p. 14) are wrought from sheet gold trimmed in beaded wire and decorated with wire spiral motifs. Their volute finials formed from coiled wires are added. The middle of the knot is embellished by two antithetic palmettes, the join between them masked by a rosette, as on the Abdera necklace (figs 163-164). The similarities in motifs on pieces found at such geographically distant sites are explained by the free movement of craftsmen, facilitated by the Macedonian conquests of Alexander the Great, which contributed to the creation of a common artistic vocabulary in Hellenistic jewellery.

L. Stephani, *CRPétersbourg* 1880, 35, no. 14. Reinach 1892, 49 (in nos 15-16), 51 pl. 9, 2. Deppert-Lippitz 1985, 213, fig. 149a. Pfrommer 1990, 311, no. HK110, pl. 4, 2. Here pp. 14, 23, 39.

158-159. Necklace with two chain straps and Herakles knot, early 3rd century BC.
L. 30.4 cm. Chersonesos, Crimea. Saint Petersburg, Hermitage State Museum X1899.7.

Both ends of the chain straps (on the manner of their manufacture see p. 23f.) are inserted in compressed cylindrical collars of sheet gold. The cylindrical collars of the outer terminals are edged by rows of beaded, twisted and plain wires, and decorated with two bands of tongue motifs described in double wire. On the inner terminals, towards the middle of the necklace, the cylindrical collars are likewise edged with wires, but decorated with a row of palmettes, and terminate in a lion head with pronounced relief features and triple mane with engraved details. The lion heads bear links for the hooks soldered below the Herakles knot, connecting this centrepiece to the straps. The Herakles knot (on this see p. 14), is formed from two sheet-gold loops bordered by a beaded and a plain wire, decorated with wire tongue motifs and ending in added wire volutes. At the centre of the knot is a siren playing a lyre (cf. fig. 99). The decoration is completed by four rosettes and a palmette

at the ends of each loop. It is difficult to define whether this piece of jewellery is a necklace or a diadem, because there is no exact parallel for its form. Moreover, the excavation data provide no clue as to how it was worn, since it was found together with a pair of earrings and a finger ring inside a cinerary urn. However, the fact that funerary sets comprising necklaces, earrings and finger rings are very frequent makes it more likely that the piece from Chersonesos was a necklace.

A. Manzewitsch, *Ein Grabfund aus Chersonnes*, 1932, 9, no. 1, pl. I, 1. Pfrommer 1990, 267, 311, no. HK114, pl. 4, 4. Williams - Ogden 1994, no. 131. Here pp. 14, 23, 39.

160. Necklace with two chain straps and Herakles knot, late 4th - early 3rd century BC.
L. 34 cm. Purchased in Smyrna. Berlin, Antikenmuseum GL26 (Misc. 3079).

The two chain straps (on their manufacture see p. 23f.) are united by a Herakles knot (on this see p. 14) that constitutes the principal decorative part of the necklace. The knot is fashioned from sheet-gold strip on which are soldered nine parallel wires, twisted in the opposite direction to one another so that each pair of wires forms a kind of braid. The middle of the knot is adorned by two antithetic palmettes with a rosette between them. A similar single palmette with rosette at its base covers the join of the two straps with the upper finials of the two loops of the knot. Each of the two corresponding lower finials is inserted in a decorative biconical bead from the opposite end of which sprouts a tassel of five tiny chains bearing an equal number of pendent discs with granulated triangles in concentric zones. The ends of the chain straps terminate in a plaque with embossed female head. The necklace is a rare variant of the type with chains and tassels that is associated with workshops in Asia Minor.

Greifenhagen 1975, 16ff., pl. 6. Hoffmann - Davidson 1965, no. 40. *The Search* 1980, no. 81. Pfrommer 1990, 305, no. HK57, pl. 2, 2. Here pp. 14, 23, 39. On similar necklaces see Segall 1966, pls 6, 16, 39. Deppert-Lippitz 1985, 172ff., figs 121-122.

161. Chain necklace with bifurcate terminals and four snake heads, c. 510 BC.
L. 74.2 cm. Grave 67, Sindos. Thessaloniki, Archaeological Museum 7970.

The necklace consists of a cord-chain (on its manufacture see p. 23f.), the ends of which bifurcate and end in twin terminals with snake heads. A conical cylinder of sheet gold surrounds the two points at which the ends of the chain bifurcate. The head and the beginning of the body of the four snake terminals are formed from sheet gold on which the scales are rendered in wire and the eyes by a protruding granule. Soldered in the mouth of the snakes are the links for fastening the necklace to the garment between the shoulders with the help of fibulae. Gold chain necklaces are known from the eighth century BC (see fig. 107), but twin terminals are a morphological trait of the Archaic period, that was diffused throughout the region of Macedonia. Archaic silver chains with gold snake terminals have been found at Sindos and Vergina. From the fifth century BC the terminals changed from twin to single, and from the fourth century BC the heads of snakes were replaced by those of other animals, consistent with innovations in the art of the day (see figs 162-164).

Σίνδος 1985, no. 327. Pfrommer 1990, 81. Here pp. 23, 39. Silver chains with gold terminals: Σίνδος, op. cit., no. 156. Το Έργον, 1988, 74, fig. 64. Gold chains with single snake-head terminals: Amandry 1953, 73ff., no. 215, pl. 30. Hoffmann - Davidson 1965, nos 42 and 70.

162. Chain necklace with Herakles knot and two lion heads, last quarter of 4th century BC.
L. 35 cm. Cist grave 1, Amphipolis area (Tsagezi). Amphipolis, Archaeological Museum 3414.

The necklace comprises a cord-chain (on its manufacture see p. 23f.) the ends of which are inserted in slightly conical cylinders of sheet gold, with one beaded and two plain wires at each end. Attached to the wider end of the cylinders are two sheet-gold lion heads with embossed details emphasized by engraving. A link in the mouth of one lion head and a long hook in that of the other served for fastening the piece of jewellery. Soldered

to the long hook is a Herakles knot (on this see p. 14), formed from a solid stem of quadrilateral section and decorated with a six-petalled rosette in the middle.

Χ. Μακαρόνας, *Μακεδονικά* 1, 1940, 495ff., fig. 32. Miller 1979, 15, pl. 8e. Pfrommer 1990, 308, no. HK83, pl. 29, 13. Here pp. 14, 23, 39. On lion-head terminals see Ν. Κοτζιάς, *AE* 1937, 878ff., no. 2, figs 9-10. Amandry 1963, 247, fig. 149. Miller 1979, 14ff., pl. 8a-c.

163-164. Chain necklace with Herakles knot and two female heads, late 4th - early 3rd century BC.
L. 43.5 cm. Grave at Abdera. Komotini, Archaeological Museum 1565.

The necklace comprises a plain chain, each end of which is inserted in a sheet-gold cylindrical collar, attached to the outside edge of which is a three-dimensional female head with embossed facial features and luxuriant hair. Interposed between the heads is a Herakles knot (on this see p. 14), formed from two interlocking thickish loops and embellished with two antithetic palmettes with a six-petalled rosette at the join (cf. figs 32-33, 157, 160). The convoluted ends of the knot cover rosette finials. A link on the crown of one female head, together with the hook below the corresponding edge of the Herakles knot, served as the clasp.

Δ. Τριαντάφυλλος, *ΑΔ* 29, 1973/74, Χρονικά, 809, pl. 598α. *Treasures* 1979, no. 421, pl. 58. Pfrommer 1990, 307, no. HK76, pl. 29, 17. Here pp. 14, 39, 251 in no. 157. On the Herakles knot with antithetic palmettes see also Deppert-Lippitz 1985, 201, pl. XXIII. Pfrommer, op. cit., pl. 29.

165-166. Chain necklace with two dolphins, late 2nd century BC.
L. 43.5 cm. Grave at Vatheia, Euboea. Athens, National Archaeological Museum Xp780.

Comprises a plain chain, at one end of which is a link and at the other a hook with snake-head terminal. Link and hook are masked by the decorative sheet-gold figure of a dolphin with upturned tail (fig. 166). A miniscule five-petalled rosette decorates the brow above the snout, while a row of six tiny ivy leaves in green enamel or glass, following the contour of the body, adorns each side of the sea creature. The necklace probably belonged

to Kleonike, daughter of Philiskos, whose name is inscribed on the stele of the grave in which it was found. Necklaces with dolphin terminals were evidently popular during the second and first centuries BC, particularly at Taranto in Magna Graecia.

Παπαβασιλείου 1910, 56, pl. ΙΔ, 8. M.S. Ruxer - J. Kubczak, *Greek Necklace of the Hellenistic and Roman Ages*, 1972, 236, pl. 7, 3. Pfeiler-Lippitz 1972, 108. Here p. 39. On necklaces with dolphins see Becatti 1955, 202, no. 430. Deppert-Lippitz 1985, 252, fig. 185. Pfrommer 1990, 233ff. with nn. 1714, 1721. Cf. Guzzo 1993, 58, 65, 211, figs 29, 32.

167. Chain necklace with gold-mounted medallion, early 2nd century BC.
L. 67 cm. Grave in the neighbourhood of Neapolis, Thessaloniki. Thessaloniki, Archaeological Museum 2837.

Comprises a simple chain ending in cylinders of deep red garnet encircled top and bottom by gold sheet decorated with relief annulets. Hinges (little loops through which a gold wire passes) link the cylinders to the main ornament of the necklace: an almost elliptical medallion fashioned from rather thick sheet gold, set in the middle with an ellipsoidal garnet bearing the intaglio representation of an Eros to the right. The shallow setting and the edge of the medallion are bordered by a plain and a spool or spiral beaded wire, while in the field between them is a row of wire tongue motifs. This necklace is one of the few notable pieces of jewellery recovered from the second-century BC city of Thessaloniki.

Treasures 1979, no. 307, pl. 43. *The Search* 1980, no. 100. Α. Δάφφα-Νικονάνου, *Μακεδονικά* 25, 1985/86, 192ff., no. 6, pl. 68. Pfrommer 1990, 258, no. FK107. Here p. 40.

168. Necklace with two chains, bezel-set stones and lynx heads, second half of 2nd century BC.
L. 45 cm. Artjukhov Barrow, Taman peninsula, Euxine Pontus (Black Sea). Saint Petersburg, Hermitage State Museum Art. 6.

Comprises two cord-chains linked to the centrepiece. This is formed from three gold-mounted stones, a square emerald between two ellipsoidal garnets, and flanked right and left by a gold-foil lynx head attached to a cylindrical agate. The stones are articulated with each other

and with the zoomorphic heads by means of hinges (tiny loops through which a wire passes) secured in place by two beads. Each chain ends in a heart-shaped garnet in gold setting, one bearing the link and the other the hook for fastening the necklace. This lovely, carefully executed piece is representative of the early phase of a new class of necklaces which appeared in the second century BC.

Minns 1913, 405, 430, fig. 321, no. I, 6. Higgins 1980, 166, pl. 50A. Pfeiler-Lippitz 1972, 108. Here p. 40.

169. Pair of pins with pelicans, c. 800 BC.
Max. h. 5.2 cm. Tekes, Knossos. Herakleion, Archaeological Museum X656.

Comprise a gold head and a silver shaft (missing on one pin). The cylindrical head is decorated with a biconical bead, encircled top and bottom by three modelled annulets and crowned by a solid disc on which perches a bird in the form of a pelican. The two pins are connected by a plain gold safety chain. Pins with zoomorphic heads, primarily of eastern provenance, were not frequent in Greece and the type with a bird is even rarer. The pelican especially, a unique case on pins, is scarcely encountered in other artistic genres either. The linking of the pins with a chain is also unusual but not unknown, mainly from the sixth century BC and later.

Jacobsthal 1956, 17ff., 62, 116, pl. 58. J. Boardman, *BSA* 62, 1967, 60, 69, no. 21, pls 7 and 12, 21. Deppert-Lippitz 1985, 68, col. pl. II. Here p. 40. On pins with zoomorphic heads cf. Jacobsthal, op. cit., 52ff. and with bird heads ibid., 62ff. On chains of pins: Jacobsthal, op. cit., 116ff. Bielefeld 1968, 44. Cf. S.G. Miller, *AntK* 29, 1986, 38ff.

170. Pair of pins with disc head, early 7th century BC.
H. 5.5 cm. Fortetsa, Knossos. Herakleion, N. Metaxas Private Collection 1561/62.

Complete solid gold pins preserved intact. The upper part is decorated by a faceted biconical protuberance, like a bead, encircled above and below by three raised annulets and crowned by a disc finial with a conical central boss. The form of the pins is typical of a class

found in pairs in Crete.

A. Lebessi, *BSA* 70, 1975, 169ff., pl. 23b. Higgins 1980, 111. Here p. 40.

171. Pair of silver pins with gold disc finial, c. 510-500 BC.
H. 13 cm. Grave 20, Sindos. Thessaloniki, Archaeological Museum 7935.

A significant part of the silver shafts is missing and the surviving section of them badly corroded. Formed at the upper end of each is the calyx of a closed flower and above this three successive rings or beads bearing six bulges in perimetric arrangement. The whole is crowned by a silver disc, the circumference of which is rimmed by a band of overlying twisted wires. The top is covered by a sixteen-petalled rosette of cut-out gold sheet, at the centre of which is a two-tier, sixteen-petalled flower with a conical rosette at its nucleus. All the petals are outlined in one plain and one beaded wire. The form of the flower was very common in Macedonia at this time (see figs 61-63). Likewise the beads with bulges have the same form as beads, which were used in other pieces of jewellery and were widespread throughout the Hellenic world from Archaic times (see figs 118-121). The Sindos pins with their elaborately decorated gold finials are among the most impressive of the disc-head type.

Σίνδος 1985, no. 129. Here pp. 40, 42.

172. Pair of pins with two globular beads and disc finial, c. 560 BC.
H. 21 cm. Grave 28, Sindos. Thessaloniki, Archaeological Museum 8079.8080.

The shafts are solid. The two globular beads on each head are of gold foil encircled top and bottom by rows of beaded wires. Beaded wire is also used to form the decoration on the surface of the spheres: foliate motifs in two zones on the lower one and rosettes within vertical segments on the upper. The head terminates in a disc bearing a fifteen-petalled cut-out rosette with another conical rosette at the centre. The pins were found on the shoulders of the dead female in the grave and

were used to secure her garment. This is the earliest pair of gold pins of monumental aspect, of which analogous Archaic examples are known from Macedonia (fig. 173).

Σίνδος 1985, no. 435. *Oro dei Greci* 1992, 268, no. 143. 1. Here p. 40 and for other examples (Vergina and Aiani) p. 283.

173. Pair of pins with two globular beads and disc finial, c. 510 BC.
H. 25.8 cm. Grave 67, Sindos. Thessaloniki, Archaeological Museum 7971.

The shafts are solid. The two gold-foil spheres contain a solid mass of red resin. The decoration is executed in beaded wires: The lower, smaller spheres are divided into two hemispherical sections decorated with S-shaped volutes, heart-shaped motifs and foliate ornaments. The upper, larger spheres are divided vertically into sixteen elliptical segments with a leaf top and bottom, so as to form a circlet of leaves at the top and bottom of the sphere. The pins end in a disc covered by a cut-out rosette of sheet gold, arising from the centre of which is a composite flower typical of the Sindos workshop (see figs 61-63, 171).

Σίνδος 1985, no. 330. A. Pekridou-Gorecki, *Mode in antiken Griechenland*, 1989, 77, fig. 50. Here p. 40.

174. Pin with pomegranate head, 7th century BC.
H. 6.1 cm. Ephesos. London, British Museum 958.

Comprises a solid gold shaft joined to a gold-sheet disc surrounded by beaded wire. Upon this sits a globular bead with six-petalled finial. The head probably renders a pomegranate. This is one of the many votive pins of diverse types found in the sanctuary of Artemis at Ephesos.

BMCJ 1911, 958, pl. 10. Jacobsthal 1956, 35ff., pl. 141. Higgins 1980, 119, pl. 22 C3. Deppert-Lippitz 1985, 96, fig. 49, 3. Here pp. 23, 41. On pomegranate pin heads see *Perachora* I, 174, type F, pls 76, 20-22 and 30-38. Jacobsthal, op. cit., 38ff. On the pins from the Artemision at Ephesos see D.G. Hogarth, *Ephesus*, 100ff., pl. V, 30.

175. Pin with poppy-capsule head, late 7th century BC.
H. 6.4 cm. Delos, near the Dionysos House. Delos, Archaeological Museum B517.

Comprises a silver shaft with a sheet-gold head. The lower part of the shaft is badly damaged, the upper joins to the bottom of the head which is tubular with modelled annulets of bead-and-reel form. Soldered to this is a fine disc on which is founded a deeply grooved globular bead, topped by a low cylinder bordered with beaded wire. The whole is a schematic rendering of a poppy capsule, like that encountered on other pieces of jewellery (see fig. 111). The type of pin with just one globular or other ornament on the head is of Eastern Greek-Ionian provenance, but the Delos pin was most probably created in a Cycladic workshop.

Délos XVIII, 282, no. 148, pl. 85, 726. Jacobsthal 1956, 38, 103, fig. 162. Bielefeld 1968, 52, pl. Ve. Here p. 41 and for the poppy capsule p. 281.

176. Pin with half-naked Aphrodite, 2nd century BC.
H. 13.6 cm. Syria. London, British Museum 3034.

The pin comprises a solid shaft crowned by a schematic Corinthian column capital which forms the pedestal on which a half-naked Aphrodite stands. The goddess wears a himation draped round her lower body and held in place by her left hand. Her left arm is bent at the elbow and rests on a pillar. She turns her charming head leftwards, while adjusting a lock of hair with her raised right hand. The diminutive figure recalls statue types of the goddess, particularly that known as the Venus of Arles, considered to be a copy of an early and famous work by Praxiteles, of which there are several variations. A chain hanging from the column capital is analogous to the chains preserved intact on the pin in figure 178.

BMCJ 1911, no. 3034, pl. 69. Amandry 1953, 107 in no. 241. Hoffmann - von Claer 1968, 157 in no. 69. Higgins 1980, 171, pl. 53G. Here pp. 21, 41.

177. Pin with tassel pendant, second half of 2nd century BC.
H. 8 cm, of pendant 7.5 cm. Artjukhov Barrow, Taman peninsula, Euxine Pontus (Black Sea). Saint Petersburg, Hermitage State Museum Art. 39.

The upper part of the pin shaft is decorated with bead-and-reel motif and crowned by a summarily formed Corinthian column capital. From a link at the top of the column capital hangs an impressive composite pendant, comprising a circular 'eye' decorated by a four-petalled, cloisonné-enamel rosette with heart-shaped petals (like a four-leaf clover) and a tassel of nine tiny chains ending in coiled wires, each holding a bead of semiprecious stone. The beads are encircled top and bottom by an appropriately curved foil rosette. The pin was part of a set of jewellery, along with a finger ring whose circular bezel also bears a quatrefoil rosette in cloisonné enamel, instead of a stone (fig. 219).

L. Stephani, *CRPétersbourg* 1880, 8, no. 18, pl. I, 17. Higgins 1980, 169, 171, pl. 53F. Here p. 41.

178-179. Pin with kneeling Aphrodite and Erotes, late 2nd century BC.
H. 16 cm. Unknown provenance. Athens, Benaki Museum 2062.

The solid shaft is crowned by a Corinthian column capital (fig. 179). The two faces of the abacus are decorated with a red chalcedony in a gold setting and the other two with an emerald. Upon each of the four corners sits a sedate infant Eros figure holding paraphernalia of the toilet: a perfume vase (alabastron), a round folding mirror, a spectacle fibula and another object which is unidentifiable. The Erotes surround their divine mother, who occupies the top of the ornament, on a system of three successive quatrefoil rosettes, whose schema is known from other pieces of jewellery (figs 177, 219). Aphrodite is half kneeling, resting with her left buttock on a rectangular plinth, and is washing or drying her hair. The motif is that of a marble statuette of the goddess in Rhodes, a Late Hellenistic creation dependent on Doidalsas' famous Aphrodite. Hanging from the bottom of the column capital are two chains ending in a hook, at once functional – for fastening the pin at two

other points – and decorative elements.

BCH 62, 1938, 448, fig. 4. *AA* 1939, 226, fig. 7. B. Segall in *Festschrift E. v. Mercklin*, 1964, 164ff., pls 57-58. Hoffmann - von Claer 1968, 157 in no. 69. Δελτίον 1980, 28, fig. 15. *Gold of Greece* 1990, pl. 28. *LIMC* II (1984), 105, no. 1038, s.v. *Aphrodite* (A. Delivorrias). Here pp. 21 and 41.

180. Fibula with leaf-shaped arch, c. 850 BC.
W. 8 cm. Attica. Berlin, Antikenmuseum 30553.

Comprises a spiralling stem of rectangular section, ending in a pointed shaft, and a rather flat leaf-shaped arch with relief midrib. One end of the arch continues into an almost triangular catch-plate rolled over at the back to form the catch for the pin for fastening the fibula. The points of transition to the catch-plate and to the spiralling stem at the other end of the arch are masked by a sheet-gold band framed by twisted wire. The decoration is engraved, relatively rich and carefully executed: the midrib of the leaf-shaped arch is bordered by two rows of running spiral and embellished on the crest with herring-bone motif, while the edges of the arch are decorated with a continuous zigzag linear pattern followed by a row of running spiral. Triangles, zigzags, lozenges and stippled lines enliven the other surfaces. Fibulae with leaf-shaped arch, together with the simpler and related so-called fiddle-bow ones, were the first types to appear in Greece and were mainly of bronze with very few of gold. The Berlin fibula and a second one, with which it made a pair, are among the earliest pieces with artistic pretensions.

Blinkenberg 1926, 77ff., no. 23, fig. 65. Greifenhagen 1970, 21, pl. 4, 4-5. Higgins 1980, 100. Deppert-Lippitz 1985, 56, fig. 22. Here pp. 13, 36, 41. On fiddle-bow fibulae and those with leaf-shaped arch see Philipp 1981, 262ff., 264ff. Cf. *Ancient Macedonia* 1988, no. 53.

181. Two fibulae with representations on the catch-plate, c. 775-750 BC.
W. 4.5 cm. Most probably from Athens. British Museum 1960.11-1.44-45 (Elgin Collection).

Comprise a curved arch terminating right and left in two integral beads to which are attached on the one side a stem of rectangular section that spirals and ends

in the pin, and on the other a more or less rectangular catch-plate the lower part of which forms the catch for the pin. The catch-plates are rectilinear, excepting the top which is slightly incurved with a pronounced acute angle to the outside. They bear engraved representations front and back: a galloping horse on one side of both fibulae, a lion and a sailing vessel on the other side respectively. The ship is rendered with all the basic elements: a mast in the middle and a sail with its rigging, the figurehead on the prow, the cabin, and an elevated stern. The fibulae are of the so-called Attico-Boeotian type of which numerous bronze examples have survived. Many of them can deservedly be characterized as monumental in all senses. Gold fibulae like these in the British Museum are extremely rare and truly impressive.

R. Hampe, *Frühe griechische Sagenbilder in Böotien*, 1936, 2, 19, no. 88, 3-4, pl. 7. R. Higgins, *BMQ* 23, 1960/1, 105ff., pl. 46. Higgins 1980, 100ff., pl. 14A-B. B. Schweitzer, *Greek Geometric Art*, 1971, 202, pls 230-231 top row. Here pp. 13, 36, 41.

182. Two arched fibulae with cylindrical beads, c. 510 BC.
H. 4 cm, w. 6.4 cm. Grave 67, Sindos. Thessaloniki, Archaeological Museum 7976.

Comprise an arched stem of circular section soldered to one end of which are two overlying cut-out gold-sheets decorated with a six-petalled wire rosette. Between them is affixed the splayed end of the silver shaft, held in place by a tiny silver rivet, the head of which forms the nucleus of the rosette. At the other end of the arched member is a rather thick sheet-gold disc with projecting band, folded behind to form the catch for the pin. The surface of the disc terminal is decorated by a six-petalled wire rosette. Each of the fibulae arches is embellished with three cylindrical beads encircled by three zones of triple wires. No exact parallels for these pieces exist, but they belong to the class of so-called articulated fibulae (*Scharnierfibeln*) which prevailed in Macedonia from the Archaic period onwards and are among the very few examples of gold fibulae known from that time.

Σίνδος 1985, no. 328. Cf. Philipp 1981, 315ff., no. 1133, n. 536, pl.

22, 70. On articulated fibulae and other specimens in gold see here pp. 42, 283.

183. Two arched fibulae with Pegasos and lionskin, c. 330 BC.
W. 5 cm. Grave Z, Derveni, Thessaloniki. Thessaloniki, Archaeological Museum Z7.

The heavy, cast arch bears five six-lobe rings alternating with six spool-shaped ones. Soldered to one end is a box-like plaque formed from two overlying rectangular gold sheets, decorated with the embossed head of a lionskin. The bronze pin, now lost, was affixed between them. At the other end of the arch is a gold strip with a semicircular flange either side, above which a triple wire annulet forms the base for two globules between which arises a Pegasos protome. The end of the strip is folded behind to form the catch for the pin. The fibulae from Derveni represent the final phase in the evolution of an earlier type that had developed in Macedonia during the Archaic period. These are two of the six fibulae found in the same tomb. The presence of more than two fibulae in the same grave is a phenomenon also encountered elsewhere from earlier times.

Χ. Μακαρόνας, *ΑΔ* 18, 1963, Χρονικά, 194, pl. 229γ (cited as coming from tomb E). *Treasures* 1979, no. 256. P. Amandry, *AJA* 71, 1967, 204 in nos 75-78. Βοκοτοπούλου 1990, 66. Here pp. 14, 41, 42 and for more than two fibulae in the same grave pp. 41, 283.

184-185. Two arched fibulae with Pegasos and lionskin, third quarter of 4th century BC.
W. 3.3 cm. Grave at Nea Michaniona, Thessaloniki. Thessaloniki, Archaeological Museum 7580/81.

Comprise an arched stem decorated with three plain biconical beads. Soldered to one end is a square box-like plaque, formed from two overlying sheets decorated with an embossed head of a lionskin. The iron pin, now lost, was affixed here. The other end of the arch (fig. 185) is joined to a sheet cut to form two lateral semicircular flanges and a strip in front that is bent behind to form the catch for the pin. The semicircular projections are covered by two globules on a circular base consisting of one plain and one spiral-beaded wire.

Between them arises a Pegasos protome of which the head, the two raised forelegs and wings are visible. The fibulae are two of the five contained in the tomb.

Βοκοτοπούλου 1990, 65ff., no. 44α-β, drawing 31, pl. 38ε-ζ. Here pp. 14, 41, 42.

186. Arched fibula with horse protome, griffin and head of Herakles, last quarter of 4th century BC.
W. 4.3 cm. Grave near Thessaloniki. Berlin, Antikenmuseum 30219.453.

Comprises an arched stem of circular section decorated with five six-lobe rings. One end of the arch adjoins a square box-like plaque formed from two overlying sheets between which was affixed the now lost bronze pin. The plaques are decorated with the embossed head of a young, beardless Herakles wearing the lionskin. At the other end of the arch is a rather thick gold sheet cut to form two lateral semicircular flanges, with a strip in front that is bent behind to form the catch for the pin. The semicircular flanges are covered by two globules on a cylindrical base, between which arises the three-dimensional figure of a griffin in sheet gold, while in front projects the protome of a horse. The reverse is decorated with a double wire volute and a rosette bordered by branches with leaf finials (fig. 186). The fibula is one of five from a burial assemblage that included the earrings with Ganymede (fig. 97).

Greifenhagen 1975, 89, pl. 65, 1-3, 7. Amandry 1963, 204 n. 3, fig. 113a-c. Hoffmann - Davidson 1965, no. 75. Segall 1966, 26. Here pp. 14, 41, 42 and on the representation of the head of Herakles pp. 42f. and 283.

187. Arched fibula with sphinx and head of Herakles, last quarter of 4th century BC.
W. 4.5 cm. Probably from Northern Greece. Berlin, Antikenmuseum 1960.1.

Comprises an arch bearing four biconical beads with filigree foliate patterns. Each bead is flanked by spool-shaped annulets. At one end of the arch is a square box-like plaque, in which the now lost pin was affixed. The plaque is decorated front and back with the embossed head of beardless Herakles with lionskin (on this see p.

43 and fig. 186 above), nowadays badly damaged. At the other end of the arch a fixed sheet, cut to form two lateral semicircular flanges and four leaflets behind, ends in front in a strip that is bent behind to form the catch for the pin. The semicircular flanges are covered by two globules on a cylindrical base, the face of which is decorated with wire S-shaped spirals. Between the globules arises the protome of a sphinx with a rosette upon its head. Before it projects the head of a horse. The back of the sheet is decorated with a conventional acanthus bush (fig. 187). The fibula probably belonged to the same grave assemblage as another one in the National Archaeological Museum, Athens (H. Stathatos Collection) and a third in the Carl Kempe Collection in Stockholm. These fibulae are similar to six others from tomb Γ at Sedes, Thessaloniki.

Amandry 1963, 204 n. 3, fig. 111a-d. Greifenhagen 1975, 89, pl. 65, 4-6. *The Search* 1980, no. 54. Here pp. 14, 41, 42. On the fibulae from Sedes: N. Κοτζιάς, *AE* 1937, 879ff., no. 3, figs 11-12, drawing XI.

188. Fibula in the form of a hawk, second half of 7th century BC.
H. 4 cm, w. 6 cm. Said to be from Ephesos. Berlin, Antikenmuseum 1963.6.

The fibula consists of two cut-out sheets the back one of which is flat and bears the pin for fastening it. On the front sheet the general features of the face and body of a hawk are embossed. The individual details, conventionally but characteristically rendered, are described or emphasized with rich granulation: a row of granules emphasizes the contour of the body, the eyes and the eyebrows. Two angulated lines distinguish the beak from the plumed forehead and a row of triangles, like a kind of diadem, sets off the forehead from the feathered part of the head. Two rows of granules frame the fold in the neck like a necklace. The flecked plumage on the hawk's breast is rendered with mesh pattern and the feathers on the strong wings with zigzag lines. Lastly, vertical hatching indicates the feathered socks and talons of the bird. The work of an East Greek workshop, the fibula in Berlin is undoubtedly the loveliest of all

the examples of this type found at Ephesos.

Greifenhagen 1970, 28, pl. 8, 5-7. Idem, *Schmuck der alten Welt*, 1979, 22. Higgins 1980, 120, pl. 22D. Deppert-Lippitz 1985, 97, pl. IV. Here p. 43.

189. Bracelets with snake-head terminals, 470-460 BC.
Diam. 3.5 cm. Grave 68, Sindos. Thessaloniki, Archaeological Museum 7993.

Comprise a stout sheet of concave section forming a penannular hoop with hollow inside. The two terminals are solid and fashioned as snake heads. On the upper surface of each is a double forked incision bordered laterally by elevated flaps that continue the ridge of the 'eyebrow' above the oblong eye socket, in which the round eye is engraved. Although numerous bracelets with snake-head terminals are known, examples in gold are extremely rare. A pair dating from the late sixth century BC was discovered at Vergina, another bracelet of about the fifth century BC is known from Duvanlij in Southern Bulgaria and two fourth-century BC pairs were found at Kozani and Halykes, Kitros in Pieria. The snake, chthonic symbol *par excellence,* was also a protective daemon with apotropaic properties. Its representation was used elsewhere, but above all in Macedonia, on diverse pieces of jewellery.

Σίνδος 1985, no. 49. On other gold examples: Filow 1934, 44, no. 9, figs 51-52. Β. Καλλιπολίτης - D. Feytmans, *AE* 1948/49, 92, no. 4, figs 3-5. Amandry 1953, 52. *Νομός Κοζάνης. Τουριστικός Οδηγός*, 1994, 20, with fig. Μ. Ανδρόνικος, *Το Έργον*, 1988, 74, fig. 63 and *ΑΕΜΘ* 2, 1988, 1. Μ. Μπέσιος, *ΑΕΜΘ* 2, 1988, 189. Μ. Μπέσιος - Μ. Παππά, *Πύδνα*, 1995, 116. Here pp. 43, 283f.

190. Snake bracelets, late 3rd - early 2nd century BC.
Diam. 6 cm, h. 8.5 and 9 cm. Perhaps from Thessaly. Athens, National Archaeological Museum Στ346Α-Β (H. Stathatos Collection).

Comprise a thick sheet-gold ribbon forming two coils, flat on the inside and with a midrib on the slightly curved exterior. The two terminals, with an eight-shaped antithetic twist, end in the reared head of a snake and its tail. The details on the head are rendered in relief, while the eyes are indicated by two miniscule round bulges. The scales were hammered with a curved chisel. Both ends of the snake bracelet are enlivened by two red amygdaloid sards mounted in gold in the void of each eight-shaped twist. Written in pointillé lettering on the flat inside is the name ΖΩΙΛΑC – of the jeweller or of the owner –, a name encountered on other pieces of jewellery (figs 155-156, 192-193). The bracelet in the form of a full-bodied coiled snake was the paramount type that held sway during the Hellenistic period and throughout the Hellenic world, from which a large number of examples have survived, including ones in gold.

Amandry 1953, 117ff., nos 256/7, pl. 46. Παπαποστόλου 1990, 105 nn. 83 and 87. Pfrommer 1990, 349, no. SR17, fig. 18, 26. Here p. 43. On the inscription: Amandry, op. cit., 133. Williams - Ogden 1994, 83 in no. 37.

191. Bracelet in the form of intertwined snakes, first half of 2nd century BC.
Diam. 9.5 cm. Said to be from Eretria or Egypt. Pforzheim, Schmuckmuseum 1957.12.

A thick sheet-gold ribbon forms the bodies of two snakes, intertwined in their lower part to form a Herakles knot (on this see p. 14). The heads of the serpents, which constitute the top and bottom terminal of the bracelet, are rendered with chiselled details. The eyes in the corresponding sockets were of inlaid coloured stone or glass. The tails, arranged symmetrically right and left of the Herakles knot, develop in several spirals as a free ornament that together with the deep-red stone mounted in gold at the centre of the knot contribute to the enhancement of the centrepiece. The sheet-gold ribbon, flat on the inside and slightly curved on the outside with a relief midrib, is covered with schematic scales executed in pointillé. This is one of the most original and impressive specimens of a snake bracelet. A gold finger ring of similar form was found in a tomb at Abdera, while the tails of two snakes on a bracelet of another type, found at Pelinnaion, Trikala, also intertwine in a Herakles knot.

Amandry 1963, 253 n. 7, fig. 152. *The Search* 1980, no. 66. Deppert-Lippitz 1985, 268, col. pl. XXIV. Pfrommer 1990, 58, 135ff.,

349, no. SR13, fig. 18, 10, pl. 22, 6. Here p. 43. Ring from Abdera: Χρ. Σαμίου, *AEMΘ* 2, 1988, 476, no. 4, fig. 10. Bracelet from Pelinnaion: Miller 1979, 41ff., 61, no. Pel. J 3, pl. 24a-b.

192-193. Bracelets in the form of a Triton and a Tritoness, early 2nd century BC.
H. 14.6 and 16 cm. Unknown provenance. New York, Metropolitan Museum of Art 56.11.5-.6.

Both bracelets are formed by two modelled figures of a couple of Tritons, fantastic sea-creatures, human from the waist upwards and with a squamate lower body, usually in the form of a snake, ending in a fishtail. The serpentine bodies of the Triton and Tritoness coil twice; they are concave inside and curved and scaley outside. The torso and the facial features are rendered in minute detail, as on statuettes. The transition from the human to the scaley body is masked by fins in the form of acanthus leaves. The edge of a himation, that seems to billow behind the head, swathes round the arm with which the Triton and the Tritoness hold an infant Eros. The other hand is raised towards the back of the head. This gesture – uninterpreted for the bracelets – is perhaps taken from some other composition that inspired the gifted goldsmith with this unique theme for bracelets. An analogous theme occurs on an early second-century BC grave stele from Gavalou, Aetolia (ancient Trichonion), on which a Triton is represented with the himation swathed round one arm, while he raises the other to throw a stone, defending himself against a sea monster (*ketos*). Statue groups of hybrid figures, such as those of the young and the aged Centaur with an infant Eros on their back, that was perhaps copied from some Hellenistic original by the sculptors Aristeas and Papias from Aphrodisias, are thematically close to the wonderful bracelets in New York. The existence of analogous groups with Triton figures, alone or in compositions of the marine *thiasos*, can be postulated in Hellenistic times. According to Hesiod (*Theogonia* 933) the Triton was originally an 'awesome god'. Later, like the Nereids and other marine deities, there was a proliferation of them in art. A family of Tritons is represented on a Hellenistic sealstone. On the inside of the serpentine stem of both

bracelets is the inscription ΖΩΙ, which is the abbreviated form of a name known from other pieces of jewellery (figs 155-156, 190) and denoted either the creator or the owner of the pieces.

Higgins 1980, 168, pl. 51B. Deppert-Lippitz 1985, 268, fig. 202. Pfrommer 1990, 134, 353, no. SR65/66. Williams - Ogden 1994, no. 37. Here p. 43. Stele from Trichonion: H. Möbius, *Die Ornamente der griechischen Grabstellen²*, 1968, 68, 117, pls 60c-61. P.M. Fraser - T. Rönne, *Boeotian and West Greek Tombstones*, 1957, 65ff., 144ff., 173, 195, pl. 28, 1. Sculptural groups by Aristeas and Papias: M. Bieber, *The Sculpture of the Hellenistic Age*, 1961, 140ff., pls 581, 583-584. Sealstone: Furtwängler 1900, 197, no. 41, pl. 41.

194. Bracelet with lion-head terminals, late 7th - early 6th century BC.
Diam. 9.9 cm. Kameiros, Rhodes. London, British Museum 1205.

Comprises a silvered bronze penannular hoop of circular section, terminating in gold lion heads with schematically rendered details emphasized by rows of granules. The ferocity of the beasts is stressed by the bared teeth in the open mouth. On top of the heads rows of zigzag, triangles and granulated spiral motifs occupy the place of the mane. The bracelet is one of the early examples of a type with zoomorphic terminals that can be traced back to eastern models and became particularly popular in Persian art of the Achaemenid dynasty. Stylistically the lion heads are close to monuments of the Orientalizing and Early Archaic periods, expressing the animal's old mythical daemonic character rather than its vital force.

BMCJ 1911, no. 1205, pl. 13. Laffineur 1978, 160 nn. 2 and 3. Higgins 1980, 117ff. Pfrommer 1990, 335, no. TA40. Here p. 43. On bracelets of the Achaemenid period: P. Amandry, *AntK* 1, 1958, 11ff. Pfrommer, op. cit., 95ff.

195-196. Bracelets with ram-head terminals, third quarter of 5th century BC.
Diam. 8.4 cm. Kourion (Curium), Cyprus. London, British Museum 1985/86.

Comprise a gilded bronze penannular hoop of circular section, to the ends of which are attached gold-sheet ram heads with embossed details. A collar with tongue

pattern in plain wire, behind each head, serves as a transition to the hoop. The animals' curly fleece is denoted by impressed roundels hammered with a punch. The eyes are hollow and were perhaps inlaid with enamel. The clarity and precision in the rendering of the details of the horns retains the severity of analogous figures depicted on ring gems of the years after the Persian Wars, yet the facial features and particularly the eyes are rendered with Classical forms. A contemporary pair of bracelets with similar heads was found at Chrysochou on Cyprus, while a later one, of the late fifth century BC, comes from Nymphaion in the Crimea. The bracelets from Kourion and Chrysochou are elegant examples of a skilled goldsmith's art in Classical times.

BMCJ 1911, nos 1985/86, pl. 39. Higgins 1980, 131, pl. 30A. Deppert-Lippitz 1985, 156, fig. 110. Williams - Ogden 1994, no. 161. Here p. 43. Bracelets from Nymphaion: Vickers 1979, 48, pl. XVIIIe. Pfrommer ·1990, 343, no. TA136, pl. 20, 6. Ring gems: Boardman 1968, 147, 151, no. 519, pl. 34. Ram-head bracelets from Chrysochou, Cyprus: *BMCJ*, op. cit., nos 1987/88. Pfrommer, op. cit., 344, no. TA144, pl. 20, 5.

197. Bracelet with sphinx terminals, c. mid-4th century BC.
Diam. 11.5 cm. Scythian grave at Kul Oba, near Pantikapaion (Kerch), Crimea. Saint Petersburg, Hermitage State Museum KO20.

Comprises a twisted penannular hoop, the spiralling grooves of which are traced by a beaded or spiral-beaded wire. Each end of the hoop terminates in a sheet-gold sphinx protome, bedecked in diadem, necklace and earrings. The front paws of the two sphinxes are linked by a coiled wire with snake heads. The points where the sphinxes are attached to the hoop are concealed by a collar, bordered above by a row of granules and below by a bead-and-reel wire, and divided into two unequal zones with filigree decoration. In the wide zone lotus flowers alternate with palmettes, picked out in blue and green enamel respectively, while the narrow is filled with egg-and-dart pattern (Ionic cymatium), likewise variegated with blue and green enamel. The hollow inside of the hoop and the inside of the sphinxes contain a resinous substance. Typologically the Kul Oba bracelet

with its virtually full-bodied figures as terminals, belongs in the Scythian repertoire. It is an exquisite example of the miniature sculpting produced in Greek goldsmiths' workshops on the northern shores of the Euxine Pontus.

Artamonov 1969, 68, pls 200, 205. Higgins 1980, 131, pl. 30B. Deppert-Lippitz 1985, 189, fig. 138. Pfrommer 1990, 119ff., 342, no. TA123, fig. 16, 5. Williams - Ogden 1994, no. 83. Here pp. 23, 44.

198. Rock crystal bracelets with gold ram-head terminals, last quarter of 4th century BC.
Diam. 7.7 cm. Thessaloniki area. New York, Metropolitan Museum of Art 37.11.11-12.

Comprise a thick penannular hoop carved from rock crystal, its spiralling grooves enhanced by a single gold wire. The ends of the hoop are inserted and fixed in tubular sections of sheet gold, terminating in three-dimensional ram heads and elaborately ornamented with filigree motifs in three main zones: an ivy wreath in the upper, a row of palmettes alternating with lotus flowers in the middle, rinceaux, palmettes and rosettes in the lower. A foliate band at top and bottom of each tube masks the transition to the hoop and to the ram head. The zoomorphic terminals and the highly embellished tubular collars endow these rare pieces with a certain majesty.

G.M.A. Richter, *BMetrMus* 32, 1937, 290ff., figs 1-3, 6. Segall 1966, 26ff., pl. 45 below. Higgins 1980, 167, pl. 51A. Pfrommer 1990, 343, no. TA131, pl. 21, 1. Here p. 44.

199-200. Bracelet with caprine-head terminals, early 3rd century BC.
Diam. 7.7 cm. Mottola, Southern Italy. Taranto, Museo Archeologico Nazionale 54.118.

The bracelet comprises a twisted hoop of sheet gold with spiralling ribs and deep grooves. The ends terminate in two remarkable caprine heads (fig. 200). The join with the hoop is masked by a collar decorated with wire S-shaped volutes and a foliate circlet towards the hoop. The zoomorphic heads, embossed with engraved details, display a remarkable naturalism and vitality in

the rendering of the features and the hair. The eyes were inlaid in coloured stone, now lost. The horns are of wire with horizontal grooves and resemble those of antelope heads, a characteristic decorative theme in Persian art, that passed to bracelets and earrings made in Greek workshops. The caprine heads on the Mottola bracelet are a work of exceptional power. The formation of the hoop from twisted corrugated sheet is rare. The hoops of a pair of bracelets reported as coming from the Pangaion region, but nowadays lost, were similar.

Hoffmann - Davidson 1965, 162 in no. 57, fig. 57b. *Ori di Taranto* 1987, 243ff., no. 167. Deppert-Lippitz 1985, 232, fig. 168. Pfrommer 1990, 331ff., no. TA4, pl. 10, 1.3. Guzzo 1993, 78, fig. 37. Here p. 44. On other examples with twisted hoop: Greifenhagen 1970, 33, pl. 12, 2. A. Garside (ed.), *Jewelry Ancient to Modern*, 1978/80, no. 267. Pfrommer, op. cit., 332, no. TA5, fig. 16, 45.

201. Bracelets with horned lynx-head terminals, early 2nd century BC.
Diam. 6.5 cm. Grave in the Neapolis neighbourhood, Thessaloniki. Thessaloniki, Archaeological Museum 2831-2832.

The hoop comprises one or possibly more plain wires coiled carefully around a core, perhaps of metal judging from the weight of the bracelets. The terminals are heads of horned lynxes, which though tiny are rendered with considerable plasticity and attention to detail, particularly the cheek whiskers and the characteristic pointed ears (cf. figs 94 and 128-129) that distinguish them from the heads of the so-called lion-griffins. The join with the hoop is masked by a sheet-gold collar ending in a foliate band and decorated with a spiral-beaded wire. Likewise of beaded wire are the spiralling horns that class these heads among the hybrid beings generated by the creative imaginative of Oriental art. Their presence on bracelet terminals, not so frequent in Greek goldwork, is the result of syncretism in the thematic repertoire, observed primarily after the Macedonian conquests. The bracelets of the fourth century BC found in the wider environs of ancient Pydna are perhaps the earliest Greek examples of this type featuring heads of horned creatures.

Α. Δάφφα-Νικονάνου, *Μακεδονικά* 25, 1985/86, 188ff., no. 2, pl. 48.

Θεσσαλονίκη 1986, 116, figs 107-108. Pfrommer 1990, 258, 340, no. TA108, fig. 16, 50, on the difficulty of distinguishing from the heads of lion-griffins p. 105 and on lynxes p. 107ff. Here p. 44. Bracelets from Pydna: Μ. Μπέσιος, *ΑΕΜΘ* 2, 1988, 189. Μ. Μπέσιος-Μ. Παππά, *Πύδνα*, 1995, 116-117.

202. Two band finger rings, c. 850 BC.
Diam. 2 cm. Grave on the northwest slope of the Areopagos. Athens, Museum of the Ancient Agora J145. J147.

Comprise a sheet-gold band decorated with engraved linear motifs. One ring bears a row of rhomboid ornaments formed from successive linear lozenges, the central one of which is enhanced by a stippled surround. The other ring is decorated with stacked zigzag lines. At the edges of the rings a row of embossed dots defines the decorated surface top and bottom. The motif of zigzag lines is also encountered on early gold band diadems. Both this and the motif of successive lozenges feature in the decoration of contemporary Attic vases.

E.L. Smithson, *Hesperia* 37, 1968, 112, 113, nos 74, 76, pl. 32. Coldstream 1979, 56. Higgins 1980, 99, no. 2. Here p. 44.

203. Finger ring with sphinx, second quarter of 5th century BC.
L. of bezel 1.7 cm. Grave near Nymphaion, Crimea. Oxford, Ashmolean Museum 1885.492.

Comprises a hoop and a solid elliptical bezel bearing an intaglio representation of a couchant sphinx, its schema adapted to the available space. The sphinx, a protective daemonic figure and familiar iconographic theme on earlier and later rings, sealstones and coins, is here flanked right and left by a tripartite vegetal motif, comprising a bud between two leaves. In using this framing the goldsmith follows an Archaic practice for filling the empty field, known also from other examples. The ring from Nymphaion belongs typologically to a group of five finger rings, two of which are from Nymphaion while a third is from Phanagoreia, opposite Pantikapaion in the Crimea.

Boardman 1970, 215, 296, pl. 657. Vickers 1979, 38, fig. 3, pl. VIb-c. Here p. 44. On the sphinx theme: Philipp 1981, 171.

204. Finger ring with flying Nike, second quarter of 5th century BC.
L. of bezel 1.6 cm. Grave at Eretria. Athens, National Archaeological Museum Xρ687.

Comprises a hoop and an integral elliptical bezel with peripheral groove and an intaglio representation of a flying Nike. The figure wears a long garment and with both hands carries a wreath, indicated by a stippled line. The Eretrian ring continues the Late Archaic tradition of rings of similar type, which have a parallel history in Cyprus, where the favourite theme was a flying Eros. A ring related to that from Eretria was found at Nymphaion in the Crimea. The theme of Nike on finger rings was popular mainly in the first half of the fifth century BC. Nike was a relatively new member of the Greek pantheon. Daughter of a Titan, according to Hesiod (*Theogonia* 384), she was among those forces supporting the sovereignity of Zeus. The beginning of her affinity (that emerges from their direct iconographic correspondence) with Eros, authoritative force over man's fate, can perhaps be sought in these roots. The ancient authors speak of 'mistress' and 'great august Nike'. Her iconographic type, a winged female figure, personification of victory in martial or athletic and other contests, was crystallized in the sixth century BC. Holding a wreath or ribbon, she is frequently rendered as messenger of victory. Of daemonic nature, like the Erotes, sirens and other winged figures, Nike is represented on the Eretria ring as bringing 'ἀρετᾶς τέλος', to use Bacchylides' phrase (*Epin.* 11, 6-7 Snell), that is the reward for virtue, the wreath.

K. Kuruniotis, *AM* 38, 1913, 296, 299, pl. 16, 5-5a. Boardman 1970, 417 n. 465. Here p. 45. Finger rings from Cyprus: Boardman 1967, 25, and 1970, 157. *BSA* 65, 1970, 12, nos 38-40, pl. 6. Nymphaion: Boardman 1970, 215, pl. 658. On winged figures: E. Buschor, *Die Musen des Jenseits*, 1944, 30ff., 53ff. A. Gulaki, *Klassische und Klassizistische Nikedarstellungen*, 1981, 140. H.A. Shapiro, *Personifications of Abstract Concepts in Greek Art and Literature*, 1977, 27ff., 66ff. On Late Archaic tradition and the motif: Boardman 1970, 157 and *BSR* 34, 1966, 15 with n. 19.

205. Finger ring with seated female figure, last quarter of 5th century BC.
Dimensions of bezel 2.4 x 1.9 cm. Grave on the area of Pantikapaion (Kerch), Crimea. Saint Petersburg, Hermitage State Museum BB124.

Comprises a hoop and a broad elliptical bezel with intaglio device calculatedly adapted to the available space. Represented is a female figure sitting on a stool with turned legs (*diphros*). She is clad in a chiton and a himation that covers the head, on which she wears a diadem (*stephane*). Her left hand is outstretched towards a small animal, perhaps a fawn or a dog, standing before her feet. Notwithstanding its originality, the schema is thematically comparable to analogous ones on Classical funerary reliefs in which the dead are shown in scenes from everyday life. However, because the figure on the ring wears a diadem, which is never seen on adults in funerary monuments, we are hesitant in attributing a meaning linked with daily life. Another sphere may be alluded to here, in which the figure exists, perhaps divine.

L. Stephani, *CRPétersbourg* 1870/71, 211ff., pl. VI, 19. Artamonov 1969, 77, pl. 281 (provenance recorded as Great Bliznitsa). Boardman 1970, 220, 297, pl. 690. Here p. 45. Cf. Guzzo 1993, 30ff., figs 6-7. Funerary stelae with analogous theme: Κ. Κώστογλου, *ΑΔ* 24, 1969, Μελέται, 118ff., pl. 58. Γ. Μπακαλάκης, *Ανάγλυφα*, 1969, 41ff., fig. 16.

206. Finger ring with Aphrodite and Eros, first quarter of 4th centuty BC.
L. of bezel 2.1 cm. Grave at Great Bliznitsa, Taman peninsula, Euxine Pontus. Saint Petersburg, Hermitage State Museum BB38.

Comprises a hoop and a broad elliptical bezel with intaglio representation of Aphrodite and an infant Eros. The goddess sits on a turned stool (*diphros*), her feet resting on a footstool. She wears a chiton, a himation draped round the lower body, a necklace and bracelets, while her hair is drawn back into a *sakkos*. Before her stands the winged infant, extending his right hand towards the 'wryneck' (jynx), which she is teaching him to handle. The wryneck was a toy consisting of a disc-shaped wheel through which passed two threads that loosened

and taughtened to make it spin. Known from vase-paintings, in the hands of children and especially of Eros, the 'wryneck' was considered to be magical with the power to enchant a desired person (see also fig. 72). Eros with 'wryneck' also appears on a finger ring from Naukrates. The representation on the Bliznitsa piece is rendered as a joyful moment from Eros' childhood.

Segall 1966, 19, pl. 37, 3. Artamonov 1969, 75, pl. 283. Boardman 1970, 222, 298, pl. 713. Here p. 45. Ring from Naukrates: *BMCR* 1907, no. 1258. On the wryneck: G.N. Nelson, *AJA* 44, 1940, 448ff. H. Ruhfel, *Das Kind in der griechischen Kunst*, 1984, 234ff. with fig. 99. V. Pirenne-Delforge, *Kernos* 6, 1993, 282ff.

207. Finger ring with Kourotrophos, third quarter of 4th century BC.
Dimensions of bezel 2 x 1.6 cm. Grave Γ, Sedes, Thessaloniki. Thessaloniki, Archaeological Museum 5420.

Comprises a hoop and an integral heavy and wide elliptical bezel with intaglio representation: seated on a chair is a female figure, cradling and suckling a naked babe. She wears a sleeved chiton and a himation falling in folds from the hips. The scene occupies the middle of the bezel and is rendered with realistic tenderness. The subject of suckling is rather rare, known mainly from vase-painting where goddesses or heroines are shown in this act. Mortals suckling were not depicted in ancient Greek art. The mortal women on grave stelae simply hold the infants in their arms and are usually their mothers – in one case the grandmother. In wealthy families wet nurses were encharged with this task, but on those grave stelae featuring nursemaids they are not shown giving suck. An exception is a Thessalian grave relief from Rhodia, Tyrnavos, on which a seated female figure is shown suckling the child. Whether she is the mother or the wet nurse is difficult to say, though the first possibility is the more plausible. In any case the rarity of the theme leads us to believe that a divine figure is shown on the ring. Because clues to her identity are absent (Aphrodite, Hera, Demeter or another goddess), she can simply be qualified as a *Kourotrophos* (divine nurse). The ring was found in a grave in which the associated pottery is dated to about 320 BC (see p. 232

in no. 90), but according to Boardman the ring type is slightly earlier.

N. Κοτζιάς, *AE* 1937 Γ΄, 882, fig. 15. Boardman 1970, 226, 284, fig. 235. *Treasures* 1979, no. 323, pl. 45. Here p. 45. On the theme: Arias - Hirmer - Shefton, *A History of Greek Vase Painting*, 1962, 389ff. in no. 238. N.M. Kontoleon, *Aspects de la Grèce Préclassique*, 1970, 19ff. Th. Hadzisteliou-Price, *Kourotrophos*, 1978. Stele from Rhodia: Α. Μπάτζιου-Ευσταθίου, *AAA* 14, 1981, 47ff., fig. 1.

208. Finger ring with Aphrodite and Eros, last third of 4th century BC.
Dimensions of bezel 2.2 x 2 cm. Kalymnos. Berlin, Antikenmuseum 10823c.

Comprises a hoop and a solid, almost circular bezel with intaglio representation of Aphrodite teaching the young Eros how to use a bow. The goddess is clad in a himation covering her lower body and holds her young son on a high rocky support. Eros is a chubby, carefree infant who nevertheless stretches the bow firmly. This is at present the earliest representation of Aphrodite training Eros as an archer of hearts in this motif. The theme occurs on a sealstone and in a lovely marble sculpted group of Late Hellenistic date from Kos. The figure of Aphrodite in the Kos group is perhaps related to a statue type attributed to the major sculptor Lysippos. Though the rendering of the figures on the ring from Kalymnos is somewhat inept, its immediacy and vitality is truly charming.

Boardman 1970, 225, 299, pl. 742. Greifenhagen 1975, 73, pl. 55, 7-9. *LIMC* II 1984, 72, no. 634, s.v. *Aphrodite* (A. Delivorrias). Here p. 45.

209. Finger ring with bearded head, last quarter of 5th century BC.
L. of bezel 1.7 cm. Unknown provenance. Berlin, Antikenmuseum FG287.

Comprises a hoop and an elliptical bezel with an intaglio head of a bearded elderly man, shown frowning, with a large nose, a beard and moustache, wrinkled skin, a bald forehead and dishevelled hair. The representation is an important example of a study of the type of an elderly person and is unusual among the monuments of

the *par excellence* idealistic Classical period. A similar figure, though not quite so strongly characterized, occurs on a finger ring from Nymphaion in the Crimea. On the ring in Berlin the puzzling device in front of the old man's neck has been identified as male genitalia and interpreted as a symbol in some way associated with the ring's owner, or as corresponding to the penis on the herms. The subject of a head with particular physiognomic features first appeared in glyptics on a jasper sealstone of the third quarter of the fifth century BC, found at Athens and bearing the signature of the great Chian seal-engraver Dexamenos. But while the noble head on Dexamenos' seal recalls Pliny's comments (XXXIV 74) on the sculptor Kresilas, who represented noble men even nobler, the representation on the ring in Berlin, on the contrary, expresses a rejection of established values in an Aristophanic vein.

Greifenhagen 1975, 72, pl. 54, 11, 17. Boardman 1970, 216, 219, 284, fig. 220. D. Metzler, *Portrait und Gesellschaft*, 1971, 312, fig. 27. Higgins 1980, 131, pl. 31D. Here p. 45. Dexamenos' sealstone: Boardman 1970, 195ff., pl. 466 and the ring from Nymphaion 219, pl. 670. Vickers 1979, 46, fig. 10, pl. XVIIb-c.

210. Gold hoop supporting a sealstone with a flying heron, engraved by Dexamenos of Chios, third quarter of 5th century BC.
L. of bezel 2 cm. Grave at Jouz Oba, near Pantikapaion (Kerch), Crimea. Saint Petersburg, Hermitage State Museum JuO24.

Comprises a penannular hoop terminating in schematic lion paws linked by an axle around which swivels a scaraboid sealstone of sapphire blue jasper. The sealstone bears the intaglio representation of a flying heron and below it the signature of a famous seal-engraver: ΔΕΞΑΜΕΝΟΣ ΕΠΟΙΕ ΧΙΟΣ (DEXAMENOS OF CHIOS MADE [IT]). The design of the heron, down to the minutest detail, is impeccable and the strong movement a perfect rendering of nature. The position of the bird on the surface of the stone, in diagonal orientation from bottom left to top right, is superbly calculated: the beak with the plume and the line of the wing form the virtually straight upper limit of the representation, while the balanced inscription on the rightwards extension of the line of the legs sets the bottom limit, at the same distance from the periphery as the top limit. Dexamenos, a contemporary of Pheidias, was without doubt one of the leading talented exponents of the glyptic art. One other sealstone with heron by him is known. Both pieces are exceptional *études* of unparalleled Ionian delicacy. The ring accompanied a dead man in his grave, worn on his hand along with two others.

L. Stephani, *CRPétersbourg* 1861, 147ff., pl. VI, 10. Boardman 1970, 195, 236, 288, pl. 468. P. Zazoff, *Die antiken Gemmen*, *HdArch* 1983, 131ff., fig. 40a, pl. 31. Here p. 45.

211-212. Finger ring with circular bifacial bezel, early 5th century BC.
Diam. 2.7 cm. Unknown provenance, perhaps from Corfu. London, British Museum R41.

Comprises a hoop and a drum-shaped bezel of sheet gold. Both ends of the penannular hoop taper to wire-fine, cross over and pass through the hole in the drum, twisting together to secure the bezel which rotates but is prevented from moving left and right. Its upper and lower edges are bordered by beaded wire. One face is decorated with the intaglio representation of a griffin with a raised foreleg (fig. 211). The Doric inscription ΔAMO, shared above and below the creature, is probably the beginning of a name, perhaps of the ring's owner. A rosette and a foliate motif of plain wire decorate the other face and the side of the bezel respectively (fig. 212). Though the devices on the obverse and the reverse of the bezel, and the fact that it swivels, attest influence from rings with movable sealstones, the ring is very delicate for practical use. This is the earliest example of a bifacial hollow gold bezel.

BMCR 1907, no. 41, fig. 12, pl. 2. Boardman 1970, 157, 188, 430, pl. 443 and for abbreviated inscriptions 236. Idem, 1967, 27ff., no. P9, pl. 7. Williams - Ogden 1994, no. 1. Here p. 45.

213. Finger ring with Thetis bearing Achilles' weapons, third quarter of 4th century BC.
L. of bezel 2.5 cm. Grave at Omolion, Thessaly. Volos, Archaeological Museum M58.

Comprises a silver penannular hoop the ends of which

are connected by a wire axis nowadays restored. Around the axis rotates the movable bezel consisting of two plaques of rock crystal covering two faces of a third plaque which is of sapphire or blue glass. The coloured plaque served as the ground for the two embossed representations on cut-out gold foil. On one face Eros rides a dolphin, on the other (fig. 213) one of the fifty Nereids, the heavenly goddess Thetis, rides a hippocamp while holding a helmet in her right hand and a shield in her left. She is carrying to Troy the resplendent gold embellished weapons of her son Achilles, that were forged for her favour by Hephaistos, as Homer narrates in the *Iliad* (XVIII 369ff.). The representation is an excerpt from wider compositions, known mainly from vase-painting, in which an entire *thiasos* of Nereids ride on the backs of dolphins or sea-horses, each carrying one of the weapons (see fig. 83) or accompanying Thetis. A much loved theme, represented in the whole spectrum of ancient art already from Early Classical times, its culmination was perhaps the large-scale creation of Skopas, which many scholars believe was the sculptural work by the Parian sculptor mentioned by Pliny. The representation of Eros on the reverse of the ring is a similar excerpt from a wider cycle.

Δ. Θεοχάρης, *ΑΔ* 17, 1961/62, Χρονικά, 177, pl. 198γ. Miller 1979, 18ff., 56, pl. 11c. Eadem, *AJA* 90, 1986, 160ff., 168, no. 4, pl. 13, 5-6. Boardman 1970, 233ff. *Treasures* 1979, no. 4, pl. 3. Deppert-Lippitz 1985, 193, col. pl. XVI. Here p. 45. On the marine thiasos: St. Lattimore, *The Marine Thiasos*, 1976, 28ff. Miller, *AJA*, op. cit.

214. Finger ring with bifacial palmette bezel, late 5th century BC.
L. of bezel 2.3 cm. Said to be from Southern Russia. Berlin, Antikenmuseum 30219.515.

Comprises a penannular hoop fashioned entirely from lengthwise wires each twisted in the opposite direction to the other and soldered together so as to form a kind of chain. The ends of the hoop terminate in two elegant lion heads that hold a hollow elliptical bezel. The bezel is bifacial, decorated front and back with a double antithetic wire palmette and on the side with an Ionic cymatium, also in wire. Similar rings have been found at Eretria, Ialyssos on Rhodes and Kourion in Cyprus. The decoration on the reverse of the bezel – not visible when worn – as well as the form of the hoop originated in rings with a swivel bezel.

Becatti 1955, 186, no. 319, pl. 80. Greifenhagen 1970, 41, pl. 17, 6-7. Higgins 1980, 132, no. 4. Here p. 45.

215. Finger ring with Aphrodite on a chariot drawn by geese, third quarter of 4th century BC.
Dimensions of bezel 2 x 1.6 cm. Grave at Nea Michaniona, Thessaloniki (ancient Aineia). Thessaloniki, Archaeological Museum 7579.

Comprises a hoop and an integral elliptical hollow bezel set with an off-white gemstone with intaglio representation. Represented is a light, wheeled vehicle in motion, drawn by two geese and driven by a divine charioteer as is indicated by the associated imagery. The geese are inflated with supernatural powers, expressed by their dominant presence in the representation. The driver, with her body in the characteristic pose for the situation, holds the reins while her garment billows behind. She is identified as Aphrodite on account of her association with the goose which was the goddess's sacred animal. Representations of Aphrodite with geese or swans are linked with her birth and transition to the 'race of gods' (Hesiod, *Theogonia* 202). In funerary context, scenes like that on the Nea Michaniona ring were perhaps not unrelated to the symbolism of analogous ones on other contemporary pieces of jewellery (see fig. 97 and p. 15). This particular ring is one of the earliest with an engraved stone ring-bezel and its device is probably the earliest representation of a chariot drawn by geese.

Βοκοτοπούλου 1990, 65, no. 42, drawing 30, pl. 38α-β. Here pp. 15, 45 and for early rings with engraved stone bezel pp. 45 and 284. On related representations: E. Simon, *Die Götter der Griechen*, 1969, 245ff. K. Schefold, *Die Göttersage in der klassischen und hellenistischen Kunst*, 1981, 82ff. U. Krigge, *AM* 100, 1985, 291. Βοκοτοπούλου, op. cit., n. 145.

216. Finger ring with Aphrodite carrying a shield and spear, late 3rd century BC.
L. of bezel 3.1 cm. The so-called Erotes tomb, Eretria. Boston, Museum of Fine Arts 21.1213.

Comprises a hoop integral with a wide elliptical hollow bezel set with a deep red garnet with intaglio representation. Leaning over slightly and showing her back is a *kallipygos* Aphrodite holding a spear and a shield rendered in perspective. A beautifully draped himation covers her legs, leaving the well-formed buttocks bare. The goddess attempts to hold the heavy shield by passing her right arm through the handle (on the imprint of the representation it was the normal left) while steadying the weapon with her left hand. The effort is expressed in the strong complex torsion and bend of the arms, torso and legs. The representation is well balanced on the small surface of the stone, with the head and feet of the figure on the longitudinal axis and the curves of the body and the shield filling its wider section. ΓΕΛΩΝ ΕΠΟΕΙ (GELON MADE [IT]) denotes the artist, as he himself declares in the inscription behind Aphrodite. On the inside of the hoop the word XAIPE (farewell), somewhat clumsily inscribed, was possibly added as the valediction for the owner of the ring. The representation is regarded as an iconographic precursor of another of Aphrodite, characterized as Victorious (Venus Victrix), featured on sealstones and coins of the Roman Era after Augustus' victory at Actium in 31 BC. The relationship of this goddess with victory in war is more overtly manifest on later gemstones, where Aphrodite stands beside a trophy. The gemengraver Gelon is only known of from his signature on the ring from Eretria described here. However, the quality of his work bespeaks a craftsman experienced in the techniques of glyptics, conversant with the stylistic trends of his day, as well as a sensitive artist.

G.M.A. Richter, *The Engraved Gems* I, 1968, no. 552. S. Karusu-Papaspyridi, *NachrAkadWissGöttingen*, 1975, 73ff. *The Search* 1980, no. 99. E. Simon, *The Portlandvase*, 1957, 71ff. and n. 5. *LIMC* II, 75, no. 658, s.v. *Aphrodite* (A. Delivorrias). Here p. 45. Aphrodite with trophy: Maaskant-Kleinbrink 1978, 257, no. 679. K. Δαβάρας, *AE* 1985, 177. 'XAIPE' on finger rings: Boardman 1970, 236. Philipp 1981, 162 in no. 589. Williams - Ogden 1994, no. 29. On Gelon: Furtwängler 1900, 448, pl. 66, no. 4.

217. Finger ring with Herakles knot, early 3rd century BC.
Diam. 1.8 cm. Said to be from Alexandria. London, British Museum R913.

Comprises a stout broad band with two grooves on the borders framing a pronounced midrib. Instead of a bezel there is a Herakles knot formed from two cylindrical stems forming the loops and surrounded by spiral-beaded wire. The centre of the knot is occupied by a miniscule mask of Silenus. The joins of the two ends of the hoop with the knot are concealed by a zone of three parallel wires and three finely worked leaflets pendent from it. The Herakles knot, though much loved in the goldsmith's art from the second half of the fourth century BC onwards (see p. 14), is only rarely encountered on rings and bracelets. In terms of quality, this ring, which is said to be from Alexandria, is one of the best examples, wrought with care and discretion. It is also one of the early examples of pieces of jewellery with knots bearing a decorative mask.

BMCR 1907, no. 913, pl. 23. Williams - Ogden 1994, no. 196. Here pp. 14, 45. Other finger rings with knot: A. De Ridder, *Cat. Sommaire des bijoux antiques*, 1924, nos 1147-1150, pl. 18. Higgins 1980, 170, no. 9, pl. 53E. Pfrommer 1990, 10. Cf. Παπαποστόλου 1977, 318ff., pls 110-111a-ß. Pfrommer, op. cit., 75. Herakles knot with mask of Silenus: Amandry 1963, 216, no. 151, fig. 120, pl. 33. Pfrommer, op. cit., 52, 316, no. HK166.

218. Snake ring, late 3rd - early 2nd century BC.
H. 4 cm. Unknown provenance. Athens, National Archaeological Museum Στ354 (H. Stathatos Collection).

Comprises a multi-spiralling band bearing a central midrib along the length of the curved outer surface. The ends, twisted in figure of eight, terminate in the head and the tail of a snake. The head has details in relief and a half-open mouth showing the teeth. Two deep-red round sards cover the interstices of the twists near the head and a smaller one occupies the corresponding position of the tail. Earlier, isolated examples of multi-spiral finger rings with the head and the tail of a snake as terminals are known, but in base metals. Gold snake rings of this type with modelled details and twists at the

ends are characteristic products of the Hellenistic jeweller's art. Snake rings appeared at about the same time as, and enjoyed a parallel development with, corresponding multi-spiral bracelets (cf. fig. 190) with some of which they probably formed a set.

Amandry 1963, 220ff., no. 161, pl. 34. Pfrommer 1990, 352, no. SR60. Here p. 45. On earlier examples: *Hesperia* 29, 1960, 100, no. 1, pl. 30a-b. Higgins 1980, 132. Philipp 1981, 149ff., no. 562, pl. 7. Pfrommer, op. cit., 128, fig. 18, 1-2.

219. Finger ring with quatrefoil rosette of cloisonné enamel, second half of 2nd century BC.
Diam. 1.5 cm. Grave in the Artjukhov Barrow, Taman peninsula. Saint Petersburg, Hermitage State Museum Art. 13.

Comprises a hoop and a circular hollow bezel set with an artificial stone, which is decorated with a quatrefoil rosette with heart-shaped petals (like a four-leaf clover) between which a smaller lanceolate petal is interposed. In the technique of cloisonné enamel the petals are defined by fine gold strips soldered vertical to the ground. Traces of the enamel are only preserved on the periphery of the ornament. The ring formed a set with a decorative pin which bears an identical artificial stone hanging from a loop at its top (fig. 177). The use of enamel, pale blue or sapphire blue or greenish, to decorate individual elements on jewellery is known from the early sixth century BC, but mainly from the second half of the fourth century BC. The technique of cloisonné enamel was very limited in application in Late Hellenistic times. In the second century BC other types of finger rings were embellished with more composite applications that were an evolution of the earlier enamelling techniques. All were in response to the predilection for polychromy that runs through the jeweller's art in this period.

L. Stephani, *CRPétersbourg* 1880, 8, no. 14, pl. I, 13. Pfeiler-Lippitz 1972, 113, pl. 36, 10-1. Higgins 1980, 169, pl. 53D. Here p. 45. On the technique of enamelling: Higgins, op. cit., 24ff. Williams - Ogden 1994, 16ff. Finger rings with different application of enamelling: Παπαποστόλου 1977, 318ff., pls 110-111a-β.

220. Finger ring with the inscription ΔΩΡΟΝ, c. 480 BC.
Diam. 2 cm, l. of bezel 1.7 cm. Grave 111, Sindos. Thessaloniki, Archaeological Museum 8415.

Comprises a hoop of even thickness, open below, and a flat gold bezel of pointed oval shape, soldered to the hoop. Engraved on the bezel in Ionic lettering is the word ΔΩΡΟΝ (gift). Judging by the shape of the bezel and its type, the ring should be dated some fifty years prior to the rest of the grave goods in grave 111 at Sindos. The case is not rare, since, as is believed, seal-stones and finger rings are as a rule earlier than the burials in which they are found, even as much as one hundred years. Rings with gift inscriptions are known from the fourth century BC (see also fig. 221), which makes the Sindos ring the earliest example. It also constitutes the earliest epigraphic testimonium from the wider area of Thessaloniki.

Σίνδος 1985, no. 96. Here p. 45. On the type of finger ring and the shape of the bezel: Boardman 1967, 24 (M2) and 1970, 157, 215, fig. 198 (M2), pl. 659. On rings earlier than the burial: Boardman 1970, 189, 190. On 'gift' rings: *Olynthus* X, 148ff., no. 474, pl. 27.

221. Finger ring with the inscription ΚΛΕΙΤΑΙ ΔΩΡΟΝ, third quarter of 4th century BC.
Dimensions of bezel 2.1 x 1.8 cm. Tomb Z, Derveni. Thessaloniki. Thessaloniki, Archaeological Museum Z9.

Comprises a hoop with integral broad, almost circular bezel bearing on its flat surface the inscription ΚΛΕΙΤΑΙ ΔΩΡΟΝ (gift to Kleita). The writing of the name in the dative case denotes that the ring was presented as a gift to Kleita, who was probably the dead woman in the tomb. She took with her another two finger rings with sard bezel. The case is not a rare one. At various times several rings have been found in one grave: eight, ten and even twenty. In such instances at least some of the rings may not have been possessions of the deceased, but were probably silent gifts of relatives or friends, perhaps on the day of the lying in state (*prothesis*).

Χ. Μακαρόνας, *AE* 18, 1963, Χρονικά, 194, pl. 229ε-στ (cited as coming from tomb E). Boardman 1970, 422, no. 708bis. *Treasures* 1979, no. 258, pl. 33. On many rings in the same grave see here pp. 45, 284.

BIBLIOGRAPHY

ABBREVIATIONS

AAA = Αρχαιολογικά ανάλεκτα εξ Αθηνών

ΑΔ = Αρχαιολογικόν Δελτίον

AE = Αρχαιολογική Εφημερίς

ΑΕΜΘ = Το Αρχαιολογικό Έργο στη Μακεδονία και τη Θράκη

ΠΑΕ = Πρακτικά της εν Αθήναις Αρχαιολογικής Εταιρείας

AA = Archäologischer Anzeiger

ActaAntHung = Acta antiqua Academiae scientiarum hungaricae

ActaArch = Acta archaeologica København

AJA = American Journal of Archaeology

AM = Mitteilungen des Deutschen Archäologischen Instituts, Athenische Abteilung

AntK =Antike Kunst

ARepLondon = Archaeological Reports

ARW = Archiv für Religionswissenschaft

ASAtene = Annuario della Scuola archeologica di Atene e delle Missioni italiane in Oriente

AuA = Antike und Abendland

AW = Antike Welt. Zeitschrift für Archäologie und Urgeschichte

BASOR = Bulletin of the American Schools of Oriental Research

BCH = Bulletin de correspondance hellénique

BerlMus = Berliner Museen

BIBulg = Izvestija na Archeologiceskija institut. Bulletin de l' Institut archéologique bulgare

BMetrMus = Bulletin. The Metropolitan Museum of Art

BMQ = The British Museum Quarterly

BMusFA = Bulletin. Museum of Fine Arts, Boston

BSA = The Annual of the British School at Athens

BWPr = Winckelmannsprogramm der Archäologischen Gesellschaft zu Berlin

ClRh = Clara Rhodos

CMS = Corpus der minoischen und mykenischer Siegel

CRPétersbourg = Compte-Rendu de la Commission Impériale Archéologique, St. Pétersbourg

DLZ = Deutsche Literaturzeitung

EAA = Enciclopeadia dell' arte antica classica e orientale

FuB = Forschungen und Berichte. Staatliche Museen zu Berlin

GrRomByzSt = Greek, Roman and Byzantine Studies

HambBeitrA = Hamburger Beiträge zur Archäologie

HdArch = Handbuch der Archäologie im Rahmen des Handbuchs der Altertumswissenschaft. Hrsg. von W. Ott, fortgeführt von R. Herbig

IG = Inscriptiones Graecae

IstMitt = Istanbuler Mitteilungen

JdI = Jahrbuch des Deutschen Archäologischen Instituts

JHS =Journal of Hellenic Studies

JIAN = Journal International d' Archéologie Numismatique

JWAG = Journal of the Walters Art Gallery

KlPauly =Der Kleine Pauly. Lexikon der Antike

LAW = Lexikon der alten Welt

LibyaAnt = Libya antiqua

LIMC = Lexicon Iconographicum Mythologiae Classicae

MarbWPR = Marburger Winckelmann-Programm

MüJbK =Münchener Jahrbuch der bildenden Kunst

NachAkadWissGöttingen = Nachrichten der Akademie der Wissenschaften in Göttingen

OF = Olympische Forschungen

Öjh = Jahreshefte des Österreichischen archäologischen Instituts in Wien

OpAth = Opuscula Atheniensia

OxfJArch = Oxford Journal of Archaeology

PBF = Prähistorische Bronzefunde

PZ = Prähistorische Zeitschrift

RE = Paulys Realencyclopädie der classischen Altertumswissenschaft. Neue Bearbeitung

REG = Revue des études grecques

RendAccNapoli = Rendiconti della Accademia di archeologia, lettere e belle arti, Napoli

RhM = Rheinisches Museum für Philologie

RM = Mitteilungen des Deutschen Archäologischen Instituts, Römische Abteilung

SBWien = Sitzungsberichte. Österreichische Akademie der Wissenschaften

SCE = The Swedish Cyprus Expedition

SIMA = Studies in Mediterranean Archaeology

GENERAL BIBLIOGRAPHY

Αμητός 1987 = Αμητός, Τιμητικός τόμος για τον καθηγητή Μ. Ανδρόνικο, Θεσσαλονίκη 1987.

Ανδρόνικος 1969 = Ανδρόνικος Μ., Βεργίνα Ι. Το νεκροταφείο των τύμβων, Αθήναι 1969.

— 1984 = Ανδρόνικος Μ., Βεργίνα. Οι βασιλικοί τάφοι, Αθήνα 1984.

Βοκοτοπούλου 1990 = Βοκοτοπούλου Ι., Οι ταφικοί τύμβοι της Αίνειας, Αθήνα 1990.

Δεληβορριάς 1980 = Δεληβορριάς Α., Οδηγός του Μουσείου Μπενάκη, Αθήνα 1980.

Ελληνικός Πολιτισμός 1993 = Ελληνικός πολιτισμός. Μακεδονία, το βασίλειο του Μεγάλου Αλεξάνδρου. Κατάλογος Έκθεσης. Marché Bonsecours, Μοντρεάλ, 7 Μαΐου - 19 Σεπτεμβρίου 1993, Αθήνα 1993.

Θεσσαλονίκη 1986 = 2300 χρόνια Θεσσαλονίκη. Από τα προϊστορικά μέχρι τα χριστιανικά χρόνια. Οδηγός της Έκθεσης, Αθήνα 1986.

Παπαβασιλείου 1910 = Παπαβασιλείου Γ. Α., Περί των εν Ευβοία αρχαίων τάφων, Αθήναι 1910.

Παπαποστόλου 1977 = Παπαποστόλου Ι.Α., Ελληνιστικοί τάφοι της Πάτρας, ΑΔ 32, 1977, Μελέται, σ. 281 κ.ε.

— 1990 = Παπαποστόλου Ι.Α., Κοσμήματα Πατρών και Δύμης, ΑΕ 1990, σ. 83 κ.ε.

Σίνδος 1985 = Σίνδος. Κατάλογος της Έκθεσης στο Αρχαιολογικό Μουσείο Θεσσαλονίκης, Αθήνα 1985.

Τύμβος Νικήσιανης 1992 = Λαζαρίδης Δ. - Ρωμιοπούλου Κ. - Τουράτσογλου Γ., Ο τύμβος της Νικήσιανης, Αθήναι 1992.

Amandry 1953 = Amandry P., Collection Hélène Stathatos I. Les bijoux antiques, Strasbourg 1953.

— 1963 = Amandry P., Collection Hélène Stathatos III. Objets antiques et byzantins, Strasbourg 1963.

Ancient Macedonia II 1977 = Ancient Macedonia II. Papers Read at the Second International Symposium Held in Thessaloniki, 19-24 August 1973, Thessaloniki 1977.

— IV 1986 = Ancient Macedonia IV. Papers Read at the Fourth International Symposium Held in Thessaloniki, 21-25 September 1983, Thessaloniki 1986.

— V 1993 = Ancient Macedonia V. Papers Read at the Fifth International Symposium Held in Thessaloniki, 10-15 October 1989, Thessaloniki 1993.

— 1988 = Ancient Macedonia. Catalogue of the Exhibition in Australia, Athens 1988.

Artamonov 1969 = Artamonov M.I., Treasures from Skythian Tombs, London 1969.

Aurifex 1980 = Studies in Ancient Jewelry, ed. T. Hackens. Aurifex 1980, Louvain-la-Neuve 1980.

— 1983 = Gold Jewelry, ed. T. Hackens - R. Winkes. Aurifex 1983, Louvain-la-Neuve 1983.

Becatti 1955 = Becatti G., Oreficerie antiche dalle minoiche alle barbariche, Rome 1955.

Bielefeld 1968 = Bielefeld E., Schmuck. Archaeologia Homerica I, C, Göttingen 1968.

Blanck 1974 = Blanck I., Studien zum Halsschmuck der archaischen und klassischen Zeit, Köln 1974.

— 1976 = Blanck I., Griechische Goldschmuckimitationen des 4. Jh v. Chr., AW 7/3, 1976, p. 19ff.

Blech 1982 = Blech M., Studien zum Kranz bei den Griechen, Berlin 1982.

Blinkenberg 1926 = Blinkenberg C., Fibules grecques et orientales. Lindiaka V, Kopenhagen 1926.

Blümner 1887 = Blümner H., Technologie und Terminologie der Gewerbe und Künste bei den Griechen und Römern IV, Leipzig 1887.

BMCJ 1911 = Marshall F.H., British Museum. Catalogue of the Jewellery, London 1911.

BMCR 1907 = Marshall F.H., British Museum. Catalogue of the Finger Rings, London 1907.

Boardman 1967 = Boardman J., Archaic Finger Rings, AntK 10, 1967.

— 1968 = Boardman J., Archaic Greek Gems, London 1968.

— 1970 = Boardman J., Greek Gems and Finger Rings, London 1970.

Bol 1985 = Bol P.C., Antike Bronzetechnik, München 1985.

Coche De La Ferté 1956 = Coche De La Ferté E., Les bijoux antiques, Paris 1956.

Coldstream 1979 = Coldstream J.N., Geometric Greece, London 1979.

Davidson - Oliver 1984 = Davidson P.F. - Oliver A., Ancient Greek and Roman Jewelry, New York 1984.

Dawkins 1929 = Dawkins R.M., The Sanctuary of Artemis Orthia at Sparta, JHS Suppl. 5, 1929.

Deppert-Lippitz 1985 = Deppert-Lippitz B., Griechischer Goldschmuck, Mainz 1985.

Desborough 1964 = Desborough U.R. d'A., The Last Mycenaeans and their Successors, Oxford 1964.

— 1972 = Desborough U.R. d'A., The Greek Dark Ages, London 1972.

Eluère 1990 = Eluère Chr., Les secrets de l' or antique, Düdingen 1990.

Emporio 1967 = Boardman J., Excavations in Chios 1952-1955. Greek Emporio, BSA Suppl. 6, 1967.

Filow 1927 = Filow B.D., Die archaische Nekropole von Trebenischte am Ochrida-See , Berlin/Leipzig 1927.

— 1934 = Filow B.D., Die Grabhügelnekropole bei Duvanlij in Süd-

bulgarien, Sofia 1934.

Fittschen 1968 = Fittschen Kl., *Untersuchungen zum Beginn der Sagendarstellungen bei den Griechen*, Berlin 1968.

Forbes 1950 = Forbes R.J., *Metallurgy in Antiquity*, Leiden 1950.

— 1967 = Forbes R.J., *Bergbau*, Archaeologia Homerica II, K, Göttingen 1967.

— 1971 = Forbes R.J., *Studies in Ancient Technology* VIII, Leiden 1971.

Friis Johansen 1957 = Friis Johansen K., Exochi. Ein frührodisches Gräberfeld, *ActaArch* 28, 1957, p. 1ff.

Furtwängler 1900 = Furtwängler A., *Die antiken Gemmen*, Leipzig/Berlin 1900.

Gold of Greece 1990 = *Gold of Greece. Jewelry and Ornaments from the Benaki Museum. Catalogue of Exhibition in Dallas Museum of Art*, revised text by A.R. Bromberg, Dallas 1990.

Gold der Skythen 1984 = *Gold der Skythen aus der Leningrader Ermitage. Ausstellung der staatlichen Antikensammlungen am Königsplatz in München*, München 1984.

Gold der Thraker 1979 = *Gold der Thraker, Archäologische Schätze aus Bulgarien. Ausstellung Köln, München, Hildesheim*, Mainz 1979.

Greifenhagen 1970, 1975 = Greifenhagen A., *Schmuckarbeiten in Edelmetall* I, II Berlin 1970, 1975.

Guzzo 1993 = Guzzo P.-G., *Oreficerie dalla Magna Grecia*, Taranto 1993.

Hadaczek 1903 = Hadaczek K., *Der Ohrschmuck der Griechen und Etrusker*, Vienna 1903.

Hampe 1971 = Hampe R., *Neuerwerbungen 1957-1970. Katalog der Sammlung antiker Kleinkunst des Archäologischen Instituts Heidelberg*, II, Mainz 1971.

Hampe - Simon 1980 = Hampe R. - Simon E., *Tausend Jahre frühgriechische Kunst*, München 1980.

Healy 1978 = Healy J. F., *Mining and Metallurgy in the Greek and Roman World*, London 1978.

Higgins 1980 = Higgins R., *Greek and Roman Jewellery* ², London 1980.

Hoddinott 1975 = Hoddinott R.F., *Bulgaria in Antiquity*, London 1975.

Hoffmann - Davidson 1965 = Hoffmann H. - Davidson P., *Greek Gold. Jewelry from the Time of Alexander*, Mainz 1965.

Hoffmann - von Claer 1968 = Hoffmann H. - von Claer U., *Antiker Gold- und Silberschmuck. Museum für Kunst und Gewerbe Hamburg*, Mainz 1968.

Jacobsthal 1956 = Jacobsthal P., *Greek Pins*, Oxford 1956.

Krug 1968 = Krug A., *Binden in der griechischen Kunst*, Mainz 1968.

Kurtz - Boardman 1971 = Kurtz D.K. - Boardman J., *Greek Burial Customs*, London 1971.

Laffineur 1978 = Laffineur R., *L' orfèvrerie rhodienne orientalisante*, Paris 1978.

Maaskant-Kleinbrink 1978 = Maaskant-Kleinbrink M., *Catalogue Engraved Gems. Royal Coin Cabinet, The Hague*, The Hague 1978.

Marinatos 1967 = Marinatos S., *Kleidung, Haar- und Barttracht*, Archaeologia Homerica I, A und B, Göttingen 1967.

Maxwell-Hyslop 1971 = Maxwell-Hyslop K.R., *Western Asiatic Jewellery*, London 1971.

Miller 1979 = Miller St.G., *Two Groups of Thessalian Gold*, Berkeley 1979.

Minns 1913 = Minns E.H., *Scythians and Greeks*, Cambridge 1913.

Nicolini 1990 = Nicolini G., *Techniques des ors antiques*, 1990.

Nilsson 1967 = Nilsson M.P., *Geschichte der griechischen Religion* I³, München 1967.

Ohly 1953 = Ohly D., *Griechische Goldbleche des 8. Jh. v. Chr.*, Berlin 1953.

Ori di Taranto 1987 = De Juliis E.M., *Gli ori di Taranto in età ellenistica*, Milano 1987.

Oro degli Etruschi 1983 = Cristofani M. - Martelli M., *L' oro degli Etruschi*, Novara 1983.

Oro dei Greci 1992 = Musti D. et al., *L' oro dei Greci*, Novara 1992.

Oro dei Romani 1992 = Pirzio Biroli Stefanelli L., *L' oro dei Romani*, Roma 1992.

Pfeiler-Lippitz 1972 = Pfeiler-Lippitz B., Späthellenistische Goldarbeiten, *AntK* 15, 1972, p. 107ff.

Pfrommer 1990 = Pfrommer M., *Untersuchungen zur Chronologie früh- und hochhellenistischen Goldschmucks*, Istanbuler Forschungen 37, Tübingen 1990.

Philipp 1981 = Philipp A., *Bronzeschmuck aus Olympia*, Olympische Forschungen XIII, Berlin 1981.

Pierides 1971 = Pierides A., *Jewellery in the Cyprus Museum*, Nicosia 1971.

Reinach 1892 = Reinach S., *Antiquités du Bosphore Cimmérien*, Paris 1892.

Roscher *ML* = W. H. Roscher, *Ausführliches Lexikon der griechischen und römischen Mythologie*, Leipzich/Berlin 1884-1937.

Rosenberg 1918 = Rosenberg M., *Geschichte der Goldschmiedekunst. Granulation*, Frankfurt 1918.

Sakellarakis 1988 = Sakellarakis J.A., Some Geometric and Archaic Votives from the Idaian Cave, *Early Greek Cult Practice. Proceedings of the Fifth International Symposion at the Swedish Institute at Athens 1986*, Stockholm 1988, p. 182ff.

Sapouna-Sakellarakis 1978 = Sapouna-Sakellarakis E., *Die Fibeln der griechischen Inseln*, Prähist. Bronzefunde XIV, 4, München 1978.

Segall 1938 = Segall B., *Museum Benaki. Katalog der Goldschmiedearbeiten*, Athen 1938.

— 1966 = Segall M., *Zur griechischen Goldschmiedekunst des 4. Jh. v. Chr.*, Wiesbaden 1966.

The Search 1980 = *The Search for Alexander. An Exhibition*, Boston 1980.

Tocra 1966 = Boardman J. - Haynes D., *Tocra I, BSA* Suppl. 4, Oxford 1966.

Vickers 1979 = Vickers M., *Scythian Treasures in Oxford*, Oxford 1979.

Williams - Ogden 1994 = Williams D. - Ogden J., *Greek Gold. Jewellery of the Classical World*, London 1994.

Wolters 1983 = Wolters J., *Die Granulation*, München 1983.

Zazoff 1983 = Zazoff P., *Die antiken Gemmen*, München 1983.

Zimmer 1990 = Zimmer G., *Griechische Bronzegusswerkstätten*, Mainz 1990.

SPECIALIST BIBLIOGRAPHY

INTRODUCTION

On the beginnings of jewellery see: B. Musche, *Vorderasiatischer Schmuck zur Zeit der Arsakiden und der Sasaniden*, 1988, 1ff. The earliest gold jewellery is from the Balkans: Nicolini 1990, 21 n. 80. On Neolithic gold finds see here p. 273.

Rings with magical properties: Bielefeld 1968, 34ff., 65. On the use of magical finger rings in later periods see *Schol. Aristoph. Plutus* 883. C. Bonner, *Studies in Magical Amulets*, 1950, 4. A. Bernand, *Sorciers grecs*, 1991, 76ff.

Sealstones worn as amulets: Boardman 1970, 42ff. I.A. Παπαποστόλου, *Τα σφραγίσματα των Χανίων*, 1977, 112ff. A. Onassoglou, *Die 'talismanischen' Siegel* (*CMS* Beih. 2, 1985), ixff., 200ff. E. Πουλάκη-Παντερμαλή, *AEMΘ* 1, 1987, 204. *Ancient Macedonia* 1988, no. 63. On pendants-amulets see Nilsson 1967, 199ff. C. Bonner, *Studies in Magical Amulets*, 1950, 3ff. A. Bernand, *Sorciers grecs*, 1991, 21ff.

On early relations between Greece and the East, recently: O. Lordkipanidgé - P. Levêque, *Le Pont-Euxin vu par les Grecs. Symposium de Vani (Colchide) 1987*, 1990, 27ff. E. Guralnick in *Daidalikon. Studies in Memory of R.U. Schoder*, 1989, 151ff. J. Boardman, *OxfJArch* 9, 1990, 169ff. and 10, 1991, 387ff. I.S. Lemos - H. Hatcher, *OxfJArch* 10, 1991, 197ff.

Relations between Cyprus and mainland Greece during the Geometric period: *Kerameikos* V 1, 193. R.A. Higgins, *BSA* 64, 1969, 144 and *Lefkandi* I, 1980, 218ff. Desborough 1972, 196ff., 348. Coldstream 1979, 60. Idem in *Cyprus and the East Mediterranean in the Iron Age. Proceedings of the Seventh British Museum Classical Colloquium 1988*, 1989, 90ff. Laffineur 1978, 73. Idem in *Aurifex 1980*, 26 and nn. 79-80. M. Popham - E. Touloupa - L.H. Sackett, *Antiquity* 56, 1982, 170, 171. A. and S. Sherratt in *Bronze Age Trade in the Mediterranean* (*SIMA* 90, 1991), 374ff.

References to jewellery in the Homeric epics: Bielefeld 1968, 1ff. On relevant references in subsequent literary tradition: W. Miller, *Daidalus and Thespis* II, 1931, 486ff.

On the significance of daemonic figures in art in general: E. Buschor, *Die Musen des Jenseits*, 1944, 19ff. Chr. Karusos, *Aristodikos*, 1961, 30. I. Scheibler, *Griechische Malerei der Antike*, 1994, 135. Specifically on daemonic figures in 7th-century BC jewellery see A. Lebessi, *BSA* 70, 1975, 174ff. Laffineur 1978, 72, 124ff., 177ff. Later jewellery with daemonic figures: Παπαποστόλου 1977, 317ff. and 1990, 119 in no. 26.

On the Egyptian origin of the Herakles knot see Segall 1966, 38ff. H. Kenner, *SBWien* 279/3, 1972, 15. Higgins 1980, 154. Idem, *The Aegina Treasure*, 1979, 37. H. Tait, *Seven Thousand Years of Jewellery*, 1986, 27, fig. 16. On the manner of its construction: Hoffmann - Davidson 1965, 30ff.

On the Herakles knot in general: L. Stephani, *CRPétersbourg* 1880, 32ff., 43ff. *RE* VIII 1, 594ff., s.v. *Hercules* (Haug). Becatti 1995, 89. *The Search* 1980, no. 88. *Oro dei Greci* 1992, 269 in pl. 145.

On the appearance of the Herakles knot in Macedonian goldwork: Pfrommer 1990, 1ff., 4ff. Here pp. 14, 30. On the Argeads' descent from Herakles and the related political propaganda see recently B. Hintzen-Bohlen, *JdI* 105, 1990, 132ff. F.W. Walbank, *Ancient Macedonia* V, 1993, 1728ff.

On the significance of the figure of Herakles in 4th-century BC sepulchral art see N. Himmelmann-Wildschütz, *Studien zum Ilissos-Relief*, 1956, 27 and n. 121. In the art of later times: Παπαποστόλου 1977, 304ff., 340.

On the protective properties of the knot: *RE* XVII, 806ff., s.v. *Nodus* (K. Keyssner). H. Kenner, *SBWien* 279/3, 1972, 15ff. Cf. Segall 1966, 39. Deppert-Lippitz 1985, 201. Pfrommer 1990, 4.

On substitute jewellery made of gold foil see Παπαποστόλου 1977, 287ff. and 1990, 83ff. *Σίνδος* 1985, nos 58, 83, 110, 112, 220, 407, 464. The terracotta imitations of jewellery used to be considered as exclusively for funerary use, a view refuted by modern scholarship: Blanck 1976, 27. M. Maass, *AM* 100, 1985, 324ff. M. Pfrommer, *IstMitt* 36, 1986, 60. Παπαποστόλου 1990, 118. In the Sindos excavation the gold foil imitations of gold jewellery (examples cited immediately above) were found in the less wealthy graves.

On funerary substitutes in general: J. Wiesner, *Grab und Jenseits*, 1938, 131, 149, 159, 169ff., 201. Amandry 1963, 215ff., nos 148-150. Bielefeld 1968, 16ff. Kurtz - Boardman 1971, 213. G. Zimmer, *BWPr* 132, 1991, 12ff.

On faith in a happy life in the Netherworld see Nilsson 1967, 673ff. E. Buschor, *Grab eines attischen Mädchens*, 1962, 19ff., 60. B. Segall, *BMusFA* 40, 1942, 52. J. Thimme, *AA* 1967, 208ff. On the immortality of the soul and transmigrations: Nilsson, op. cit., 691ff., 701ff.

On the reflection of the ideology of man's fortune in jewellery substi-

tutes see Παπαποστόλου 1977, 339ff.

On the function of myth in funerary art see E. Buschor, *Grab eines attischen Mädchens*, 1962, 54ff. Representations of the apotheosis of Herakles: H. Metzger, *Les représentations dans la céramique attique du IVe siècle*, 1951, 210ff., 216ff. B. Schweitzer, *Platon und die bildende Kunst der Griechen*, 1953, 64.

On the amalgamation of eschatological beliefs see Nilsson 1967, 695ff.

On the trends in funerary art of the 4th century BC: N. Himmelmann-Wildschütz, *Studien zum Ilissos-Relief*, 1956, 27ff. Χρ. Καρούζος, *Χαριστήριον εις Α.Κ. Ορλάνδον Γ΄*, 1966, 270ff., 274ff.

Jewellery with winged figures from the second half of the 4th century BC: Deppert-Lippitz 1985, 226ff. Παπαποστόλου 1977, 337 and 1990, 118ff. On their interpretation: Segall 1966, 37. Cf. E. Buschor, *Die Musen des Jenseits*, 1944, 31.

GOLD IN MYTH

The myth of the gold and the griffins is mentioned by Herodotus, III 116, IV 13 and 27, who knew of the *Arimaspian Epics* by Aristeas from Prokonnesos. On the surviving fragments of the Epics see *KlPauly* 1, 555ff., s.v. *Aristeas* (Mette). *LAW*, 302, s.v. *Aristeas* (G. Knebel). On a squat lekythos from Eretria two griffins guard a heap of gold: Williams - Ogden 1994, 13, fig. 4a. The mythical land of the North is nowadays associated with the auriferous Altai Mountains on the northwest border of Siberia: S.I. Rudenko, *Der zweite Kurgan von Pazyryk*, 1951, 5ff. E.D. Phillips, *AJA* 61, 1957, 276. Other mythological traditions about gold: Β.Κ. Λαμπρινουδάκης, *Μπροτραφής*, 1971, 352 n. 6. *EAA* V, 765, s.v. *oro* (F. Magi). B. Pettinau in *Oro dei Romani* 1992, 17.

On griffins see Roscher, *ML* I. 2, 1767ff., s.v. *Gryps* (A. Furtwängler). I. Flagge, *Untersuchungen zur Bedeutung des Greifen*, 1975, 54ff. A. Greifenhagen, *Schmuck der alten Welt*³, 1979, 24.

The extract from Sappho is cited in *Schol. Pind. Pyth.* IV, 410c. See also M. Treu, *Sappho*⁴, 1968, 102ff. J. Duchemin, *REG* 65, 1952, 54.

On Pythagoras: *LAW*, 2489, s.v. *Pythagoras* (K. von Fritz). *RE* XXIV 1, 178, s.v. *Pythagoras* (K. von Fritz). Cf. Β.Κ. Λαμπρινουδάκης, *Μπροτραφής*, 1971, 141 n. 6, 365ff.

On the Lernaian Hydra see Λαμπρινουδάκης, op. cit., 359 with n. 1. On Hesiod's races Λαμπρινουδάκης, op. cit., 354. J.P. Vernant, *Myth and Thought among the Greeks*, 1983, 6. *EAA* V, 765, s.v. *oro* (F. Magi). See also M.L. West (ed.), *Hesiod Works and Days*, 1978, 173ff.

Gold as a symbol of immortality and eternity: R. Lullies, *Vergoldete Terracotta-Apliken aus Tarent*, 1962, 41ff. and *JdI* 97, 1982, 115. I. Flagge, *Untersuchungen zur Bedeutung des Greifen*, 1975, 56. J. Gy. Szilagyi, *ActaAntHung* 5, 1957, 54ff. Segall 1966, 31. Cf. Blech 1982, 325 with n. 47.

Neolithic gold pendants: Forbes 1971, 157. A. Hartmann, *Prähistorische Goldfunde aus Europa*, 1970, 116ff., no. 1733, pl. 29. Idem, *Studia Praehistorica (Sofia)* 1-2, 1978, 182ff. D. Zanotti, *Talanta* 16/17, 1984/85, 59 with n. 25. *Ancient Macedonia* 1988, nos 7b and 10.

H.-J. Weisshaar, *Das späte Neolithikum und das Chalkolithikum. Die Deutschen Ausgrabungen auf der Pevkakia Magula in Thessalien* I, 1989, 52 with n. 277. Nicolini 1990, 77, pl. 5a-b. Eluère 1990, 37, pl. 40. Δ.Β. Γραμμένος, *Νεολιθικές έρευνες στην Κεντρική και Ανατολική Μακεδονία*, 1991, 109, pl. 29 (read 30), 3-4. J. Makkay in *Ancient Macedonia* V, 1993, 821ff. G.A. Papathanassopoulos (ed.), *Neolithic Culture in Greece*, 1996, 339ff., nos 299, 302.

The healing properties of gold are mentioned by Pliny, *NH* XXXIII, 25. J. Gy. Szilagyi, *ActaAntHung* 5, 1957, 54ff.

SOURCES OF GOLD

On the formation of metal-bearing deposits see Healy 1978, 20ff. On the formation of the argentiferous lodes at Lavrion: C. Conophagos, *Le Laurium antique*, 1980, 156ff., fig. 9, 1b. Ε. Κακαβογιάννης, *Τα αρχαία μεταλλεία της Λαυρεωτικής*, 1988, 9ff.

On the main gold-extracting regions see Blümner 1887, 12ff. Forbes 1971, 162ff. P. Amandry, *AntK* 1, 1958, 18. Ch. Seltman, *Greek Coins*, 1960, 20. *LAW*, 1108, s.v. *Gold* (C. Krause). *EAA* V, 766, s.v. *oro* (F. Magi). Cf. St. Foltiny, *AJA* 65, 1961, 294ff.

On the gold of the Mycenae treasures: Σ.Ε. Ιακωβίδης, *Περατή* Β΄, 1970, 375. H.J. Unger - E. Schütz in B. Hänsel (ed.), *Südosteuropa zwischen 1600-1000 v. Chr.*, 1982, 155.

On the golden fleece see Healy 1978, 75ff. O. Lordkipanidge, *GrRomByzSt* 32, 1991, 171. Here p. 18. On the gold in the river Paktolos: Blümner 1887, 17. W.J. Young, *BMusFA* 70, 1972, 5ff. Healy, op. cit., 74ff. J.C. Waldbaum, *Metalwork from Sardis* (Sardis M 8, 1983), 3ff.

On early contacts with the East see here p. 272.

On the invention of coinage see Seltman, op. cit., 8, 15, 17ff.

Neolithic gold finds from Sesklo: Χρ. Τσούντας, *Αι προϊστορικαί ακροπόλεις Διμηνίου και Σέσκλου*, 1908, 350ff., fig. 291. C. Renfrew, *The Emergence of Civilisation*, 1972, 311, fig. 16.2c. Δ. Θεοχάρης, *Νεολιθική Ελλάς*, 1973, 339, drawing 46. From Rizomylos: G.A. Papathanassopoulos (ed.), *Neolithic Culture in Greece*, 1996, 339, no. 299. From Sitagroi: Renfrew, op. cit., 311. Θεοχάρης, op. cit., 191, fig. 117. Papathanassopoulos, op. cit., no. 300. From Aravissos: *Ancient Macedonia* 1988, nos 7-10. Δ.Β. Γραμμένος, *Νεολιθικές έρευνες στην Κεντρική και Ανατολική Μακεδονία*, 1991, 109, pl. 30. Papathanassopoulos, op. cit., nos 301-303. From Dimitra, Serres: Γραμμένος, op. cit., 109 and *XI. Internationales Symposium über das Spätneolithikum und die Bronzezeit, Xanthi 1981. Symposia Thracica 1982* I, 171. From Dikili Tash: M. Seferiades, *BCH* Suppl. 24, 1992, 113.

On the lack of reliable methods for locating the source of the gold, from which ancient gold objects were made, see J.C. Waldbaum, *Metalwork from Sardis* (Sardis M 8, 1983), 3ff. with n. 25.

On the sites where gold was extracted in Greece see Blümner 1887, 18ff. Α.Σ. Γεωργιάδης, *AE* 1915, 88ff. M.A.S. Casson, *Macedonia, Thrace and Illyria*, 1926, 59ff. H. Quiring, *Geschichte des Goldes*, 1948,

102ff. Α.Σ. Αρβανιτόπουλος, *Πολέμων* Ε´, 1952/54, 85ff. Forbes 1967, 6ff. Healy 1978, 45ff. B. Holtzmann, *BCH* Suppl. 5, 1979, 345ff. N.G.L. Hammond - G.T. Griffith, *A History of Macedonia* II, 1979, 69ff. W.L. Adams - E.N. Borza (eds), *Philip II, Alexander the Great and the Macedonian Heritage*, 1982, 8ff. G.A. Wagner - G. Weisgerber, *Silber, Blei und Gold auf Siphnos*, 1985, 174ff., 226ff. G.A. Wagner - G. Weisgerber, *Antike Edel- und Buntmetallgewinnung auf Thasos*, 1988, 113ff.

On Kadmos and Rhesos (Homer *Iliad* X 438ff. Eurip. *Rhesus* 301ff., 340, 370ff., 383, 386) in relation to the region of Pangaion: Blümner 1887, 3. Roscher *ML* II. 1, 864, s.v. *Kadmos*. J. Wiesner, *Die Thraker*, 1963, 33. Bielefeld 1968, 64 with n. 579. Δ. Τσεκουράκης, *Μακεδονικά* 21, 1981, 77 with n. 2. D. Tzavellas in *Aurifex* 1983, 163. Cf. H.J. Unger - E. Schütz in B. Hänsel (ed.), *Südosteuropa zwischen 1600-1100 v. Chr.*, 1982, 155.

On the gold in the region of Pangaion: Tzavellas, op. cit., 162ff. Unger - Schütz, op. cit. On the references to Peisistratos and Istiaios, as well as to Miltiades and Thucydides see Α.Σ. Αρβανιτόπουλος, *Πολέμων* Ε´, 1952/54, 85, 90, 93, 94, 99. Tzavellas, op. cit., 164ff. Τσεκουράκης, op. cit., 80ff.

On native (*ἄπυρον*) gold: Blümner 1887, 14 n. 5, 119 n. 2. Α.Κ. Ορλάνδος, *Τα υλικά δομής* 2, 1958, 31 n. 6. Nicolini 1990, 43.

Modern prospecting in Thasos and its Peraia: B. Holtzmann, *BCH* Suppl. 5, 1979, 345ff. G.A. Wagner - G. Weisgerber, *Antike Edel- und Buntmetallgewinnung auf Thasos*, 1988, 113ff. Χ. Κουκούλη-Χρυσανθάκη, *ΑΔ* 36, 1981, Χρονικά, 338ff. and *ΑΕΜΘ* 2, 1988, 425 n. 22. Eadem in *Πόλις και Χώρα στην αρχαία Μακεδονία και Θράκη. Μνήμη Δ. Λαζαρίδη*, 1990, 494ff. On the name *Chryse* (Golden) for Thasos: Blümner 1887, n. 5 of pp. 19-20.

On the mines in the Pangaion region during the reign of Philip V see Αρβανιτόπουλος, op. cit., 86. Tzavellas, op. cit., 168.

MINING AND METALLURGY

On gold as the first metal used by man see Forbes 1971, 155, 157. *LAW*, 1108, s.v. *Gold* (C. Krause). J. Ramin, *La technique minière et métallurgique des anciens*, 1977, 127. R. Shepherd, *Prehistoric Mining and Allied Industries*, 1980, 216, 239. G. Tanelli - M. Benvenuti - I. Mascaro in R. Francovich (ed.), *Archeologia delle attività estrattive e metallurgiche*, 1993, 263ff. Cf. Χ. Τσούντας, *Αι προϊστορικαί ακροπόλεις Διμηνίου και Σέσκλου*, 1908, 351.

On washery installations: Κ. Κονοφάγος, *Η μέθοδος του εμπλουτισμού των μεταλλευμάτων των αρχαίων Ελλήνων*, 1970. Healy 1978, 144ff., fig. 23, pls 41-44. C.E. Conophagos, *Le Laurium antique*, 1980, 224ff., 386ff. Π. Ζορίδης, *AE* 1980, 75ff., figs 2-5, pls 16-18. J.E. Jones, *Greece and Rome* 29, 1982, 169ff., figs 2-5, 8b-10. H. Calcyk, *AW* 14/3, 1983, 25ff. Ε. Κακαβογιάννης, *Πρακτικά Α´ Συμποσίου Αρχαιομετρίας, Αθήνα 1990*, 1992, 79ff. *Πρακτικά Δ´ Επιστημονικής Συνάντησης ΝΑ Αττικής 1989*, 1993, 165ff., 183ff. Cf. C.N. Bromehead, *Antiquity* 16, 1942, 198ff.

The Athenians' knowledge of mining techniques was perhaps due to experience gained in the mines of Pangaion: D. Tzavellas in *Aurifex* 1983, 164. Cf. Calcyk, op. cit., 15ff.

On the collection of gold using fleeces see Healy 1978, 75ff. O. Lordkipanidge, *GrRomByzSt* 32, 1991, 171.

On the natural alloys of gold: Forbes 1950, 152ff. A. Hartmann, *Prähistorische Goldfunde aus Europa*, 1970, 9ff. Forbes 1971, 170. Healy 1978, 75, 217. R.F. Tylecote, *A History of Metallurgy²*, 1979, 4. Nicolini 1990, 21ff. On analyses of the alloys of certain pieces of jewellery see Hoffmann - Davidson 1965, 49. W.J. Young, *BMusFA* 70, 1972, 9. R.E. Jones in *Lefkandi* I, 461ff.

On the refining of gold by the Sumerians and the Amarna letter: Forbes 1950, 155. Hartmann, op. cit., 13ff. Forbes 1971, 173ff. Nicolini 1990, 39ff. On the installations at Sardis for refining gold by heating: G.M.A. Hanfmann, *Letters from Sardis*, 1972, 230ff., figs 173-179. S.M. Goldstein, *BASOR* 228, 1977, 53ff., figs 9-11. G. Hanfmann, *Sardis from Prehistoric to Roman Times*, 1983, 34ff., figs 42, 45-48, 55-58, 139. J.C. Waldbaum, *Metalwork from Sardis* (Sardis M 8, 1983), 7. A. Rammage in *Sardis. Papers presented at a Symposium*, Chicago 1987, 10ff.

On the time when gold refining was practised by the Greeks: D.E. Strong, *Greek and Roman Gold and Silver Plate*, 1966, 2. Healy 1978, 153ff., 155ff. Higgins 1980, 7.

On the method of cupellation for refining gold or argentiferous gold from other metallic compounds: Forbes 1950, 158ff. H. Hodges, *Artifacts*, 1964, 92ff. Hartmann, op. cit., 13ff. Forbes 1971, 177ff. G. Ramin, *La technique minière et métallurgique des anciens*, 1977, 130ff. Healy 1978, 152ff. Higgins 1980, 7ff. Waldbaum, op. cit. Nicolini 1990, 40ff. B. Pettinau in *Oro dei Romani* 1992, 34ff.

On the methods of refining gold from silver: Forbes 1950, 159ff. Hodges, op. cit., 93ff. Strong, op. cit., 2. Forbes 1971, 180ff. Higgins 1980, 8. Waldbaum, op. cit., with n. 60. B. Pettinau, op. cit., 35.

Small pieces of cast gold were found inside a skyphos at Eretria: Π. Θέμελης, *ΠΑΕ* 1980, 87ff. and *AAA* 14, 1981, 189ff.

PRODUCTION AND DECORATION OF SHEET GOLD

On the mechanism of recrystallizing metal through annealing, essential for hammering a sheet see H. Maryon, *AJA* 53, 1949, 93ff. Α.Κ. Ορλάνδος, *Τα υλικά δομής* 2, 1958, 6. Higgins 1980, 12. Cf. Γ. Βαρουφάκης, *AE* 1978, 167ff.

On the maximum degree of thinness of the sheet see Ορλάνδος, op. cit., 33. *LAW*, 2719, s.v. *Schmuck* (R. Tölle) and 1938, s.v. *Metall* (W. Krenkel). Higgins 1980, 12. Cf. also R. Higgins in D. Strong - D. Brown, *Roman Crafts*, 1976, 54.

On the investment of wooden caskets with gold sheet: Ohly 1953, 56ff. Π. Θέμελης, *Πρακτικά Δ´ Επιστημονικής Συνάντησης ΝΑ Αττικής 1989*, 1992, 148ff.

Hollow moulds or dies in which embossed decoration was executed on sheet gold: D.K. Hill, *Hesperia* 12, 1943, 98. Ohly 1953, 14, 119ff.

Laffineur 1978, 24ff., 169ff. R. Higgins, *The Aegina Treasure*, 1979, 56. I. Kriseleit, *FuB* 20/21, 1980, 189ff., figs 1-4. Higgins 1980, 14ff. E.R. Williams, *Hesperia* 54, 1985, 116ff. and *JWAG* 42/43, 1984/85, 24ff. M.J. Treister, *JWAG* 48, 1990, 29ff. Williams - Ogden 1994, 18ff. On wooden moulds see also Cl. Bérard, *Eretria* III, 37. St. Kolkowna in *Aurifex* 1980, 107, 114ff. According to Boardman 1970, 110, 113, the moulds for sheet gold might have been of clay too.

Hollow moulds were made by the goldsmith himself or some other craftsman: Ohly 1953, 119. R. Hampe, *DLZ* 76, 1955, 682. Bielefeld 1968, 52ff. Fittschen 1968, 226. Laffineur 1978, 26. Bérard, op. cit., 37, 42, 44.

Embossed themes selected from larger moulds: Friis Johansen 1957, 173. Ohly 1953, 53ff.

On the bed of pitch or other material: Hoffmann - Davidson 1953, 26 (Stamping). M. Destrée in *Aurifex* 1983, 178. Williams - Ogden 1994, 19, fig. 10b. This bed was used mainly for hammered decoration (*sphyrelata*) see G.M.A. Richter, *AJA* 45, 1941, 377. H. Maryon, *AJA* 53, 1949, 121. H. Hodges, *Artifacts*, 1964, 78. Hoffmann - Davidson, op. cit., 26ff. Higgins 1980, 12. Destrée, op. cit., 171. A. Λεμπέση, *Το ιερό του Ερμή και της Αφροδίτης στη Σύμη Βιάννου. Χάλκινα κρητικά τορεύματα*, 1985, 60. Cf. D. Strong - D. Brown, *Roman Crafts*, 1976, 54.

Stamps (punches) with the decorative motif in exergue relief: Strong - Brown, op. cit., 55, fig. 54. Higgins 1980, 13, fig. 1. St. Kolkowna in *Aurifex* 1980, 111ff., pls I-V, 1. Destrée, op. cit., 174, fig. 26. Eluère 1990, 178, fig. 206. Nicolini 1990, 91, pl. 216h. Williams - Ogden 1994, 19, fig. 10c.

On wooden or bronze cores-models, on which the details of a sheet-gold object could be formed: Blümner 1887, 236ff. B. Pharmakowsky, *AA* 1913, 220ff., fig. 66 and *AA* 1914, 257, fig. 81. Hoffmann - Davidson 1965, 28ff. Higgins 1980, 14, fig. 2. Kolkowna, op. cit., 107, pl. IX, 2. Strong - Brown, op. cit., 55, fig. 57. J. Ogden, *Interpreting the Past. Ancient Jewellery*, 1992, 44, fig. 27. Cf. D.K. Hill, *Hesperia* 12, 1943, 98 n. 6. Bol 1985, 98ff. A clay core inside a pendant is mentioned by Βοκοτοπούλου, *Βίτσα*, 1986, 53, no. 1, pl. 73α. See here p. 239 on no. 111.

On the processes of applying repoussé decoration, the task of the chaser, see G.M.A. Richter, *AJA* 45, 1941, 377. H. Maryon, *AJA* 53, 1949, 121. H. Hodges, *Artifacts* 1964, 77ff. Γ. Βαρουφάκης, *AE* 1978, 168ff. A. Stewart, *AntK* 23, 1980, 24ff. Λεμπέση, op. cit., 60ff.

CAST JEWELLERY

Casting was known in the Aegean from the 3rd millennium BC: K. Branigan in J. Thimme (ed.), *Kunst der Kykladen. Ausstellungskatalog*, Karlsruhe 1976, 124. Bol 1985, 19ff. On the 'cire-perdue' technique: Zimmer 1990, 13ff., 127, 133ff. with relevant bibliography. On techniques of channelling off the melted wax: Zimmer, op. cit., 37, 64, 141ff.

On the first bronzecasters and toreutic artists who were considered to be daemonic creatures see *RE* VA1, 197ff., s.v. *Telchinen* (Herter). Ch. Seltman, *Approach to Greek Art*, 1948, 12ff. M. Delcourt, *Héphaistos ou la légende du magicien*, 1957, 43ff., 48ff., 154ff., 226ff. H. Philipp, *Tektonon Daidala*, 1968, 62, 68. Idem in *Daidalische Kunst auf Kreta. Ausstellungskatalog*, Hamburg 1970, 6ff. and *Polyklet. Der Bildhauer der griechischen Klassik. Ausstellung im Liebighaus*, Frankfurt 1990, 84. Bol 1985, 22ff.

On gold statues: Bol 1985, 104, 157ff. J. Floren, *Die griechische Plastik* I, 1987, 21. Cast gold ornaments in general: Hoffmann - Davidson 1965, 31ff. Higgins 1980, 18. S. Cornelis in *Aurifex* 1983, 181ff.

Moulds for cast jewellery: Hoffmann - Davidson 1965, 32. R. Tölle-Kastenbein, *AuA* 12, 1966, 91ff. O.W. Muscarella, *Phrygian Fibulae from Gordion*, 1967, 49ff. I. Kriseleit, *FuB* 20/21, 1980, 196ff., figs 5-6. St. Kolkowna in *Aurifex* 1980, 115ff. A. Μιχαηλίδη - I. Τζαχίλη in *Ancient Macedonia* IV, 1986, 365ff. Three-piece moulds for casting finger rings: Hoffmann - Davidson, op. cit., 33. Γ. Μυλωνάς, *Το δυτικόν νεκροταφείον της Ελευσίνος* Β΄, 1975, 254ff., pl. 64. A. Lipinsky, *Oro, Argento, Gemme e Smalti*, 1975, 170 with fig. R. Higgins, *The Aegina Treasure*, 1979, 57, fig. 57. Higgins 1980, 18. Μιχαηλίδη - Τζαχίλη, op. cit., 372, fig. 6.

On pouring molten metal directly into the mould and the effect on the form of the ornaments: Tölle-Kastenbein, op. cit., 91. Williams - Ogden 1994, 28ff. See also R.-B. Wartke, *FuB* 20/21, 1980, 223. On the view that the wax model of the ornament was formed in the moulds: Hoffmann - Davidson 1965, 32. Tölle-Kastenbein, op. cit., 92. Cf. E. Pernice, *ÖJh* 7, 1904, 182ff. D.E. Strong, *Greek and Roman Gold and Silver Plate*, 1966, 11 n. 2. On the technique in general of preparing half wax models and the treatment of them before being cast in metal see Bol 1985, 70, 110, 116.

Of the two sections of the moulds for casting ornaments usually only one plaque is preserved. Very few pairs have survived: A. Λεμπέση, *AΔ* 24, 1969, Χρονικά, 418, pl. 426α. K. Δημακοπούλου, *AAA* VII, 1974, 166ff., fig. 1. *BCH* 99, 1975, 642, fig. 114.

Cast ornament from Stavroupolis, Thessaloniki: K. Ρωμιοπούλου, *Φίλια Έπη εις Γ.Ε. Μυλωνά* Γ΄, 1989, 209ff., especially n. 56, pl. 52.

Galjub statuettes: A. Ippel, *Der Bronzefund von Galjub*, 1922, 12, 16, 17. B. Segall, *Festschrift E. v. Mercklin*, 1964, 166ff.

WIRE, FILIGREE, CHAINS

On filigree technique in general: Bielefeld 1968, 48 n. 425. Higgins 1980, 19ff., 22ff. *Reallexikon z. Deutschen Kunstgeschichte* VIII, 1987, 1062ff., s.v. *Filigran* (J. Wolters). Silver jewellery in filigree technique: Βοκοτοπούλου 1990, 108, no. 10, pl. 66δ.

On early relations between Greece, the East and Cyprus see here p. 272.

On open-work filigree technique in general: Amandry 1953, 43. Higgins 1980, 20, 23.

8th-century BC finger ring with wire guilloche, from Athens: O. Αλεξανδρή, *AΔ* 22, 1967, Χρονικά, 80, pl. 80β below. Higgins 1980,

100, no. 4. Earlier rings with the guilloche on sheet gold: X. Τσούντας, *AE* 1889, 147, pl. 7, no. 8 (Vapheio). *BMCR* 1907, no. 680, fig. 98 (Enkomi). Cf. also Maxwell-Hyslop 1971, 187, pl. 132d (Susa).

The Egyptians were already fashioning wire in the late 4th or the early 3rd millennium BC: W.M. Petrie, *Arts and Crafts in Ancient Egypt*, 1910, 86. D.L. Carroll, *AJA* 74, 1970, 401. Nicolini 1990, 99. Eluère 1990, 140.

On wire in general: H. Maryon in Ch. Singer et al., *A History of Technology* I², 1955, 654ff. Hoffmann - Davidson 1965, 36ff. Hoffmann - von Claer 1968, 219ff. Higgins 1980, 15ff. Fr. De Cuyper in *Aurifex* 1983, 197ff., figs 40-47. *Reallexikon*, op. cit., 1067ff. Nicolini 1990, 99ff. J.M. Ogden, *Jewellery Studies* 5, 1991, 95ff. Williams - Ogden 1994, 23ff.

On the manufacture of wire in Greece using a drawplate: Blümner 1887, 250ff. Carroll, op. cit., and *AJA* 75, 1971, 197. *AJA* 76, 1972, 321ff. Higgins 1980, 15. Idem in D. Strong - D. Brown, *Roman Crafts*, 1976, 55. Cf. G. Jacobi, *Germania* 57, 1979, 111ff. In general see Nicolini 1990, 99, 104, 113ff. For an opposite point of view: Hoffmann - von Claer 1968, 231, s.v. *Zieheisen*. C. Aldred, *Die Juwelen der Pharaonen*, 1976, 86. Eluère 1990, 145. Ogden, op. cit., 96ff. Williams - Ogden 1994, 23. According to Carroll, *AJA* 76, 1972, 323 Greek goldsmiths combined both methods of making wire.

Rope wire: Hoffmann - Davidson 1965, 36, fig. I. *Reallexikon*, op. cit., 1071ff., fig. 1, nos 5 and 16. Nicolini 1990, 126, pl. 223a. On braid-shaped wire: Hoffmann - Davidson, op. cit., fig. J. *Reallexikon*, op. cit., 1075. Nicolini, op. cit., 126. Williams - Ogden 1994, 23. Beaded wire: Hoffmann - von Claer 1968, 220 fig. D. Hoffmann - Davidson, op. cit., fig. K. A. Lipinsky, *Oro, Argento, Gemme e Smalti*, 1975, 206ff. *Reallexikon*, op. cit., 1068, fig. 1, no. 7. Wolters 1983, 23. Cuyper, op. cit., 198. Williams - Ogden, op. cit., 23ff., fig. 20a. According to Laffineur 1978, 172 the origin of this wire should be sought in the series of decorative annulets on pins. Bead-and-reel wire: Hoffmann - Davidson, op. cit., fig. M. Spool wire: Hoffmann - Davidson, op. cit., fig. L. Hoffmann - von Claer, op. cit., 220, fig. E. Spiral-beaded wire: Williams - Ogden, op. cit., 24ff., figs 20b, 21, 23.

On chains in general: M.E. Vernier, *La bijouterie et la joaillerie égyptiennes. Mémoires Inst. Franc. Arch. Orient. 2*, 1907, 94ff., figs 103-110. Lipinsky, op. cit., 201ff. Aldred, op. cit., 87ff. Higgins 1980, 16ff., fig. 3. A.C. Lemaigre in *Aurifex* 1983, 205ff. Nicolini 1990, 126ff., pl. 223, nos e-m. Eluère 1990, 146ff., fig. 164. B. Pettinau in *Oro dei Romani* 1992, 45, figs 32-34. Williams - Ogden 1994, 26, fig. 24.

On loop-in-loop chains of the 3rd millennium BC at Ur: C.L. Woolley, *Ur Excavations. The Royal Cemetery* II, 1934, pls 146c, 159b. Maxwell-Hyslop 1971, 14, pl. 12. H. Tait (ed.), *Thousand Years of Jewellery*, 1986, 31, fig. 29. Nicolini 1990, 127. B. Musche, *Vorderasiatischer Schmuck*, 1992, 82, type 2, pl. 22. Chains of the 3rd millennium BC in Egypt: W.M. Petrie, *Arts and Crafts in Ancient Egypt*, 1910, 86, fig. 94. Nicolini, op. cit.

Chains in Minoan Crete: R.B. Seager, *Explorations in the Island of Mochlos*, 1912, 32, 73, figs 10-11 (nos II.30 and II.35) and 43 (nos XIX.20 and 22). Loop-in-loop chains of Mycenaean times: G. Karo, *Die Schachtgräber von Mykenai*, 1930/33, 185, pl. 39, nos 236-239. Σ. Μαρινάτος, *AE* 1932, 40ff., fig. 37, pl. 18. C.W. Blegen, *Prosymna*, 1937, 271, fig. 460, no. 7. A. Ξενάκη-Σακελλαρίου, *Οι θαλαμωτοί τάφοι των Μυκηνών*, 1985, 172, no. 2882, pl. 70.

On the manufacture of chain straps: E. Formigli, *Tecniche dell' oreficeria Etrusca e Romana*, 1985, 86, fig. 35. Eluère 1990, 149, fig. 164, 4. B. Pettinau in *Oro dei Romani* 1992, 45, fig. 33. Williams - Ogden 1994, 26, fig. 24c-d. Chain straps from Nimrud possibly in the 8th century BC: J. Ogden, *Interpreting the Past. Ancient Jewellery*, 1992, 49. Williams - Ogden, op. cit., 26.

Examples of chain straps in Etruscan jewellery of the 7th century BC, from Cerveteri (Caere): Becatti 1955, 175, no. 240, pl. 52. K.A. Lipinsky, *Oro, Argento, Gemme e Smalti*, 1975, 202, fig. on p. 199. *Oro degli Etruschi* 1983, no. 31. E. Paschinger, *AW* 24, 1993, 113, no. 2, fig. 11. From Palestrina: *BMCJ* 1911, no. 1357, fig. 29. R. De Puma in J. Swaddling (ed.), *Italian Iron Age Artefacts*, 1986, 384, figs 5 and 10. From Marsiliana: A. Minto, *Marsiliana d' Albegna*, 1921, 121, pl. 12, no. 14. A necklace fragment of the 6th century BC with strap ending in separate chains is known from Trebenischte: Filow 1927, 38, fig. 34, no. 3. Amandry 1953, 74, fig. 44, no. 3.

THE TECHNIQUE OF GRANULATION

On granulation in general: *EAA* III, 999ff., s.v. *Granulazione* (G. Becatti). Hoffmann - Davidson 1965, 47ff. Bielefeld 1968, 26 n. 185. Higgins 1980, 20ff. J. Wolters, *Die Granulation*, 1983. F. De Callataÿ in *Aurifex* 1983, 185ff. Nicolini 1990, 129ff. G. Nestler - E. Formigli, *Etruskische Granulation*, 1993.

Jewellery with granulated decoration, of the 9th century BC (except these in figs 59 and 68): M.R. Popham - E. Touloupa - L.H. Sackett, *Antiquity* 56, 1982, pl. 23d. *BSA* 77, 1982, 217, no. 39, 236, pls 17 and 30a. *ARepLondon* 1988/89, 120, fig. 25. On the development of granulated decoration during the 7th century BC on Rhodes: Laffineur 1978, 170ff., 186.

On the methods of preparing and soldering the granules: D.L. Carroll, *AJA* 78, 1974, 33ff. P. Parrini - E. Formigli - E. Mello, *AJA* 86, 1982, 118ff. In general see *EAA* V, 768, s.v. *oro* (F. Magi). Higgins 1980, 21ff. and *The Aegina Treasure*, 1979, 58. G. Nestler - E. Formigli, *Etruskische Granulation*, 1993, 21ff. Williams - Ogden 1994, 26ff. On *chrysokolla*: A.K. Ορλάνδος, *Τα υλικά δομής* 2, 1958, 35 with n. 5. Carroll, op. cit., 37ff. *LAW*, 1938, s.v. *Metall* (W. Krenkel). Nestler - Formigli, op. cit., 29ff.

Ancient craftsmen did not use magnifying lenses: Boardman 1970, 382, 448. Higgins 1980, 11. L. Gorelick - A.J. Guinnett, *Expedition* 23/2, 1981, 27ff.

WREATHS

On gold wreaths of the 5th century BC, known from the texts see M. Burzachechi, *RendAccNapoli* 36, 1961, 107ff. R. Meiggs - D. Lewis, *A Selection of Greek Historical Inscriptions*, 1969, 288ff. *IG* I³, 297-316, 319-340, 342-346, 350-359. M. Τιβέριος, *Περίκλεια Παναθήναια*, 1989, 32. H. Kotsidu, *Die musischen Agone der Panathenäen in archaischer und klassischer Zeit*, 1991, 85ff. In general see Blech 1982, 143ff., 155ff., 299ff.

Wreath fragments from the sanctuary of Artemis Orthia: Dawkins 1929, 383, no. 7, pl. 203, 14. Higgins 1980, 102. Blech 1982, 298 n. 133. Deppert-Lippitz 1985, 91, fig. 46. A leaf and a fruit from a gold olive wreath come from the foundation pit of the cult statue of Hera Akraia, the finds from which are dated to the early 5th century BC at the latest: *Perachora* I, 81ff., pl. 84, 1-2. Likewise bronze laurel leaves and one gilded, probably of the first half of the 5th century BC, were found in the temple of Apollo in Corfu: Π. Καλλιγάς, *AΔ* 23, 1968, Χρονικά, 311, pl. 251α. For other votive wreaths see Blech, op. cit., 298 n. 133.

Funerary wreaths from Taranto and ancient Barke: *Ori di Taranto* 1987, 74. E. De Juliis, *Das Gold von Tarent. Ergänzungsheft* in *Ori di Taranto*, Hamburg 1989, 32. Cf. *AA* 1966, 292, fig. 42. M. Vickers - A. Bozama, *LibyaAnt* 8, 1971, 69, 79ff., pl. 32.

Wreaths from Athenian and Macedonian graves dated to the 5th century BC: 1) The gilded bronze myrtle wreath from Olynthos (*Olynthus* X, 158ff., no. 505, pl. 28). 2) Gilded bronze olive wreath from a grave on the Sacred Way (*Hiera Hodos*), Athens (L. Ross, *Archäologische Aufsätze* I, 1855, 28. Vickers - Bozama, op. cit., 80). 3) Gold myrtle branch, surely belonging to a wreath, from a grave near Piraeus Street, named by Elgin 'Aspasia's tomb' (R. Higgins, *BMQ* 23, 1960/1, 106, no. 48, pl. 47a. *ARepLondon* 1962/63, 52, fig. 5. Recently Williams - Ogden 1994, no. 10 have dated it to the first half of the 4th century BC). 4) Branches of a gold olive wreath in the H. Stathatos Collection, from Eleftheres, Kavala. It was delivered together with two earlier ornaments (Amandry 1953, 74, no. 216, pl. 30). 5) The silver wreath in the British Museum no. 1959.7-20.1 (*ARepLondon* 1959/60, 59, no. 9, fig. 3. R.A. Higgins, *BMQ* 22, 1960, 30, pl. 18. D. Burr Thompson - R.E. Griswold, *Garden Lore of Ancient Athens*. Picture Book 8, 1963, fig. 48), which has been shown to be a forgery (Vickers - Bozama, op. cit., 80 n. 80).

The remains of gilded bronze wreaths from the grave at Katerini, of the second quarter of the 4th century BC, are the earliest securely dated examples of the 4th century BC: Αικ. Δεσποίνη, *AAA* 13, 1980, 207. Of the two other known Macedonian wreaths, mentioned above, that from Olynthos is perhaps the earlier, while that from Eleftheres, Kavala is probably contemporary with the Katerini one.

The leaves found in the sanctuary of Apollo on Corfu certainly render laurel, see Π. Καλλιγάς, *AΔ* 23, 1968, Χρονικά, 311, pl. 251α. On the difficulty in distinguishing between laurel and olive leaves: K. Δαβάρας, *AE* 1985, 181 with n. 161. On leaf shapes and the rel-evant opinions: Σ. Καρούζου, *AΔ* 31, 1976, Μελέται, 16ff.

Wreaths with a mixture of plant species: From tomb III ('of the Prince') at Vergina, Thessaloniki Museum B 83. Of gilded bronze with olive leaves and myrtle berries (Ανδρόνικος 1984, 217). The wreath from Anapa (ancient Gorgippia) on the Taman peninsula. Of gold with olive, rather than laurel, leaves and myrtle berries (N.P. Kondakoff, *CRPétersbourg* 1882/88, 34, no. 11, pl. 1). More frequent mixtures are observed in wreaths from the cemeteries of Magna Graecia, the best known example being that from Armento in Lucania (Basilicata). Of gold with leaves of oak, laurel or myrtle and ivy (M. Guarducci, *Epigrafica* 35, 1973, 9. F.W. Hamdorf, *MüJbK* 30, 1979, 32, 35. R. Lullies, *JdI* 97, 1982, 95ff.).

On the reasons for the preference for various species of plants see Blech 1982, 93ff. Reasons of preference obtaining for victory, honorary and votive wreaths: Blech, op. cit., 147ff. 161, 301.

The descent of the lineage of the Argead kings of Macedonia from Herakles, son of Zeus, as well as from Macedon, eponymous hero of the Macedonians, also a son of Zeus according to Hesiod (fragm. 7 Merkelbach-West), is well known.

On the chthonic character of fertility symbols see Αικ. Κώστογλου-Δεσποίνη, *Προβλήματα της παριανής πλαστικής του 5ου π.X. αιώνα*, 1979, 114. Cf. K. Branigan, *Dancing with Death*, 1993, 120.

On the absence of laurel wreaths from tombs, the ancient sources are indicative: Callim. *Iamb*. IV, fragm. 194, 40ff. Artemid. *On Dreams* IV, fragm. 57, 20ff. On some exceptional cases see Blech 1982, 93.

Ivy wreaths are rarely worn even by comasts (revellers) or symposiasts (banqueters) in scenes on vases: B. Schmaltz, *MarbWPr*, 1968, 30. See also in this connection Blech 1982, 95ff. On gold ivy wreaths: K. Δαβάρας, *AE* 1985, 181 n. 166. *Gold of Greece* 1990, pl. 41. They appear more frequently in Magna Graecia: Guzzo 1993, 115, 283ff., fig. 66.

On the dedication of vegetal and metal victors' wreaths see J. Klein, *Der Kranz bei den alten Griechen*, 1912, 74ff. Blech 1982, 114, 144. On the dedication of personal honorary wreaths see the case of Spartakos and Parisades: M. Guarducci, *Epigrafica* 35, 1973, 20. On other honorary wreaths see Blech, op. cit., 160.

On the absence of gold wreaths from Athenian graves see Blech 1982, 92. On those who were entitled to wear gold wreaths: Blech, op. cit., 145, 308ff. On *choreuts'* gold wreaths see Demosth. *Against Meidias* 520. Official bestowal of gold wreaths on the dead: Guarducci, op. cit., 16ff., 22, 34. Blech, op. cit., 108 with n. 138.

Several wreaths in one grave: Segall 1966, 31ff. Παπαποστόλου 1977, 288ff., pls 98-99. Blech 1982, 86. Μ. Μπέσιος, *AEMΘ* 1, 1987, 212. Βοκοτοπούλου 1990, 66, pl. 39. Guzzo 1993, 114. At Derveni, in addition to the gold wreaths (figs 5-7), remains of more than two gilded bronze ones were found in graves A, B and Δ.

On the funerary destination of the wreaths found in graves see E. Langlotz, *Anthemon. Festschrift C. Anti*, 1955, 78 n. 13. R. Lullies, *JdI* 97, 1982, 95.

Well-known is the custom of wearing wreaths during religious rites and

the libation contests at the Anthesteria: L. Deubner, *Attische Feste*[2], 1962, 99. Nilsson 1967, 587. Blech 1982, 302ff. On bewreathed symposiasts see Blech, op. cit., 72ff. Deubner, *ARW* 30, 1933, 96 maintains that the use of wreaths passed from the *symposia* to the comasts, see, however, op. cit., 104. On the use of wreaths in general see also Κ. Δαβάρας, *AE* 1985, 184ff.

Wreaths in the etiquette of laying-out the dead (*prothesis*): W. Burkert, *Griechische Religion*, 1977, 295. Blech 1982, 82, 85. According to Plutarch (*Pericles* 36, 5), when Pericles placed the wreath on the head of his dead son Paralos, he burst into tears. On the identical meaning of the wreath and the band diadem in funerary rites see below on this page.

On some indications of bewreathing the dead in the 7th century BC see Blech 1982, 36. *Kerameikos* VI 2, pls 12b, 13b. Archaic representations of the dead wearing a wreath: W. Zschietzschmann, *AM* 53, 1928, 22, nos 36, 53-55. Blech, op. cit., 89, 103. Α.Κ. Λεμπέση, *Οι στήλες του Πρινιά*, 1976, 99 n. 543.

On Mousaios' son Eumolpos and the relevant passage in Plato see Nilsson 1967, 688 n. 4. On the eudaemonic teachings and the dead as a symposiast see Segall 1966, 32. Blech 1982, 100ff. Furniture accompanying the dead: *Σίνδος* 1985, nos 123, 124 et al. and spits with firedogs: op. cit., nos 125, 126 et al. On the *symposium* in relation to the continuation of life in the Netherworld: I. Scheibler, *Griechische Malerei der Antike*, 1994, 137ff.

On the 'μελιτοῦττα' (*melitoutta*) see s.v. in Suidas. On the expression 'ὡς ἀθλητής' see also Plutarch *Pericles* 28, 4. Blech 1982, 113 with n. 20, 154. On the significance of virtue in connection with the games: Blech, op. cit., 151ff. S.G. Miller, *Arete*, 1991, VIIff.

On the various views concerning the meaning of the funerary wreath see J. Gy. Szilagyi, *ActaAntHung* V, 1957, 52ff. Segall 1966, 31ff. Λεμπέση, op. cit., 99. Blech 1982, 98ff. R. Lullies, *JdI* 97, 1982, 114ff. Κ. Δαβάρας, *AE* 1985, 185ff.

DIADEMS

On the meaning of the word diadem: H.-W. Ritter, *Diadem und Königsherrschaft*, 1965, 3, 6ff. Idem, *Historia* 36, 1987, 290ff. Krug 1968, 118, 136. Blech 1982, 35 with n. 59. Cf. H. Brandenburg, *Studien zur Mitra*, 1966, 155ff., 160ff. R.R.R. Smith, *Hellenistic Royal Portraits*, 1988, 35ff. does not accept the Persian origin of the diadem.

On the use of bands of perishable material, as deduced from the monuments: Krug 1968, 113ff.

Gold funerary bands identical in meaning with wreaths: G. Heck, *Griechische Weihegebräuche*, 1905, 93. E. Langlotz, *Anthemon. Festschrift C. Anti*, 1955, 78 n. 13. J. Gy. Szilagyi, *ActaAntHung* V, 1957, 52ff. Blech 1982, 82ff., 84ff.

Earlier diadems from Mochlos and elsewhere: Higgins 1980, 54ff., 58, 61ff., 74, 85. Blech 1982, 425 in no. 4, 1-2. See also H.-G. Buchholtz - V. Karageorghis, *Altägäis und Altkypros*, 1971, nos 1794-1798. Pierides 1971, pls IV-VI. K. Branigan, *Aegean Metalwork*,

1974, 37ff., 183ff., pls 20 and 30. Ν. Πλάτων, *Ζάκρος*, 1974, 15, fig. 5. S. Dietz, *Archaeology* 28, 1975, 160. O.T.P.K. Dickinson, *The Origins of Mycenaean Civilisation*, 1977, 74ff.

Gold funerary bands of the 9th century BC: *Kerameikos* V 1, 185ff., pl. 158a. *Lefkandi* I, 219, pls 189, 229, 232a. Higgins 1980, 96, 105, 108. See also *AM* 81, 1966, 8, no. 7, Beil. 13, 6. *AΔ* 22, 1967, Χρονικά, 95, pl. 87a2. *AAA* 1, 1968, 22, fig. 5β. *BSA* 64, 1969, 144, pl. 34i. *BSA* 77, 1982, 236 (T39, 23 and T42, 9), pls 17, 23, 30h. Pedimental funerary gold diadems of the 9th century BC: *Kerameikos*, op. cit., inv. no. M 111. *AΔ* 20, 1965, Χρονικά, 78, pl. 44a-β. *AΔ* 23, 1968, Χρονικά, 55, pl. 31a. Higgins, op. cit., 212.

Two fragments of a 9th-century BC band diadem from Lefkandi: *Lefkandi* I, 219 (T33, 7), pls 187, 232c. Higgins 1980, 105, no. 2. The diadem from Tekes, Knossos: J. Boardman, *BSA* 62, 1967, 68, no. 3, pl. 12. Coldstream 1979, 103ff., fig. 32c. Higgins, op. cit., 108. 8th-century BC bands with engraved decoration: Higgins, op. cit., 96. *AAA* 1, 1968, 26 (tomb XVI), fig. 5a. Greifenhagen 1970, 19ff., pls 3, 2 and 4, 1. *AAA* 5, 1972, 169, 170, 173 (tombs III, IX, XII), fig. 6.

Bands with embossed representations from Attica: Ohly 1953, 9ff. J. Gy. Szilagyi, *ActaAntHung* V, 1957, 48ff. with n. 4. B. Schweitzer, *Greek Geometric Art*, 1971, 186ff. Fittschen 1968, 222ff. Π. Θέμελης, *Πρακτικά Δ΄ Επιστημονικής Συνάντησης ΝΑ Αττικής 1989*, 1992, 143ff. On the problems of making bands see here pp. 19ff. and 274ff. R. Laffineur, *Amathonte* III, 103.

Eretrian and Skyrian diadems: Ohly 1953, 12ff., 46ff., 130 n. 21. Cl. Bérard, *Eretria* III, 36ff. with n. 1. L. Marangou, *BCH* 99, 1975, 370, 376, no. 12, fig. 12. Coldstream 1979, 198. A. Andriomenou, *ASAtene* 59, *N.S.* 43, 1981, 192ff., fig. 7. *Proceedings of the 2nd International Symposium at the Swedish Institute at Athens 1981*, 165.

Hellenistic pedimental diadems: *BMCJ* 1911, nos 1611-1614, figs 52-54. A. De Ridder, *Catalogue sommaire des bijoux antiques*, 1924, nos 98-99, pl. 2. Coche De La Ferté 1956, pl. 18, 1-2. Hoffmann - Davidson 1965, no. 7. Segall 1966, 22, fig. 1. Pierides 1971, 28ff., pl. 17. Higgins 1980, 158, no. 2. Deppert-Lippitz 1985, 195, fig. 143. M. Dickers, *AA* 1981, 552, fig. 13. *Ancient Macedonia* 1988, no. 313. Μ. Μπέσιος in *Οι αρχαιολόγοι μιλούν για την Πιερία 1985*, 1986, 57, no. 4, fig. 2. Williams - Ogden 1994, nos 168-169. Μ. Μπέσιος - Μ. Παππά, *Πύδνα*, 1995, 102.

Gold bands of the 7th and 6th centuries BC with representations of animals and other figures: Higgins 1980, 101ff., 124. *BMCJ* 1911, no. 1218, pl. 14 (Aegina). De Ridder, op. cit., no. 92, pl. 2 and P. Demargne, *Naissance de l' art grec*, 1964, 350, 359, fig. 471 (Corinth). H. Payne, *Necrocorinthia*, 1931, 222, 224ff., pl. 45, 3. Higgins, op. cit., 15, 102, pl. 1B-C. Laffineur 1978, 24 n. 7 (bronze matrix from Corfu). Friis Johansen 1957, 80ff., 174ff., figs 183 (Z 50), 187-189 (Z 51-52) (Rhodes). Cl. Bérard, *Eretria* III, 36ff., fig. 13, pl. 13, col. pl. B (Eretria). T. Hackens in *Aurifex* 1980, 1ff. (unknown provenance). R. Laffineur, *BCH* 104, 1980, 356ff., no. 21, fig. 19 (un-

known provenance). *ARepLondon* 1957, 15ff., pl. 1a and *Guide de Thasos*, 1967, 162, fig. 102 (Thasos). *ClRh* VIII, 112ff., figs 98, 100-101 (Ialyssos, Rhodes). M. Ανδρόνικος, *Το Έργον*, 1988, 74 with drawing, figs 63-64 (Vergina).

On the diadem in the N. Metaxas Collection see G. Neumann, *AM* 80, 1965, 143ff., Beil. 56, 1 and 57, 2-4. Other Hellenistic examples with representations: Neumann, op. cit., 146ff. with n. 13, Beil. 56, 2-4. K. Kuruniotis, *AM* 38, 1913, 321ff., fig. 11. *BMCJ* 1911, no. 1614, fig. 53. A. De Ridder, *Catalogue sommaire des bijoux antiques*, 1924, nos 98-99, pl. 2. Δ. Λαζαρίδης, *Το Έργον*, 1956, 57. Segall 1966, 22ff., fig. 1. Williams - Ogden 1994, no. 44. Here figs 23-24.

Diadems with rosettes: Laffineur 1978, 85ff. Idem in *Aurifex* 1980, 16ff. Pierides 1971, 25ff., pl. 14, no. 1. Higgins 1980, 108, no. 3. Cf. Marinatos 1967, B18, fig. 6b. On individual rosettes perhaps from diadems see also Ν. Χρ. Σταμπολίδης, *Ελεύθερνα*, 1994, 120, no. 72, pl. XXVI. A Protogeometric Cypriot diadem: V. Karageorghis, *BCH* 108, 1984, 918, no. 17, fig. 82. Assyrian and Egyptian diadems: B. Segall, *AJA* 60, 1956, 167, pl. 63, 7. Laffineur, op. cit., 114. P.O. Harper et al., *BMetrM* 41, 1984, 37, fig. 47. R.R.R. Smith, *Hellenistic Royal Portraits*, 1988, 36. M. Pfrommer, *IstMitt* 36, 1986, 62, fig. 1, 1-2.

On 6th- and 5th-century BC diadems with rosettes: K. Kuruniotis, *AM* 38, 1913, 310, pl. 14, 5. P. Amandry, *BCH* 63, 1939, 100, no. 31, pl. 30a. Higgins 1980, 124ff. Deppert-Lippitz 1985, 134. *Σίνδος* 1985, no. 514. A. Despini in *Ancient Macedonia* IV, 1986, 166, pl. 3c. U. Kron, *Festschrift für Jale Inan*, 1989, 379. Θεσσαλονίκη 1986, 94, inv. no. 751, fig. 77 in the middle. *Oro dei Greci* 1992, 253, pl. 96, 6. *Ελληνικός Πολιτισμός* 1993, no. 131.

Floral decoration on diadems of marble Archaic korai: G.M.A. Richter, *Korai*, 1968, 71 (no. 111), 77 (no. 119), 79 (no. 123) et al. Gold diadems with palmettes and lotus flowers, from Amathous, Cyprus: Higgins 1980, 124. R. Laffineur, *Amathonte* III, 102ff., fig. 70, 120. Idem, *La nécropole d' Amathonte* VI (*Études Chypriotes* XIV, 1992), 23ff.

Gold bands from Macedonia: *Σίνδος* 1985, nos 111, 116, 287, 316. The guilloche is the predominant motif, though others appear too, see *Σίνδος*, op. cit., nos 482, 514. Μ. Ανδρόνικος, *Το Έργον*, 1988, 74 with drawing, figs 63-64.

On the funerary destination of sheet-gold diadems: Ohly 1953, 68ff. Friis Johansen 1957, 172ff. J. Gy. Szilagyi, *ActaAntHung* V, 1957, 52. Bielefeld 1968, 14, 52. Segall 1966, 23. Cl. Bérard, *Eretria* III, 37 n. 4, 38. Higgins 1980, 96, 101. Deppert-Lippitz 1985, 65, 195.

That some gold bands may have been worn as head ornaments in life is suggested by: Laffineur 1978, 115. Higgins 1980, 112, 124. Deppert-Lippitz 1985, 134. See also J. Carter, *BSA* 67, 1972, 42 n. 93.

In earlier literary tradition divine or mythical figures wore a diadem (wreath): Homer *Hymn to Aphrodite* 6. Hesiod *Theogonia* 578. The diadems found in Scythian tombs perhaps also allude to special cases, see U. Kron, *Festschrift für Jale Inan*, 1989, 379ff. On diadems with rosettes worn by Egyptian and Neoassyrian kings see

R.R.R. Smith, *Hellenistic Royal Portraits*, 1988, 36.

On examples of gold-foil diadems that covered a band of other material, see Reinach 1892, 41ff. in n. 2, pl. II, 2. G. Zahlhaas - H. Fuchs, *AA* 1981, 577ff.

On the provenance of the 'second Thessalian hoard' and the stylistic evaluation of it see Amandry 1953, 89ff., 129ff.

Anta capitals of sofa type: St. Miller, *Hellenistic Macedonian Architecture*, 1971 (1979), 30ff. Ι. Παπαποστόλου, *AAA* 8, 1975, 297ff. V. Heermann, *Studien zur makedonischen Palastarchitektur*, 1980, 395ff., 402ff., 530ff. A. Fraser in *Studies in the History of Arts* 10, 1982, 200. J.A. Papapostolou, *Achaean Grave Stelai*, 1993, 70. On the form of the trapezoidal sections of the diadems cf. in particular the Olynthos anta capital: *Olynthus* II, 92ff., figs 134, 214-216.

Diadems from Pantikapaion and Egypt: Amandry 1953, 120ff., fig. 72. Pfrommer 1990, 299ff., 311, nos HK4, HK112, pls 12, 1 and 29, 46.

Metal diadems with stem of circular section, from Taranto: *Ori di Taranto* 1987, 119ff., nos 49-51. Deppert-Lippitz 1985, 196. The diadem from tomb II (of Philip) at Vergina: *The Search* 1980, no. 162, col. pl. 29. Ανδρόνικος 1984, 171ff., figs 138-139. Deppert-Lippitz, op. cit., 196. E.A. Fredricksmeyer, *AJA* 87, 1983, 99ff. and n. 13. A.M. Prestianni Giallombardo in *Ancient Macedonia* IV, 1986, 497ff. R.R.R. Smith, *Hellenistic Royal Portraits*, 1988, 34ff. with n. 29. *Oro dei Greci* 1992, 271, pl. 147, 3.

EARRINGS

On the suspension of earrings from a link see Amandry 1953, 55 in no. 140. Laffineur 1978, 150, 151 n. 1. S. Hood, *The Arts in Prehistoric Greece*, 1978, 201, fig. 200. Κ. Σισμανίδης in *Αμητός* 1987, 799, no. 1. Μ. Τσιμπίδου-Αυλωνίτη, *AEMΘ* 3, 1989, 323, fig. 8. I had earlier suggested that the Macedonian band earrings (figs 60-65) were hung from the ear with the help of the hook on the back of their wider end (*Ancient Macedonia* IV, 1986, 164ff.), but after the find from Epanomi (*AEMΘ* 3, op. cit.) I consider it more likely that these earrings hung from a link.

Gold hoop earrings of the 11th century BC: *Lefkandi* I, 218 with n. 3, pl. 99 (22, 2-3), 103 (38, 4-5), 204e. Higgins 1980, 91.

Spiral earrings from Ur: Maxwell-Hyslop 1971, 5, pl. 5a (with suspension link). B. Musche, *Vorderasiatischer Schmuck*, 1992, 85, type 4, pl. XXIII.

Earrings from Palaiomanina, Agrinion: Ε. Μαστροκώστας, *AΔ* 22, 1967, Χρονικά, 323, pl. 231B. Higgins 1980, 91. Cf. those of similar form in the Benaki Museum, inv. nos 30011-30013.

On earrings like those from Lefkandi (fig. 44) with slightly conical disc terminals cf. those from Corinth: Jacobsthal 1956, 4, 6, 44, fig. 15 middle b. Coldstream 1979, 175, fig. 57d. From Tegea: Ch. Dugas, *BCH* 45, 1921, 387, no. 168, fig. 20. From Thebes, of gold and much larger: Coche De La Ferté 1956, 27, pl. X, 3. Higgins 1980, 105, pl. 16J (marked I instead of J in the plate). Of bronze, from Perachora:

Perachora I, 183, pl. 83, 1 and from Amphikleia, National Archaeological Museum 16487-16488: *BCH* 78, 1954, 132. I. Kilian-Dirlmeier, *PBF* XI, 2, 1979, 17, no. 73.

Spiral earrings with thick stem and a single coil: W.A. Heartley - T.C. Skeat, *BSA* 31, 1930/31, 34, nos 2-4, fig. 14. Δ.Π. Θεοχάρης, *ΑΔ* 17, 1961/62, Χρονικά, 175, pl. 195β above. Amandry 1963, 188, no. 96, pl. 28. *Lefkandi* I, 220, pl. 139 (no. 33), 230 (no. 1). Higgins 1980, 105, pl. 16H (marked G instead of H in the plate).

Late Geometric earrings from Rhodes, loop-shaped with disc terminals: G. Jacopi, *ClRh* III, 96, no. 12 and 100, no. 3, pl. V, 1 and 5 (LVII, 3 and LVI, 12). Laffineur 1978, 153ff. Idem in *Aurifex* 1980, 17, with n. 24. Deppert-Lippitz 1985, 108.

Earrings with twisted terminals: Amandry 1953, 54ff. in nos 137-140. *Emporio* 1967, 221ff., fig. 144, pl. 91 (of the Late Geometric period and the 7th century BC). Κ. Τσάκος, *AAA* 2, 1969, 203, fig. 3. Higgins 1980, 126, no. 2a-c. Deppert-Lippitz 1985, 179. Μ. Πωλογιώργη, *AAA* 14, 1981, 167, fig. 3.

On Geometric earrings with conical terminals, similar to those in fig. 58, see J. Sieveking, *AA* 1917, 29, fig. Ib. *Perachora* I, 75, pl. 18, 16-17. Amandry 1953, 139, nos 279/80, pl. 52. Κ. Kilian, *PBF* XIV 2, pl. 70, 24. Philipp· 1981, 114ff., no. 394, pl. 7.

Omega-shaped earrings with snake heads: Amandry 1953, 55, nos 141/142, pl. 24, figs 28, 4 and 29, 2. *Σίνδος* 1985, nos 71 et al. Σισμανίδης in *Αμητός* 1987, 799, no. 1. Gold: Γ. Καραμήτρου-Μεντεσίδη, *AEMΘ* 2, 1988, 20, fig. 4. Μ. Μπέσιος, *AEMΘ* 3, 1989, 156 (T51). Μ. Μπέσιος - Μ. Παππά, *Πύδνα*, 1995, 72.

Omega-shaped earrings with bud terminal: Σισμανίδης in *Αμητός* 1987, 799, no. 1, pl. 164, fig. 2 bottom left. Σ. Μοσχονησιώτου, *AEMΘ* 2, 1988, 285, fig. 5. Gold: Μπέσιος - Παππά, op. cit., 70, fig. Α. On the decoration cf. Amandry, op. cit., 54ff., nos 137-140, pl. 24. Amandry 1963, 199 n. 1.

Band earrings from grave 28 at Sindos, dating from about 560 BC: *Σίνδος* 1985, no. 436. On the band earrings from grave 20 at Sindos and their like see *Σίνδος*, op. cit., no. 150. Amandry 1953, 35, 42, 71ff., no. 69, pl. 16 (= *Treasures* 1979, 81, 110, no. 341. Laffineur, *BCH* 103, 1979, 218 n. 7). Amandry 1963, 191 n. 3, fig. 97. Μ. Ανδρόνικος, *Το Έργον*, 1988, 74, fig. 62α. On the earrings from Aiani and graves 56 and 101 at Sindos see Καραμήτρου-Μεντεσίδου, op. cit., fig. 3 and *Αιανή Κοζάνης*, 1989, 63, fig. 29. *Σίνδος*, op. cit., no. 286, primarily 476.

8th-century BC ring with guilloche, from Athens: Ο. Αλεξανδρή, *ΑΔ* 22, 1967, Χρονικά, 80, pl. 80, 82. Cf. also the 'bracelets' from Cerveteri (Caere) in Etruria: *BMCJ* 1911, nos 1360/1, pl. 18.

Silver band earrings from Nea Michaniona: Βοκοτοπούλου 1990, 108, no. 10, drawing 58, pl. 668.

Other earrings with bands of parallel wires, like those in fig. 65: H. Stathatos Collection, Amandry 1953, 43, nos 74-77, pl. 17. Amandry 1963, 191, nos 99/100, pl. 29. There is another pair now in the Pforzheim Museum: Amandry 1963, 193, fig. 98. R. Laffineur, *BCH* 103, 1979, 217 n. 4, fig. 1.

On earrings with one end developed cf. S. Piggot, *Ancient Europe*, 1973, fig. 52, 2. J. Ogden, *Jewellery of the Ancient World*, 1982, 23, fig. 2, 9. Φ. Πέτσας, *ΑΔ* 17, 1961/62, Μελέται, 224, no. IIIΔ 80-82, drawing 10. Ανδρόνικος 1969, 137, 224ff., 240, 259, fig. 80 left, pl. 112 bottom right (ΑΓ pithos 3γ). D.M. Bailey, *OpAth* 9, 1969, 24, fig. 5 and 6 right. M. Vickers in *Ancient Macedonia* II, 1977, 30, fig. III, 7-8, pl. C, 4. K. Kilian, *PZ* 50, 1975, 98, pls 32, 2 and 34, 1. R. Laffineur, *BCH* 103, 1979, 226. For these cf. also *Σίνδος* 1985, no. 58.

In addition to fig. 66 there are another nine Late Archaic earrings of double wire with heart-shaped terminal, in the H. Stathatos Collection (Amandry 1953, nos 102/103, pl. 18., nos 120-123 and 129, pl. 23. O. Picard, *Coll. H. Stathatos* IV, 1971, 18, nos 570/571, pl. I), two in the Canellopoulos Collection (R. Laffineur, *BCH* 104, 1980, 357ff., no. 24, figs 22-23) and one in the Benaki Museum, inv. no. 8114 (R. Laffineur, *BCH* 103, 1979, 221 n. 28). Moreover, in addition to the specimens from Toumba and Epanomi, Thessaloniki (bibliography in the description of fig. 66 here), there are three more in the Thessaloniki Museum, inv. nos 4007-4009.

Earlier earrings of double wire with one end emphasized: Χ. Ντούμας, *ΑΔ* 18, 1963, Χρονικά, 280, pl. 325γ (with suspension link). R. Vasić, *The Chronology of the Early Iron Age in Serbia* (*B.A.R.* Suppl. Series 31, 1977), pl. 2, no. 15, 5, nos 16-17, 9A, nos 4-7 (with suspension link).

Precursory forms of earrings with mulberry pendant: Higgins 1980, 62ff., 74ff., 86, pl. 12C. Cf. Cl.F.A. Schaeffer, *Missions en Chypre*, 1936, pl. 36, 1 below. Idem. *Ugaritica* I, 1939, 44, fig. 31. L. Woolley, *Alalakh*, 1955, pl. 69g. Pierides 1971, 19, pl. IX, 2. Maxwell-Hyslop 1971, 116, 130, pl. 96, fig. 79. R. Laffineur, *Πεπραγμένα Δ΄ Διεθνούς Κρητολογικού Συνεδρίου, Ηράκλειο 1976*, Α΄, 1980, 284. Π. Muhly, *Μινωικός λαξευτός τάφος στον Πόρο Ηρακλείου*, 1992, 122ff., no. 239, pl. 26. Later related examples with three mulberries: B. Musche, *Vorderasiatischer Schmuck*, 1992, pls 102-103, nos 2 and 4, 3.

On the correlation of the Lefkandi earrings (fig. 68) with the Homeric 'τρίγληνα μορόεντα' see Higgins 1980, 106, pl. 16C. Deppert-Lippitz 1985, 63, fig. 28. Earlier thoughts on the 'τρίγληνα': W. Helbig, *Das homerische Epos²*, 1887, 271ff. Hadaczek 1903, 25ff. Chr. Kardara, *AJA* 65, 1961, 62ff. Γ. Κορρές, *Χαριστήριον εις Α.Κ. Ορλάνδον* Β΄, 1966, 214ff. See also Laffineur, op. cit., 284 n. 12.

On the form and method of manufacture of the cones on the Argos earrings (fig. 69) cf. the earring from Poros, Herakleion, Muhly, op. cit.

On early bronze and silver earrings with pendants in the form of an inverted pyramid and cone see Σ. Παπασπυρίδη-Καρούζου, *ΑΔ* 15, 1933/35, 43ff., fig. 22 bottom row. Philipp 1981, 116ff., particularly 121ff., nos 400-421, pls 7 and 41. Παπαποστόλου 1990, 115.

Early earrings with pyramid pendant: Ο. Αλεξανδρή, *ΑΔ* 22, 1967, Χρονικά, 80, pl. 808 top. Cf. Maxwell-Hyslop 1971, 195, pl. 147. A lovely Hellenistic example: H. Tait (ed.), *Seven Thousand Years of Jewellery*, 1986, 94, no. 205.

Earrings from grave 70 at Amphipolis: *Treasures* 1979, no. 381, pl. 53.

The Search 1980, no. 89. The examples in the British Museum and Basle: Higgins 1980, 128, pl. 25F. Deppert-Lippitz 1985, 126, fig. 75. Williams - Ogden 1994, no. 12.

Modelled figures on top of the pyramidal pendant are encountered on a pair of earrings from Aiani, Kozani (*Ancient Macedonia* 1988, no. 332) and on another pair in the British Museum (*BMCJ* 1911, nos 1666/67. Williams - Ogden 1994, no. 176). In general see Higgins 1980, 162, no. 5a.

On the origin of boat-shaped earrings and their distribution in Greece see *Olynthus* X, 85ff. Amandry 1963, 218 n. 3. Miller 1979, 7 n. 19. Higgins 1980, 119, no. 1. Deppert-Lippitz 1985, 93ff. On their stylistic and chronological classification: Segall 1966, 19ff. Blanck 1976, 22ff.

Early Bronze Age boat-shaped earrings from Lefkada (Leucas), Athens, National Archaeological Museum, inv. no. 6285: W. Dörpfeld, *Alt-Ithaka*, 1927, 235, 288ff., Beil. no. 4 (Tomb R15b). C. Renfrew, *The Emergence of Civilisation*, 1972, 334, 433, fig. 19, 11. S. Hood, *The Arts of Prehistoric Greece*, 1978, 192, fig. 189D. On the dating of tomb R15b see N.G.L. Hammond, *BSA* 69, 1974, 135.

On the boat-shaped earrings from Madytos: Higgins 1980, 159, pl. 25A. Pfrommer 1990, 203ff., pls 26, 14 and 31, 14. Williams - Ogden 1994, no. 63. From Trebizond (Trapezous): *The Search* 1980, no. 61. Deppert-Lippitz 1985, 183, fig. 130. Pfrommer, op. cit., 204. From Chersonesos: A. Manzewitsch, *Ein Grabfund aus Chersonnes*, 1932, 12, no. 7, pl. II, 2. Pfrommer, op. cit., 204ff., pl. 27, 5-6. From Crete: *BMCJ* 1911, nos 1655/56, pl. 30. Pfrommer, op. cit., 205 n. 1283. In the Louvre, from Bolsena: A. De Ridder, *Catalogue sommaire des bijoux antiques*, 1924, nos 272/273, pl. 8. Coche De La Ferté 1956, 64, pl. 21, 1. Pfrommer, op. cit., 205 n. 1284.

On the origin and diffusion of earrings with an animal or human head on one terminal see P. Amandry, *AJA* 71, 1967, 203ff. Higgins 1980, 159ff. Deppert-Lippitz 1985, 223ff. Pfrommer 1990, 143ff. Παπαποστόλου 1990, 120ff., 138ff.

Lion-head earrings from ancient Mieza: Β. Μισαηλίδου-Δεσποτίδου, *ΑΕΜΘ* 4, 1990, 130, fig. 118.

Earrings with hoop of wires coiled round a gold core: Hoffman - von Claer 1968, no. 70ff. Hoffmann - Davidson 1965, 105ff., no. 25. T. Hackens, *Catalogue of the Classical Collection. Classical Jewelry. Museum of Art, Rhode Island*, 1976, no. 28. *Treasures* 1979, no. 69, pl. 12. *The Search* 1980, nos 68-69. Παπαποστόλου 1990, 112, no. 27. Williams - Ogden 1994, no. 132. Cf. *Ori di Taranto* 1987, nos 110 and 116. On the technique of coiling wires see M.E. Vernier, *La bijouterie et la joaillerie égyptiennes*, *Memoires Inst. Franc. Arch. Orient.* 2, 1907, 91, fig. 98.

On the different types of zoomorphic or anthropomorphic earring terminals see Higgins 1980, 159ff. Deppert-Lippitz 1985, 223ff. Pfrommer 1990, 146ff. Specifically on earrings with negro-head terminals see Pfrommer, op. cit., 185ff. and recently Π. Θέμελης, *Γ΄ Επιστημονική Συνάντηση για την ελληνιστική κεραμική, Θεσσαλονίκη 1991*, 1994, 154ff.

NECKLACES AND PENDANTS

On the term 'ὅρμος' see Blanck 1974, 1ff.

A necklace was used as the hieroglyphic sign for gold, see W.M.F. Petrie, *Arts and Crafts of Ancient Egypt*, 1910, 83ff.

Necklace from the area of the University of Crete Medical School: *ARepLondon* 1978/79, 46, fig. 11. Higgins 1980, 92. On other early beads: Ε. Μαστροκώστας, *ΑΔ* 22, 1967, Χρονικά, 323 (Agrinion region). Higgins, op. cit., 89 (Athens). Α.Ν. Σκιάς, *ΑΕ* 1898, 103 (Eleusis). P. Courbin, *Tombes géométriques d' Argos*, 1974, 34, no. O, 1, pl. 27. Higgins, op. cit., 103. Deppert-Lippitz 1985, 65 (Argos).

Necklace with four-spiral beads, from Lefkandi: *ARepLondon* 1986/87, 13 cover photograph and 1988/89, 120, fig. 23. Four-spiral ornaments comparable to those in fig. 106, from Skyros (L. Marangou, *BCH* 99, 1975, 367, nos 5-6, figs 5-6. The composition on a pin is later) and from the Idaean Cave, Crete (Sakellarakis 1988, 182ff., fig. 18. 20). Mycenaean examples: Σ. Μαρινάτος, *ΑΕ* 1932, 24ff., 40, fig. 30, pls 15γ and 188. Higgins 1980, 59, 67, 76, fig. 11. Deppert-Lippitz 1985, 19, fig. 2. *Ο μυκηναϊκός κόσμος. Κατάλογος έκθεσης στο Εθνικό Αρχαιολογικό Μουσείο*, Athens 1988, no. 87. On examples from Vergina and Central Europe see Ανδρόνικος 1969, 255ff., fig. 91.

Chain necklace from Anavyssos, Attica: Ν. Βερδελής - Κ. Δαβάρας, *ΑΔ* 21, 1966, Χρονικά, 97 (grave II). Higgins 1980, 99.

It appears that the pomegranate enjoyed wide distribution as a pendant into the 6th century BC: Blanck 1974, 55, 57, 58ff., 64-69, 78ff., 128. See also here figs 59, 69, 75, 108, 115, 117-118. On examples in bronze of the Geometric period see I. Kilian-Dirlmeier, *PBF* XI, 2, 1979, 123ff., 126, pl. 35.

On jewellery similar to that from Argos (fig. 111) see M.S. Thompson, *BSA* 15, 1908/9, 142, pl. 8, no. 9. Dawkins 1929, 383, pl. 202, no. 5 (= Deppert-Lippitz 1985, 84, fig. 39). Α. Δεληβορριάς, *ΑΔ* 23, 1968, Χρονικά, 149, pl. 99β. Higgins 1980, 103. Ι. Βοκοτοπούλου, *Βίτσα*, 1986, 53, no. 1, pl. 73α. In general on pendants of this shape: Philipp 1981, 368ff.

On the poppy capsule see Jacobsthal 1956, 38, 185, figs 159-160. Σ. Χαριτωνίδης, *ΑΕ* 1960, 162ff. Π. Κρητικός, *Η μήκων, η λήψις του οπίου και η χρησιμοποίησις τούτου κατά τους υστερομινωικούς III χρόνους*, 1960, pls I and III. Π. Κρητικός - Σ. Παπαδάκη, *ΑΕ* 1963, 80ff.

On single vase-shaped pendants worn as medallions see Philipp 1981, 369 with n. 720. *Σίνδος* 1985, nos 59, 350, 483. Archaic vase-shaped pendants: Amandry 1953, 46ff., nos 82-94. Philipp, op. cit., 368ff. Deppert-Lippitz 1985, 116, figs 63-65. Cf. also Blanck 1974, 58 (A3), 63 (A6), 81 (B10)ff.

Peloponnesian vase-shaped ornaments hanging from cylindrical beads in T-formation: Dawkins 1929, op. cit. (the cross bar tube is missing) and M.S. Thompson, *BSA* 15, 1908/9, 142, pl. 8, no. 9.

On a new manner of suspension in the 5th century BC see the examples from Cyprus (*BMCJ* 1911, no. 1237, pl. 14. Deppert-Lippitz 1985,

141, fig. 88, pl. VIII. Williams - Ogden 1994, nos 179-180), from Duvanlij, Bulgaria (Filow 1934, 42, no. 3, 132, no. 3, 193, figs 47 and 154), one from the Seven Brothers Barrow, Taman peninsula (Williams - Ogden, op. cit., no. 71) and a later one from Theodosia, Crimea (Reinach 1892, 53, pl. XIIa, no. 3 = Deppert-Lippitz, op. cit., 170, fig. 120, no. 3).

On animal-head and acorn pendants see Amandry 1963, 230ff. Blanck 1974, 73ff. (M7a, M10b), 82 (O10), 128ff. Deppert-Lippitz 1985, 120ff., 144ff., figs 68-69. Cf. the terracotta figurine in Taranto: E. Langlotz, *Die Kunst der Westgriechen*, 1963, pl. 20b. See also *IG* I³, 360: 'ὅρμος ῥόδων' with ram head.

On necklaces worn on the chest (pectorals) see Amandry 1963, 210ff. Laffineur 1978, 79ff., 157, 168 and in *Aurifex* 1980, 26ff.

On the motif of antithetic lotus blossoms in Assyrian art see M. Pfrommer, *IstMitt* 36, 1986, 62ff. Necklaces with the related theme embossed on gold sheet, from Cyprus: *SCE* IV 2, 164ff., fig. 35, no. 20. V. Karageorghis, *BCH* 108, 1984, 922, fig. 103. Deppert-Lippitz, op. cit., 142, fig. 91, pl. IXb. Pfrommer, op. cit., 67, fig. 2, 1. R. Laffineur, *Amathonte* VI (*Études Chypriotes* XIV, 1992), 26 (T 283/41), pl. 9. On the related ornament from Ephesos: D.G. Hogarth, *Ephesus*, 115, pl. 9, 18. Pfrommer, op. cit., 62 n. 14.

Necklaces with rosettes and lotus blossoms: Blanck 1974, 126. Miller 1979, 10ff. Deppert-Lippitz 1985, 142ff., 164ff. Pfrommer, *IstMitt* 36, 1986, 59ff. Williams - Ogden 1994, in no. 135.

On the necklaces from Taxila see M. Σαρίφ, *Τα ελληνιστικά στοιχεία στα κοσμήματα της Γανδάρας* (PhD thesis, Thessaloniki 1978), 57, pl. II, 3. M. Pfrommer, *IstMitt* 36, 1986, 66, 74ff., pl. 22, 3. On the Hellenistic elements at Taxila see also Σ.Ρ. Νταρ, *Ελληνιστικά στοιχεία στην αρχιτεκτονική των Ταξίλων* (PhD thesis, Thessaloniki 1973).

Etruscan examples of strap chains of the 5th century BC: Becatti 1955, 180, nos 273, 275, pls 70, 71b-c. Higgins 1980, 143, pl. 34. *Oro degli Etruschi* 1983, nos 158-161. There are examples of similar straps in Etruscan jewellery from the 7th century BC, see here pp. 23, 39 and 276. A 6th-century BC fragment from Trebenischte: Filow 1927, 38, no. 3, fig. 34. Amandry 1953, 74, fig. 44, no. 3.

On spear-head chains and chains of amphorae: Amandry 1953, 81, 110ff. Blanck 1974, 40ff., 43ff., 90ff., 127.

On the duration of the spear-head necklaces see Amandry 1953, 112. Blanck 1974, 116ff. (O´ 10a and Q´ 10) and 131. A fragment from Eretria is associated with the 3rd century BC (Hoffmann - Davidson 1965, 61, fig. 3c bottom) and the chains mentioned in the inscriptions of the *hieropoioi* of Delos, from the year 279 et seq.: *IG* XI 2, 161, B23ff. Blanck, op. cit. A necklace from Kurdish Haftashan, nowadays in Berlin, constitutes a very distant survival: W.-D. Heilmeyer, *Jahrbuch Preussischer Kulturbesitz* 24, 1987, 230ff., fig. 39 bottom.

On cord-chains outside Greece before the late 6th century BC see the Etruscan necklaces from Cerveteri (Caere): L. Pareti, *La tomba Regolini - Galassi*, 1947, 180ff., no. 2, 207, nos 128-131, pls 5 and 12. *Oro degli Etruschi* 1983, no. 31. E. Paschinger, *AW* 24, 1993, 113,

no. 2, fig. 11. From Gesseri: *Oro degli Etruschi*, op. cit., no. 68. From Marsiliana: A. Minto, *Marsiliana d' Albegna*, 1921, 48, 73, pls 12, 16 and 14, 4. See also the necklace from Ziwiye: R. Ghirshman, *Perse*, 1963, 114, fig. 151. P. Amandry, *AA* 1965, 895, fig. 6. Maxwell-Hyslop 1971, 208, pl. 166. B. Musche, *Vorderasiatischer Schmuck*, 1992, 246, no. 8, pl. 96. From the Litoi tumulus, Ukraine (Melgounov find): Amandry, op. cit., fig. 4. Artamonov 1969, 22, fig. 4. Deppert-Lippitz 1985, 105ff., fig. 55.

Fragments of a chain with two pins, from the sanctuary of Artemis Orthia, Sparta: Dawkins 1929, 383, no. 2, pl. 202, 1 (= Deppert-Lippitz 1985, 84, fig. 39, 1). Chains with bifurcate terminals on 7th-century BC jewellery from Rhodes: Laffineur 1978, nos 198-199, pl. 23, 1 and 3. *Oro dei Greci* 1992, 249, pls 80-81.

Archaic chains from Sindos: *Σίνδος* 1985, nos 62, 156, 232. Vergina: M. Ανδρόνικος, *Το Έργον*, 1988, 74, fig. 64. Trebenischte: Filow 1927, 37ff., fig. 34. Amandry 1953, 74, fig. 44.

5th-century BC chain with bifurcate terminals: *Σίνδος* 1985, no. 351. Chain from Eleftheres, Kavala: Amandry 1953, 73ff., no. 215, pl. 30. Amandry 1963, 244 in no. I.215. Chain from Elis: *BMCJ* 1911, nos 2845-2848, pl. 67. Amandry 1963, 212, fig. 116. Williams - Ogden 1994, no. 6. On other chains with snake terminals: Hoffmann - Davidson 1965, nos 42 and 70. Pfrommer 1990, 81, 329, no. TK120. On chains from the 4th century BC and after: Blanck 1974, 13, 18, 43.

PINS

On pins in prehistoric times: Higgins 1980, 50ff., 52ff. Deppert-Lippitz 1985, 30. I. Kilian-Dirlmeier, *PBF* XIII, 8, 1984, 14ff. In general on the early pins of historical times and their use: Desborough 1964, 53ff. and 1972, 295ff. Marinatos 1967, A36ff., A52, B26ff. Bielefeld 1968, 38ff., 44. Σ.Ε. Ιακωβίδης, *Περατή* Β´, 1970, 288ff. A.M. Snodgrass, *The Dark Ages of Greece*, 1971, 226ff. A. Kanta, *AAA* 8, 1975, 266ff. Philipp 1981, 31ff. Higgins, op. cit., 90, 100, 107, 111 et al. Deppert-Lippitz, op. cit., 51. Kilian-Dirlmeier, op. cit., 66ff.

Two pairs of 10th-century BC gold pins, from Fortetsa and Tekes, Knossos: J.K. Brock, *Fortetsa* (*BSA* Suppl. 2, 1957), 96, nos 1066/67, pl. 75. *ARepLondon* 1976/7, 12, fig. 25. Higgins 1980, 92.

Iron pins invested with gold foil, from Athens: *Kerameikos* V 1, 190ff., 235ff., pl. 159, no. M42. O. Αλεξανδρή, *AAA* 1, 1968, 26, fig. 11 and *AAA* 5, 1972, 173, fig. 10. Philipp 1981, 38 n. 169. Higgins 1980, 100.

7th-century BC pins with vertically ribbed beads: Ch. Waldstein, *The Argive Heraeum* II, 1905, 225ff., nos 512-553, pl. 82. Dawkins 1929, 383, pl. 202, no. 1 (=Deppert-Lippitz 1985, 84, fig. 39, 1). *Perachora* I, 173, pl. 75, nos 2, 4, 6. Philipp 1981, 60, nos 116-117, pls 3 and 30. I. Kilian-Dirlmeier, *PBF* XIII, 8, 1984, 256 (the earliest in group BVI), pls 98-103, nos 4186-4372.

Archaic gold pins from Vergina: M. Ανδρόνικος, *Το Έργον*, 1988, 74, fig. 62. Aiani: Γ. Καραμήτρου-Μεντεσίδη, *AEMΘ* 2, 1988, 20, fig. 5.

Eadem, *Αιανή Κοζάνης*, 1989, 63, fig. 30. On pins in representations on 4th-century BC vases see I. Kilian-Dirlmeier, *PBF* XIII, 8, 1984, 298. On Hellenistic hair pins: Amandry 1953, 107 in no. 241.

FIBULAE

On the time fibulae appeared and their use: Blinkenberg 1926, 14ff., 45 ff. Desborough 1964, 54ff. Bielefeld 1968, 40ff., 43ff., 49ff. Marinatos 1967, A36. Σ.Ε. Ιακωβίδης *Περατή* Β΄ 1970, 275ff. Sapouna-Sakellarakis 1978, 8, 34. Philipp 1981, 261ff. in nos 984-985. Α. Ωνάσογλου, *ΑΔ* 36, 1981, Μελέτες, 39 with n. 91. Higgins 1980, 87, 90, 100ff. Deppert-Lippitz 1985, 56ff.

Several fibulae in the same grave: Bielefeld 1968, 50, 52. Amandry 1963, 204ff. Α. Ωνάσογλου, *ΑΔ* 36, 1981, Μελέτες, 38. Βοκοτοπούλου 1990, 65ff., no. 44.

On fibulae of the so-called Attico-Boeotian type see Blinkenberg 1926, 147ff. Hampe 1971, 88ff., nos 121-129. Idem, *Frühe griechische Sagenbilder in Böotien*, 1936, 1ff. Fittschen 1968, 213ff. B. Schweitzer, *Greek Geometric Art*, 1971, 202ff. Sapouna-Sakellarakis 1978, 104ff. Philipp 1981, 270ff., mainly 276ff. Higgins 1980, 100ff. On the related type in Thessaly see K. Kilian, *PBF* XIV, 2, 1975, 105ff.

The three pairs of silver fibulae in grave 119 at Sindos had not been restored when the Exhibition Catalogue was prepared. On other finds from the same grave see *Σίνδος* 1985, nos 415-417.

On Archaic and Classical articulated fibulae (*Scharnierfibeln*) from Macedonia see *Olynthus* X, 107ff., pls 21, 23. Jacobsthal 1956, 204ff., figs 639-650. Amandry 1953, 56, nos 148-151, fig. 30, pl. 25. Amandry 1963, 203ff. n. 1, fig. 109. Kilian, op. cit., 155ff. Αικ. Ρωμιοπούλου, *ΑΔ* 29, 1973/74, Χρονικά, 677, pl. 488α top right. *Treasures* 1979, no. 47, pl. 10. Higgins 1980, 133, pl. 31E. Philipp 1981, 315ff., nos 1131-1134, pl. 22, 70. *Σίνδος* 1985, nos 63, 132-133, 484-485, 493-494, 516 et al. R. Vasić, *Godisnjak* 21, 1985, 121ff. (in the English summary 152ff.) with all the examples from the Balkans. On gold articulated fibulae see Amandry 1963, 203 n. 1. Vasić, op. cit., 153, 154. Μ. Μπέσιος - Μ. Παππά, *Πύδνα*, 1995, 70, fig. Β.

On the early articulated fibulae at Olympia: Philipp 1981, 315ff., nos 1128-1130. R. Vasić, *Godisnjak* 21, 1985, 153.

On the T-shaped catch-plate of fibulae of Phrygian type see Jacobsthal 1956, 206. *Emporio* 1967, 205ff., 210ff., types G-K, fig. 138, pl. 86. Sapouna-Sakellarakis 1978, 126ff., pls 52-53. Philipp 1981, 304ff., no. 1104, pls 22, 68-69. Higgins 1980, 120, pl. 22B.

On the interpretation as Omphale of the head with lionskin at the edge of arched fibulae: R. Zahn, *Amtliche Berichte* 35, 1913/14, line 74. G.M.A. Richter, *BMetrMus* 32, 1937, 295. Becatti 1955, 93, no. 396. K. Schauenburg, *RhM* 103, 1960, 62 with n. 29.

Head of Herakles on coins of Philip II and Alexander the Great: M. Price, *Coins of the Macedonians*, 1974, pls VIII-XI. Idem, *The Coinage in the Name of Alexander the Great*, 1991, 31. G. Le Rider, *Le mon-*

nayage d' argent et d' or de Philippe II, 1977, pls 1, 13, 27, 28 et al. On metal vases: *The Search* 1980, no. 165, col. pl. 32. Ανδρόνικος 1984, 155, figs 118-120. On the gilded plaques from the tomb at Katerini: Αικ. Δεσποίνη, *AAA* 13, 1980, 208. *Ancient Macedonia* 1988, 226-227. Cf. also C. Reinsberg, *Studien zur hellenistischen Toreutik*, 1980, 316, no. 45, figs 54-56.

On the use of articulated fibulae with hexalobe annulets until the 2nd century BC see M. Korkuti, *Iliria* II, 1972, 457ff., pl. III, 1-5. L. Ognenova-Marinova, *Proceedings of the Xth Intern. Congress of Classical Archaeology, 1973*, 1978, 990 with n. 5. Philipp 1981, 316 n. 538. R. Vasić, *Godisnjak* 21, 1985, 155.

Spectacle spiral brooches: Ανδρόνικος 1969, 121, 227ff., fig. 68, no. NIII8. K. Kilian, *PBF* XIV, 2, 1972, nos 1576, 1619, pls 56-57. Philipp 1981, 295ff., no. 1070, pls 21, 65. Ωνάσογλου, op. cit., 43. Four-spiral: Bielefeld 1968, 50, fig. 6k. Kilian, op. cit., pl. 58, no. 1715. Idem, *HamBeitrA* III/1, 1973, 28ff. Philipp, op. cit., no. 1087, pls 21, 67. Disc-shaped or shield-shaped: Higgins 1980, 120, pl. 22A. Philipp 1981, 303ff., nos 1102-1103, pl. 67. Shield-shaped of Hellenistic times: Higgins, op. cit., 171ff. Hoffmann - Davidson 1965, no. 74. B. Μισαηλίδου-Δεσποτίδου, *ΑΕΜΘ* 4, 1990, 131ff., fig. 13 top. *Ελληνικός Πολιτισμός* 1993, nos 336-337.

BRACELETS

Early bracelets: *Kerameikos* I, 86. Ανδρόνικος 1969, 241ff. Bielefeld 1968, 58ff. Philipp 1981, 195ff. Deppert-Lippitz 1985, 54, 64, 132, fig. 30. Guzzo 1993, 237, fig. II B1.

Bracelets from ʿSpata: Α. Φιλαδελφεύς, *ΑΔ* 6, 1920/21, Παράρτημα, 138, fig. 10 top. Bielefeld 1968, 58. Philipp 1981, 7, 223. On earlier oriental examples with snake heads see Segall 1938, 42 in no. 35. P.R.S. Moorey, *Cat. of Ancient Persian Bronzes in Ashmolean Museum*, 1971, 220.

Snake-head bracelets from Macedonia: *Olynthus* X, 68ff., nos 179-225, pls 12-13. Amandry 1953, 51ff. Amandry 1963, 239ff. *Σίνδος* 1985, nos 49, 60, 134, 310, 487, 495. Κ. Σισμανίδης in *Αμητός* 1987, 796, no. 5, 799, no. 4. From Olympia: Philipp 1981, 6, 22, 196, 222ff. See also Deppert-Lippitz 1985, 90ff., 131, 189, 234ff. Παπαποστόλου 1990, 106ff.

On gold bracelets with two snake heads see the bibliography in the description of fig. no. 189 and: Reinach 1892, 55, pl. XIV, 1 and 6. Amandry 1963, 239ff., fig. 141. Artamonov 1969, pl. 133. Παπαποστόλου 1990, 102, 106ff., no. 20, fig. 20. Idem, *ΑΔ* 33, 1978, Μελέται, 361, no. 4, pl. 111γ-δ.

Hellenistic snake bracelets and their significance: Segall 1938, 116 in no. 171. Philipp 1981, 196, 225 n. 430. Passages on snake bracelets from ancient literary testimonia are collected in L. Stephani, *CR-Pétersbourg* 1873, 53 n. 5, discussing the example in pl. III, 7.

Earlier examples of Hellenistic snake bracelets: Philipp 1981, 225 n. 430. A bracelet in the Prague Museum is dated to the late 4th century BC: I. Ondrejová, *Acta Univ. Carol. Philologica* 1, 1974, 95ff., no.

10, fig. 1, 3. See also Amandry 1953, 83, fig. 48c, 88 n. 5 (on the dating). Pfrommer 1990, 128. Cf. the earring Παπαποστόλου 1990, 112ff., 122, no. 29, fig. 29.

On the distribution and duration of Hellenistic snake bracelets see Segall 1938, 116 in no. 171. Amandry 1953, 118. Παπαποστόλου 1977, 314 with n. 236. Higgins 1980, 168, no. 5. Deppert-Lippitz 1985, 235. Pfrommer 1990, 126ff.

On the eastern provenance of bracelets with zoomorphic terminals: Segall 1938, 42 in no. 35. P. Amandry, AntK 1, 1958, 11ff. Philipp 1981, 6, 10. Pfrommer 1990, 95ff.

7th-century BC bracelets with zoomorphic terminals, from Rhodes: Laffineur 1978, 160, 238, nos 232-233, pl. XXVI, 1-3. Deppert-Lippitz 1985, 113, 132.

Earlier bracelets with twisted stem: A. Ωνάσογλου, ΑΔ 36, 1981, Μελέτες, 46ff. A. Ανδρειωμένου, ΑΔ 40, 1985, Χρονικά, 152 drawing 1ζ and finger rings: Παπαβασιλείου 1910, 77, pl. ΙΣΤ΄, no. 6. K. Kuruniotis, AM 38, 1913, 300ff., pl. 16, 6-9. See also Pfrommer 1990, 97ff.

Hellenistic band bracelets: Greifenhagen 1970, pl. 12, 1. Pfeiler-Lippitz 1972, 109ff., pl. 33. Higgins 1980, 168, no. 4, pl. 50B. Deppert-Lippitz 1985, 235ff., 271, 292, figs 172-173, 203-204, 224-225. Pfrommer 1990, 141, pl. 23, 2.

FINGER RINGS

On a gold ring of the Neolithic Age see Ancient Macedonia 1988, no. 8.

On early finger rings see Kerameikos V 1, 192ff., pl. 159 (M 44-46, M 72-73). Bielefeld 1968, 46ff., 59ff. Coldstream 1979, 33 (fig. 5b), 42 (fig. 10), 58 (fig. 14a), 64 (fig.19c). Philipp 1981, 139ff. Higgins 1980, 99ff., 104, 106ff.

Finger ring with filigree guilloche, from Athens: O. Αλεξανδρή, ΑΔ 22, 1967, Χρονικά, 80, pl. 80β bottom. On similar Mycenaean ones, here p. 275f.

On solid finger rings from the Submycenaean period onwards see Dawkins 1929, 199, pl. 85, Q-V. W.A. Heartley - T.C. Skeat, BSA 31, 1930/31, 34ff., figs 14-15, nos 6-7 and 19-21. Kerameikos I, 85, fig. 3 middle. Filow 1927, 13, no. 3, pl. 2, 1. Perachora I, 185, pl. 84, 36. A. Lebessi, BSA 70, 1975, 169 with n. 2, pl. 23c. Lefkandi I, 248, pls 95 (16, 14-16), 97 (17, 2-3), 99 (22, 5) et al.

Submycenaean and Geometric finger rings with elliptical bezels, similar to the bezels of Mycenaean rings: Kerameikos I, 86, fig. 5. Desborough 1972, 304, pl. 60c. Boardman 1967, 5. Idem, The Cretan Collection in Oxford, 1961, 37 with n. 1, fig. 18, nos 189-190. Idem,

Island Gems, 1963, 157, pl. XXh. R.A. Higgins, BSA 64, 1969, 144, pl. 34a. Lefkandi I, 247 (S 38, 10).

Gold finger ring with bezel, of about 700 BC: Boardman 1967, 5, pl. 1a and 1970, 154, 187, pl. 421. J. Boardman - M.-L. Vollenweider, Cat. Engraved Gems and Finger Rings in Ashmolean Museum, 1978, 11, 20, no. 59, pl. 11. Gold-sheet finger rings with rhomboid or elliptical bezel, of the 8th and 7th centuries BC, but with luxurious decoration, are known from Rhodes and Crete: G. Jacopi, ClRh III, 53, fig. 44. A. Lebessi, BSA 70, 1975, 169ff., pls 23a, 24. Higgins 1980, 110, 118, fig. 16.

'Cartouche-rings' and Archaic finger rings with intaglio devices: Boardman 1967, 3ff., fig. on p. 4 and 1970, 154ff., fig. 198. Philipp 1981, 152ff.

Bronze rings were also used for sealing, the gold ones perhaps only for adornment: Boardman 1970, 14, 236. Idem, Intaglios and Rings, 1975, 20. Boardman - Vollenweider, op. cit., 20.

The Minoan and Mycenaean rings with intaglio representation were usually hung round the neck or the wrist: Boardman 1970, 62 ff., 154, 429 as were scarabs outside Greece: Boardman 1967, 5. See also B. Rutkowski, Cult Places in the Aegean World, 1972, 60. Deppert-Lippitz 1985, 43. K. Δαβάρας, AE 1986, 48.

On the development of the schemas and the iconography of the intaglio representations: Boardman 1967, 3ff. and 1970, 155ff., 212ff., figs 198, 217. Higgins 1980, 131ff.

On the birth of the Greek portrait, with full bibliography, lately, E. Voutiras, Studien zu Interpretation und Stil griechischer Portraits des 5. und frühen 4. Jahrhunderts, 1980, 11ff. N. Himmelmann, Realistische Themen in der griechischen Kunst der archaischen und klassischen Zeit, 1994, 49ff.

On Dexamenos: Furtwängler 1900, 137ff. Boardman 1970, 194ff. On the attributing of unsigned sealstones to Dexamenos: E. Diehl, BerlMus 17, 1967, 44ff. Boardman 1970, 196ff.

On an eponymous engraver of sealstones and coin-dies: Boardman 1970, 236, 290, pl. 529. E. Zwierlein-Diehl, AntK 35, 1992, 106ff.

Swivel sealstones on finger rings: Boardman 1970, 237, 429. Higgins 1980, 131, no. 1. On the ornamental character of rings with sealstones: Boardman 1970, 14, 236.

Early finger rings with gems set in gold: Boardman 1970, 230, 237. Higgins 1980, 132 with n. 33 (= BMCR 1907, no. 350, fig. 71, pl. 10).

Several finger rings in one grave: A. Σκιάς, AE 1898, 106. Bielefeld 1968, 46, 59 and nn. 400, 543. Desborough 1972, 65. A. Ωνάσογλου, ΑΔ 36, 1981, Μελέτες, 35, 44. X. Σαμίου, ΑΕΜΘ 2, 1988, 476.

GENERAL INDEX

LIST OF MUSEUMS AND PRIVATE COLLECTIONS

The numbers in italics refer to the figures and the corresponding entries, those in roman type to the pages on which jewellery not illustrated is mentioned.

MUSEUMS

AGRINION, Archaeological Museum:
spiral earrings: 31, 219, 279

AIANI, Archaeological Museum:
pins 40, 255, 283
band earrings 32, 280

AMPHIPOLIS, Archaeological Museum:
3413: necklace *123-124*
3414: chain necklace *162*

ARGOS, Archaeological Museum:
3426, 3427: earrings *48*

ATHENS, Ancient Agora Museum:
J 145. J 147: finger rings *202*
J 148: earrings *59*

ATHENS, Benaki Museum:
1530: band diadem *22*
1532: earrings *77*
1548: diadem *32-33*

1549: diadem centrepiece *34*
1550: diadem 216
1554: necklace *155-156*
1562: earrings 236
1573: earring *70*
2062: pin *178-179*
2089: earrings 33, 224f.
2101: earrings *73-74*
6242: band diadem *19-20*
30011-30013: earrings 279

ATHENS, Canellopoulos Museum:
288: earrings *91*

ATHENS, Cycladic and Ancient Greek Art
 Museum:
609, 610: four-spiral beads 237, 281

ATHENS, National Archaeological Museum:
6285: earrings 34, 281
16487/88: earrings 280
A 10960: earrings *75*
A 10961: earrings 227
Χρ 10: necklace *119-120*
Χρ 147 (3534-3538): necklace plaques *110*
Χρ 687: finger ring *204*
Χρ 780: chain necklace *165-166*
Χρ 928: earrings *76*
Χρ 1041: necklace *130*

Χρ 1050: necklace *148-149*
Χρ 1058: Kastellorizo wreath 209
Χρ 1065: necklace pendants *112*
Χρ 1065α-γ: three pendants 238, 240
Χρ 1177-1181: rosettes from a diadem *13-18*
Χρ 1517: chain 23, 36, 39, 281
Χρ 1519: earrings 227
Χρ 1520: pendant *106*
Στ 169: earrings *64*
Στ 175: earrings *60*
Στ 177: band earring 32
Στ 181: earrings *66*
Στ 183: chain 39, 282
Στ 237: earrings *78*
Στ 260: fibula 258
Στ 294: earring *56*
Στ 297: earrings *58*
Στ 309: earrings *69*
Στ 318: pendant *111*
Στ 339: diadem *28-29*
Στ 340: necklace *151-152*
Στ 346A-B: bracelets *190*
Στ 353: diadem *36-37*
Στ 354: finger ring *218*

BERLIN, Antikenmuseum:
1960.1: fibula *187*
1963.6: fibula *188*
30219.453: fibula *186*

30219.515: finger ring *214*
30553: fibula *180*
31093: band diadem *11*
FG 287: finger ring *209*
GI 11 (Misc. 8399): necklace *118*
GI 15 (Misc. 8398): necklace *121*
GI 26 (Misc. 3079): necklace *160*
GI 141 (Misc. 1845 S.94): earring *52*
GI 165/6 (Misc. 7035): earrings *72*
Misc. 8943: necklace plaque *134*
Misc. 8946: necklace plaques *132*
Misc. 10823a-b: earrings *71*
Misc. 10823c: finger ring *208*

BOSTON, Museum of Fine Arts:
21.1213: finger ring *216*
98.788: earring with Nike 15, 229, 235
seal ring of Dexamenos 45, 265

CHIOS, Archaeological Museum:
earring 221

COPENHAGEN, Nationalmuseet:
861: necklace pendants *109*
12485: necklace plaque 239

CORINTH, Archaeological Museum:
6091: spiral earrings *47*

DELOS, Archaeological Museum:
B 517: pin *175*

DION, Archaeological Museum:
2119: myrtle wreath 209
2579: ivy wreath *1*

ERETRIA, Archaeological Museum:
8510A-B: earrings *44*
8644: earrings *68*
earrings with conical appendages *67*
band fragments from Lefkandi 28, 278
necklace with four-spiral beads 36, 237, 281

HERAKLEION, Archaeological Museum:
648: necklace *107*
656: pair of pins *169*
715: Fortetsa pins 40, 282
1024: Poros earring 33, 280
1234-1235: Tekes pins 40, 282
1294: Medical School beads 36, 281

1304: Tekes diadem band 28, 278
four-spiral beads from Idean Cave 237, 281

JERUSALEM, Israel Museum:
91.71.346: Trebizond earring 35, 281
91.71.347: necklace *150*

KAVALA, Archaeological Museum:
M 185 (1263): band diadem *25*
M 190: earrings 33, 281
M 1353-M 1356: necklace section *122*
M 2403: olive wreath *8*

KOMOTINI, Archaeological Museum:
1565: chain necklace *163-164*
1570: necklace *125*
Abdera finger ring: 259

KOZANI, Archaeological Museum:
bracelets 259

LONDON, British Museum:
958: pin *174*
1103: necklace plaques *131*
1128-1130: necklace plaques *133*
1160: band diadem *12*
1166: earring *51*
1173: earring *53*
1174/75: earrings *50*
1176: necklace *146*
1205: bracelet *194*
1240: earring 227
1245: earring *49*
1585/86: earring *54*
1653/54: earrings *79*
1655/56: earrings 35, 281
1889/1890: earrings *101*
1920.12-21.5-6: earrings 33, 281
1951: necklace *142-143*
1952: necklace *138-139*
1960.11-1.20-21: necklace (Elgin) *108*
1960.11-1.44-45: fibulae (Elgin) *181*
1985/86: bracelets *195-196*
1987/88: bracelets 260f.
2331: earrings *102*
2845-48: chain with fibulae 39, 282
3034: pin *176*
Gr 1894.11-1.454-6: Cyprus necklace 246
R41: finger ring *211-212*
R913: finger ring *217*

R1258: Nafkratis finger ring 264

LOS ANGELES, County Museum of Art:
M.47.6.1: earrings *45*

MÜNCHEN, Staatliche Antikensammlungen:
3711e: Lousoi earring 222

NEW YORK, Metropolitan Museum of Art:
06.1217.1: diadem *23-24*
06.1217.11-.12: Madytos earrings 35, 226, 229
06.1217.13: necklace *154*
08.258.49: earring *99*
37.11.9-.10: earrings *97*
37.11.11-.12: bracelets *198*
48.11.2-.3: earrings *82*
56.11.5-.6: bracelets *192-193*
58.11.5: diadem *35*
61.89A: finger ring 216
74.51.3392: Cyprus necklace 246

NICOSIA, Cyprus Museum:
earrings 221

OLYMPIA, Archaeological Museum:
Br. 1016: earring 222

OXFORD, Ashmolean Museum:
1885.479: bracelets 260f.
1885.482: necklace *137*
1885.483: earrings *55*
1885.484: finger ring 265
1885.492: finger ring *203*
1885.502: necklace *136*
1927.1329: earrings *46*
Corinth earrings: 31, 218, 280

PARIS, Musée du Louvre:
BJ 93 (MNC 1291): band diadem *9-10*
BJ 142: Thebes earrings 31, 218, 280
BJ 272: Bolsena earrings 35, 281

PATRAS, Archaeological Museum:
2141: necklace *128-129*

PFORZHEIM, Schmuckmuseum:
1957.12: bracelet *191*

PLOVDIV (PHILIPPOUPOLIS), Local

Archaeological Museum:
1538: earrings *57*
1641/42: earrings 221

SAINT PETERSBURG, Hermitage
 State Museum:
2492/2: necklace *141*
Art. 1: diadem *40*
Art. 6: necklace *168*
Art. 13: finger ring *219*
Art. 39: pin *177*
Art. 40: earrings *105*
BB 33: necklace *249*
BB 38: finger ring *206*
BB 114: earrings *86*
BB 124: finger ring *205*
Dn 1913.1/1: comb *41-43*
F1: earrings *85*
F2: necklace *153*
JuO 24: finger ring *210*
KO 6: earring *83*
KO 7: earring *84*
KO 20: bracelet *197*
P 1838.3: necklace *127*
P 1840.29: necklace *157*
P 1840.37: earrings *233*
P 1845.1: earrings *103*
P 1854.22: necklace *246*
Pav. 3: earrings *100*
TG 4: necklace *247*
X 1899.7: necklace *158-159*
X 1899.19: earrings 35, 226, 281
Fanagoreia finger ring 262
Nymphaion finger ring 262, 263

SOFIA, National Archaeological
 Museum:
6426-6428: necklace *126*
6128, 6189: bracelets 259
6136, 6192: necklace 243

TARANTO, Museo Archeologico Nazionale:
6.430 A-B: earrings *104*
22.437: diadem *38*
54.114: diadem *39*
54.115 A-B: earrings *95-96*

54.118: bracelet *199-200*
110.090: earring *88*

THESSALONIKI, Archaeological Museum:
753 (5432): earrings *65*
754: earrings 224
755: silver earrings 224
2831-2832: bracelets *201*
2837: chain necklace *167*
5410: diadem *26-27*
5412-5417: fibulae 258
5418: earring *90*
5420: finger ring *207*
7402-7403: Katerini plaques 43, 283
7418: Stavroupolis ornament 21, 275
7579: finger ring *215*
7580/81: fibulae *184-185*
7935: pair of pins *171*
7936: Sindos earrings 32, 280
7939-7943: necklace *116*
7944: pendants *115*
7958: Sindos earrings 32, 280
7962/63, 7966/67: necklace *117*
7964/65, 7967γ: necklace *114*
7970: chain necklace *161*
7971: pair of pins *173*
7972: necklace *135*
7975: earrings *62-63*
7976: fibulae *182*
7993: bracelets *189*
8045-8046: earrings *61*
8064-8065: Sindos earrings 32, 280
8079-8080: pair of pins *172*
8091: necklace *113*
8094: Sindos earrings 32, 280
8415: finger ring *220*
8719: silver chain 39, 282
10822: earring *92*
12207/8: earrings 31, 224, 279
B 136: diadem *21*
B 138: berry-bearing myrtle wreath *7*
Bε 10: circular diadem 31, 279
Bε 17: oak wreath *4*
Bε 70: flowering myrtle wreath *2*
Bε 75: Vergina diadem *30-31*
Bε 97: oak wreath *3*

Δ1: flowering myrtle wreath *5-6*
H4: earring *89*
Πυ 69: bracelet with snakes 259
Πυ 70: Pydna bracelet 262
Πυ 773: Pydna necklace 248
Z1: necklace *147*
Z2: necklace *144-145*
Z7: fibulae *183*
Z8: earrings *81*
Z9: finger ring *221*

VERGINA, IZ' Ephorate of Antiquities:
Λ II 6869: band earrings 32
Λ II 7677: bracelets 259
Λ II 7879: pins 40, 255, 283

VEROIA, Archaeological Museum:
1115: earrings *93*
M 1207: earrings *94*

VOLOS, Archaeological Museum:
M 36-M 48, M 55: necklace section *140*
M 49-50: earrings *87*
M 58: finger ring *213*
M 194-195: earrings *98*
M 197: bracelet 259
1708: Feres earring 222

VRATSA, Bulgaria, Local Historical Museum:
B 60: earrings *80*

VRAVRONA, Archaeological Museum:
1307, 2349, 2427: necklace plaques 239

PRIVATE COLLECTIONS

HERAKLEION, N. Metaxas Collection:
442: diadem *29*
1561/62: pair of pins *170*

NEW YORK, Herskovits Collection:
band earrings 32

STOCKHOLM, Carl Kempe Collection:
121: fibula 258

PHOTO CREDITS

Ekdotike Athenon expresses its thanks to the museums, private collections, publishing houses, photographers, photographic agencies and all others who have collaborated by kindly providing transparencies for the illustration of this volume. The numbers in italics refer to the illustrations.

ATHENS, Benaki Museum: *19-20, 22, 31-34, 70, 73-74, 77, 155-156, 178-179*

BERLIN, Staatliche Museen Preußischer Kulturbesitz - Antikenmuseum. © bpk 1993. Fotos I. Geske: *11, 71-72, 118, 134, 160, 186-188, 208-209, 214*, Fotos J. Laurentius: *52, 121, 180*. © bpk 1995. Foto J. Laurentius: *132*

BOSTON, Museum of Fine Arts. Frances Bartlett Fund, Donation of 1912: *216*

COPENHAGEN, Nationalmuseet - Department of Near Eastern and Classical Antiquities. Foto K. Weiss: *109*

JERUSALEM, Israel Museum. Bequest of Norbert Schimmel. Photo D. Harris: *150*

LONDON, British Museum: *12, 49-51, 53-54, 79, 101-102, 108, 131, 133, 138-139, 142-143, 146, 174, 176, 181, 194-196, 211-212, 217*

LOS ANGELES, County Museum of Art. Gift of Harvey S. Mudd: *45*

NEW YORK, The Metropolitan Museum of Art. © 1993. Harris Brisbane Dick Fund, 1937: *97, 198*. Purchase, Joseph Pulitzer Bequest, 1958: *35*. Rogers Fund, 1906: *23-24, 154*, 1908: *99*, 1948: *82*, 1956 (Photos S. Lee): *192-193*

OXFORD, Ashmolean Museum - University of Oxford: *46, 55, 136-137, 203*

PARIS, Musée du Louvre. © Photos R.M.N.: *9-10*

PFORZHEIM im Reuchlinhaus, Schmuckmuseum. Foto G. Meyer: *191*

SAINT PETERSBURG, Hermitage State Museum. Photos V. Terebenine: *40, 85-86, 100, 103, 105, 127, 153, 157-159, 168, 177, 205, 210, 219*

THESSALONIKI, Archaeological Museum: *2, 81*

AURORA ART PUBLISHERS (Saint Petersburg)
Hermitage State Museum: *206*

ARTEPHOT (Paris). Photos V. Terebenine
Saint Petersburg, Hermitage State Museum: *83-84, 141, 197*

L. PEDICINI (Naples)
Taranto, Museo Archeologico Nazionale: *39, 95-96, 104, 199-200*

SCALA (Florence)
Taranto, Museo Archeologico Nazionale: *38, 88*

V. VITANOV (Sofia)
Plovdiv (Philippoupolis), Local Archaeological Museum: *57*
Sofia, National Archaeological Museum: *126*
Vratsa, Local Historical Museum: *80*

D. BENETOS (Athens)
Athens, National Archaeological Museum: *110*
— Museum of the Ancient Agora: *59*
Corinth, Archaeological Museum: *47*
Delos, Archaeological Museum: *175*
Eretria, Archaeological Museum: *67*
Volos, Archaeological Museum: *87, 98, 213*

S. CHAIDEMENOS (Thessaloniki)
Kavala, Archaeological Museum: *8, 25, 122*
Komotini, Archaeological Museum: *125, 163-164*
Veroia, Archaeological Museum: *93-94*

I. ILIADIS (Athens)
Herakleion, Archaeological Museum: *107, 169*

N. KONTOS (Athens)
Patras, Archaeological Museum: *128-129*
Thessaloniki, Archaeological Museum: *4*

R. PARISIS (Athens)
Athens, National Archaeological Museum: *13-18, 28-29, 36-37, 56, 58, 60, 64, 66, 69, 75-76, 78, 106, 111-112, 119-120, 130, 148-149, 151-152, 165-166, 190, 204, 218*
— Museum of the Ancient Agora: *202*
— Canellopoulos Museum: *91*
Dion, Archaeological Museum: *1*
Eretria, Archaeological Museum: *44, 68*
Thessaloniki, Archaeological Museum: *3, 5-7, 21, 26-27, 61-63, 65, 89-90, 92, 113-117, 123-124, 135, 144-145, 147, 161-162, 167, 171-173, 182-185, 189, 201, 207, 215, 220-221*
Volos, Archaeological Museum: *140*

V. TSONIS (Athens)
Argos, Archaeological Museum: *48*

G. XYLOURIS (Herakleion)
Herakleion, N. Metaxas Private Collection: *170*